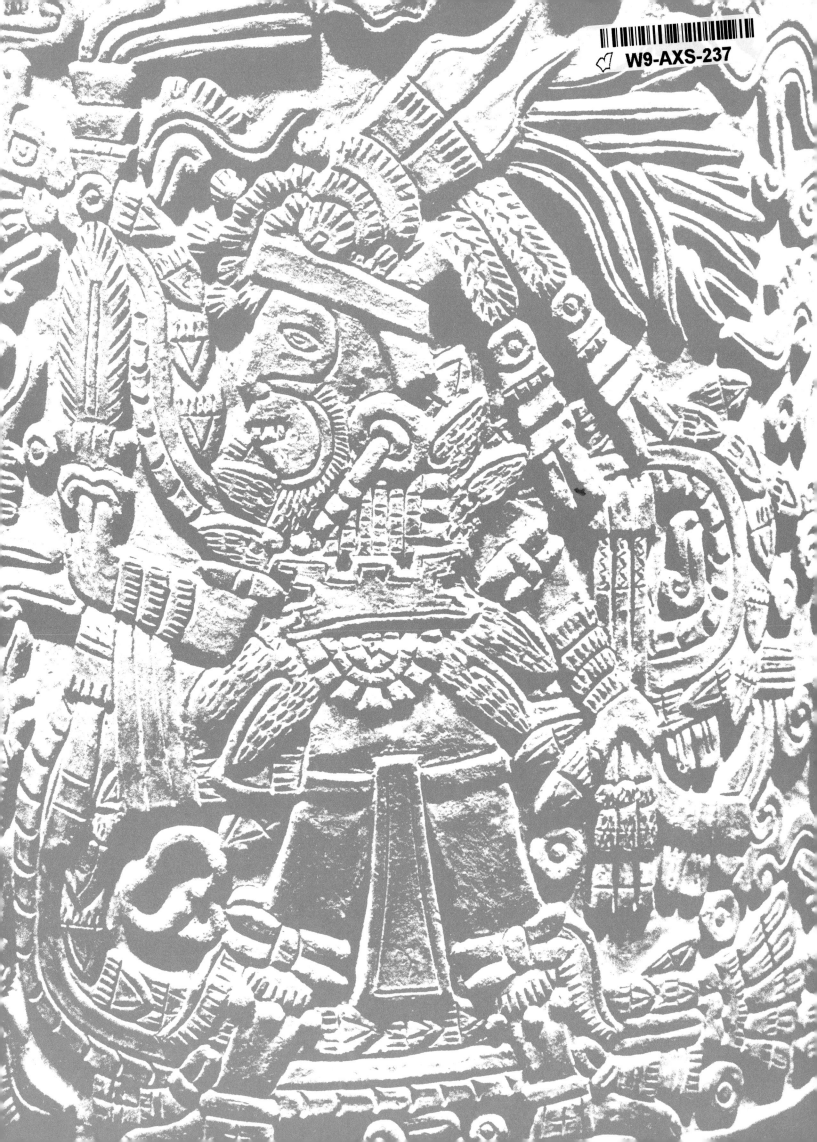

ART OF AZTEC MEXICO
Treasures of Tenochtitlan

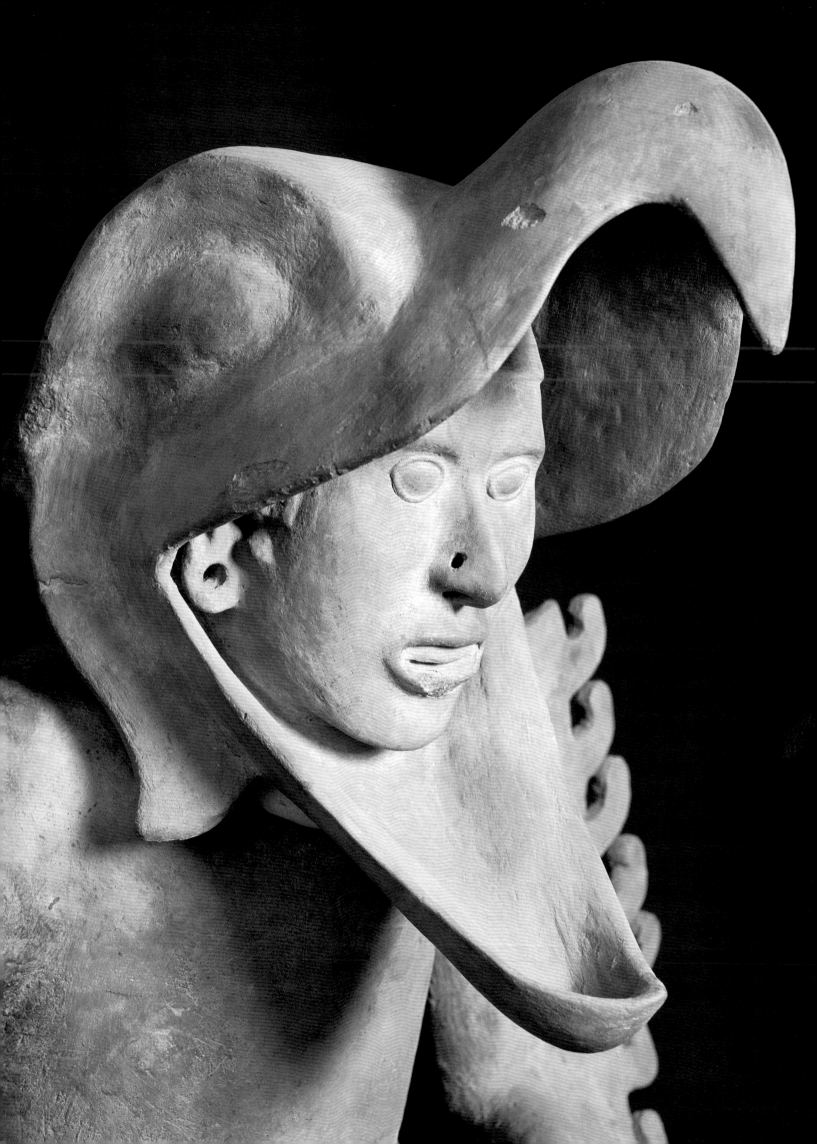

ART OF AZTEC MEXICO
Treasures of Tenochtitlan

H. B. NICHOLSON
with
ELOISE QUIÑONES KEBER

NATIONAL GALLERY OF ART, WASHINGTON

This exhibition has been generously supported by a contribution from the GTE Corporation

Library of Congress Cataloging in Publication Data
Nicholson, Henry B.
 Art of Aztec Mexico.
 Catalog of an exhibition at the National Gallery
of Art.
 Bibliography: p.
 1. Aztecs—Art—Exhibitions. 2. Indians of
Mexico—Mexico City—Art—Exhibitions. I. Keber,
Eloise Quiñones. II. National Gallery of Art (U.S.)
III. Title.
F1219.76.A78N5 1983 730'.0972'53 83-17217
ISBN 0-89468-070-6

Contents

Foreword

AZTEC CULTURE HAS BEEN THE SUBJECT OF SCHOLARLY CURIOSITY since the Spanish Conquest of the New World in the sixteenth century. A vast body of surviving ethnohistorical records and many archaeological excavations have revealed the nature of Aztec society more clearly than that of any other pre-Columbian people. Indeed, the Aztecs had become so familiar by the twentieth century that interest in them waned, and archaeologists, anthropologists, and art historians turned their attention to other, less well-known cultures of pre-Columbian Mesoamerica. From 1978 to 1982, however, excavations in downtown Mexico City gave new impetus to Aztec research. The discovery of the ritual heart of the Aztec empire—the Templo Mayor and the sacred precinct of Tenochtitlan—has brought to light much new information that both alters and confirms our views of Aztec religion, art and architecture, politics, and economics.

In the fall of 1981, Dumbarton Oaks, Harvard University's research center in Washington for Byzantine and pre-Columbian studies and the history of landscape architecture, began to make plans for a scholarly symposium in the fall of 1983 on the results of the Templo Mayor excavations. There was also discussion of a small exhibition of objects from the archaeological site. By summer 1982, when Professor Eduardo Matos Moctezuma, Coordinator of the Templo Mayor project, came to Washington to organize the conference with Professor George Kubler of Yale University, Professor Gordon Willey of Harvard, and Dr. Elizabeth Boone of Dumbarton Oaks, the Mexican embassy had become interested in the plans. Counselor Alberto Campillo in particular proposed a larger and more comprehensive exhibition, a suggestion which was supported by the new ambassador to the United States, His Excellency Bernardo Sepúlveda. This idea of a major presentation of Aztec art was captivating, for there has never been a truly representative survey displayed outside of Mexico. Since it would have been impossible to mount an exhibition of this size at Dumbarton Oaks, the National Gallery of Art was approached and was delighted to join in the undertaking. *Art of Aztec Mexico: Treasures of Tenochtitlan* is the result of much collaborative and cooperative effort.

Dr. Elizabeth Boone, Curator of the Pre-Columbian Collection at Dumbarton Oaks, has served as coordinating curator for the show, working with Professor H. B. Nicholson of the University of California at Los Angeles to select the objects to be included. We are grateful to Professor Nicholson for helping to organize the exhibition and its presentation, and for writing the catalogue with the collaboration of Eloise Quiñones Keber of Columbia University. George Kubler agreed to add a preface to the catalogue.

At the National Gallery the organization and administration were carried out by Gaillard F. Ravenel, Mark Leithauser, and Dodge Thompson. The exhibition was designed by Gaillard F. Ravenel and Mark Leithauser, in consultation with H. B. Nicholson and Elizabeth Boone. Also at the National Gallery, Victor Covey, Cameran Greer, José Naranjo, Frances Smyth, and Mei Su Teng participated in the preparation of the exhibition and the catalogue.

Throughout the planning and presentation of the exhibition we have been fortunate to have had strong support and close cooperation from the Mexi-

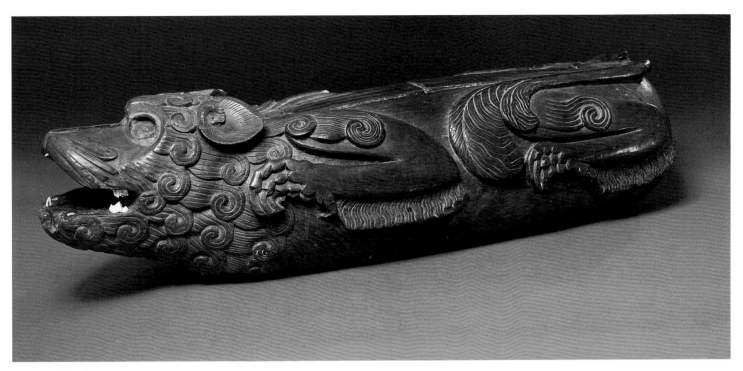

Zoomorphic slit gong, no. 63

can Office of the Secretary of Foreign Affairs, Office of the Secretary of Public Education, and the embassy in Washington. The continued personal interest of Ambassador Sepúlveda, who in 1982 became Secretary of Foreign Affairs, has been crucial for the show's success, as has the support of Lic. Jesús Reyes Heroles, Secretary of Public Education, and the active role of His Excellency Jorge Espinosa de los Reyes, who put the services of the embassy at our disposal. Lic. Ricardo Valero Bercerra, Subsecretary for Cultural Affairs, and Dra. Luz del Amo, Director General of Cultural Affairs, of the Office of the Secretary of Foreign Affairs; and Lic. Juan José Bremer M., Subsecretary for Culture and Recreation in the Office of the Secretary of Public Education, helped immensely with the project. Particular thanks are also due to Minister Walter Astie-Burgos, who gave valuable advice and assistance, and to Alberto Campillo, who was involved from the beginning in all phases of the planning and has continued to work on behalf of the exhibition even after leaving the embassy in Washington.

The exhibition could not have been possible without the close collaboration of the National Institute of Anthropology and History of Mexico. Shortly after Dr. Enrique Florescano assumed the directorship of the Institute, he endorsed the plans for the exhibition, and he has continually given it his full support. He joins us in thanking the directors of the Mexican museums and projects that have lent objects to the show, especially Lic. Salomón González Blanco of the Templo Mayor and Mtro. Mario Vásquez of the Museo Nacional de Antropología, who agreed to the loan of many of the finest treasures of his museum and who oversaw the loans of all the objects from Mexico. Mtro. Vásquez was ably assisted by Mtra. Marcia Castro-Leal, Subdirectress of the Museo, and Mtro. Felipe Solís Olguín, curator of the museum's Mexica collection. We are also grateful to Dr. Valentín Molina Piñeiro for the loan of a piece from the Fundación Cultural Telavisa.

The support among museums both in the United States and Europe has been gratifying, for the directors and curators of the major pre-Columbian collections enthusiastically agreed to participate by sending some of their most famous pieces. In this respect we wish to thank our colleagues William Andrews, Gerhard Baer, Henning Bischof, Piergiuseppe Bozzetti, Elizabeth Carmichael, Claudio Cavatrunci, Dieter Eisleb, Gordon Ekholm, Diana

Fane, Christian Feest, Heinz Fischer, Anna-Marie Foote, Jean Guiart, Wolfgang Haberland, David Joralemon, Julie Jones, Kurt Krieger, Hans Manndorff, John Nunley, Betsy Olsen, Valeria Petrucci, Anna Roosevelt, Charles Rozaire, Mireille Simoni-Abbat, Gordon Willey, David Wilson, Fausto Zevi, and Jürgen Zwernemann.

We also wish to express our gratitude to the Honorable John Gavin, American ambassador to Mexico, for his important participation in the negotiations with officials in that country, and for the assistance of the embassy's cultural affairs office, especially through Sidney Hamolsky and Robert L. Chatten. In Switzerland too, American ambassador John Davis Lodge and cultural affairs officer Robert McLaughlin were extremely helpful. Dumbarton Oaks especially is indebted to the French ambassador to the United States, M. Bernard Vernier-Paillez; his predecessor, M. François de Laboulaye; the American ambassador to France, the Honorable Evan G. Galbraith; the cultural staffs of the two embassies; and in particular Professor Jacques Soustelle for their support on behalf of the exhibition. In Rome we wish to thank Nicola Vernola and the Ministry of Cultural Patrimony for their particular help with crucial loans.

The response of scholars and curators has shown us that an exhibition such as *Art of Aztec Mexico: Treasures of Tenochtitlan* has long been desired by the pre-Columbian scholarly community. Our hope to bring together in Washington and present to the public the finest of both known and newly discovered works of Aztec art has to a great extent been realized. Although inevitably a few great pieces could not be included owing to their size or condition, the exhibition affords visitors the opportunity to see familiar masterpieces like the colossal jaguar *cuauhxicalli* from the Museo Nacional de Antropología as well as magnificent new discoveries like the ceramic eagle warrior from the Templo Mayor, a work which has never before been on view away from the excavation site. *Art of Aztec Mexico* is supported by an indemnity from the Federal Council on the Arts and the Humanities, which was secured through the efforts of Alice Martin of the National Endowment for the Arts' Office of Museum Programs. We are honored to be offering it under the generous sponsorship of the GTE Corporation and wish especially to thank its chairman, Theodore F. Brophy, for his continuing interest. Presented under the special patronage of President Ronald Reagan of the United States and President Miguel de la Madrid of Mexico, this exhibition is meant to allow the world to share in the cultural riches of Mexico's Aztec past.

J. CARTER BROWN
Director, National Gallery of Art

GILES CONSTABLE
Director, Dumbarton Oaks

Mask of Tezcatlipoca, no. 35

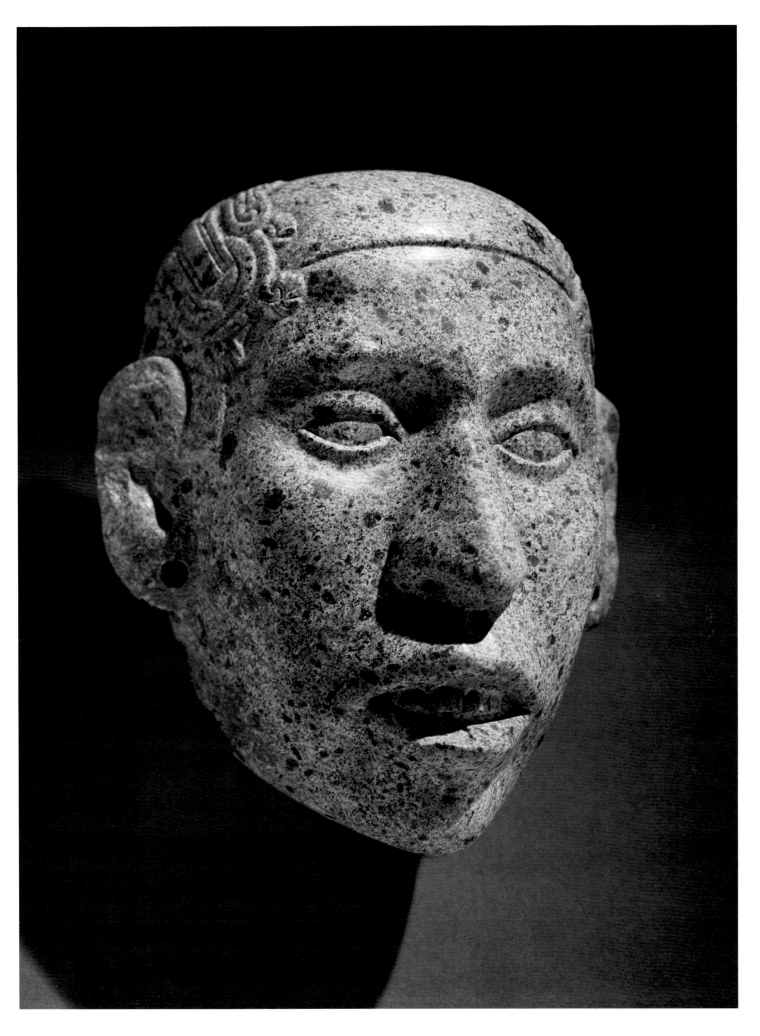

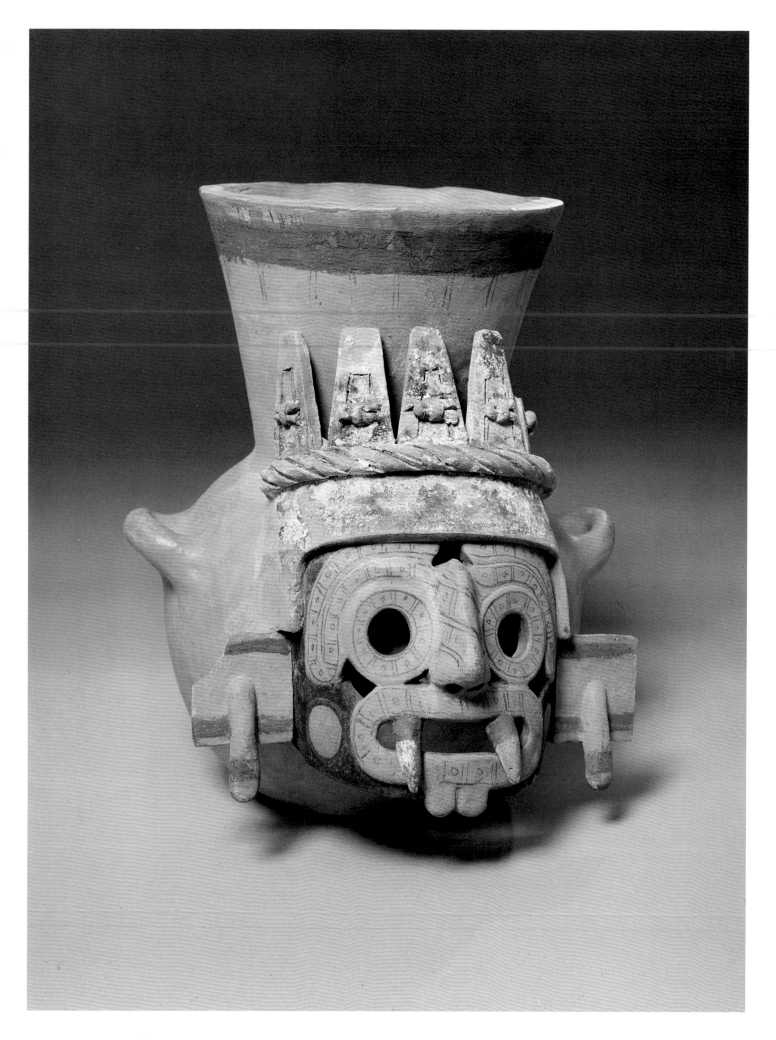

Preface

THE AZTECS ARE THE BEST-KNOWN PEOPLE AMONG THE MANY that contributed to the creation of the cultural multiethnicity of today's Mexico. Invaders of the Mexican Valley, mysterious region with a long historical tradition, in less than two centuries (1325-1521) the Mexicas assimilated the basic elements of that culture, became the most powerful nation in Mesoamerica, and made their capital Mexico-Tenochtitlan the political and cultural center of their time. Aztec art, one of the mightier expressions of this nation of conquerors, stands out because of its majestic architecture and monumental sculpture, which awed both the indigenous nations subdued by the Mexicas and the Spaniards who knew it in its splendor.

The person who today shares that awe while visiting this exhibition is the beneficiary of a difficult process of appreciation and protection of a cultural patrimony. That which is now considered beautiful and extraordinary, unique work which widens our understanding of men and cultures different from ours, was in other ages destroyed by those who saw in it the essence of evil, or plundered and moved it from the cultural environment which would have facilitated its scientific appreciation, or called it monstrous and classified it as second-rate.

In order to preserve and assimilate our inheritance, we Mexicans had to break with classical standards of beauty and create an aesthetic and scientific openness which would encourage appreciation of these works within their own cultural context. Museums were created to avoid dispersion of this inheritance; scientific institutions founded and specialists trained to study it; and a body of legislation enacted to assure its preservation as a permanent patrimony of Mexico and the world at large as well.

Art of Aztec Mexico: Treasures of Tenochtitlan has been put together with many of the most important works from the Aztec Room of the Museo Nacional de Antropología in Mexico City and some of the more recent discoveries from the Templo Mayor of the ancient Aztec capital, Mexico Tenochtitlan. The people and the government of Mexico are pleased to share with the people of the United States, in the superb setting of the East Wing of the National Gallery, this display of archaeological treasures from one of the greatest Mesoamerican cultures. It is our hope that an exhibition devoted to the artistic roots which give life to the contemporary personality of our country will serve to increase understanding and respect between our neighboring nations.

DR. ENRIQUE FLORESCANO, *Director*
National Institute of Anthropology and History
Mexico City

Tlaloc effigy vessel, no. 28

Lenders to the Exhibition

American Museum of Natural History, New York
The Brooklyn Museum
Dumbarton Oaks, Washington, D.C.
Mrs. Dudley T. Easby, Jr.
Fundación Cultural Televisa, Mexico City
Thomas Gilcrease Institute of American History and Art,
 Tulsa, Oklahoma
Hamburgisches Museum für Völkerkunde, Hamburg
Instituto Nacional de Antropología e Historia, Mexico
 Museo Nacional de Antropología
 Proyecto Templo Mayor
Los Angeles County Museum of Natural History
The Metropolitan Museum of Art, New York
Musée de l'Homme, Paris
Museo Arqueología del Estado de México, Tenango
Museo Nazionale Preistorico ed Etnografico Luigi Pigorini, Rome
Museo Regional de Puebla, Mexico
Museum für Völkerkunde, Basel
Museum für Völkerkunde, Vienna
Museum of the American Indian, Heye Foundation, New York
Museum of Mankind, The British Museum, London
Peabody Museum of Archaeology and Ethnology,
 Harvard University
The St. Louis Art Museum
Staatliche Museen Preussischer Kulturbesitz, Museum für
 Völkerkunde, West Berlin
The Time Museum, Rockford, Illinois
Völkerkundliche Sammlungen der Stadt Mannheim im
 Reiss-Museum, Mannheim

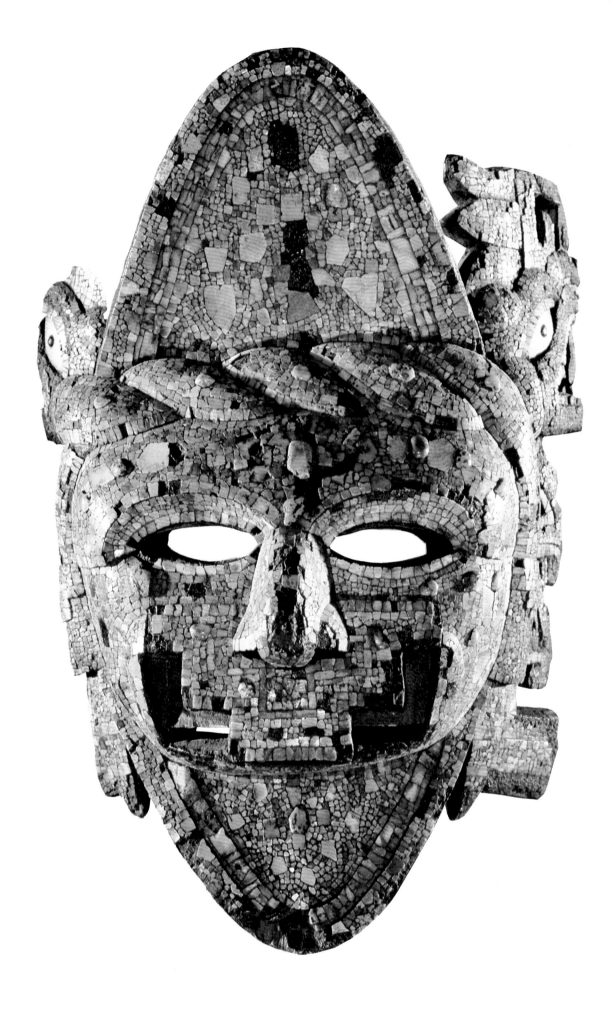

Mosaic mask, no. 84

Preface

GEORGE KUBLER

AS TO THE REMOTE PAST of that fourth of the globe called America, the indifference of the United States (of North America) has long been noted, in the absence of a word encompassing native America.

"America" comes from Amalric, a name of the Visigothic kings who ruled in Spain and France in the sixth century. It means "mighty laborer" in Old High German, and it continues in use today in France as Amaury and in Italy as Amerigo. But it was applied to the New World by a German geographer in 1507, Martin Waldseemüller, to honor Vespucci with its sound, then less common in Spain than in Italy. This navigator and astronomer wrote of the coasts from Honduras to Florida that they were the continent of Asia. He named Brazil in 1501-1502 as *Mundus Novus,* being unaware of an "Indian" history and cosmography, which had eras of 20,000 years, or of an archaeology now embracing at least 45,000 years.

Latin America now is a name of convenience for most of the Americas. Amerindian art is a term of so recent a coinage that no one yet has objected to its presence.

Art of Aztec Mexico: Treasures of Tenochtitlan comes forty-three years after *Twenty Centuries of Mexican Art* at the Museum of Modern Art, and thirteen years after *Before Cortés* at the Metropolitan Museum of Art. The National Gallery of Art for years displayed the pre-Columbian collection of Robert Woods Bliss before its transfer to Dumbarton Oaks in 1962-1963. In 1982 *Between Continents/Between Seas: Pre-Columbian Art of Costa Rica* appeared in the East Building.

This year *Art of Aztec Mexico: Treasures of Tenochtitlan* brings us to consider two leading questions: what is its museological purpose; and why is it of importance to our theory of art now?

As to the role of the museum, without this exhibition we would lose the timely chance to show the *tragic other side* of all Old and New World art. Most museums offer the pleasures of existence, but the *Art of Aztec Mexico* at the National Gallery offers other thoughts: 1) this art is that of an empire at its capital and in its central shrines during the course leading to its destruction; 2) its message comes from the hidden, lost energy of an art of *tragic necessity* based on human sacrifice.

We have lived with equally tragic human sacrifices since 1914, and we will cease to live with them only when there are no wars, because all are dead.

Aztec Mexico is the tragic model. The human fault placed human sacrifice as the eucharist that would keep the gods of war alive. Without knowing it, we are repeating that cycle. This theme has no place in a garden of pleasure, but it does belong in the place where aesthetic experience takes moral form among thinking people.

As to the place of the exhibition in art theory today, Ludwig Wittgenstein in this century openly recognized language as "a form of life," and Richard Wollheim extended this perception to art: "the content of art is not some state of affairs in the world, but that state of affairs permeated by art." Hence the autonomy of art appears as a form of life—as *sui generis*—yet "socially embedded."

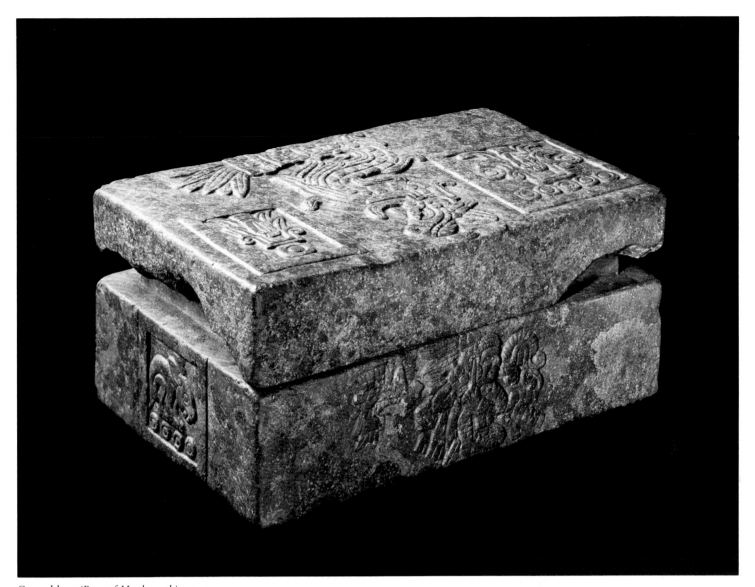

Carved box (Box of Hackmack), no. 15

This analogy between language and art suggests further that the difficulty of comprehending an unfamiliar work of art parallels that of understanding another culture. As Michael Podro recently put it, "art itself sets up . . . complex and irregular movements of thought" which cannot "be gathered into a single system or perspective" (*The Historians of Art* [1982], 217). He also defines the functions of art criticism as "the retrieval of past art for the present and the relation of art to the mind's freedom."

Let us all now wish the exhibition a secure hold on the present, which must not again return to willed human sacrifice, so common in Amerindia, and expanding over at least twenty centuries, until the sudden end in Tenochtitlan.

Knotted rattlesnake, no. 55

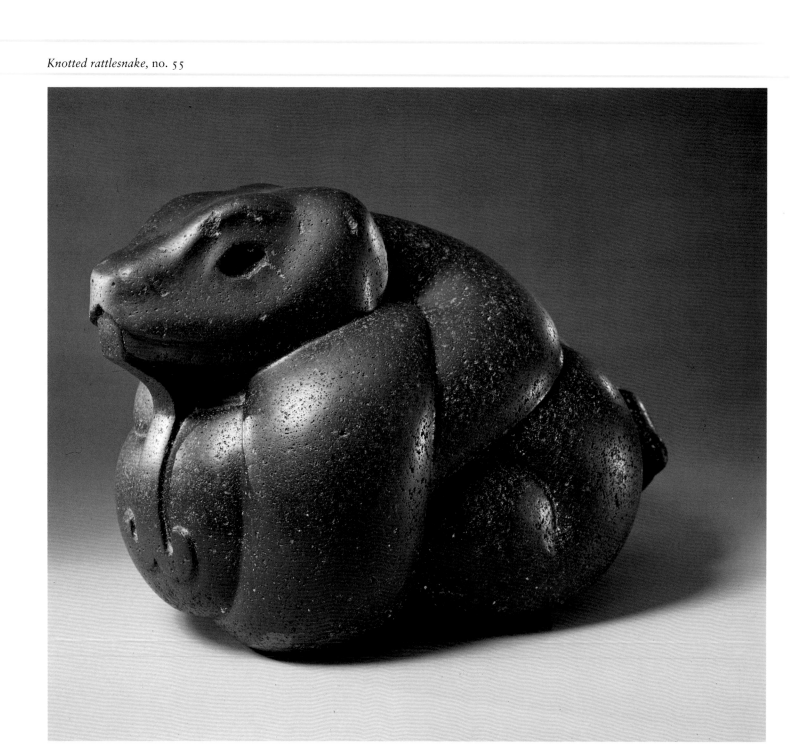

Introduction

The Discovery of Aztec Art

IN THE LATE AFTERNOON OF 13 AUGUST 1521, Cuauhtemoc, the *Huey Tlatoani,* the "Great Speaker" of Mexico Tenochtitlan, was escorted before Hernando Cortés, commander of a small army of Spanish invaders who had kept his city under siege for seventy-five days. Once the glittering capital of a great empire, a New World Venice interlaced with canals and studded with temples, palaces, and gardens, it now lay devastated, the broken shell of its former greatness. Cuauhtemoc formally surrendered to his antagonist, and then, pointing to the dagger on the Spaniard's belt, requested that Cortés use it to end his suffering, to send him to his eternal rest with his Lord the Sun—the fitting and desired fate of any courageous Aztec warrior. Cortés, in a magnanimous mood after his hard-won victory, accepted Cuauhtemoc's surrender, promising him and his family no harm. Quickly the word spread throughout the remnant of the great city where flurries of desperate, last-ditch resistance continued, that the Lord of Men had lowered the shield. All combat ceased. The glory and power of the Mexica of the twin cities of Mexico Tenochtitlan and Tlatelolco, the chosen people of Huitzilopochtli, had ended. While still in the distant north before their long trek to the Basin of Mexico, their god had promised them a great destiny. They had achieved it, and now it was over. A new power, one that had materialized unexpectedly from across the eastern sea, bringing a different ideology, technology, and way of life, now ruled the land.

Soon a great European-style city arose directly upon the ruins of the old, expressing different architectural and artistic canons. The art and architecture of the Indian capital and that of the many others it had once ruled were smashed and despised, for pre-Hispanic aesthetic expression had been created and employed, above all, to convey the concepts of a religious-ritual system that the new masters were determined to obliterate. Thus began the long sleep for the broken stones of Mexico. The destruction continued even long after the conquest, for around the turn of the seventeenth century the archbishop of Mexico ordered that various monumental sculptures incorporated into the houses of the Spaniards and still visible be disfigured and destroyed. And as late as the middle of the eighteenth century, the century of the Enlightenment, the well-preserved cliff portrait sculpture of the last pre-Hispanic ruler of Mexico Tenochtitlan, Motecuhzoma II, at Chapultepec, the Hill of the Grasshopper just west of the capital (fig. 1), was savagely mutilated, again by orders of the ecclesiastical authorities.

Then a certain turning point came almost exactly three centuries after the discovery of America. In 1790, during the repaving of the central square of the City of the Palaces, two extraordinary monuments were discovered—the colossal, macabre idol of Coatlicue, mother of Mexico's Tenochtitlan's patron god, Huitzilopochtli (fig. 2), and that masterpiece of intricate concentric patterning, the great image of the solar disk, the "Calendar Stone" (fig. 3). The following year another enormous "sun stone," the Cuauhxicalli of Tizoc commissioned by Motecuhzoma's predecessor and uncle, came to light (fig. 4). An enlightened viceroy ordered all three monuments to be preserved, although after a time when offerings were discovered laid down before it, the great Coatlicue idol

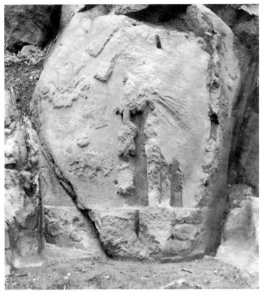

fig. 1 Mutilated cliff sculpture of the ruler Motecuhzoma II at Chapultepec.

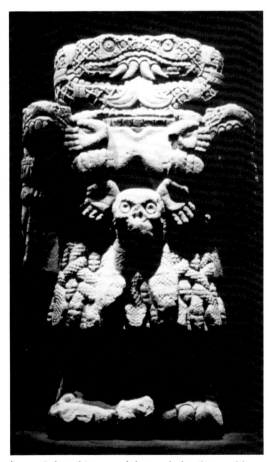

fig. 2 Colossal image of the earth-fertility goddess Coatlicue. Museo Nacional de Antropología, Mexico City.

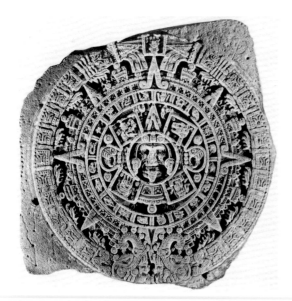

fig. 3 "Calendar Stone." Museo Nacional de Antropología, Mexico City.

was buried to hide it from too adoring eyes. The Calendar Stone, set into the southwest tower of the cathedral, did not suffer this fate. On the contrary, believed to incorporate in its complex iconography much of the calendric wisdom of the ancients, it became the subject of a detailed interpretation by Mexico's leading astronomer of this period, Antonio León y Gama.

Not long afterward in 1803, the famed Prussian scientist and explorer Alexander von Humboldt, "the scientific discoverer of the New World," arrived in New Spain. Excited by the Calendar Stone and other ancient wonders, he later published in 1813 an album of prints partly devoted to Mexican archaeology, which was instrumental in awakening a more serious interest in the ancient cultural heritage of the country. Soon after Humboldt's visit the king of Spain, the cultivated Bourbon Charles IV, commissioned an enthusiastic amateur antiquarian, the Walloon ex-captain of Spanish dragoons Guillermo Dupaix, to conduct between 1805 and 1808 a three-expedition survey of Mexican ruins and antiquities. Although publication of his not inconsiderable results was delayed by the War of Independence (1810-1821), Dupaix' efforts were not completely in vain, for the accounts of his three expeditions and versions of the illustrations prepared by his traveling companion, the Mexican artist Luciano Castañeda, were finally published in London in 1831 and in Paris three years later. As with the earlier work of Humboldt, this well-illustrated work stimulated a greater appreciation of ancient Mexican civilization.

When after 1821 the Spanish "iron curtain" was finally lifted and a steady flow of foreign travelers began to appear in Mexico, interest in the country's past was further encouraged. As early as 1794 Dupaix had compiled a crudely illustrated but extensive album of Mexican archaeological pieces, many discovered in the capital itself. In connection with his researches concerning the three great monuments found in the Zócalo in 1790-1791, León y Gama also drew up a similar list of archaeological finds in Mexico City that was published posthumously in 1832. During the two or three decades before and after Independence the first sizable collections of Mexican archaeological pieces were formed, with emphasis on the aesthetically more attractive Aztec specimens. Both residents and foreigners joined in the scramble to acquire these intriguing manifestations of the pre-Hispanic culture. Earlier collectors worth noting include León y Gama and Dupaix; Ciriaco Gonzáles Carvajal, a Spanish official; Humboldt during his 1803-1804 visit; and after Independence, William Bullock, the enterprising English showman who took the first substantial Aztec collection back to England; Latour-Allard, the French

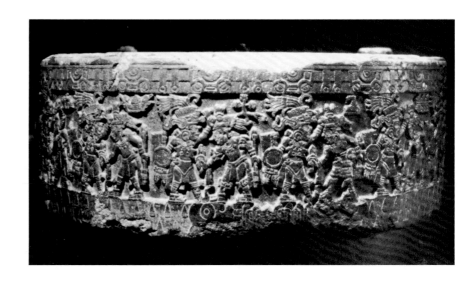

fig. 4 *Cuauhxicalli* of the ruler Tizoc. Museo Nacional de Antropología, Mexico City.

artist who similarly carried the first sizable collection of Aztec pieces to France; Jean Frédéric Maximilien de Waldeck, the most colorful and certainly the longest lived of these early collectors; Lukas Vischer, Swiss businessman and artist, whose important collection reached Switzerland as early as 1837; José Mariano Sánchez y Mora, ex-Conde de Peñasco, whose large collection much impressed the American visitor, Brantz Mayer, in 1841; and the German merchant, Carl Uhde, who amassed the largest private Aztec collection probably ever compiled before he returned to Heidelberg with it in mid-century. Most of these early collections eventually enriched the archaeological holdings of the British Museum, the Musée du Louvre, and the museums für Völkerkunde in Basel, Vienna, and Berlin, as well as other leading European museums.

Occasionally, important pieces from these collections were published, but rarely in any sustained or systematic way. However, the presence of these sizable European collections so conveniently at hand played a considerable role in the emerging perception of the artistic achievements of the Aztecs. Nevertheless, in the second half of the century when the major ethnographic museums of Europe and the United States were being more formally organized, Aztec objects, along with those of other advanced Mesoamerican traditions, including that of the Maya, were almost invariably consigned to these repositories as examples of the "material culture" of "primitive" or "non-literate" peoples. At this time the leading art museums normally did not mount important permanent displays of Mesoamerican pieces.

In Mexico itself a national museum that focused particularly on archaeology was formally established as early as 1825. It was not, however, until over sixty years later (1887) that a suitable display facility was opened to the public, in the structure that had been used as the mint in colonial times, part of the complex of buildings constituting the National Palace—built over the ruins of the palace of Motecuhzoma II. By this time the Aztec collection that was its centerpiece had grown to impressive proportions. It comprised all of the larger monuments that had been found up to then in Mexico City, including the Calendar Stone that was now moved to it. Although the aesthetic aspect was not particularly stressed either in the display formats or in the labeling, no other museum in the world came close to exhibiting so many important Aztec pieces. The notable concentration in the famous long, high room called the "Salón de los Monolitos" became a prominent tourist attraction in Mexico City from that time on.

In 1900 its collection was considerably enriched by the extensive finds of late Aztec material made during the construction of a sewer line along the Calle de las Escalerillas (present-day Calle de Guatemala), north of the cathedral of Mexico City in an area once included within the Great Temple (Templo Mayor) precinct of Mexico Tenochtitlan. Salvaged by Leopoldo Batres, General Inspector of Archaeological Monuments, these discoveries, which were widely reported in local and foreign publications, created quite a stir and directed attention to the abundant remains of the ancient Aztec capital underlying the modern city. The next year one of the most striking Aztec monumental sculptures, the colossal jaguar with a receptacle for human hearts, was found one block to the north. At this time it was still generally believed that the Great Temple had been located where the cathedral now stands. In 1913, however, the accidental exposure to the east of the cathedral of the southwest corner of the Great Temple conclusively demonstrated its actual location and led to the first systematic archaeological excavation in Mexico City, supervised by Manuel Gamio. Sixty-five years later, another chance discovery, the gigantic relief sculpture of Huitzilopochtli's sorceress half-sister

fig. 5 Relief sculpture of the goddess Coyolxauh-
qui. Templo Mayor of Mexico Tenochtitlan.

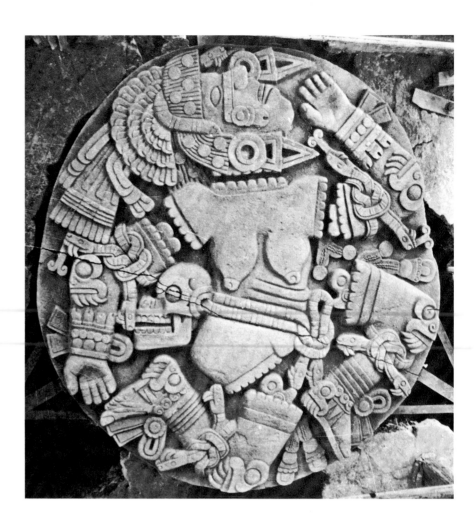

Coyolxauhqui (fig. 5), resulted in the most important archaeological
project ever undertaken by the Mexican government in the capital, su-
pervised by Eduardo Matos Moctezuma. These excavations between
1978 and 1982 revealed the entire series of superposed Great Temple
structures, rich offertory caches, and several major sculptures.

Toward the close of the last century two significant developments, pri-
marily in Europe, led to an increased knowledge and appreciation of Az-
tec art and ideology. One was the emergence of a more scholarly and ana-
lytic methodology in the study of the meaning, the iconography, of Aztec
archaeological pieces. The key figure here was Eduard Seler, a prime ex-
emplar of the heroic age of high level German scholarship before the First
World War. Utilizing all available sources—archaeological, documen-
tary, pictorial, and linguistic—his productive research, concentrated be-
tween 1887 and 1923, tremendously advanced knowledge of the subject
and set a new standard for other researchers entering the field. Although
not insensitive to the Aztec aesthetic achievement, Seler concentrated on
iconographic interpretation. He also set new illustrative standards with
his fine photographs, usually contributed by his constant collaborator,
his wife Caecelie, and, especially, the famous and oft-reproduced Wil-
helm von den Steinen drawings. An indirect disciple of Seler, fellow coun-
tryman Hermann Beyer, early in this century moved to Mexico, where he
introduced similar rigorous methods in iconographic analysis and,
joined by his foremost pupil Alfonso Caso, firmly established the
Selerian tradition in the Aztec homeland. Although interest in Aztec and
the related Mixteca-Puebla stylistic-iconographic tradition has gone
through various cycles of lesser and greater activity since his day, Seler
opened a door to deeper understanding of the meanings of the many
symbol-laden Aztec pieces in our museums, and even now students rou-

tinely utilize his classic studies as points of departure.

The other important, more strictly aesthetic development was the emerging recognition in Europe during the final decades of the last century and the opening decades of this one of the artistic value of non-Western aesthetic traditions, particularly those of Africa, Oceania, and America. This was intimately intertwined with the turn-of-the-century investigation of styles that contributed to what is now called the modernist movement in Western art, fostered by artists like the Fauves, Matisse, and Picasso in France and Die Brücke group in Germany. The creative artists led the way, but they were eventually followed by the critics and art historians. Finally, those leaders and arbiters of public taste, the major art museums, have begun to respond more explicitly to this powerful trend and are increasingly adding new exhibits, and even whole wings, to their overall displays illustrating the range of mankind's artistic heritage.

This exhibit in our national art museum—the largest collection of Aztec art ever shown in the United States—is therefore timely. It should further expand an awareness of the aesthetic accomplishments of that part of North America where indigenous civilizations comparable to the earliest Old World civilizations (Old Kingdom Egypt, Early Dynastic Mesopotamia, Indus Valley civilization of Northwest India, and Shang China) flourished in pre-European times. In this country and to a large extent in Europe a certain stereotypical view of the American Indian, it can be argued, has inhibited a more perceptive understanding of the advanced pre-Columbian cultures that emerged south of our border. There is now a positive movement away from this cultural downgrading tendency that for so long was characteristic of western attitudes toward the native New World civilizations.

IN VIEWING AN EXHIBITION OF AZTEC ART, one might first ask: what does the word "Aztec" mean? At the time of the conquest the term was not used as a generic designation for the peoples and cultures of Central Mexico. This usage, introduced by Humboldt, was popularized by William H. Prescott, whose classic account of the Cortesian conquest of Mexico has been immensely influential since its publication in 1843. The term has proved so convenient that to discard it now for technical reasons of greater historical accuracy seems pedantic and futile. In the narrower sense it usually refers to the people of the twin cities of Mexico Tenochtitlan and Mexico Tlatelolco, whose ancestors migrated in the thirteenth century to the Basin of Mexico from a semilegendary homeland, Aztlan, and were then known as Azteca, "people of Aztlan." In language and culture most of the Central Mexican city-states were quite similar, and the majority were included in one polity, the Empire of the Triple Alliance, at the time of the conquest. Some overarching label, then, for the culture of this area and period is eminently useful. "Aztec" has been most widely employed in this sense, and it is so used in this essay and catalogue.

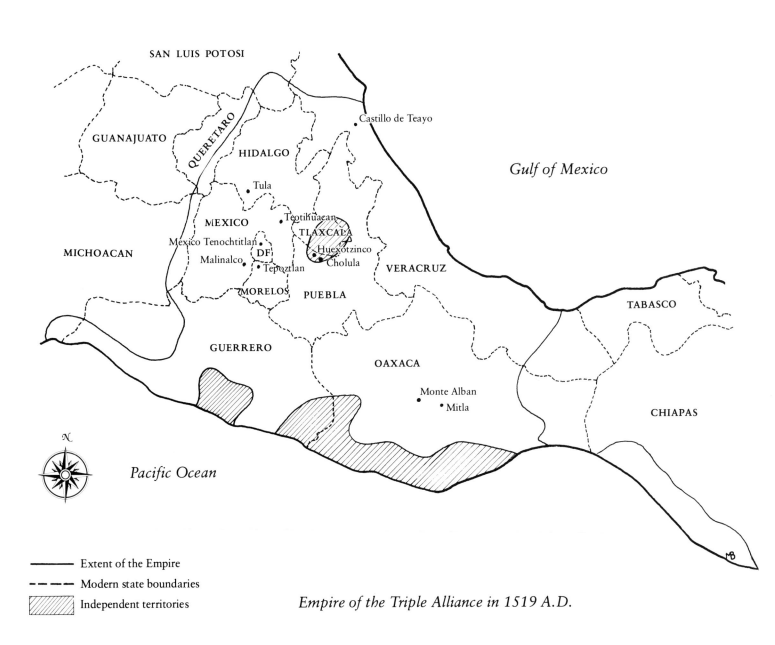

———	Extent of the Empire
– – – –	Modern state boundaries
▨	Independent territories

Empire of the Triple Alliance in 1519 A.D.

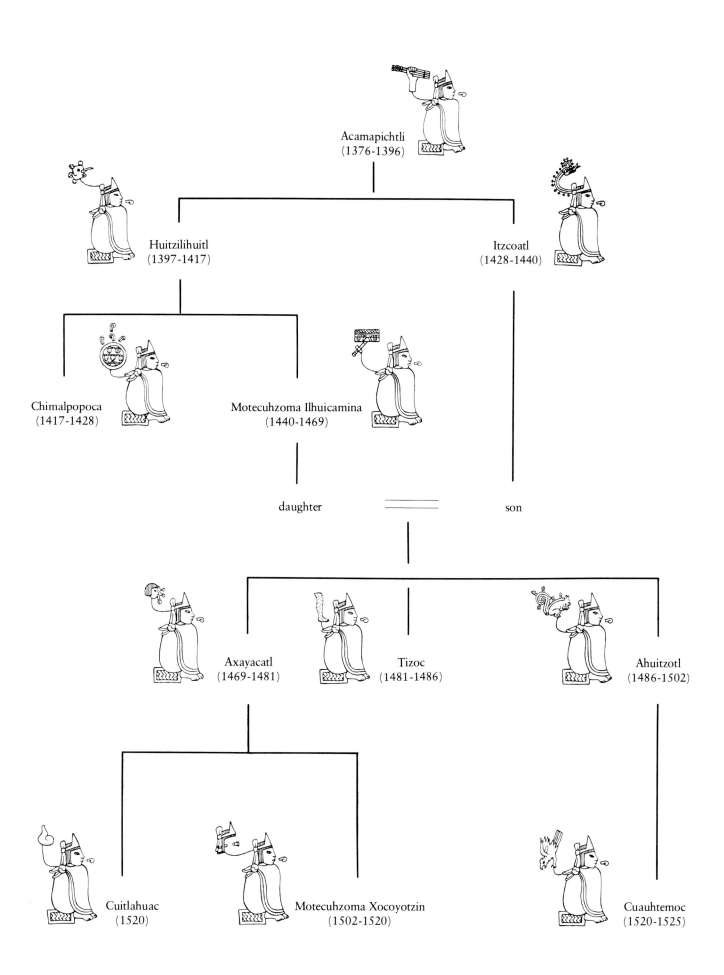

Acamapichtli
(1376-1396)

Huitzilihuitl
(1397-1417)

Itzcoatl
(1428-1440)

Chimalpopoca
(1417-1428)

Motecuhzoma Ilhuicamina
(1440-1469)

daughter ——————— son

Axayacatl
(1469-1481)

Tizoc
(1481-1486)

Ahuitzotl
(1486-1502)

Cuitlahuac
(1520)

Motecuhzoma Xocoyotzin
(1502-1520)

Cuauhtemoc
(1520-1525)

Royal Dynasty of Mexico Tenochtitlan

"Aztec culture" was the product of many centuries of intense cultural evolution in western Mesoamerica. It inherited most of the fundamental cultural achievements of the earlier Olmec, Teotihuacan, Xochicalco, Tajín, and Toltec traditions, melding them into a new synthesis that was in full, vigorous flower when cut off so abruptly by the sudden invasion from Europe. Its art reflected this same process. It too was the result of a long evolutionary sequence of styles and iconographies. The most immediate roots of the stylistic-iconographic tradition we call Aztec were evidently Toltec (centered in Tula, north of the Basin of Mexico), with powerful influences from the neighboring Mixteca-Puebla heartland (southern Puebla, western Oaxaca, and the Gulf Coast) and perhaps, to a somewhat lesser degree, Guerrero and West Mexico. Although derived from these well-developed earlier traditions, Aztec style is by no means a mere composite or imitation of them. Rather, it is a well-integrated new synthesis, which to a sensitive eye is clearly distinguishable from these prior styles and from contemporaneous ones flourishing elsewhere in Mesoamerica. In contrast to most of its artistic predecessors, Aztec art is characterized by more depictive literalness, more attention to anatomical specifics in human and animal figures, and the representation of complex symbols and deity insignia with a remarkable faithfulness to naturalistic detail. Its iconographic system, perhaps best expressed visually by the ritual-divinatory screenfold called the *Codex Borbonicus* (e.g., figs. 8a, 17a, 25b), is intricate and consistent. It is similar to the closely related Mixteca-Puebla tradition, typified by the pre-Hispanic pictorial manuscripts of the *Codex Borgia* group (e.g., figs. 21c, 25a, 27a). Aztec symbolic imagery, however, is less stylized and more literally conceived.

In sculpture various forms and motifs continue, usually somewhat modified, from Toltec and even earlier traditions. These include Chacmool figures, files of warriors on banquette friezes (benches with cornices attached to the inner walls of rooms), standard bearers, colossal serpent heads at the bases of stairway balustrades, and atlantean figures. New forms also appear, such as replicas in stone of objects in other media, and various animal representations executed three-dimensionally for the first time. Two classes of sculpture are far more common in Aztec than in any other Mesoamerican tradition: anthropomorphic and zoomorphic images. The former, which are often quite specifically designated by consistently patterned sets of insignia, appear to have functioned as genuine idols, i.e., as depictions of particular deities placed in shrines where propitiary rituals dedicated to them were performed. The zoomorphic category constitutes what many consider the special achievement of Aztec art, and some of the animal images are indeed remarkably powerful and vivid creations, comparing with the best animal portraiture in any ancient culture. Certainly no school of sculpture more successfully represented the rattlesnake, a particular favorite of the Aztec master carvers.

The specific stages in the evolution of Aztec art have yet to be clarified. The key links between Tula, the Toltec capital, where monumental art flourished from about A.D. 900-1200, and Mexico Tenochtitlan, Tetzcoco, and Tlacopan, the great centers of the Triple Alliance established about 1433-1434, where monumental sculpture was revived and most concentrated, were the cities of Colhuacan and especially Azcapotzalco. "Aztec style" as usually defined, that is, with Tenochtitlan its type site, was probably well underway as an evolving stylistic-iconographic synthesis during the period (c. A.D. 1350-1428) when Azcapotzalco predominated as the capital of the empire immediately preceding the Triple Alliance. Unfortunately, the ceremonial centers of Colhuacan and Azcapotzalco dating to the post-Toltec, pre-Aztec era have not been excavated.

Reconstruction of an Aztec pyramid-temple, Santa Cecelia Acatitlan, northwest of Mexico City (photograph: José Naranjo)

fig. 6 Archaic style "standard bearer." Found in the Templo Mayor of Mexico Tenochtitlan.

The archaic-style "standard bearers" recently found associated with the third major construction stage of the Huitzilopochtli-Tlaloc temple of Mexico Tenochtitlan (e.g., fig. 6) provide some clue to the earlier phases of Aztec style. This stage might be more or less contemporary with the final phase of the Azcapotzalco period, although in this great center itself a more sophisticated art might have prevailed. In any case, it appears that by the mid-fifteenth century, at the latest, the Aztec stylistic-iconographic tradition had crystallized, although its finest and most spectacular productions probably cluster within the final half century or so before the conquest. The number of superior pieces produced during this final outburst and still extant is truly prodigious, considering the effort made after the conquest to destroy every vestige of native religious art. Furthermore, most Aztec sculptures had been discovered only accidentally, usually during construction activities, until the Templo Mayor project. Certainly Mexico Tenochtitlan at the apogee of its imperial glory, along with its urban partners in power, possessed the wealth and political motivation to commission the finest artisans of the empire to create numerous monumental works of enduring grandeur. And these same factors clearly promoted the flowering of the elite arts of ornamental metallurgy, featherwork, and precious stone mosaic during this same period, where the achievement, if less grandiose, was also remarkable.

Clearly much has been discovered about Aztec art, but much still remains to be discovered: the role and function of the master artisans within their society; their training; their working methods; the relationship between them and those who commissioned their work; the procedure by which the iconographic programs of the complex symbolic sculptures were devised; the attitude toward tradition and originality; the role of the individual artist as opposed to the known team effort in the production of major works; and the question of the Aztecs' own concept of "art" and their view of its place within their culture.

The war drums of the Aztec are stilled forever. The towering temples dedicated to their awesome gods were demolished long ago. But many of the artistic creations placed in and around them to express their faith in these deities have somehow survived. These battered stones, despised and neglected for so long, have begun to speak to us again.

THE OBJECTS IN THIS EXHIBITION have been selected for their aesthetic quality and representativeness within the Aztec artistic tradition. Some media, especially manuscript painting and featherwork, are minimally represented or do not appear in the exhibition because of problems of availability or conservation. Some of the ceramic pieces included are not stylistically Aztec in the narrower sense (i.e., made in pottery manufacturing centers in or near the Basin of Mexico), but are representative of the more elaborate polychrome ceramics produced in areas to the south and east and widely traded throughout the Empire of the Triple Alliance. The same is true of the goldwork. This was clearly one of the great Aztec arts, but few specimens from the capital and nearby centers have survived. Most of the pieces in this exhibition, surely or probably originating in Oaxaca or adjacent regions, are characterstic of the types of gold jewelry produced and traded throughout the empire. It is hoped that this sample of the artistic riches of the Aztec world will effectively convey the magnitude of the aesthetic achievement of the best documented of the indigenous New World civilizations.

Two sets of numbers are given for pieces from the Museo Nacional de Antropología in Mexico City. The old 24-series, that of the Caso-Mateos catalogue, was the standard for many years. The current 11-series was introduced with the transfer of the museum in 1964 to its present location in Chapultepec Park. The 10-series given for the pieces of the Proyecto Templo Mayor are inventory numbers assigned to the objects discovered during the 1978-1982 Templo Mayor project. All other numbers are those of their respective repositories.

Dimensions of objects are given in meters, followed parenthetically in inches.

Acknowledgments

MANY PERSONS supplied us with additional information concerning the objects in the exhibition and other types of assistance during the preparation of this catalogue. We would like to express our thanks to Christian Feest, Museum für Völkerkunde, Vienna; Julie Jones, Metropolitan Museum of Art, New York; Gordon Ekholm, American Museum of Natural History, New York; and Charles Rozaire, Los Angeles County Museum of Natural History, for data regarding the pieces in collections under their custody. Our thanks to Elizabeth Boone for the important information she provided on a number of the pieces, which was very helpful in the preparation of the catalogue. Wayne Ruwet, Powell Library, University of California, Los Angeles, provided bibliographic aid and general support. Michel Besson aided in research and produced some excellent drawings. A special debt of gratitude is owed to Felipe Solís Olguín, Museo Nacional de Antropología, Mexico, for supplying key information on various objects in the collection for which he is curator and for facilitating many aspects of the preparation of the catalogue in Mexico.

H.B.N. E.Q.K.

*I have also seen the objects they have brought to the
king from the new golden land: a sun of solid gold that
measures a full fathom; also a moon of pure silver, equal
in size; also two halls filled with curious armaments,
all kinds of weapons, armour, artillery, extraordinary
shields, odd garments, breastplates and an endless number
of strange objects of multiple uses that are even more
beautiful to the eye for being the curiosities they are.
All these things were of great worth, for they have been
valued at some one-hundred thousand florins. In all my
life I have never seen anything that has so delighted
my heart as did these objects; for there I saw strange
works of art and have been left amazed by the subtle
inventiveness of the men of far off lands.*

ALBRECHT DÜRER

*Mexican sculpture seems to me to be true and right.
Its 'stoniness,' by which I mean its truth to material,
its tremendous power without loss of sensitiveness,
its astonishing variety and fertility of form invention
and its approach to a full three-dimensional conception
of form, make it unsurpassed in my opinion by any other
period of stone sculpture.*

HENRY MOORE

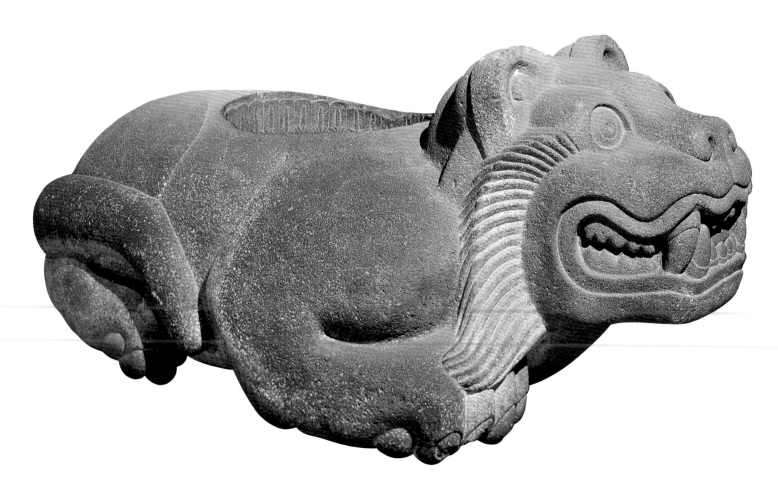

Colossal jaguar cuauhxicalli (vessel for human hearts)
Length 2.25 (88⅝); width 1.20 (47¼); height .93 (36⅝)
Andesite
Museo Nacional de Antropología, Mexico City, no. 24-136; 11-3227
Found in Mexico City in 1901

This masterpiece of Aztec monumental sculpture was discovered in December 1901, during alterations to the Palacio del Marqués de Apartado at the corner of the Primer Calle del Reloj (present-day Avenida República de Argentina) and Calle Cordobanes (present-day Calle de Donceles), a block north of the cathedral. Excavation in the patio, supervised by Captain Porfirio Díaz, Jr., also uncovered a somewhat damaged colossal head of a "fire serpent" *(xiuhcoatl)* (Seler 1902-1923, 2: 897, Abb. 106) and the well-preserved lower section of a broad stairway facing south and flanked by two balustrades (Dawley 1902: upper photo; Galindo y Villa 1903: plan; Seler 1902-1923, 2: 896, Abb. 105, and 1903: lám. VI).

As the most feared Middle American predator, the jaguar *(ocelotl)* was an animal of outstanding importance in Mesoamerican ideology and, consequently, in the art and iconography of this area. From the Olmec period on (c. 1200-400 B.C.), it seems to have been the "were-animal" par excellence, the creature into which the sorcerer most preferred to transform himself in order to acquire all of its potency and ferocity. The association of this fearsome feline with witchcraft and black magic, accordingly, was very intimate. Along with the eagle, it was the symbol of male virility and courage, and the standard metaphor for warriors as a class was *in cuauhtli in ocelotl,* "the eagles, the jaguars." Above all, it connoted the valor and military prowess of the ruler, whose throne was characteristically draped with a jaguar skin. It formed, moreover, a contrastive dualism with the eagle: the one, fierce creature of the celestial sphere and symbol of the sun, and the other, the most dangerous terrestrial animal, which signified the earth and the

realm of darkness (it has been suggested that its spotted hide may have been connected with the starry night sky). As the zoomorphic disguise *(nahualli)* of the omnipotent, omniscient supreme deity, Tezcatlipoca, the jaguar also functioned as an aspect of this protean god called Tepeyollotl (cf. no. 25), whose basic terrestrial associations are well established. Nuttall (1904: 18) believed that this great feline image symbolized Tezcatlipoca, but Bernal's (1969: 20) suggested identification with his Tepeyollotl aspect may be more likely.

The jaguar sits in a crouching position, his enormous paws placed beneath him. Smoothly contoured volumetric surfaces define the powerful musculature of his body. The achievement of these rounded expanses is the more remarkable when one considers that they were attained without the aid of metal tools. The Aztec sculptor had at his disposal only hard stone tools with which to block out, chisel, and incise his shapes; surfaces were refined and polished by abrading tech-

niques. The angular planes of the large, blocklike head contrast with the rounded swells of the body, and its features are more realistically detailed. His round staring eyes, alert ears, and mouth stretched wide in a menacing grin express the ferocity latent in the controlled forms of the crouching body. The prominent whiskery "sideburns" are an unusual feature. Although they resemble the ruff on the lynx or bobcat, nothing like them appears on the jaguar. Possibly they can be related to the beard frequently shown on representations of Tepeyollotl (cf. no. 25). Traces of color still survive, including spots on the animal's abdomen.

Set into the figure's back is a cylindrical receptacle .64m (25½ in.) in diameter and .24m (9½ in.) in depth. Carved in relief on its side walls are motifs commonly found on stone vessels into which sacrificed human hearts and blood were deposited. A lower band shows double circles, symbolizing precious greenstone (chalchihuitl), placed between undulating lines, representing the precious liquid, sacrificial blood. An upper band displays a row of stylized eagle feathers. This motif appropriately connotes the name of these receptacles, "eagle vessels" (cuauhxicalli), emphasizing the importance of the eagle as a symbol of the sun, to whom all sacrifices were, in theory, directed. The monument as a whole can be considered a zoomorphic cuauhxicalli, which was probably originally positioned near a sacrificial stone.

Two figures carved in relief on the bottom surface of this cavity have been identified, probably correctly, as deities, Tezcatlipoca on the left and Huitzilopochtli, in one sense another aspect of Tezcatlipoca, on the right (Beyer 1912; cf. Seler 1902-1923, 2: 902, and 1903: 262, who identifies the figure on the right with the "soul of the dead warrior"). Seated opposite each other, they draw sacrificial blood from their ears with pointed bones. Each one has a leg drawn up with the

foot replaced by Tezcatlipoca's smoking mirror (see annotation to no. 35), which includes the "fire strip" element of the "water and conflagration" (atl tlachinolli) symbol, the Nahuatl metaphor for war (cf. nos. 6, 9, 14, 61). Smoke volutes and forked "fire tongues" behind their headdresses may also connote the smoking mirror device. The arms and legs of both figures are striped, and both display elaborate speech scrolls in front of their fleshless mouths. Below one knee of each are four maguey spines for drawing blood, set into a leaf of that plant.

Although both wear what appears to be a version of the pleated paper neck fan (amacuexpalli) with a pendant strip, their headdresses differ. That on the left is the "stellar crown" frequently worn by Tezcatlipoca, consisting of a headpiece with vertical striations studded with small circles symbolizing stars. At the back of his head is the curved "snout" of the "fire serpent" (xiuhcoatl) (cf. no. 8). The transverse stripe at eye level is also typical of this god. The headdress of the second figure is composed of two types of vertical feathers above a rather complex headband. Behind him is the head of a long-billed bird, surely

the hummingbird, the disguise (nahualli) of Huitzilopochtli (Beyer 1912). The face is decorated with the dark eye mask edged with small circles (also connoting stars), sometimes worn by Huitzilopochtli and certain other deities with stellar associations. A distinctive, probably turquoise, nose ornament, a particular insignia of the lords (yacaxihuitl), is also worn. Similar figures performing the type of autosacrifice depicted here are represented on other Aztec sculptures, especially stone boxes (e.g., no. 15; Seler 1902-1923, 2: 717) and on two fragments of an unpublished colossal "skull cuauhxicalli" in the Museo Nacional de Antropología in Mexico City.

Nuttall (1904: 18) praised this monument as "the finest piece of animal sculpture that has as yet been found on the American Continent." It can justly be described as one of the greatest sculptural masterpieces ever produced by any standard. Few other feline images can match its monumental power. It impressively demonstrates the degree of mastery over stone achieved by the sculptors of Mexico Tenochtitlan in the last few years before the conquest.

Ignacio Bernal, 100 Great Masterpieces of the Mexican National Museum of Anthropology (New York, 1969); Hermann Beyer, "Sobre algunas representaciones del dios Huitzilopochtli," XVII Congreso Internacional de Americanistas, Reseña de la Segunda Sesión: México, 9-14 Septiembre, 1910 (1912): 364-372; Thomas R. Dawley, "Some Recent Archaeological Discoveries in Mexico City," Scientific American 87, no. 8 (1902): 118-119; Jesús Galindo y Villa, "La escalinata descubierta en el nuevo edificio de la Secretaría de Justicia é Instrucción Pública," Boletín del Museo Nacional de México 1, no. 1 (1903): 16-18; Zelia Nuttall, A Penitential Rite of the Ancient Mexicans, Archaeological and Ethnological Papers of the Peabody Museum, Harvard University, 1, no. 7 (1904); Eduard Seler, Gesammelte Abhandlungen zur Amerikanischen Sprach- und Altertumskunde, 5 vols. (Berlin, 1902-1923); and "El cuauhxicalli del telpochcalli del Templo Mayor de México," Anales del Museo Nacional de México, primera época, 7 (1903): 260-262.

Carvings, interior cavity.

1

Chacmool
Height .73 (28¾); length 1.06
(41¾); depth .54 (21¼)
Andesite
Museo Nacional de Antropología,
Mexico City, no. 24-1374; 11-3013
Found in Mexico City in 1943

One of the most distinctive types of Mesoamerican images is that called "Chacmool," a name applied to them in 1875 by Augustus le Plongeon, the romantic pioneer student of the ancient Maya. Although a fanciful term, it has proved convenient and is now routinely employed by modern scholars. These pieces represent reclining male figures holding receptacles on their midsections, with their heads turned ninety degrees to one side. They apparently first appeared during the Early Postclassic or Toltec period (c. A.D. 900-1200) and continued to be made up to the time of the conquest. They are a hallmark of Toltec and Toltec-related sites (especially Tula, the Toltec capital in Central Mexico, and Chichen Itza in northern Yucatan). Aztec-period Chacmools are less common, but various others, also found in Mexico City, are known, including two that closely resemble this piece (e.g., Cuéllar 1981: fig. C.T. 49.0; Seler 1902-1923, 2: 819, Abb. 18, a-c; Solís Olguín 1976: 22-24). Our example, the best preserved of the three, was discovered in 1943 during construction at the corner of Venustiano Carranza and Pino Suárez streets, a block south of the Zócalo, the central plaza of Mexico City (Lizardi Ramos 1944; Mateos Higuera 1979: 233).

In overall configuration this sculpture represents a classic Chacmool, reclining on its back, its legs drawn up, its hands holding a large cylindrical object against its midsection, with its head turned to the left. Aside from its simple loincloth, it wears elaborate ornaments: beaded bracelets and anklets; sandals with heel caps decorated with stone knives bearing "demon faces"; a massive, three-strand beaded necklace with a trapezoidal pendant on which an *en face* figure is carved; large, round ear accessories with pendants trimmed with the symbol for preciousness; and a complex headdress featuring a broad rim from which masses of beautifully carved feathers descend, completely

covering the back, and adorned with a circular device that resembles a mirror within a carved frame. The cylindrical object held between the knees is a *cuauhxicalli* or "eagle vessel" for the containment of sacrificed human hearts (see annotation to no. 3), in this case with a solid top surface without any cavity (cf. Beyer's [1921] hypothesis that the Calendar Stone also functioned as a solid-topped *cuauhxicalli*). It corresponds to the Berlin *cuauhxicalli* (no. 3) in its decorative scheme, even to the top band of human hearts. The top surface, however, instead of the more usual solar disk, is a slightly more stylized version of the reclining figure's face, which displays a variant of the usual visage of Tlaloc, the rain deity. In this case, quadrangular fields surround both the eyes and mouth of the Chacmool and relief head, with tusks protruding from the corners of the mouth, in contrast to the usual Tlaloc features of round "goggles" and a thick, fanged labial band—which, interestingly, appear on the head of the Earth Monster on the underside of the sculpture (cf. the variant form of Tlaloc on no. 2 and the more conventional representation on no. 28).

Carved on the underside is an unusual version of the Earth Monster (Tlaltecuhtli) (cf. nos. 3, 6, 13, 14, 15, 58), set against a background marked by wavy lines symbolizing water. It bears the head of Tlaloc wearing a version of the cord-band headdress, edged above and below with rows of spheres (cf. annotation to no. 17), topped with paper and feather ornaments, and the pleated, paper neck fan *(amacuexpalli)* commonly worn by fertility deities. Surrounding this central figure on the watery surface are various maritime creatures: sea snake, globular spiny fish, conch shell, and a pair of oval shells. Numerous eddies in the water are indicated by wavy-lined spirals.

Ever since Le Plongeon's discovery of the original Chacmool at Chichen Itza, controversy has surrounded the identification and function of these arresting figures, which normally were positioned in the vestibules of shrines (summary of various views in Graulich 1981; incomplete but useful illustrated survey of extant Chacmool figures in Cuéllar 1981). If we confine our coverage to this and the other two similar Aztec pieces found in Mexico City, there can be little doubt that these examples represent an aspect of Tlaloc. A similar figure with identical facial markings, portrayed amid clouds and raindrops and holding a precious jug from which he pours water and maize ears, is carved on the side of a stone box in the British Museum (fig. 1a). The cylindrical object our figure holds is certainly a solid *cuauhxicalli,* upon which human hearts were set, in this case specifically as an offering to the rain god whose face appears on this surface. These particular Chacmools, then, were probably positioned, as is the early polychrome example discovered fronting the Tlaloc shrine of Stage II of the Mexico Tenochtitlan Templo Mayor (Bonifaz Nuño and Robles 1981: lám. 42), before entrances to shrines dedicated to the great god of fertility and rain.

Hermann Beyer, *El llamado "Calendario Azteca"* (Mexico, 1921); Alfredo Cuéllar, *Tezcatzoncatl escultórico: el "Chac-Mool" (el dios mesoamericano del vino)* (Mexico, 1981); Michel Graulich, "Einige Anmerkungen zu den mesoamerikanischen Skulpturen mit der Bezeichnung 'Chac Mool,'" *Mexicon* 3, no. 5 (1981): 81-87; Thomas A. Joyce, *A Short Guide to the American Antiquities in the British Museum* (London, 1912); César Lizardi Ramos, "El Chacmool mexicano," *Cuadernos Americanos* 3, no. 2 (1944): 137-148; Salvador Mateos Higuera, "Herencia arqueológica de Mexico Tenochtitlan," in *Trabajos arqueológicos en el centro de la ciudad de México,* edited by Eduardo Matos Moctezuma (Mexico, 1979): 205-273; Eduard Seler, *Gesammelte Abhandlungen zur Amerikanischen Sprach- und Altertumskunde,* 5 vols. (Berlin, 1902-1923); Felipe Solís Olguín, *La escultura mexica del Museo de Santa Cecilia Acatitlan, Estado de México* (Mexico, 1976).

View of underside, no. 1. (at left)

fig. 1a Tlalocoid figure carved on the side of a stone box. Museum of Mankind, The British Museum, London. From Joyce 1912:17, fig. 9.

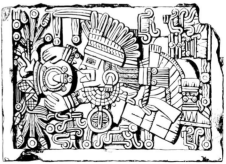

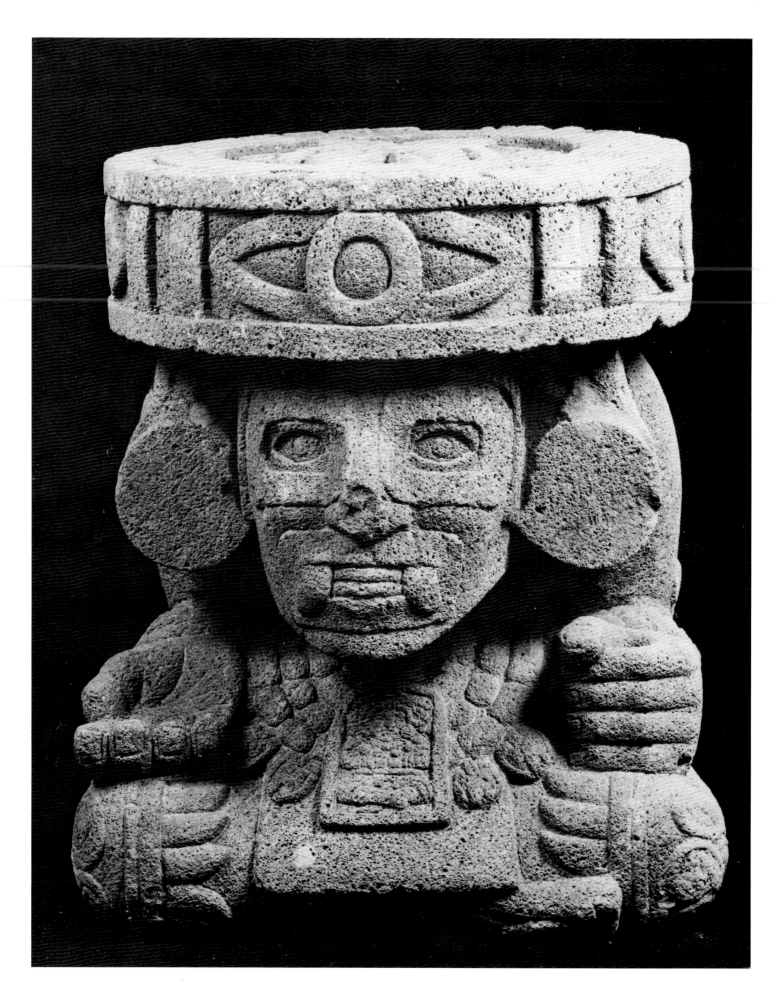

2

Tlalocoid fire god brazier
Height .77 (30¼); width .56 (22);
depth .60 (23⅝)
Stone
Proyecto Templo Mayor, Mexico
City, no. 10-205302
Found in the Templo Mayor pre-
cinct of Mexico Tenochtitlan in
1980

Archaizing (reviving ancient forms) in Aztec art is not common, but a few pieces are extant (cf. nos. 29, 30), among which this sculpture is a prime example. It is directly mod-eled on the well-known stone images of the Teotihuacan culture (c. A.D. 100-750) that represent the old god of fire (Huehueteotl) seated hunched and cross-legged with a large circular brazier on his head (e.g., fig. 2a). Here the hands are rest-ing on the knees, the right one palm up, the left one a clenched fist hol-lowed perhaps to hold an object. Large "demon faces" adorn the knees and elbows (cf. nos. 3, 6, 13, 15). The figure wears a three-strand beaded necklace, edged with styl-ized bells and supporting a trape-zoidal pendant with an *en face*, seated, cross-legged figure on it (cf. no. 1). The face is decorated with quadrangular fields surrounding both eyes and the mouth, with two protruding fangs in the corners of the mouth. Plain, round earplugs adorn the ears. The edges of striated hair, a typically Aztec convention, appear around the face, and the pupils of the eyes are incised, an un-usual feature. The edge of the circu-lar brazier atop the head bears the typical vertical bar and diamond-shape motifs found on Teotihuacan fire god braziers. On its top surface, somewhat depressed below the en-circling border strip, wavy lines in-dicate water, in the center of which an interlinked double shell floats (cf. same motifs on the undersides of Aztec Chacmools [Seler 1902-1923, 2: 819, Abb. 18, c; Solís Olguín 1976: 24]). Below a kind of feather ruff on the back is a panel featuring various linear motifs, in the center

fig. 2a Teotihuacan-period fire god brazier. Museo Nacional de Antropología, Mexico City.

View of back, no. 2.

of which is the date 11 Acatl (Reed) within a square cartouche, which possibly equates with the Christian year 1503 or, less likely, 1451, fifty-two years earlier.

This piece was discovered in 1980 in fill north of the Templo Mayor proper (Matos Moctezuma 1982: 70). Although fashioned directly after a Teotihuacan fire god image, at least one of which had to be available as a model—classic Teoti-huacan masks have been found in the Templo Mayor offertory caches —it appears to depict an aspect of Tlaloc, the rain-fertility god, also represented by the Chacmool of no. 1, and by a figure on a relief carving on the side of a stone box in the British Museum (see annotation to no. 1). These Tlaloc figures are characterized by quadrangular fields around the eyes and mouth instead of round "goggle-eyes" and the thick labial band and prominent fangs of the usual Tlaloc faces (see annotation to no. 1). What the sig-nificance of the combining of the iconography of Tlaloc and the old fire god may be is problematic. Per-haps a contrastive dualism was in-volved, i.e., fire and water. Another possibility may be that because to the Aztecs Tlaloc was the Teotihua-can deity par excellence, his insignia were incorporated into an image otherwise modeled on Teotihuacan figures of the old god of fire. What-ever its significance, this unique sculpture is one of the most interest-ing discovered during the Templo Mayor project. It successfully com-bines the monumentality of Teoti-huacan with the somewhat more "realistic" approach of the Aztec sculptor. It is unquestionably the most impressive archaized Aztec sculpture so far discovered.

Eduardo Matos Moctezuma, ed., *El Templo Mayor: excavaciones y estudios* (Mexico, 1982); Eduard Seler, *Gesammelte Abhand-lungen zur Amerikanischen Sprach- und Al-tertumskunde*, 5 vols. (Berlin, 1902-1923); Felipe Solís Olguín, *La escultura mexica del Museo de Santa Cecilia Acatitlan, estado de México* (Mexico, 1976).

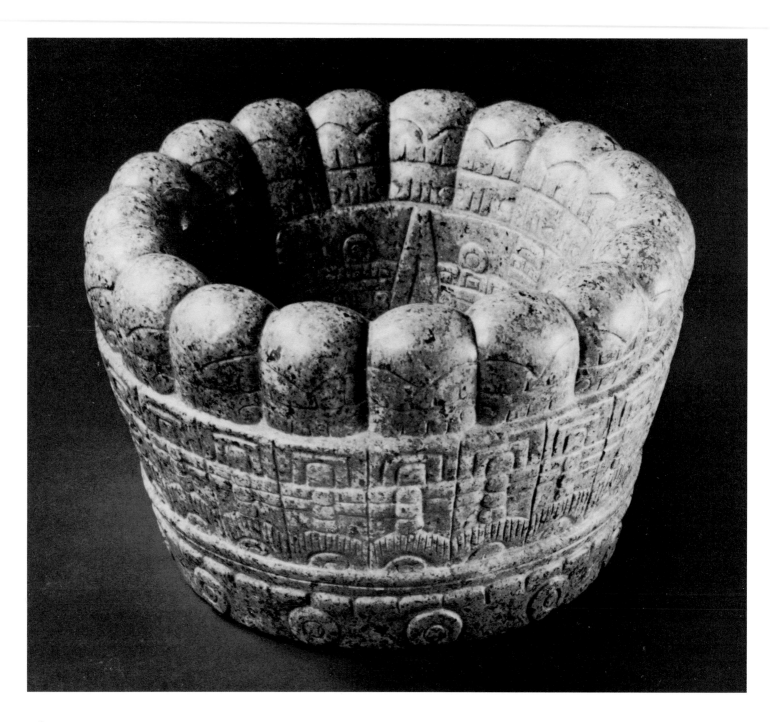

3

Cuauhxicalli (vessel for human hearts)
Height .14 (5½); diameter .24 (9½)
Greenstone
Staatliche Museen Preussischer Kulturbesitz, Museum für Völkerkunde, West Berlin, no. IV Ca 1
Ex-Waagen collection

Acquired by the Berlin museum in 1844, this circular stone receptacle, of unknown provenance, is the most expertly carved example of its type. Stone vessels decorated with the motifs that cover this piece were known as *cuauhxicalli,* which literally means "eagle vessel." The eagle was the surrogate of the sun, and many metaphors incorporate the word "eagle" *(cuauhtli)* to express solar-related concepts: for example, the sun, "ascending eagle" *(cuauhtlehuanitl)*; and the sacrificed victim's heart that fed the sun, "eagle cactus fruit" *(cuauhnochtli)* (Seler 1902-1923, 2: 704). Most *cuauhxicalli* display as their central motif the solar disk; that is, the sun itself, in this case carved on the base and lower sides of the vessel's interior. Thus when the heart of the victim was extracted from the great gash in his chest and deposited in this stone container, it was laid directly upon the image of the deity Tonatiuh, the sun, for whom it was primarily intended. The stylization of the solar disk here is typical, with the 4 Ollin (Movement) day sign in the center and the circular edging motifs, interrupted by the tips of the solar ray devices, connoting preciousness. Four Ollin (Movement) was the day on which the present "sun" or cosmic age was supposed to end, and thus it gave its name to the whole era (cf. no. 6). The outer surface of the vessel is decorated with three bands of symbols. The lowermost shows a row of concentric circles symbolizing jewels or preciousness. Stylized eagle feathers with down balls at their bases occupy the middle register. The scalloped rim is formed by a wreath of eighteen conventionalized human hearts. In the

260-day divinatory cycle section *(tonalamatl)* of the *Codex Borbonicus, cuauhxicalli* representations also show this circular border of hearts (fig. 3a), as does another stone *cuauhxicalli* in the British Museum (Joyce 1912: pl. II, b). On the underside of this vessel is a representation of the crouching, open-jawed type of Earth Monster (Tlaltecuhtli), very similar to those on the undersides of the Stone of the Five Suns (no. 6), the Bilimek pulque vessel (no. 14), the Box of Hackmack (no. 15), and the Musée de l'Homme feathered serpent (no. 58). The iconography of this grotesque, composite creature is summarized in the annotation to no. 13.

Numerous stone *cuauhxicalli* are known, exemplifying a range of types (cf. no. 4) (useful, well-illustrated discussion in Beyer 1921: 1-12). The two closest to this Berlin specimen are one in the Vienna Museum für Völkerkunde (ex-Becker collection) (Seler 1902-1923, 2: 712-716, Abb. 1-3) and another in the Museum of the American Indian, Heye Foundation, New York (ex-Chavero collection) (Chavero 1882, 3: 126, drawings of all carved surfaces; Pasztory 1976: covers, photographs of interior and underside). Except that both lack the wreath of hearts forming the rim of the receptacle, the two are almost identical to this example from Berlin.

Hermann Beyer, *El llamado "Calendario Azteca"* (Mexico, 1921); Alfredo Chavero, "La piedra del sol: estudio arqueológico," *Anales del Museo Nacional de México,* primera época, 3 (1886): 124-136; Thomas A. Joyce, *A Short Guide to the American Antiquities in the British Museum* (London, 1912); Esther Pasztory, et al., *Aztec Stone Sculpture* [exh. cat., The Center for Inter-American Relations] (New York, 1976); Eduard Seler, *Gesammelte Abhandlungen zur Amerikanischen Sprach- und Altertumskunde,* 5 vols. (Berlin, 1902-1923).

fig. 3a Two depictions of *cuauhxicalli.* Codex Borbonicus 8, 18. From Seler 1902-1923, 2:705, Abb. 1,2.

Interior view, no. 3.

Bottom of vessel, no. 3.

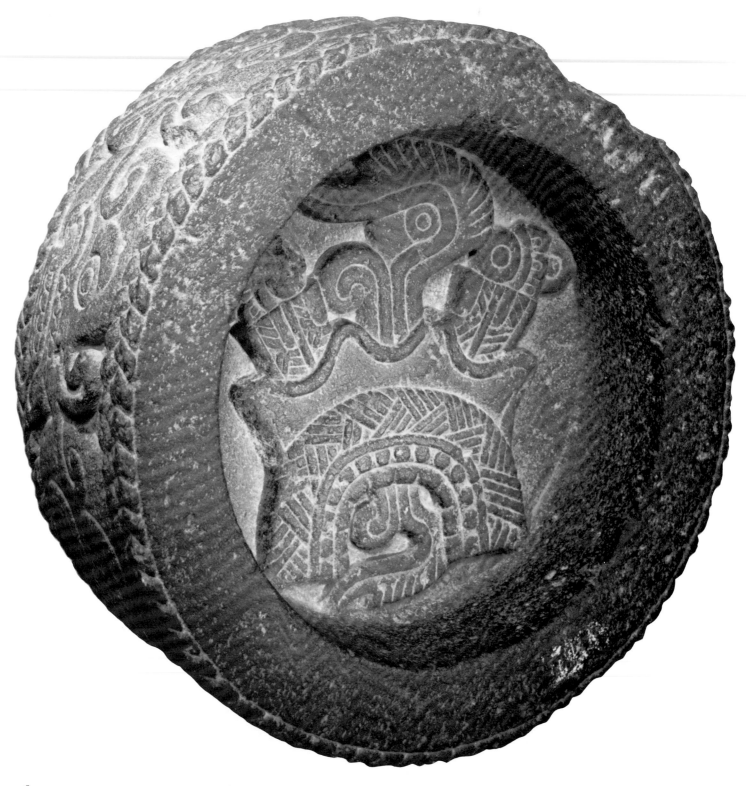

4
Skull cuauhxicalli
Height .18 (7⅛); diameter .40
(15¾)
Andesite
Museo Nacional de Antropología,
Mexico City, no. 24-137; 11-2925
Collected in 1913 in Tlahuac by
Pablo Henning

An expertly carved example of another type of *cuauhxicalli* (see annotation to no. 3), this ritual vessel, judging from the motif on the bottom of its cavity, may have been intended more to contain auto-sacrificial blood than human hearts. However, the skull motif carved in relief on its outer surface may indicate that it functioned to receive both. It was collected and first published (two photographic views) in 1913 by Pablo Henning in Tlahuac, the ancient Cuitlahuac, an important island town tributary to Mexico Tenochtitlan located in the freshwater lake area southeast of the capital (Henning 1913: 140, figs. 9-10). The outer face is decorated with opposing pairs of profile skulls, characterized by the usual circle-within-circle eyes topped by curving supraorbital ridges and double-outlined, back-curving snouts from the base of which issue scrolled prolongations that overlap onto the back section of the next skull. The fleshless jaw is well detailed, with the exposed rows of teeth, protruding tongue, and mouth scroll that curves back onto the cheek. Interwoven strips provide an upper and lower braided border for this row of skulls. On the base of the interior is carved in relief a *zacatapayolli*, the plaited grass ball into which the blood-stained maguey spines used for drawing auto-sacrificial blood were thrust (cf. no. 11). The spines are tipped with the circular symbol denoting preciousness *(chalchihuitl)*. A scalloped "fire wing" rises from the arched top edge of the *zacatapayolli*, and smoke volutes issue from it above and below (Seler 1902-1923, 2: 722-723).

Various stone receptacles of this type survive. A closely related one, also in the Museo Nacional de Antropología (Peñafiel 1910: 59, 60), was illustrated by the usual poor drawing in the 1794 Dupaix catalogue and described as being in a patio near the Plaza de Loreto, three blocks northeast of the Zócalo. In this case, the profile skulls, again with upturned snouts, are separated by knotted devices. Vertical rows of stylized maguey spines line the inner wall, but the *zacatapayolli* on the interior bottom is very similar to that on our piece. A second stone vessel in the same museum, whose sides are unfortunately missing (*Arte azteca* 1979: 50), displays a typical *zacatapayolli* on the interior floor, and the head of the Earth Monster (Tlaltecuhtli) on the underside. Mateos Higuera (1979: 267, object 24-569) ascribes it to Mexico City, with the exact provenance and date of discovery uncertain. A third relevant Museo Nacional de Antropología example consists of two fragments of a very large basin with the outer circumference carved with a row of skulls nearly identical to that on our piece. Relief figures on the interior walls perform auto-sacrifice like the Huitzilopochtli-Tezcatlipoca pair on the basin in the back of the colossal jaguar *cuauhxicalli*. On the base of the interior a remnant of the *zacatapayolli* appears. In a private collection in Los Angeles another "skull *cuauhxicalli*" closely resembles our piece, but it is much restored (von Winning and Stendahl 1968: pl. 383). Another example in the Philadelphia Museum of Art (ex-Arensberg collection; Kubler 1954: 43) exhibits the row of skulls and the braided border strips on the vessel rim. Although these are nearly the same as those on our receptacle, no other carvings are present. Finally, the Tamayo museum in Oaxaca has a stone vessel with profile skulls alternating with crossed bones on the exterior wall, a motif known from other Aztec monuments that constitutes an interesting anticipation of the famed "Jolly

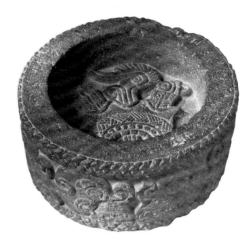

Roger" of the Caribbean pirate. Despite the similarity of form and motifs, it is noteworthy that no two of these rather commonly employed ritual receptacles are exactly alike. A feature of the Aztec art-making process was the apparent latitude given to sculptors in realizing their assignments. Certain basic patterns recur frequently, but rarely are they expressed in precisely the same way. Variations on a theme are a hallmark of certain classes of Aztec monuments.

Arte azteca [exh. cat., Museo di Palazzo Venezia, introduction and bibliography by Alessandra Ciattini] (Rome, 1979); Guillermo Dupaix, "Descripción de monumentos antiguos mexicanos," 1794 (manuscript in the Museo Nacional de Antropología, Mexico); Pablo Henning, "Informe del colector de documentos de etnología," *Boletín del Museo Nacional de Arqueología, Historia y Etnología*, tercera época, 2, no. 7 (1913): 139-140; George Kubler, *The Louise and Walter Arensberg Collection: Pre-Columbian Sculpture* (Philadelphia Museum of Art, 1954); Salvador Mateos Higuera, "Herencia arqueológica de México, Tenochtitlan," in *Trabajos arqueológicos en el centro de la ciudad de México*, edited by Eduardo Matos Moctezuma (Mexico, 1979): 205-273; Antonio Peñafiel, *Destrucción del Templo Mayor de México* (Mexico, 1910); Eduard Seler, *Gesammelte Abhandlungen zur Amerikanischen Sprach- und Altertumskunde*, 5 vols. (Berlin, 1902-1923); Hasso von Winning and Alfred Stendahl, *Pre-Columbian Art of Mexico and Central America* (New York, 1968).

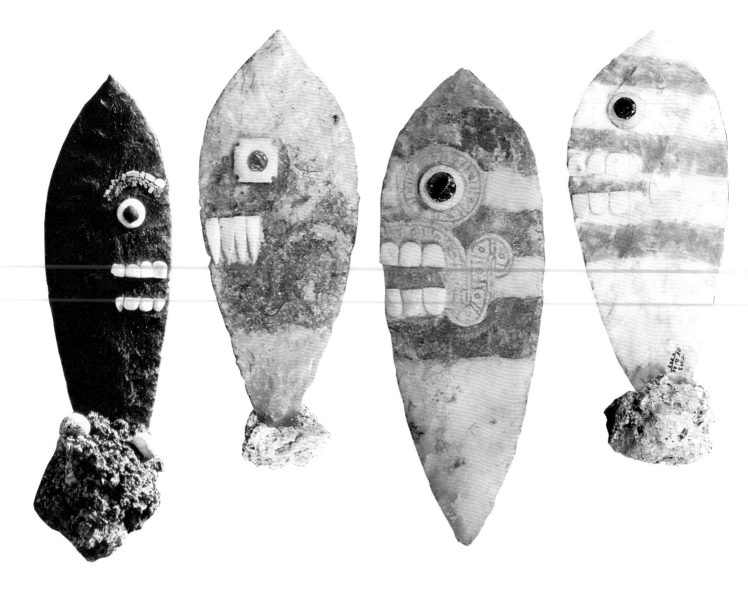

5 A-D

Decorated knives

A. Height .172 (6½), width .068 (2⅝); B. height .163 (6⅜), width .065 (2½); C. height .184 (7¼), width .064 (2½); D. height .175 (6⅞), width .067 (2⅝)

Flint, shell, turquoise, hematite, obsidian

Proyecto Templo Mayor, Mexico City, nos. 10-168813, 10-220286, 10-220285, 10-220291

Found in the Templo Mayor precinct of Mexico Tenochtitlan, 1978-1982

These beautifully chipped flint knives (*tecpatl*) were found in offertory caches during the project to excavate the Templo Mayor conducted between 1978 and 1982 by the National Institute of Anthropology and History. They all display so-called "demon faces" in profile, consisting of a single eye, sometimes topped by an eyebrow, and two rows of teeth that resemble the exposed dentition of the fleshless mouths of skeletal depictions (cf. nos. 4, 14, 16). These features, formed by the application of pieces of shell, turquoise, hematite, and obsidian, are individually characterized. No. 5B, for example, exhibits pointed teeth, and instead of a round design, a maltese cross forms the eye. No. 5C shows a painted band across the top of the mouth that ends in a curl and a similar circular band around the eye. The markings of these strips, which form rectangular units with enclosed circles, are similar to the painted snake bands that form the diagnostic "goggle eye" and scrolled mouth of some Tlaloc representations (cf. no. 28). Painted horizontal stripes decorate the lighter colored knives. Three of them (nos. 5A, 5B, 5D) were found set in balls of copal incense. Stone sacrificial knives embellished with these faces are common decorative motifs in Aztec art, both in pictorial manuscripts and on sculpture (e.g., nos. 1, 7, 13, 14). The concept appears to have involved a kind of personification of the fearsome instrument ritually employed to dispatch the victims whose hearts and blood nourished the sun on which the survival of the universe depended.

Eduardo Matos Moctezuma, ed., *El Templo Mayor: excavaciones y estudios* (Mexico, 1982).

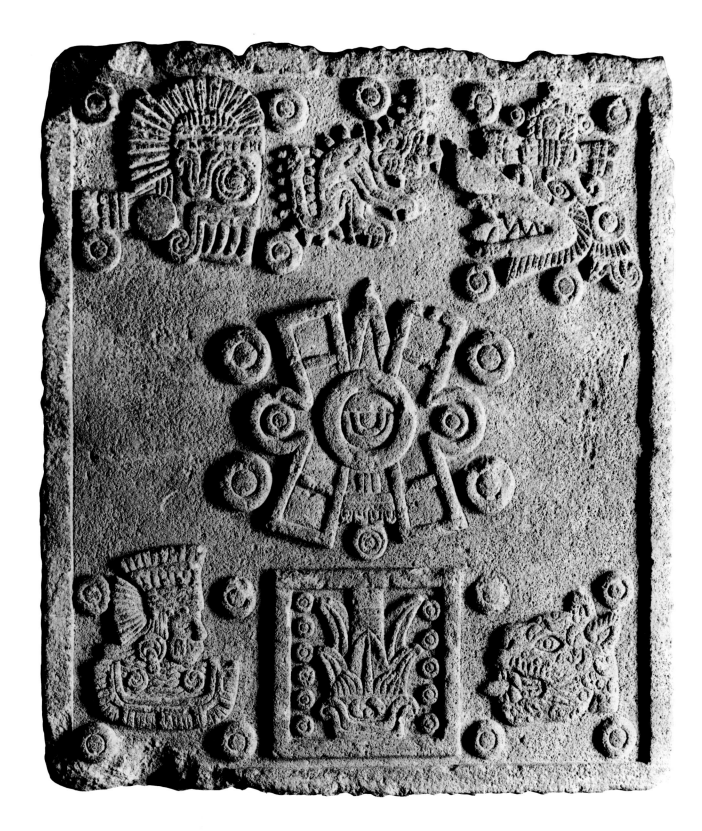

6
Stone of the Five Suns
Height .228 (9); length .673 (26½);
width .577 (22¾)
Basalt
The Time Museum, Rockford,
Illinois
Purportedly found in Mexico City

This carved rectangular block en-
tered a Los Angeles private collec-
tion in the winter of 1971 and is
now in the Time Museum in Rock-
ford, Illinois. No precise provenance
data are available, but it was prob-
ably discovered somewhere near the
center of Mexico City. Carved in
high relief on its top surface are
seven dates in the indigenous calen-
dric system. Five of these, depicted
in each case by a profile figure and
four dots, represent the days 4 Oce-
lotl (Jaguar, lower right), 4 Ehecatl
(Wind, upper right), 4 Quiahuitl
(Rain, upper left), 4 Atl (Water,
lower left), and 4 Ollin (Movement,
center). They designate the termina-
tion dates of the five cosmic eras, or
"suns," into which the history of the
universe was divided in the cosmo-
gonical scheme current in the impe-
rial capital, Mexico Tenochtitlan, in
late pre-Hispanic times. Four of

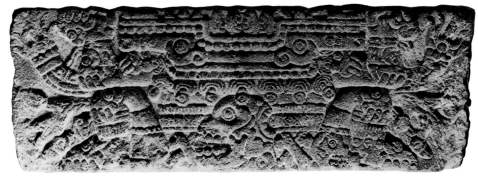

Side view, no. 6.

Underside, no. 6.

these ages were believed to have preceded the present era. On these days of destruction, shown in the four corners, the human inhabitants (with the exception of a single male-female pair who survived to continue the race) were annihilated by four different kinds of cataclysms, respectively: swarms of ferocious jaguars, hurricanes, rains of fire, and a great deluge. The present, or fifth, sun, represented by the 4 Ollin (Movement) symbol in the center, was to have been terminated by violent earthquakes. Stylistically, these dates symbolizing the Five Suns are quite similar to those on other Aztec monuments; for example, the Calendar Stone (see fig. 3) and the Stone of the Suns, both in the Museo Nacional de Antropología, Mexico, and a carved rectangular stone in the Yale Peabody Museum (Beyer 1921: figs. 81-82, 92, 102, 114).

In addition, between the 4 Ehecatl (Wind) and 4 Quiahuitl (Rain) dates is the date 1 Cipactli (Crocodilian Monster), the first day of the 260-day divinatory cycle (*tonalpohualli*), here shown in a rare full-figured form (cf. Box of Hackmack, no. 15). Between the 4 Atl (Water) and the 4 Ocelotl (Jaguar) dates is the date 11 Acatl (Reed) within a square cartouche. These two dates probably connoted a year and a day within it. Because of the obviously very late style of the carving, 11 Acatl must equate with A.D. 1503. In the Caso correlation of the calendric system of Mexico Tenochtitlan (Caso 1939), the day 1 Cipactli (Crocodilian Monster) fell only once during this year, as the eighth day of

Hueytecuilhuitl, equivalent to 15 July 1503, o.s. Evidence exists in the ethnohistorical sources that Motecuhzoma II, who ruled Mexico Tenochtitlan from 1503 to 1520, was crowned on the day 1 Cipactli (Crocodilian Monster) in that year. It is probable, therefore, that these two dates were carved on this essentially religious monument to commemorate that significant dynastic event. This conjunction of dates on the upper face of the monument was most likely intended to link the initiation of the reign of Motecuhzoma II, Mexico Tenochtitlan's last pre-Hispanic ruler, to the sequence of cosmogonical ages, the last of which was particularly characterized by the rise to imperial glory of the Mexica metropolis. The combination of mythological and historical dates indicates that dynastic-historical events were placed within a cosmogonical-cosmological frame of reference.

All four sides of the piece are fully carved in relief, displaying typical, nearly identical, representations of Tlaltecuhtli, the earth in the guise of a grotesque, crouching monster with a gaping mouth studded with knife-teeth (cf. nos. 3, 14, 15, 58). This splayed creature is flanked by two *atl tlachinolli*, or "sacred war," symbols (cf. no. 14). On the underside of the stone, the more usual position for Tlaltecuhtli images, is another large date, 1 Tochtli (Rabbit), the calendric name of the Earth, which was created in that year. It is incised in the stone in a style that differs from the relief carving of the other surfaces.

The precise function of this monument is uncertain since no examples of its type have been found *in situ*. Stylistically and iconographically it constitutes an excellent example of a late Aztec religious monument, in this case—as with some other well-known sculptures—including dates with apparent historical-dynastic referents. Aesthetically, it is a decidedly superior specimen. The high-relief of the carvings, particularly on the top surface, lends them a striking boldness and vigor.

Hermann Beyer, *El llamado "Calendario Azteca"* (Mexico, 1921); Alfonso Caso, "La correlación de los años azteca y christiana," *Revista Mexicana de Estudios Antropológicos* 3, no. 1 (1939): 11-45.

7
Fifty-two-year bundle stone (xiuh-molpilli)
Length .61 (24); diameter .31 (12¼)
Basalt
Museo Nacional de Antropología,
Mexico City, no. 24-152; 11-3331
Found probably in Mexico City be-
fore 1845

In 1845 in the second of the three-
volume Navarro Spanish translation
of William H. Prescott's classic *His-
tory of the Conquest of Mexico*, José
Fernando Ramírez, a pioneer Mexi-
can student of Mexican archaeology
and ethnohistory, published with
drawings a study of four Aztec
monuments in the Mexican national
museum, including this piece and
the Dedication Stone of the Great

Temple of Mexico Tenochtitlan
(no. 11). He interpreted this sculp-
ture as a replica in stone of a bundle
of fifty-two sticks (*xiuhmolpilli*),
symbolizing the years of the fifty-
two-year cycle, conceptually equiva-
lent to our century. He explained
the 2 Acatl (Reed) date conspicu-
ously carved on it as the year in
which this cycle terminated and re-
commenced, marked by the celebra-
tion of the New Fire ceremony
(*toxiuhmolpia*) (Ramírez 1845:
106-115).

The New Fire ceremony was the
most important in the entire Aztec
ritual system, occurring only every
fifty-two years. According to Fray
Bernardino de Sahagún's vivid de-
scription of the event (Sahagún
1950-1982, part 7: 25-32), at dusk

all the fire priests of the imperial
capital, Mexico Tenochtitlan, ar-
rayed as gods, issued forth from the
sacred precinct of the Great Temple
of Huitzilopochtli and marched
south in a stately procession down
the long causeway that led out of
the city to a small hill, Huixachtlan,
called today Cerro de la Estrella,
Hill of the Star. Fires were doused,
and idols and household utensils
discarded. All climbed to their
housetops, straining to perceive
through the darkness the flare-up of
the New Fire on the summit of the
little hill. It was an anxious mo-
ment, for if New Fire could not be
created the universe would come to
an end, the sun would be extin-
guished, and the stars would be
transformed into monsters and de-

vour all mankind. Pregnant women were guarded in the granaries lest they turn into fierce monsters, and children were kept awake with cuffs and pinches lest they fall asleep and turn into mice. At midnight the most competent fire priest (who had been practicing all evening) twirled the fire sticks on the fire board placed on the chest of a specially selected young prisoner. When fire had been produced, his heart was torn out and cast into the flames, followed by his body. Then swift couriers from the capital and all the neighboring towns sped to their home communities holding aloft blazing torches with which they ignited the sacred fires in their temples, from which householders drew fire, carrying it to their domestic hearths. At noon the next day a great feast was celebrated, hailing the passing of the danger and the renewal of the universe, at least for another fifty-two years.

Ramírez also believed that this piece commemorated the shift, mentioned by one of the annotators of the *Codex Telleriano-Remensis*, of the celebration of the New Fire ceremony from 1 Tochtli (Rabbit, 1506), to the following year, 2 Acatl (Reed, 1507), allegedly decreed by the ruler, Motecuhzoma II, because of the ominous famines of the former year. Ramírez' interpretation of the two dates on the ends of the

stone, 1 Tecpatl (Stone Knife) and 1 Miquiztli (Death), was not very successful.

The outstanding German scholar Eduard Seler (1902-1923, 2: 872-883) challenged Ramírez' view, suggesting instead that this sculpture and others like it actually functioned as seats made from bundles of reeds (*tolicpalli*) for the supreme deity Tezcatlipoca. The year bundle interpretation of Ramírez, however, has clearly predominated (cf. Mena 1914). The most satisfactory explanation of the actual function of such pieces was advanced in 1937 by the leading Mexican archaeologist Alfonso Caso (1940), citing above all the pictorialization in the *Codex Borbonicus* (1974: 34, 36) of the New Fire ceremony of 1507 and a subsequent follow-up ceremony. He advanced the hypothesis that these stone year bundles were placed in ritual "tombs" decorated with the skull-and-crossed-bones motif of the skirts of the earth-death goddesses, in effect to "bury" them at the expiration of the fifty-two-year cycle. Three of these "tombs" were discovered in 1900 during the Escalerillas Street excavations north of the Mexico City cathedral, two of them containing interred stone *xiuhmolpilli* (fig. 7a; Caso 1940: figs. 7, 8).

Approximately twenty of these year bundle stones are extant, scattered in various collections throughout the world. This example is definitely the finest, depicting with exceptional realism the bundle of fifty-two sticks and the double twisted cords that bind them at both ends. Superimposed on the side of the bundle is a large 2 Acatl (Reed) date within a square cartouche, the Reed symbol particularly well carved (see annotation to no. 11). Sculpted in relief on the ends of the bundle are two dates: 1 Miquiztli (Death), represented by a skull with a knife in its mouth and a smoking mirror symbol on its head, and 1 Tecpatl (Stone Knife), shown by a stone knife with a "demon face" and another smoking mirror on its side. The date 2 Acatl (Reed) clearly connotes the New Fire year, most likely 1507. The other two dates have been variously interpreted, but both have solar associations and possibly represent the birth and death days of the Aztec patron deity Huitzilopochtli, whose solar connections have long been recognized (Caso 1940: 75-76). Both 1 Miquiztl (Death) and 2 Acatl

fig. 7a Two year bundle stone replicas ritually interred in an "altar of skulls." *In situ*, Calle de las Escalerillas excavations, Mexico City, 1900. From Batres 1902:45.

(Reed) are also calendric names of Tezcatlipoca, and 1 Tecpatl (Stone Knife) is the calendric name of Huitzilopochtli, an aspect of the great god of the smoking mirror.

Of the thirteen examples of *xiuhmolpilli* once in the Museo Nacional de Antropología, seven of which bear dates, only one other displays these same dates in the same positions as on our piece—an unpublished, unusually thick specimen that bears considerable traces of color. Another, also unpublished, shows floral motifs on the body of the bundle and, similar to our example, the dates 1 Miquiztli (Death) and 1 Tecpatl (Stone Knife) on the ends. A third unpublished specimen in a Mexican private collection exhibits only the 1 Tecpatl (Stone Knife) date in a square cartouche on the bundle. The date 1 Miquiztli (Death) in this same position is more common, with three models in the Mexican national museum (Mena 1914: fig. 2; Seler 1902-1923, 2: 876, Abb. 76a) and one in the Stadt Museum für Völkerkunde, Frankfurt am Main (*Präkolumbische Kunst aus Mexiko und Mittelamerika* 1960: Tafel 24). The stone year bundle that manifests the most interesting and complex representations was found in Mexico City in 1950 (Moedano Koer 1951). It bears

a 1 Acatl (Reed) date within a square cartouche; a banner, probably symbolizing the twenty-day period ceremony, Panquetzaliztli, "Raising of Banners"; the head of a macabre being; and a scene that appears to depict a spider or other insect descending from a star-studded sky. This writer (Nicholson 1955) has interpreted these motifs as indicating the day of the New Fire ceremony, 1 Acatl (Reed), twentieth day of Panquetzaliztli (Caso correlation), and as two versions of the stellar death demons (*tzitzimime*), who would devour mankind if the New Fire could not be struck.

Leopoldo Batres, *Archaeological Explorations in Escalerillas Street, City of Mexico: Year 1900* (Mexico, 1902); Alfonso Caso, "El entierro del siglo," *Revista Mexicana de Estudios Antropológicos* 4 (1940): 65-76; *Codex Borbonicus, Commentary by Karl A. Nowotny* (Graz, Austria, 1974); Ramón Mena, "Asiento grande de Tezcatlipoca? (refutación al Sr. Dr. Ed. Seler)," *Memorias de la Sociedad Científico "Antonio Alzate"* 33 (1914): 157-164; Hugo Moedano Koer, "Ce Acatl igual a Ome Acatl como fin del Xiuhmolpilli," *Revista Mexicana de Estudios Antropológicos* 12 (1951): 103-131; H. B. Nicholson, "Aztec Style Calendric Inscriptions of Possible Historical Significance: A Survey" (mimeographed, Mexico, 1955); *Präkolombische Kunst aus Mexiko und Mittelamerika, Mai bis September, Historisches Museum Frankfurt am Main* [exh. cat., Historisches Museum Frankfurt am Main] (Frankfurt am Main, 1960); José Fernando Ramírez, "Descripción de cuatro lápidas monumentales conservadas en el Museo Nacional de México, seguida de un ensayo sobre su interpretación," in William H. Prescott, *Historia de la conquista de México . . . traducida al español por Joaquín Navarro*, 3 vols. (Mexico, 1844-1846) 2: 106-124; Fray Bernardino de Sahagún, *Florentine Codex, General History of the Things of New Spain, translated from the Aztec into English, with notes and illustrations, by Arthur J. O. Anderson and Charles E. Dibble*, Monographs of the School of American Research, Santa Fe, New Mexico, no. 14, parts 1-13 (1950-1982); Eduard Seler, *Gesammelte Abhandlungen zur Amerikanischen Sprach- und Altertumskunde*, 5 vols. (Berlin, 1902-1923).

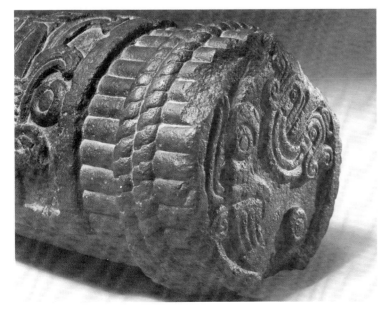

Detail, no. 7.

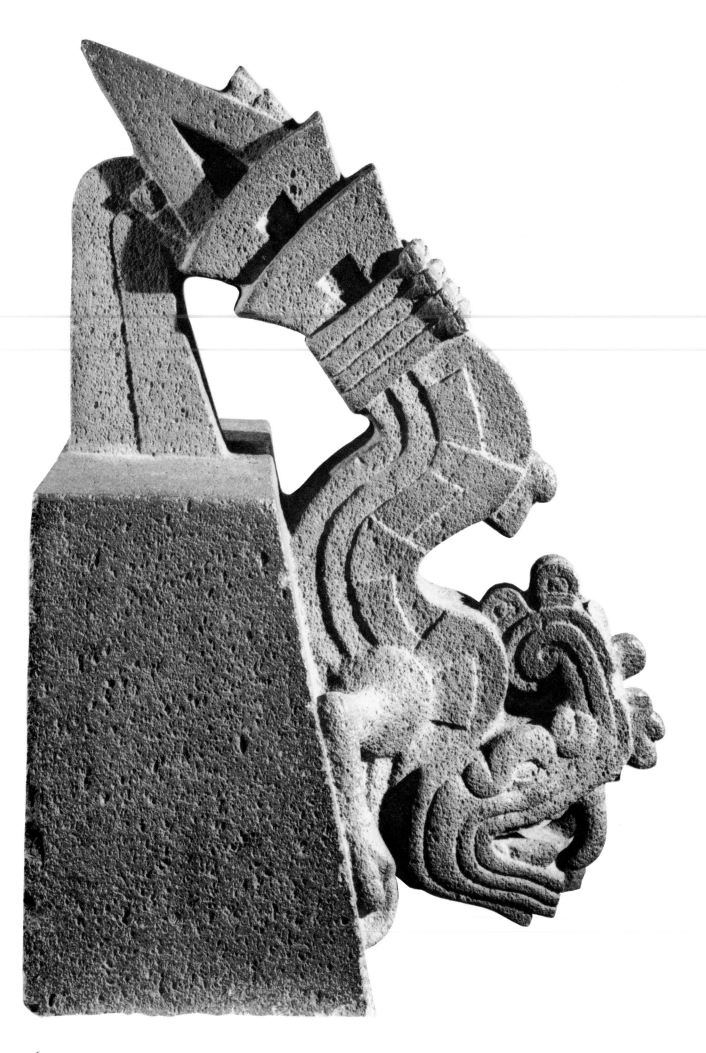

8

Fire serpent (xiuhcoatl)
Height (without base) .755 (29¾);
width .605 (23⅞); depth .565 (22¼)
Stone
Museum of Mankind, The British
Museum, London, no. 1825.12-10.1
Reported in the Texcoco customs
house in 1794; acquired by William
Bullock in 1823

Aztec stone snakes are deservedly
famous, and the pieces in this exhi-
bition typify the range and variety
of this richest category of a remark-
able sculptural bestiary. The major-
ity of Aztec serpents are based on
the rattlesnake. Even when covered
with feathers to represent the myth-
ical feathered serpent, the rattle-
snake is usually depicted with con-
siderable realism (cf. nos. 57-60).
One type of snake, however, was
much more fantastic, the *xiuhcoatl*,
literally "turquoise snake." Al-
though modeled to some extent on
the living reptile, it was a composite
creature somewhat equivalent to a
dragon. Because its igneous associa-
tions are signified by its usual red-
yellow coloration in the ritual-
divinatory pictorial manuscripts
and the frequent decoration of its
body with flame and smoke sym-
bols, it is more commonly referred
to as a "fire serpent." Its origins are
probably connected with the celes-
tial dragons of Classic Lowland
Maya civilization (c. A.D. 250-900),
whose sectioned bodies bore stellar

and other celestial symbols. One of
the hallmarks of the Aztec *xiuhcoatl*
is its sectioned body, although here
the celestial motifs within the seg-
ments are absent (replaced by flame
devices on the famous Calendar
Stone, fig. 3).

The Aztec *xiuhcoatl* usually dis-
plays an essentially serpentine head,
but with a peculiar extended snout
that curves back on itself and is
edged with circular eye symbols,
i.e., the eyes of night, the stars. This
fantastic creature also invariably
possesses short forelegs terminating
in formidable claws. Its tail is par-
ticularly distinctive: a set of parallel
paper strips, usually four, with cen-
tral knots precedes a trapezoidal
element and ray device. This combi-
nation of trapeze and ray consti-
tuted the well-known symbol for the
year (*xihuitl*), conveying the first
element in the creature's name. This
was sometimes reinforced by the ad-
dition, between the paper strips and
trapeze device, of grass stalks tipped
with round buttons, connoting
grass, which in Nahuatl was also
called *xihuitl*. Many differing inter-
pretations of the ideological signifi-
cance of the *xiuhcoatl* have been of-
fered (e.g., Seler 1900-1901: 75-77;
Beyer 1921: 97-109). Basically, it
seems to have been a member of a
profusely variegated Mesoamerican
celestial bestiary, with strong solar
associations (as depicted on the Cal-
endar Stone). It also served as the
nahualli, the zoomorphic disguise of
Xiuhtecuhtli, the fire god (fig. 8a),
and sometimes Tezcatlipoca (cf. re-
lief figure on colossal jaguar
cuauhxicalli) and Huitzilopochtli,
the martial Aztec patron deity.

Two poor drawings of this piece
appear in the 1794 Dupaix cata-
logue, and their annotations ascribe
it to Texcoco, more specifically, to
its customs house. William Bullock,
the English entrepreneur, acquired it
during his trip to Mexico in 1823
and illustrated it in an engraving in

fig. 8a Fire god, Xiuhtecuhtli, with the fire
serpent (*xiuhcoatl*) as a back ornament. Co-
dex Borbonicus 9. From Seler 1902-1923,
2:936, Abb. 39.

his book describing his journey
(Bullock 1924b: pl. 2, no. 2). The
caption reads: "A curious Idol, of
stone, representing the fore-part of a
Crocodile, terminating in sacred or-
naments often met with in the MSS.
and Calendars; it appears to be the
only one yet discovered, and weighs
upwards of 500 lbs." It was in-
cluded in Bullock's famous London
exhibit, "Ancient Mexico," at the
Egyptian Hall, Piccadilly, and is no.
13 in his catalogue, with the same
caption as the illustration in his
book (Bullock 1824b: 41). The Brit-
ish Museum obtained it in 1825 (see
annotation to no. 17).

Our piece portrays the fantastic
creature in fairly typical fashion:
with a sectioned body, clawed fore-
legs, prominent back-curling snout
edged with star-eyes, and the stan-
dard tail assemblage. The doubling
of the trapezoidal element in the
"year symbol" is unusual, as are the
two teeth edging the body (the other
pair, just above the gaping jaw, is
common). Unique is the attachment
of the creature to a massive trape-
zoidal block, the tail supported by a
connective piece. This block has
been called a coping stone. Whether
this designation is accurate, the
piece as a whole probably func-
tioned as an architectural adorn-
ment of some kind, probably in a
temple. Stylistically, the piece is dis-
tinguished by its remarkable planar
angularity, with the creature de-
picted, in effect, as a large stone cut-
out. Carved with great skill, it again
exhibits the mastery over stone of
the Aztec sculptors.

Hermann Beyer, *El llamado "Calendario
Azteca"* (Mexico, 1921); William Bullock, *A
Description of the Unique Exhibition,
Called Ancient Mexico; Collected on the
Spot in 1823, by the Assistance of the Mexi-
can Government, and Now Open for Public
Inspection at the Egyptian Hall, Piccadilly*
(London, 1824a); and *Six Months' Resi-
dence and Travels in Mexico* (London,
1824b); Guillermo Dupaix, "Descripción de
monumentos antiguos mexicanos," 1794
(manuscript in the Museo Nacional de An-
tropología, Mexico); Eduard Seler, *Gesam-
melte Abhandlungen zur Amerikanischen
Sprach- und Altertumskunde*, 5 vols. (Berlin,
1902-1923).

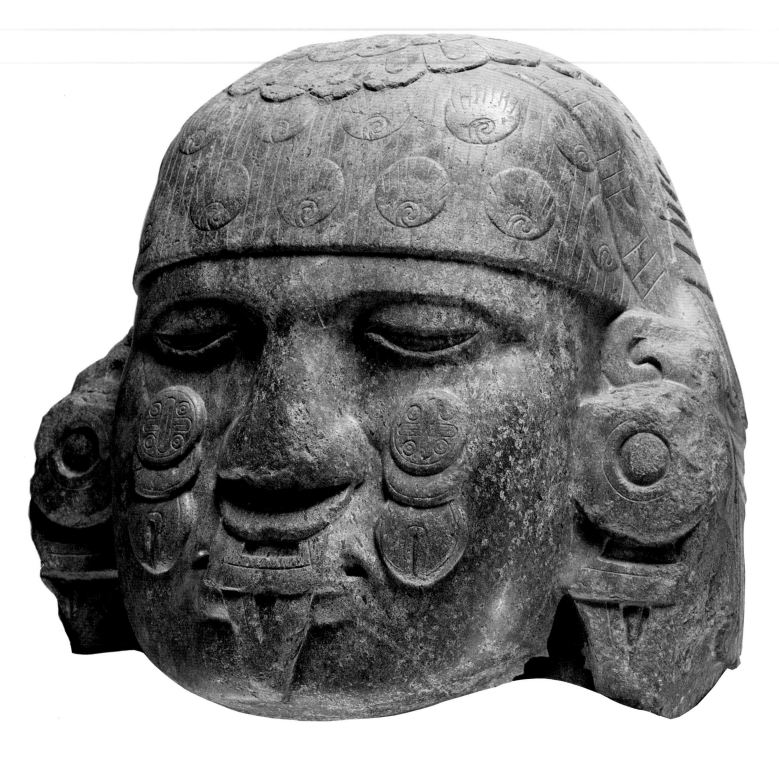

48

9
Colossal head of Coyolxauhqui
Height .75 (29½); width .83 (32⅝);
depth .55 (21⅝)
Green porphyry
Museo Nacional de Antropología,
Mexico City, no. 24-135; 11-3338
Discovered in Mexico City in 1830

This magnificently conceived and executed sculpture is one of the masterpieces of Aztec stone carving. Glimpsed from afar, the colossal head communicates a sense of massive grandeur, while a closer view reveals delicate surface treatment and finely incised ornamental details. The subtleties of the carving admirably balance the size and solidity of this impressive image of the malevolent goddess. Particularly outstanding is the delineation of the facial surfaces, the gently curving planes effectively expressing the soft contours of human flesh. The eyes, lids lowered to convey the fact that she is dead, form sharply chiseled crescent shapes beneath strongly defined brow ridges and the abrupt horizontal edge of her hair or headdress. The nose is broad and slightly flattened; the cheeks and chin full and rounded. Attached to her cheeks are stylized bells composed of three circular elements, with the cruciform symbol for gold engraved on the upper one. Beneath the overhanging nasal attachment, the downturned mouth appears slightly open. The distinctive nose ornament, probably a version of that worn by lords and certain deities (*yacaxihuitll*), is composed of circular, trapezoidal, and triangular elements and replicated in the ear decorations. Her striated hair, or more likely a headcloth, is studded with down balls, a symbol of sacrifice. The head is also adorned on top with an elaborate radial feather ornament with a long pendant that hangs down on the left side. The beauty of the stone itself is brought out by the high polish of its rich, green surface.

This monumental sculptured head was discovered in March 1830 in the foundations of a colonial structure behind the church of Santa Teresa la Antigua (present-day Lic. Verdad Street). With the authorization of Lucas Alamán, Minister of Foreign Relations, the historian Carlos María Bustamante offered to purchase the head for Mexico's recently established national museum. The superior of the convent that owned the land on which it was found freely ceded it, however, and ever since it has been one of the museum's most prized treasures. Bustamante (in León y Gama 1832, part 2: 89-90) erroneously identified the head as that of Temazcalteci, an aspect of the earth-mother goddess, Teteoinnan. In a short article published in 1840 he provided further details on its discovery and added Centeotl, the maize deity whom he mistakenly equated with Temazcalteci, as a label for it. He also published the first illustrations of the piece, lithographs of front and back views of the head and of the complex relief on the underside. More accurate illustrations of the head appeared many years later in 1882, three attractive pencil drawings by the distinguished Mexican artist José María Velasco (in Chavero 1882-1903: 426-427). The correct identification of the goddess represented was not made until 1900 by the leading European Mexicanist of his day, Eduard Seler, in his classic commentary to the *Tonalamatl Aubin* (English edition, 1900-1901: 117). He recognized the motifs on the cheeks as bells (*coyolli*), enabling him to identify the head as that of Coyolxauhqui, the goddess "painted with bells."

In the myth of the birth of the Aztec patron deity Huitzilopochtli (Sahagún 1950-1982, part 4: 1-5), Coyolxauhqui appears as a malevolent sorceress and half-sister of this hero god. When Coatlicue, the earth-fertility goddess, miraculously conceived Huitzilopochtli, Coyolxauhqui, indignant over the disgrace of their mother's supposed sexual transgression, led her brothers, the Centzon Huitznahua ("400 Southerners") against their progenitress. As they charged up Coatepec (Hill of the Snake) with matricide their aim, a defector among his half-brothers warned Huitzilopochtli, still in his mother's womb. At the crucial moment he was born, fully accoutered and armed. After slaying and scattering his hostile half-brothers with his magic weapon, the *xiuhcoatl*, he decapitated and dismembered Coyolxauhqui. He then went on to lead his chosen people, the Azteca-Mexica, to their glorious destiny as masters of the Empire of the Triple Alliance.

This famous myth has given rise to diverse interpretations. The most popular has been the solar-lunar-astral interpretation of Seler (1902-1923, 2: 327-328; 4: 157-167), wherein Huitzilopochtli is the sun, who at the moment of his birth or rising from the earth (his mother Coatlicue, a recognized earth goddess) conquers and disperses the moon (Coyolxauhqui) and the host of stars of the southern firmament (Centzon Huitznahua). This hypothesis is seductive and logical, which probably explains its wide acceptance. With regard to Coyolxauhqui, however, there seems to be little or nothing in her iconography that is specifically lunar. On the other hand, she does relate closely to various female fertility deities, particularly Xochiquetzal, whose lunar associations have been generally accepted.

The central shrine of the empire, the Templo Mayor of Huitzilopochtli that was shared with Tlaloc, the ancient rain-fertility god, was also called Coatepec, the site of Huitzilopochtli's birth. There is evidence (discussion in Nicholson, in press) that this monumental sculpture, representing Coyolxauhqui's decapitated head, was positioned on the top platform or on one of the stages of the Templo Mayor to commemorate this mythic incident. If so, it would have been complementary to her full representation on the great circular relief carving situated at the foot of the Stage IVb stairway lead-

ing up to the Huitzilopochtli shrine, which was discovered in 1978 (fig. 5; García Cook and Arana 1978; Aguilera 1978; Nicholson, in press).

Carved in relief on the undersurface of the head is the "sacred war" symbol (*atl tlachinolli*) (cf. colossal jaguar *cuauhxicalli* and nos. 6, 14, 61) intertwined with a "sacrificial cord" trimmed with down balls (*aztamecatl*) and a two-headed coral snake, a type particularly associated with fertility-earth goddesses. These symbols undoubtedly refer to the nature of her sacrificial death at the hands of her warlike half-brother. On the upper left is a date, probably 1 Tochtli (Rabbit), in a square cartouche, and on the upper right what appears to be a spider. The interpretation of the date is problematic. One Tochtli, the date of the creation of the present earth, is sometimes carved on the underside of Aztec monuments (cf. no. 6). One colonial pictorial source (*Códice Azcatitlan* 1949: pl. 5) seems to indicate 1 Tochtli (equated with 1194 in the Spanish gloss) as the year of Coyolxauhqui's slaughter by Huitzilopochtli, although in other sources the following year, 2 Acatl (equated with 1143), is more frequently given for this event. The spider was a feared, loathsome creature of the earth, connected with darkness and sorcery, of which the evil Coyolxauhqui was a mistress.

Carmen Aguilera, "Coyolxauhqui: ensayo iconográfico," *Biblioteca Nacional de Antropología e Historia, Instituto Nacional de Antropología, Cuadernos de la Biblioteca, Serie Investigación*, 2 (1978); Carlos María Bustamante, "Monumentos de la antigua México: diosa Centeotl o de los temascales," *El Mosaico Mexicano* 3 (1840): 402-404; Alfredo Chavero, "La piedra del sol: estudio arqueológico," *Anales del Museo Nacional de México*, primera época (1882-1903) 2: 3-46, 233-266, 291-310, 403-430; 3: 3-26, 37-56, 110-114, 124-136; 7: 133-136; Angel García Cook and Raúl M. Arana A., *Rescate arqueológico del monolito Coyolxauhqui: informe preliminar* (Mexico, 1978); Antonio León y Gama, *Descripción histórica y cronológica de las dos piedras que con ocasión del nuevo empedrado que se está formando en la plaza principal de México se hallaron en ella el año de 1790*, edited by Carlos María Bustamante, 2d ed., rev. and enl. (Mexico, 1832); H. B. Nicholson, "The New Tenochtitlan Templo Mayor Coyolxauhqui-Chantico Monument," in press, Festschrift honoring Prof. Gerdt Kutscher, Ibero-Amerikanisches Institut, Berlin; Fray Bernardino de Sahagún, *Florentine Codex, General History of the Things of New Spain*, translated from the Aztec into English, with notes and illustration, by Arthur J. O. Anderson and Charles E. Dibble, Monographs of the School of American Research, Santa Fe, New Mexico, no. 14, parts 1-13 (1950-1982); Eduard Seler, *Gesammelte Abhandlungen zur Amerikanischen Sprach- und Altertumskunde*, 5 vols. (Berlin, 1902-1923).

Side views, no. 9.

Underside, no. 9.

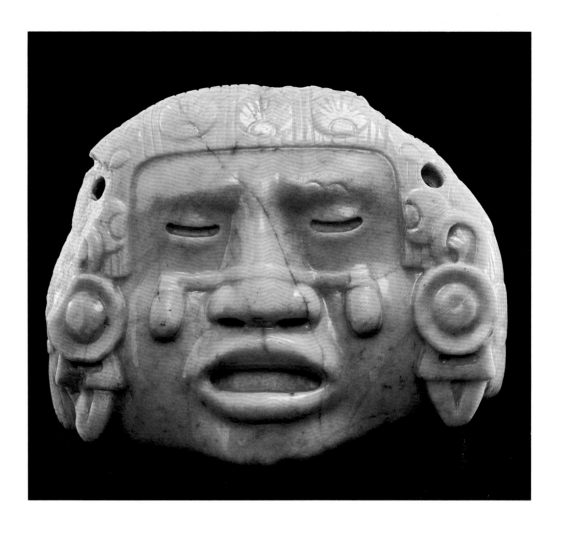

10
Mask of Coyolxauhqui
Height .115 (4½); width .145 (5¾)
Jadeite
Peabody Museum of Archaeology
and Ethnology, Harvard University,
Cambridge, Massachusetts, no.
28-40-20

This small, handsome mask was acquired by the Peabody Museum by purchase in 1928. It has two conspicuous perforations above the ears and may have been worn as a pectoral. A series of small perforations along the rear edge of the underside of the mask might have been bored to facilitate the hanging of pendants or other attachments. Although in most respects it replicates the essential facial depiction and ornamenta-

tion of the colossal head of Huitzilopochtli's half sister (no. 9), it lacks the complex feather decoration on the top and side of the head, as well as the nose ornament (*yacaxihuitl*). It displays one significant element missing on the great head, however, the band incised across the nose linking the bells on the cheeks. These bells are here stylized more simply than those of the head. The band is also present on the Templo Mayor Coyolxauhqui relief found in 1978 (fig. 5). While the three-dimensional greenstone head is particularly distinguished for its volumetric monumentality, this smaller, more stylized mask version, which is essentially a two-dimensional treatment of the same image, effectively maintains the strength and elegance of the colossal head.

11

Dedication Stone of the Great Temple of Mexico Tenochtitlan
Height .88 (34⅝); width .60 (23⅝)
Green metamorphic stone ("serpentine")
Museo Nacional de Antropología, Mexico City, no. 24-2; 11-3203
Found in Mexico City before 1845

Aside from constituting a superior example of relief sculpture, this famous slab bears the distinction of being the Aztec monument that can be most securely related to a specific, pre-conquest historical event. It was first published (drawing) and interpreted in 1845 by José Fernando Ramírez after it had come into the possession of the Museo Nacional de México. Ramírez did not state precisely where it had been discovered nor by whose agency it had reached the museum, but its Mexico City provenance seems virtually certain. Ramírez' interpretation of it as the dedication stone of the 1487 renovation of the Templo Mayor (Great Temple) of Mexico Tenochtitlan was basically correct, but later scholars, especially Orozco y Berra (1877), Seler (1904), Nuttall (1904), Peñafiel (1910), Beyer (1919, 1921), Caso (1939, 1959), Nicholson (1955), Townsend (1979), and Aguilera (1982), have expanded and clarified his pioneer analysis.

In format the relief is divided into two registers. The slightly larger lower one consists of a calendric sign enclosed in a square cartouche. A reed arrow (or hollow sucking reed) edged with leaves or feathers is set in a vessel depicted in cross-section. This was the standard late Aztec manner of representing Acatl (Reed), thirteenth of the twenty day signs. It is flanked by eight large circles-within-circles, four on each side, constituting the numerical coefficient that produces the date 8 Acatl (1487).

The upper register features two facing, profile male figures. They are identified by their name signs behind their heads as two sequent rulers of Mexico Tenochtitlan—Tizoc on the left (ruled 1481-1486) and his younger brother Ahuitzotl on the right (ruled 1486-1502). The name signs are well known from pictorial histories and other monuments: Tizoc ("the bled one"?), a wounded or bleeding leg; Ahuitzotl, a quasi-mythical aquatic quadruped (based on the water opossum, *Chironectes panamensis*?). Both rulers wear loincloths and *xicolli*, the fringed, sleeveless jacket of the priests. On their backs they carry the gourd vessel for tobacco pellets (*yetecomatl*), characteristically trimmed with tied strips and plugged with stoppers of precious stone. Incense pouches of typical triple-tasseled form (*copalxiquipilli*) hang from their forearms. On their heads they wear the forked, white heron feather ornament (*aztaxelli*). Large circular earplugs and bracelets with two circular ornaments complete their attire. As penitent priests, they wear no sandals. With pointed bones they perform autosacrifice, drawing from their ears blood that flows in thick streams into the open mouth of the face of the earth deity, depicted symbolically as a strip below their feet and marked with ovoid motifs that represent the spines on the body of the crocodilian earth monster, the *cipactli* (Beyer 1919). Bleeding wounds on their arms and legs indicate other parts of the body from which they have also drawn blood. Resting on the earth monster body are two "frying pan incensarios" (*tlemaitl*) with long handles that end in serpent heads, smoke volutes issuing from their incense receptacles. Centrally located between the two rulers is a *zacatapayolli*, a plaited grass ball set within a leafy frame. Into it have been thrust two blood-smeared maguey spines, which were also employed to draw auto-sacrificial blood. They are tipped with symbols for jade and flowers to connote the preciousness of sacrificial blood. This standardized format, with two lords flanking the *zacatapayolli*, is known from other dynastic monuments, for example, a Templo Mayor banquette frieze (Beyer 1955: fig. E) and the "Stone of the Warriors" (Peñafiel 1910: lám. 107). Directly above the *zacatapayolli* is a second date, 7 Acatl.

The overall significance of the imagery of this block has been universally accepted since it was first published in 1845. Many textual and pictorial sources ascribe to the date 8 Acatl (1487) the completion of the last major enlargement of the Great Temple of Huitzilopochtli and Tlaloc, the supreme shrine of the Empire of the Triple Alliance of which Mexico Tenochtitlan was the capital. The renovation was commenced by Tizoc about 1483 and, after his death in 1486, completed the following year by his younger brother and successor, Ahuitzotl. It appears to have been dedicated with the ritual immolation of more persons than any other sacred structure in the history of the world, and many accounts of this sanguinary ceremony are extant. The most elaborated pictorial representation of the event is in the *Codex Telleriano-Remensis* (fig. 11a). A scene for the year 8 Acatl features Tizoc and Ahuitzotl, the completed temple, and the numerical specification of the twenty thousand prisoners, three from named communities, sacrificed during the dedication.

Townsend (1979:43) has recently interpreted the scene in the upper register of the stone in cosmological-political terms, suggesting that the "terrestrial monster strip"

is not only a symbol of the sacred earth, it is the earth of Tenochtitlan itself; *cem anahuac tenochca tlalpan*, "the world, Tenochca (Mexica) land." The sacred earth is here a metaphor for the territory of the nation. The open jaws of Tlaltecuhtli provide symbolic access to the "heart of the earth," the conceptual place of the earth's procreative and sustaining force, the *omphalos* of the universe; correspondingly, the main ceremonial center of Tenochtitlan acted not only as the central point of reference for the city, but also for the empire.

Townsend (1979: 42-43) also emphasizes the sacerdotal role of the two rulers, citing Fray Diego Durán's statement that at the dedica-

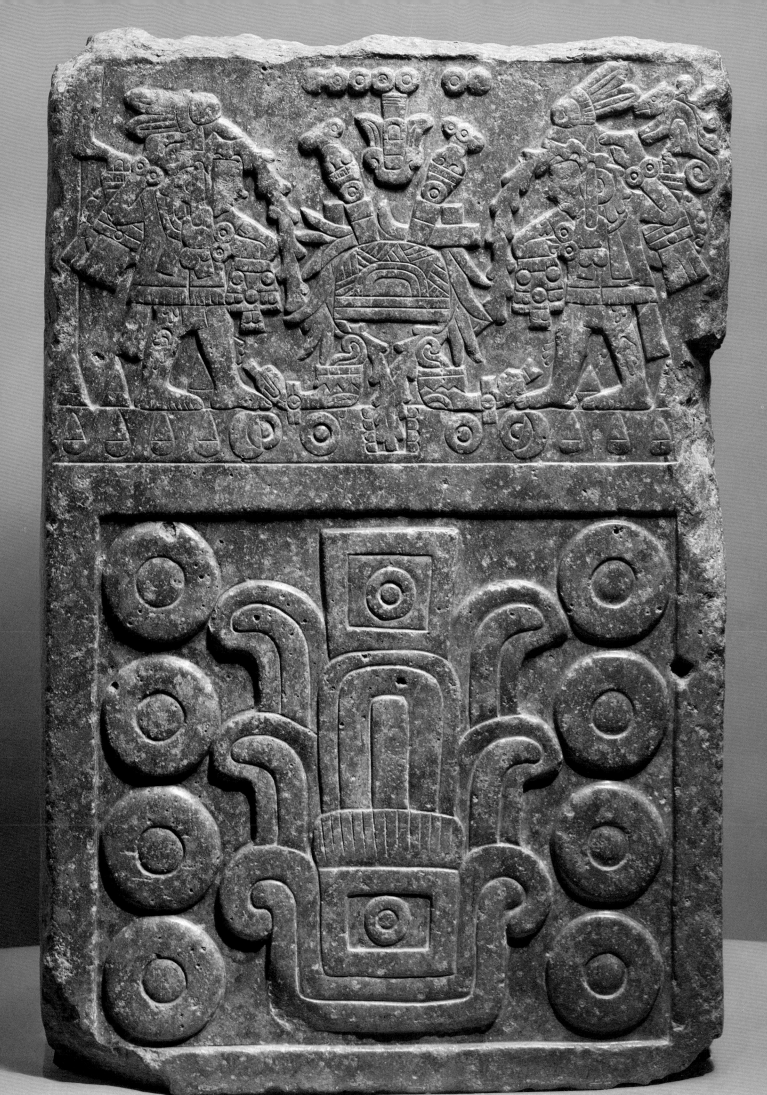

fig. 11a Dedication of the Great Temple of Huitzilopochtli and Tlaloc in Mexico Tenochtitlan in the year 8 Acatl (Reed), 1487. *Codex Telleriano-Remensis* 39r.

tion of new temples the ruler presided specifically as priest, acting symbolically as "the primate of the priestly hierarchy" and the "spiritual leader of the nation."

The 7 Acatl date has posed the greatest problem of interpretation. Ramírez (1844-1846, 2: 120-121) believed that it indicated the day within the year 1487, which he equated with February 19. Caso (1939: 39-40) agreed with the diurnal interpretation of this date but equated it with December 18 (Julian calendar; December 28, Gregorian calendar), the twentieth day of Panquetzaliztli, the special feast of the Mexica patron deity Huitzilopochtli that fell precisely on 7 Acatl. He felt that this provided strong support for the correctness of his correlation between the Aztec and Christian calendars. More recently, Aguilera (1982) cited this monument to support her hypothesis of a pre-Hispanic system of maintaining the synchronization of the vague tropical year with the seasons. She correlated the day 7 Acatl with December 19 (Gregorian), two days before the winter solstice, the celebration of which she argued was the principal object of Panquetzaliztli.

The date 7 Acatl could also be interpreted as a year instead of a day, a view favored by Seler (1904: 240). Citing Chimalpahin's statement that the 1487 dedication of the renovated Templo Mayor occurred on the day 4 Acatl, he suggested that 7 Acatl be equated with the year 1447, commemorating an earlier construction on the Great Temple during the reign of Motecuhzoma I (1440-1469), grandfather of Tizoc and Ahuitzotl. One early colonial document based on pre-Hispanic sources, the *Historia de los mexicanos por sus pinturas* (1965: 61), clearly states that this greatest of the Tenochca rulers renovated the principal temple of the city precisely in that year. However, Caso (1939: 39; 1959: 17-18) in particular rejected this explanation, principally on the ground that the 7 Acatl was not framed by the square cartouche that was normally present when a year rather than a day referent was intended. This author (Nicholson 1955: 4) has suggested a third possibility, that this 7 Acatl does not denote a specific date or event but figures here as one of the well-known calendric names of the archetypal Toltec priest-ruler, Topiltzin Quet-

zalcoatl, the inventor and patron of the auto-sacrifice being performed by the two rulers. Although perhaps the least likely of the three hypotheses advanced to explain this date, it seems worthy of some consideration. Perhaps this date had multiple referents, both historical and ritual. In any case, the varying explanations point up the difficulty frequently encountered in the interpretation and correlation of Aztec dates.

This highly polished, attractively colored slab, carved only on one face, was probably set into the Templo Mayor structure at the time of the 1487 dedication, possibly on one of the lower balustrades of the stairways (cf. two dates in similar positions on the large stone model of a temple called the Teocalli of the Sacred War [Caso 1927: fig. 2]). During the Templo Mayor excavation project, four date stones (2 Tochtli, 1390?; 4 Acatl, 1431?; 1 Tochtli, 1454?; 3 Calli, 1369?) were discovered set into various sections of the superposed structures (*Estudios de Cultura Náhuatl* 15, covers). A stone plaque with the date 10 Tochtli (1502), accompanied by another with the name sign of Ahuit-

zotl, was also found built into the south wall of the first stage of the temple called "La Casa de Tepozteco" of Tepoztlan, Morelos (Seler 1907: 6-7). Many isolated stone plaques bearing dates are also extant (Nicholson 1955). Aztec commemorative dated stones, therefore, are not uncommon. None, however, compares in richness of iconographic detail and clarity of historical reference with this well-preserved, finely sculpted greenstone block.

Carmen Aguilera, "Xolpan y Tonalco. Una hipótesis acerca de la correlación astronómica del calendario mexica," *Estudios de Cultura Náhuatl* 15 (1982): 185-207; Hermann Beyer, "Objectos de forma amigdaloide existentes en representaciones mexicanas de la tierra," *El México Antiguo* 1, no. 4 (1919): 82-90; and "La lápida conmemorativa de la inauguración del Templo Mayor de México," *Revista de Revistas* 12, no. 596 (1921): 34-35; and "La 'procesión de los señores,' decoración del primer teocalli de piedra en Mexico-Tenochtitlan," *El México Antiguo* 8 (1955): 1-42; Alfonso Caso, *El teocalli de la guerra sagrada* (Mexico, 1927); and "La correlación de los años azteca y christiano," *Revista Mexicana de Estudios Antropológicos* 3, no. 1 (1939): 11-45; and "Nuevos datos para la correlación de los años azteca y cristiano," *Estudios de Cultura Náhuatl* 1 (1959): 9-25; E.-T. Hamy, ed., *Codex Telleriano-Remensis* (Paris, 1899); "Historia de los mexicanos por sus pinturas," in *Teogonía e historia de los mexicanos: tres opúsculos del siglo XVI*, edited by Angel María Garibay K. (Mexico, 1965): 23-90; H. B. Nicholson, "Aztec Style Calendric Inscriptions of Possible Historical Significance: A Survey" (mimeographed, Mexico, 1955); Zelia Nuttall, "A Penitential Rite of the Ancient Mexicans," *Archaeological and Ethnological Papers of the Peabody Museum, Harvard University* 1, no. 7 (1904); Manuel Orozco y Berra, "Dedicación del Templo Mayor de México," *Anales del Museo Nacional de México*, primera época, 1 (1877): 60-74; Antonio Peñafiel, *Principio de la época colonial: destrucción del Templo Mayor de México antiguo y los monumentos encontrados en la ciudad, en las excavaciones de 1897 y 1902* (Mexico, 1910); José Fernando Ramírez, "Descripción de cuatro lápidas monumentales conservadas en el Museo Nacional de México, seguida de un ensayo sobre su interpretación," in William H. Prescott, *Historia de la conquista de México . . . traducida al español por Joaquín Navarro*, 3 vols. (Mexico, Ignacio Cumplido, 1844-1846), 2: 106-124; Eduard Seler, "Ueber Steinkisten, *Tepetlacalli*, mit Opferdarstellungen und andere ähnliche Monumente," *Zeitschrift für Ethnologie* 36 (1904): 244-290; and "Die Wandskulpturen im Temple des Pulquegottes von Tepoztlan," *Congrès International des Américanistes, Quinzième Session, Québec, 10 au 15 Septembre, 1906*, 2 vols. (Quebec and Leipzig, 1907), 2: 351-379; Richard F. Townsend, *State and Cosmos in the Art of Tenochtitlan*, Studies in Pre-Columbian Art and Archaeology, Dumbarton Oaks, 20 (Washington, D.C., 1979).

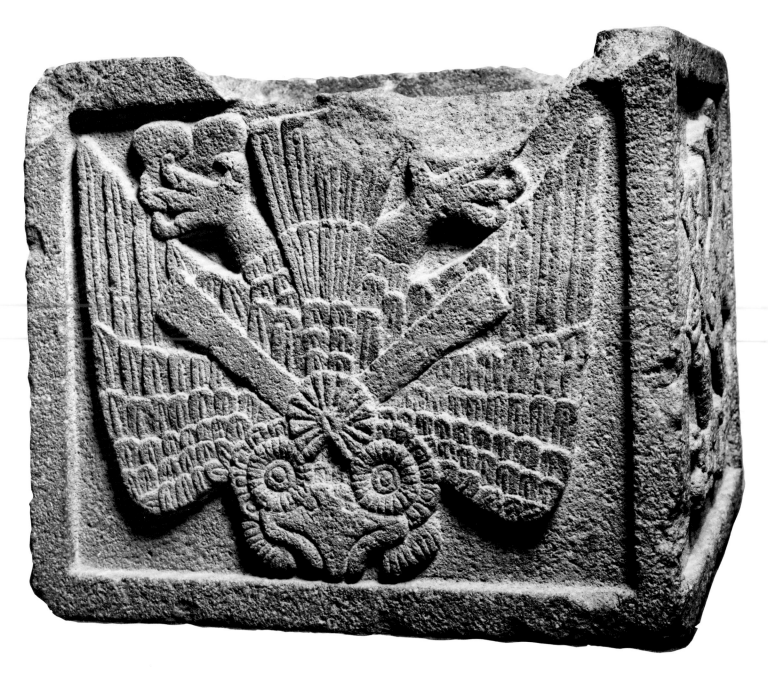

12
Stone of the Death Monsters
Height .67 (26⅜); width .56 (22);
depth .62 (24⅜)
Basalt
Museo Nacional de Antropología,
Mexico City, no. 24-1362; 11-3280
Found in Mexico City in 1940

The characterization of Aztec art as an art of the macabre has often been exaggerated, but this beautifully carved monument is one of the masterpieces of the genre. It was discovered in 1940 in the foundations of a house at 103 Calle de Donceles, two blocks north of the Zócalo, and acquired by the museum in that year. It was first published in its entirety,

with a detailed description and interpretation, by Alfonso Caso in 1952.

The uncarved top surface is enclosed by a narrow, raised border, as are the side panels. Boldly carved on the side faces in sharply defined relief are four creatures associated with death, darkness, and sorcery: owl, spider, bat, and scorpion. The owl, a different type from the horned owl (*tecolotl*) whose head appears on the British Museum slit gong (no. 62), is the smaller variety lacking "horns" (*chichtli* or *chicuatli*). It is shown flying downward, clutching in its claws human livers (sometimes sacrificed in addition to hearts). On its forehead it wears a

pleated, bark paper rosette (*ixcuatechimalli*), one of the chief distinguishing elements in the attire of the god of death, Mictlantecuhtli, and related deities. Another ornament, a long, thin paper band that was hung around the neck and crossed over the chest (*amaneapanalli*), was a standard item among the ritualistic decorations of the mummy bundle of the dead warrior; it was worn by prisoners destined for sacrifice; and it often figures among the insignia of mythological beings associated with death and sacrifice. Here the *amaneapanalli* appears simply as two pendant streamers to the paper rosette, but a comparison with the next panel, where this same death-

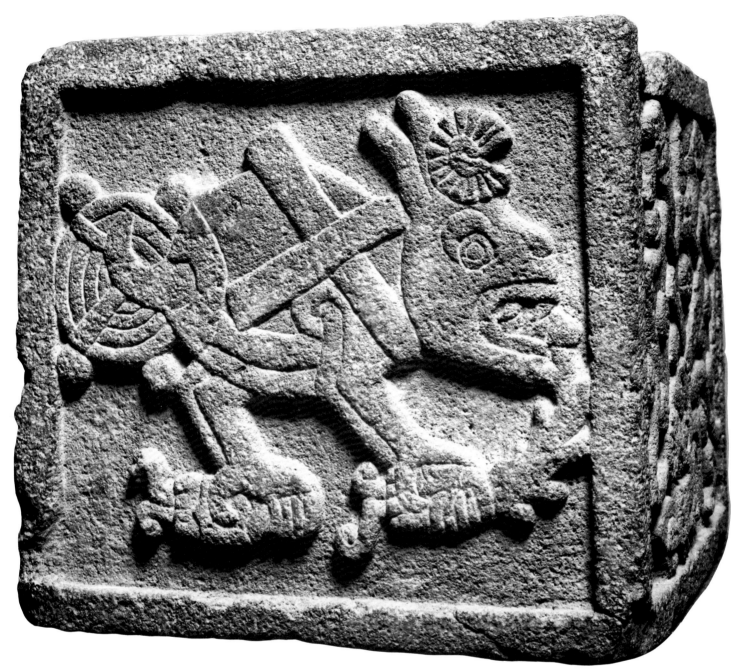

sacrifice symbol is clearly shown as a long, crossed strip wound about the neck of the creature, confirms this identification.

The spider (*tocatl*), shown in a profile view, clutches smoking human hearts and also wears the paper rosette and crossed paper streamer. The plump, oval body ends in a curved, pointed element that might be the spinner or, perhaps more likely, a stinger. Behind this element is a conventionalized web, composed of four concentric circles, edged with four globular elements and crossed by two diagonal bands. The spider portrayed here is a fantastic, perhaps composite, creature, for the head displays a large round

eye and supraorbital ridge, an open mouth filled with teeth, and even a slight indication of a nose. From the back of the head issue two long projections of such size as to suggest ears, but these probably represent antennae or feelers, for the Aztecs may have merged the arachnids into one broad group with the true insects—and these latter are almost invariably depicted with two antennae.

The stylized bat (*tzinacantli*), like the owl, is positioned to indicate downward flight, with its profile head beneath outspread wings, which are double-outlined and dotted with circular designs representing eyes (the eyes of night, the

stars), symbolizing the creature's nocturnal habits. Stone sacrificial knives replace its nose-leaf and tail, which is flanked by human hands clutching smoking hearts. The creature also wears the paper rosette and crossed paper band.

The scorpion's (*colotl*) segmented oval body, bent, jointed legs, curved and similarly jointed tail, and front feelers are all distinctly carved. Instead of three pairs of legs, however, only two are present, terminating in claws resembling a human thumb with two fingers. The tail-stinger is also replaced by this same handlike appendage. On the forehead is the paper rosette and here, as on the owl, the two ends of the long paper

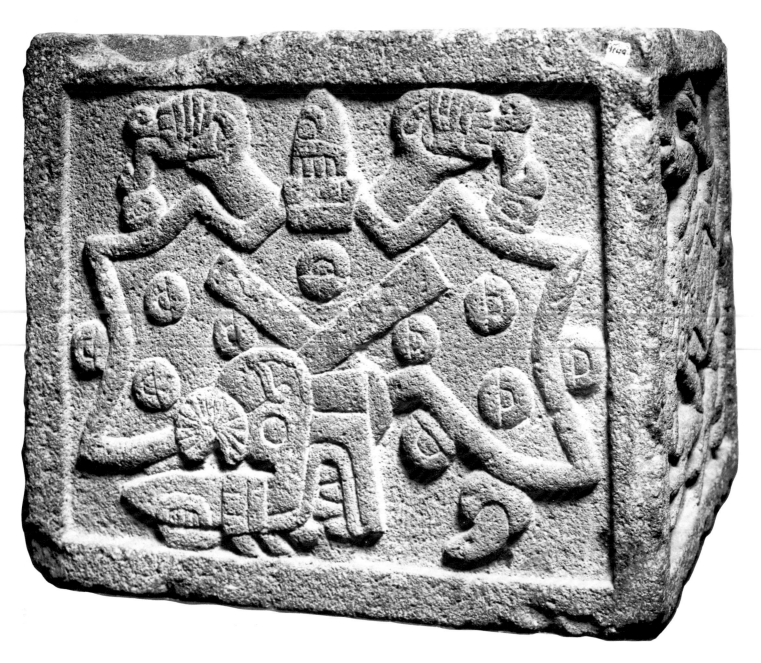

strip appear to be pendant streamers to it. The four sectioned, rodlike projections extending from beneath the scorpion's body apparently represent additional feelers, notwithstanding their absence on the actual creature.

On the underside of the stone is the image of an interesting variant of the Earth Monster (Tlaltecuhtli), with both the head and body of the squatting creature shown frontally (cf. nos. 3, 6, 13, 14, 15, 58). Instead of the monster face or the face of the earth goddess, its rimmed eyes and labial band and tusks are features of the rain and fertility deity, Tlaloc (cf. no. 28). On its midsection segmented double disks enclose a quincunx, a well-recognized sym-

bol for precious stone, indicating the heart, the heart of the earth (Nicholson 1954). Instead of the "demon faces," it shows four skulls strapped to the knees and elbows, and the upturned hands also hold skulls. This interesting, Tlalocoid Earth Monster variant is carved on the undersides of various other Aztec monuments, including the famed, colossal Coatlicue (e.g., Seler 1902-1923, 2: 792, Abb. 6)

Two other Aztec death monster stones are known, both unpublished. One beautifully carved example of unknown provenance is in the Museo Diego Rivera (Anahuacalli) in Coyoacan, a southern suburb of Mexico City. A somewhat damaged quadrangular block, it

bears on its various faces a number of creatures: two spiders, and a jaguar, coyote (?), scorpion, and rattlesnake. The other, now in the collection of the University of the

Underside, no. 12.

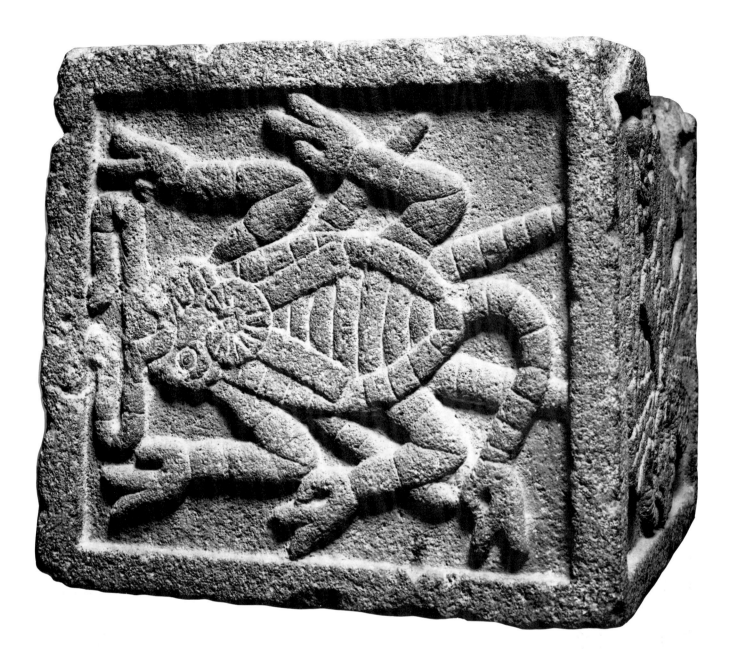

Americas near Cholula, Puebla, was acquired in the 1940s by the leading Mesoamerican ethnohistorian Robert Barlow, probably in San Bartolo Naucalpan, a suburb of Mexico City. Although fragmentary, it displays on its surviving sides figures of a scorpion, spider, and rattlesnake. The scorpion certainly and the spider and rattlesnake probably (the damage prevents certainty) wear the paper rosette and long paper band. On the remaining carved surface is a *zacatapayolli*, the plaited grass ball used as a repository for the bloodstained maguey spines in connection with autosacrificial rituals. All three of these "stones of the death monsters" are superior specimens of Aztec sculpture from an aesthetic standpoint

and feature some intriguing iconography (Nicholson, manuscript).

The function of this monument is uncertain. Caso (1952: 99-100) suggested that it might be another type of *cuauhxicalli* or "eagle vessel" for the deposition of sacrificed human hearts, dedicated to the cult of Mictlantecuhtli, the death god. Other quadrangular stone blocks with plain tops and relief carvings on their sides are extant, of which the Stone of the Suns in the Museo Nacional de Antropología is probably the best known (Caso 1958: pl. 1). Its unadorned top surface is also sunken, as on our monument, so its function may well have been the same. Perhaps it served as a special kind of *cuauhxicalli*, or possibly both stones functioned as altars on

which offerings were placed or as pedestals for idols or incense braziers. In any case, our monument, a macabre masterpiece, most likely stood in a temple dedicated to Mictlantecuhtli, lord of the underworld, at least one of which is known to have been located in the Great Temple enclosure of Mexico Tenochtitlan.

Alfonso Caso, "Un cuauhxicalli del dios de la muerte, *Memorias de la Sociedad Científica "Antonio Alzate"* 52 (1952): 99-111; and *The Aztecs: People of the Sun* (Norman, Oklahoma, 1958); H. B. Nicholson, "The Birth of the Smoking Mirror," *Archaeology* 7, no. 3 (1954): 164-170; and "The Stones of the Death Monsters" (manuscript); Eduard Seler, *Gesammelte Abhandlungen zur Amerikanischen Sprach- und Altertumskunde,* 5 vols. (Berlin, 1902-1923).

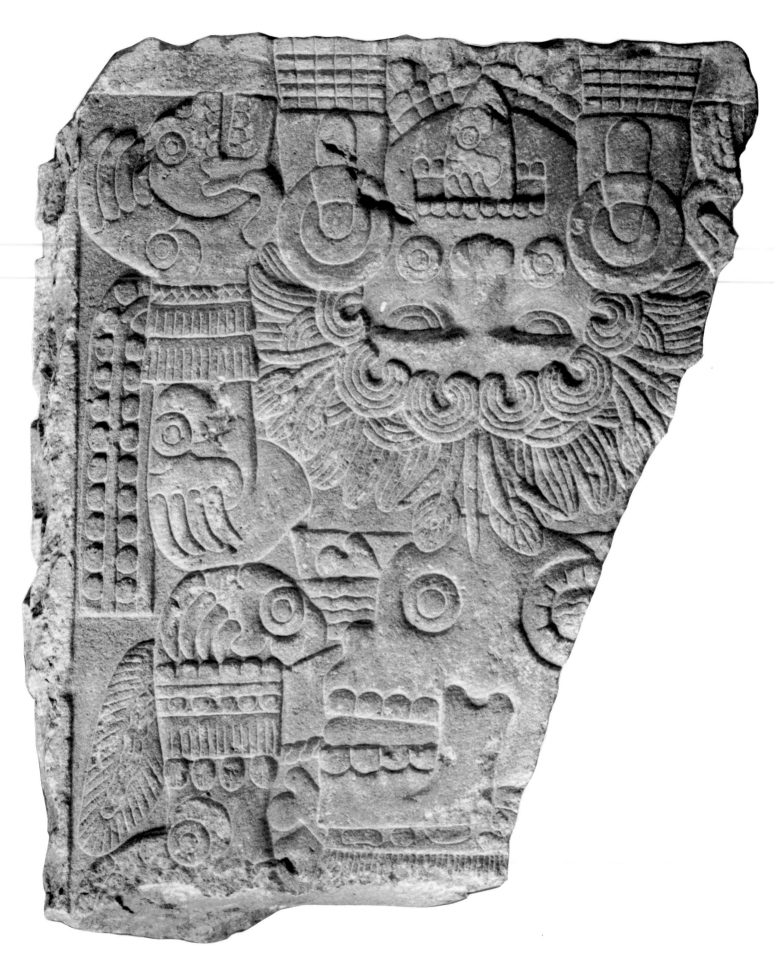

13
Tlaltecuhtli (Earth Lord) relief
Height .72 (28⅜); width .57 (22½);
depth .25 (9⅞)
Andesite
Proyecto Templo Mayor, Mexico
City, no. 10-220483
Found in the Templo Mayor precinct of Mexico Tenochtitlan

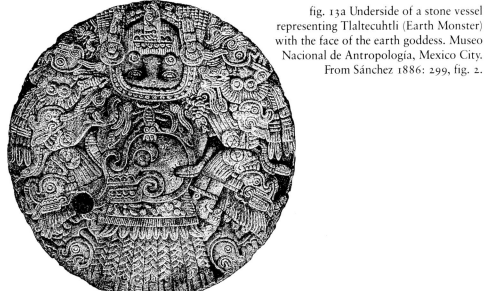

fig. 13a Underside of a stone vessel representing Tlaltecuhtli (Earth Monster) with the face of the earth goddess. Museo Nacional de Antropología, Mexico City. From Sánchez 1886: 299, fig. 2.

In Aztec ideology the earth was conceptualized and visually expressed in a vivid, metaphoric fashion in two principal images. The first was a composite but fairly simple representation, a spiny monster with an extended snout (*cipactli*), based essentially on the crocodile but sometimes with added piscatorial features (e.g., the date 1 Cipactli [Crocodilian Monster] on the Stone of the Five Suns, no. 6; interior of Box of Hackmack, no. 15). The second conception was more complex. It consisted of a crouching, grotesque monster with a gaping mouth and prominent teeth, with snapping mouths at the elbow and knee joints ("demon faces")—a bisexual creature who was believed to swallow the sun in the evening, disgorging it each dawn, and also to devour the hearts and blood of sacrificed victims and the souls of the dead in general.

It is this second image, called Tlaltecuhtli (Earth Lord), that is depicted on this relief. Tlaltecuhtli figures were frequently carved on the undersides of Aztec monuments, so that the monstrous image of the earth rested directly against the surface of the sphere it symbolized (discussion in Nicholson 1967). There are many variants and differing aspects of these Earth Monster representations (Nicholson 1972). Despite their invisibility once the monument was set in position, they are among the most sophisticated and intricately carved in the whole range of Aztec art. Although a small section on the lower right side and a strip along the bottom are missing, this Tlaltecuhtli relief is an excellent example of its type. It was apparently trimmed for reuse in colonial

times to its present size and shape. It originally was carved on the underside of a large monument, the only remaining other carving of which is a row of four inverted arrowhead-shaped elements on the left side. It was found in fill north of the Great Temple during the 1978-1982 excavation project.

The monster, frontally portrayed, is typically shown with its knees bent and outstretched in the position of parturition assumed by Aztec women, a probable connotation of the concept of fertility. Its head is flung back, facing upward, and its bent arms are similarly upraised. The hair is characteristically twisted and tangled, intertwined with *malinalli* grass. "Demon faces" appear on the elbows, knees, and claws, the upper claws clutching skulls. Striated skin cuffs encircle the wrists and lower legs, the upper set decorated with paper strips dotted with rows of circles. A skirt, mostly obscured, features the standard skull and crossed bones motif, and a large skull in profile hangs from the back of the belt.

The head of the commonest type of Tlaltecuhtli image displays a wide-open monster mouth studded with (knife) teeth (cf. nos. 3, 6, 14, 15, 58). Our example belongs to a different and important subtype. Instead of the stylized monster head, it shows the face of the earth goddess. She wears circular earplugs with

bordering rectangular panels, with pendants issuing from their centers, and a beaded necklace. Small concentric circles appear on her cheeks, a common feature of earth goddesses. A sacrificial stone knife-tongue protrudes from her fleshless mouth with the rows of teeth exposed. A number of examples of this subtype are extant, including that on the back of the Bilimek pulque vessel (no. 14). Probably the best known is the underside of a large cylindrical stone vessel that also served as a *cuauhxicalli*. First illustrated in the 1794 Dupaix catalogue, it is now in the Museo Nacional de Antropología in Mexico City (fig. 13a). The Tlaltecuhtli image on our piece, expertly designed and carved, constitutes one of the best examples of Aztec relief sculpture.

Guillermo Dupaix, "Descripción de monumentos antiguos mexicanos," 1794 (manuscript in the Museo Nacional de Antropología, Mexico); H. B. Nicholson, "A Fragment of an Aztec Relief Carving of the Earth Monster," *Journal de la Société des Américanistes* 56, no. 1 (1967): 81-94; and "The Iconography of Aztec Period Representations of the Earth Monster: (Sumario)," *Religión en Mesoamerica: XII Mesa Redonda, (Sociedad Mexicana de Antropología)* (Mexico, 1972): 225; Jesús Sánchez, "Notas arqueológicas, II: Vaso para contener los corazones de las víctimas humanas sacrificadas en ciertas solemnidades religiosas," *Anales del Museo Nacional de México*, primera época, 3 (1886): 296-299.

14

Bilimek pulque vessel

Height .365 (14⅜); width .175
(6⅞); depth .255 (10)
Phyllite
Museum für Völkerkunde, Vienna,
no. 6069
Ex-Bilimek collection

This intricately carved stone vessel
was probably collected in Mexico in
the 1860s by Dominik Bilimek, an
Austrian naturalist who accom-
panied Emperor Maximilian to
Mexico and was appointed by him
director of the Mexican national
museum. No information has been
published concerning the circum-
stances of Bilimek's acquisition of
the piece. In 1878, after his death, it
was purchased by what eventually
became the Museum für Völker-
kunde in Vienna. It was published,
with detailed drawings and an icon-
ographic analysis, by Eduard Seler
in 1902.

A striking face projects out boldly
from the cylindrical body of the ves-
sel, with hollowed-out eyes for pos-
sible inserts and a skeletal mouth
mask featuring a fleshless mandible
with teeth and bones exposed. Two
crenelated bands edge the face, rep-
resenting the hair, above which rises
an extension of the hair (or head-
dress) composed of *malinalli* grass
stalks with spade-shaped flowers
(cf. intermingling of *malinalli* grass
with the tangled hair of Earth Mon-
ster [Tlaltecuhtli] images in nos. 3,
13, 15). Malinalli figured as the
twelfth of the twenty day signs in a
form that closely approximates the
overall configuration of this image.
Large rectangular earplugs with
pendants issuing from their centers
adorn the ears, although the tops of
the ears are not depicted as usual.
This type of ear ornament is partic-
ularly diagnostic of pulque (*octli*)
deities in ritual divinatory pictori-
als, who also wear collars composed
of this grass (cf. fig. 27a). This face,
then, appears to combine the Mali-
nalli sign with a portrait of a maca-
bre aspect of a pulque god, although
it lacks the characteristic face paint-
ing of this deity and the lunar nose
ornament (see annotation to no.
27). Directly above the Malinalli
stalks is a device that combines the
solar disk (with the 4 Ollin [Move-
ment] day sign in the center) with
the symbol for night, a well-known
emblem associated with pulque
drinking in the pictorial manu-
scripts (Seler 1902: Abb. 29).

The whole back of the vessel is
devoted to a representation of the
Earth Monster (Tlaltecuhtli), the
type that displays the face of the
earth goddess (cf. no. 13) flanked by
sacred war (*atl tlachinolli*) symbols
(cf. no. 6). It displays some unusual
features, such as the serpent skirt
(cf. the famous Coatlicue idol [fig.
2] in the Museo Nacional de Antro-
pología in Mexico City), the stone
sacrificial knife and apparent tuft of
feathers on the shoulders, and the
jaguar claws. From the nipples of
her pendulous breasts two liquid
streams flow downward into the
mouth of a "pulque pot" decorated
with the facial markings of the *octli*
deities. The concept expressed here
is clearly that pulque is the "wine of
the earth." Carved on the underside,
with the design extending onto the
front of the vessel up to the level of
the chin of the projected face, is the
other more common type of Tlalte-
cuhtli with the open monster jaw. It
floats on a liquid surface indicated
by wavy lines, as do little sea crea-
tures (cf. underside of no. 1). The
calendric sign 1 Tochtli (Rabbit),
date of the creation of the earth, ap-
pears below the creature's head and,
below this, the symbol for Ollin
(Movement), another of the twenty
day signs and a recognized symbol
for the earth. The monster, as is
characteristic, wears the skirt deco-
rated with skulls and crossed bones.

Six deity figures on the sides of
the vessel, each associated with the
little circles that Seler interpreted as
the numerical coefficients of missing
day signs, include what appear to be
two pulque gods, the fire god (Xiuh-
tecuhtli) hurling the "fire serpent"
(*xiuhcoatl*), the Venus god (Tlahuiz-
calpantecuhtli), Ehecatl Quetzal-
coatl (wearing an animal mask-
helmet), and an aspect of the god of
flowers and music, Xochipilli. Most
of them hold stones and sticks, illus-
trating the Nahuatl metaphor *tetl
cuahuitl*, "stone and wood," connot-
ing punishment, a probable allusion
to the severe punishments imposed
for drunkenness. Additionally, two
little "diving gods" appear on the
left side of the vessel.

Carved on the rim of the vessel is
the date 8 Tecpatl (Stone Knife) that
falls in the eleventh 13-day period of
the 260-day divinatory cycle (*tonal-
pohualli*) beginning 1 Ozomatli
(Monkey), whose patron was the
pulque god Pahtecatl.

The iconography of this unique
sculptured vessel refers to the cult of
the pulque deities, and the vessel
was probably used in ceremonies
that involved the imbibing of the
standard intoxicant of ancient Mex-
ico. Stylistically, and even to some
extent iconographically, it is slightly
different from the general represen-
tations prevailing in the capital of
the empire. It might have been pro-
duced somewhere outside its imme-
diate vicinity, even outside of but
not too far distant from the Basin of
Mexico, possibly in the areas of
present-day Morelos or Puebla
where the pulque cult is known to
have enjoyed a special importance.

Eduard Seler, "Das Pulquegefäss der Bili-
mek'schen Sammlung im k. k. naturhistoris-
chen Hofmuseum," *Annalen des k. k. natur-
historischen Hofmuseums,* 17 (1902).

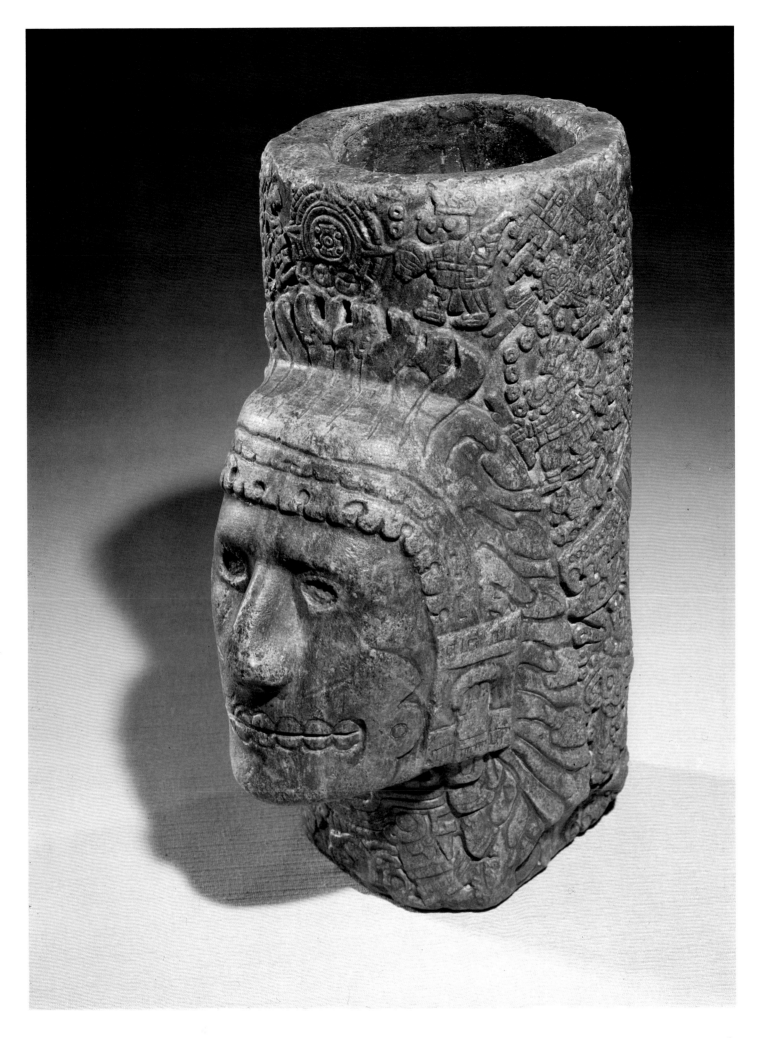

Top of lid.

15
Carved box (Box of Hackmack)
Height .15 (6); width .34 (13⅜);
depth .22 (8⅝)
Greenish gray silicate
Hamburgisches Museum für Völker-
kunde, Hamburg, no. B. 3767
Ex-Borges, ex-Hackmack collections

Among the most interesting Aztec
sculptures are boxes of stone (*tepe-
tlacalli*), often carved with lids.
About thirty are known, both plain
and carved, scattered in many re-
positories. Many are elegantly deco-
rated with various motifs, and
nearly half of them bear dates in the
native calendar. This example is
usually considered to be the finest
extant. Of unknown provenance, it

was in the collection of Juan Borges
of Mexico City in 1880, when it
was purchased with the rest of his
collection by Hackmack, a German
businessman, from whom the Ham-
burg museum acquired it in 1899. It
was first published, with excellent
drawings and a detailed icono-
graphic analysis of all the carved
surfaces, by Eduard Seler in 1904.

Including the lid, no less than
eight faces of this remarkable piece
are carved with representations in
relief. The top surface of the lid dis-
plays a feathered serpent (*quetzal-
coatl*) head facing down, flanked by
two dates in square cartouches, 1
Acatl (Reed) on the left and 7 Acatl
(Reed) on the right. On the under-
side of this lid is a circular motif

composed of three concentric bands
enclosing a macabre profile head
facing right. The outer band is deco-
rated with a row of conventional-
ized eyes (night eyes, stars). Each of
the long sides of the box features
human figures seated cross-legged,
with one leg raised higher than the
other (cf. pair of relief figures on the
colossal jaguar *cuauhxicalli*). One
bearded figure, facing left, wears a
jaguar suit and holds a tri-tasseled
incense pouch in his right hand and
a bent clublike object in his left. Be-
fore his face is an elaborate speech
scroll, and behind him is the date 1
Acatl (Reed). The other figure, fac-
ing right, draws blood from his
right ear with a bone perforator. He
wears a head ornament consisting

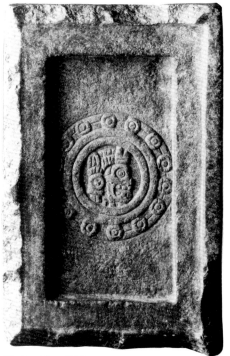

Underside of lid.

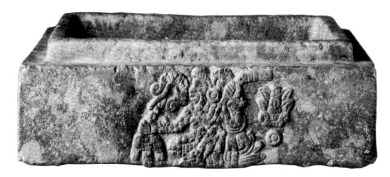

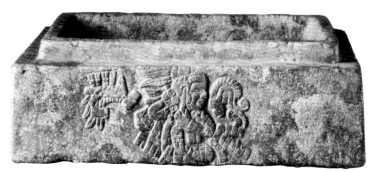

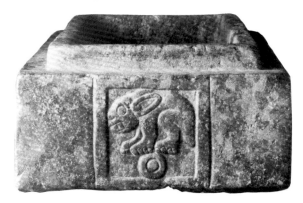

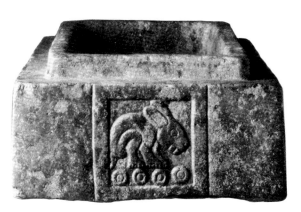

of a pair of feathers with a down ball at the base that resembles the forked eagle feather device (*cuauh-pilolli*), supports a tri-tasseled incense bag on his left arm, and displays a jaguar head as part of his back adornment. Before his face is another elaborate speech scroll, and behind him is a symbol group consisting of the headpiece of the lords (*xiuhuitzolli*), a stepped noseplug (*yacaxihuitl*), and an earplug (*xiuhnacochtli*). Attached to the *xiuhuitzolli* are four decorated parallel strips, associated with penitence and fasting, called "fasting cords."

On the ends of the box are two dates in square cartouches: 1 Tochtli (Rabbit) and 4 Tochtli (Rabbit),

with a rare full-figure version of the animal. On the floor of the interior of the box is the date 1 Cipactli (Crocodilian Monster), again with an unusual full-figure variant of the creature. Carved on the underside is the Earth Monster (Tlaltecuhtli), the most common type of these grotesque images (see annotation to no. 13), with a huge, open jaw. It displays nearly all the features characteristic of this type: outstretched arms and legs with "demon faces" adorning the elbows, knees, and claws; a skirt decorated with skulls and crossed bones; a profile skull through which the belt is threaded and from which falls the usual back flap composed of feathers and braided strips edged with sea snail

shells; tangled hair; eyes bordered by prominent supraorbital ridges; and a gaping mouth with stone-knife teeth.

The interpretation of the carvings on this magnificent box has posed some challenging problems. The dates 1 and 7 Acatl (Reed) on the top of the lid are intimately connected with Quetzalcoatl (see annotation to no. 57), whose feathered serpent emblem appears between them. The circular design on the underside of the lid perhaps symbolizes the night sky and one of its macabre supernatural denizens. The figures on the sides of the box are especially difficult to identify with precision. Neither appears to be a typical representation of a recognizable deity,

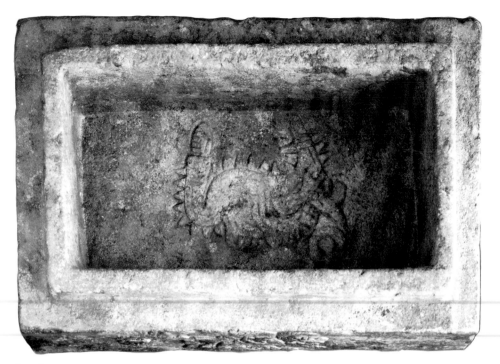

Interior, no. 15.

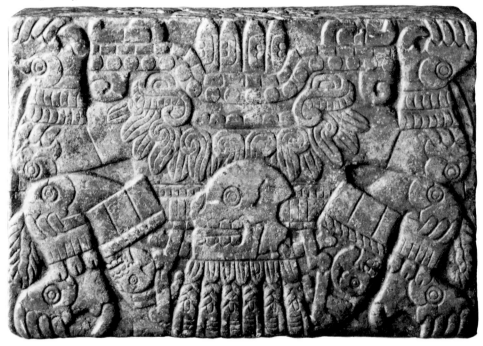

Underside, no. 15.

most likely. Similarly, interpreting the Acatl dates on the lid historically, 1467 or 1519 for 1 Acatl (Reed) and 1447 or 1499 for 7 Acatl (Reed) would be possibilities. The 1 Cipactli (Crocodilian Monster) date on the interior has to be that of a day. It initiated the 260-day divinatory cycle *(tonalpohualli)* and also appears to have been the day preferred for the crowning of the rulers of Mexico Tenochtitlan, including Motecuhzoma II (Nicholson 1961). The Earth Monster (Tlaltecuhtli) on the underside presents no problem, for the carving of this grotesque creature beneath Aztec monuments was quite common (see annotation to no. 13).

As for the function of this box and others similar to it, the most common hypothesis has been that they might have served as "funerary urns," an interpretation supported by explicit statements in various ethnohistorical sources that stone boxes were employed for this purpose. Because some of them bear images, as does this one, of figures performing auto-sacrifice, it has also been suggested that these examples at least were used to store sacrificial blood. The "funerary urn" thesis is intriguing, particularly in relation to the boxes that bear dates, for some of these might possibly be dates connected with the life (birth, death, and special events) of the deceased whose ashes may have been placed in them. Various combinations of the dates on our box could be interpreted to produce a reasonable life span for an individual, but speculations of this sort must be recognized as such. In spite of the fact that many problems remain in the specific interpretation of the iconography of this attractive stone box, it was clearly produced by a master of his craft.

H. B. Nicholson, "The Chapultepec Cliff Sculpture of Motecuhzoma Xocoyotzin," *El México Antiguo* 9 (1961): 379-444; Eduard Seler, "Ueber Steinkisten, *Tepetlacalli,* mit Opferdarstellungen und andere ähnliche Monumente," *Zeitschrift für Ethnologie* 36 (1904): 244-290.

but perhaps they exemplify special aspects not as frequently portrayed. Seler identified the bearded figure in the jaguar suit with the deity Tepeyollotl (see annotation to no. 25), but the "calendric name" 1 Acatl (Reed) placed behind the figure, if it does serve as such, does not seem appropriate since it usually belongs to Quetzalcoatl. Because the insignia of which it is composed decorated the mummy of the dead warrior, Seler identified the "name sign" behind the other figure performing sacrifice as "the soul of the dead warrior." It also corresponds to the name sign of Motecuhzoma II, although the "fasting cord" adorning the *xiuhuitzolli* is not normally included in it.

As for the two dates on the ends, 1 and 4 Tochtli (Rabbit), the first might connote the year the present earth was created (cf. annotations to nos. 6, 9, 14), while the second seems to have no such obvious cosmogonic or other ritual referent. If a historical interpretation is preferred, 1470 for the second date and 1454 or 1506 for the latter would seem

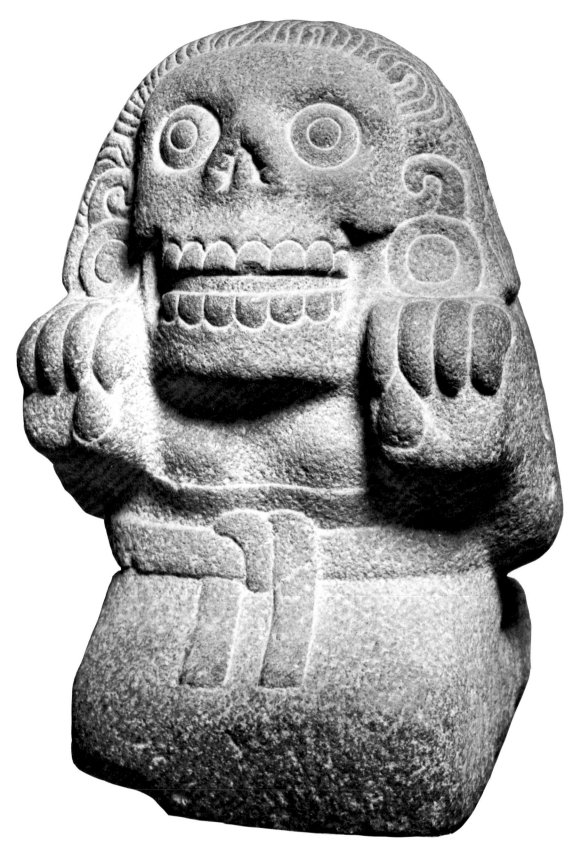

16
Cihuateotl (macabre spirit of a woman who had died in childbirth)
Height .72 (28⅜); width .47 (18½); depth .42 (16½)
Andesite
Museo Nacional de Antropología, Mexico City, no. 24-145; 11-3006
Found in Mexico City in 1907

This arresting sculpture belongs to a group of numerous stone images that represent the terrifying demons called Cihuateteo, "Goddesses," or "Celestial Princesses" (Ilhuica Cihuapipiltin), into which the souls of women who had died in childbirth were believed to have been transformed. They dwelled in the West,

"Region of Women" (Cihuatlampa), and escorted the sun from its zenith down to its resting place at dusk on the western horizon. They were the female counterparts of the male warriors slain in battle or on the stone of sacrifice, who resided in the East and accompanied the sun on its ascent each morning. On the five

days that commenced the 13-day periods of the 260-day divinatory cycle assigned to the West (1 Mazatl [Deer], 1 Quiahuitl [Rain], 1 Ozomatli [Monkey], 1 Calli [House], 1 Cuauhtli [Eagle]), these female spirits were believed to descend to haunt the crossroads, hoping to kidnap young children since they had been deprived of their opportunity to be mothers. To ward off this dangerous possibility, mothers were careful to keep their offspring away from such places on these hazardous days, and crossroad shrines, containing images of these malevolent spirits, were set up to propitiate them (Sahagún 1950-1982, parts 5 and 6: 41; part 7: 161-165). Originally this image was probably placed in one of these shrines. It was found, with three other almost identical figures, in 1907 during construction of a business establishment, Casa Boker, near the corner of the present-day avenues 16 de Septiembre and Isabel la Católica, two blocks west of the Zócalo or central plaza of Mexico City, and was acquired the following year by the Mexican national museum.

The face of the goddess is a skull, with large, staring round eyes and an open mouth with a brace of prominent teeth. Her hair, matted and twisted, a characteristic of the mortuary aspects of the earth deities, streams down in back in intricately carved swirls. Incised on the top of the head is the day that began the nineteenth 13-day period of the 260-day divinatory cycle (*tonalpohualli*), 1 Cuauhtli (Eagle). Circular earplugs bedeck her still visible ears, and just below them are the upraised, clenched claws. The equally clawed feet are tucked underneath the kneeling figure. She wears a simple, unadorned skirt fastened around the waist with a knotted belt depicted in low relief, but no upper garment.

Cihuateotl images are fairly common. At least twelve others of this type are known, all of which also display on the tops of their heads the dates that initiated the thirteen-

Detail, no. 16, showing date 1 Cuauhtli (Eagle) carved on top of head.

day periods assigned to the West (only 1 Quiahuitl [Rain] is missing). The three other images found with our piece bear, respectively, another 1 Cuauhtli (Eagle), 1 Mazatl (Deer), and 1 Ozomatli (Monkey) (all four illustrated together in Ramírez Vásquez 1968: láms. 108-109). One Calli (House) appears on a figure now in the Metropolitan Museum of Art, New York (Emmerich 1963: 221). Another, much destroyed and bearing the same date, was found in Mexico City during the excavation of the subway in the 1960s.

Two other types of these grim goddesses sometimes also bear these dates. The first category is otherwise almost identical to that to which our piece belongs except that it portrays a human face with a fleshless mouth rather than a skull. Two closely related examples are known, one in the Museum of the American Indian, Heye Foundation, with the date 1 Eagle (Pasztory 1976: 14, the date erroneously given here as "1 Vulture"), the other in the Museo Nacional de Antropología with the date 1 Ozomatli (Monkey) (Ramírez Vásquez 1968: 107). A second type shows quite a different configuration, the figure represented only as a bust with gouged out eyes, as in the codices *Borgia*

(47-48) and *Vaticanus B* (78-79). One was in the Phil Berg collection (Berg 1971: 181) and now belongs to the Los Angeles County Museum of Art. Here the date 1 Mazatl (Deer) appears not on the top but on the back right side of the head, carved on a much smaller scale than the dates on the images in the first category (von Winning 1961). Another nearly identical specimen, originally in the collection of the Munich artist Gabriel von Max and now in the Reiss Museum, Mannheim, bears the date 1 Calli (House) and, most unusual, a second date, 2 Acatl (Reed), on the other side.

Our sculpture is an excellent example of its group, vigorously expressing the fierce malevolence associated with these fearsome creatures through its active stance, its claws upraised as if poised to strike. Also contributing to its sinister effect are the glaring eyes and "grinning" fleshless mouth. The alleged mortuary obsession of Aztec art and iconography has often been overemphasized, but this masterpiece of the macabre does exemplify the tendency with particular force.

Phil Berg, *Man Came This Way: Objects from the Phil Berg Collection* [exh. cat., Los Angeles County Museum of Art] (Los Angeles, 1971); André Emmerich, *Art before Columbus: The Art of Ancient Mexico from the Archaic Villages of the Second Millenium B.C. to the Splendor of the Aztecs* (New York, 1963); Esther Pasztory, et al., *Aztec Stone Sculpture* [exh. cat., The Center for Inter-American Relations] (New York, 1976): 14; Pedro Ramírez Vásquez, *The National Museum of Anthropology, Mexico: Art—Architecture—Archaeology—Anthropology* (New York, 1968); Fray Bernardino de Sahagún, *Florentine Codex, General History of the Things of New Spain, translated from the Aztec into English, with notes and illustrations,* by Arthur J. O. Anderson and Charles E. Dibble, Monographs of the School of American Research, Santa Fe, New Mexico, no. 14, parts 1-13 (1950-1982); Hasso von Winning, "Stone Sculpture of an Aztec Deity," *Masterkey* 35, no. 1 (1961): 4-12.

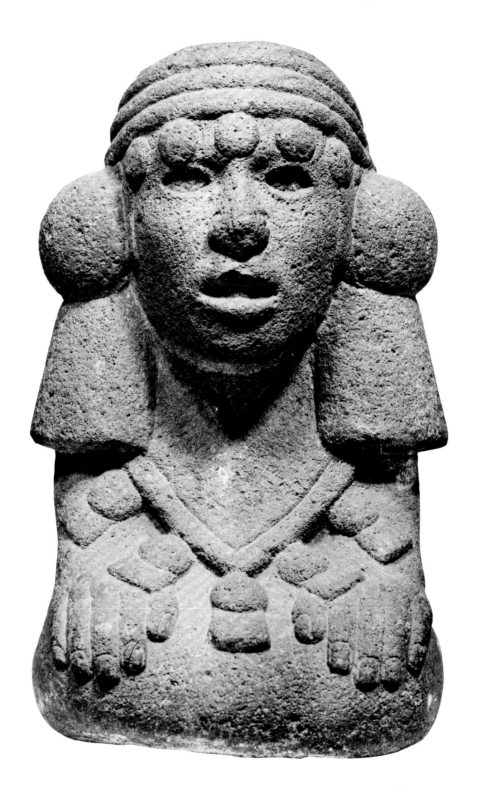

17
Kneeling fertility goddess
Height .30 (11¾); width .21 (8¼);
depth .21 (8¼)
Basalt
Museum of Mankind, The British
Museum, London, no. 1825. 12-10.6
Collected probably in Mexico City
in 1823

This well-preserved piece belongs to
a category of numerous kneeling
young female images displaying cos-
tume elements and insignia that
identify them as fertility deities. A
striking characteristic of these god-
desses is the frequent blending of
their ostensibly individual supernat-
ural personalities through the shar-
ing of diagnostic insignia (Nichol-
son 1963). Typical of the group to
which this piece belongs is a distinc-
tive headdress consisting of multiple
cords wound about the head, edged
above and below with rows of balls,
with two large tassels attached to
the side of the head (cf. fig. 17a). A
figure wearing this headdress is usu-
ally labeled a "water goddess,"
whose two most common names
were Chalchiuhtlicue and Matlal-
cueye. Some images with this head-
dress also display outstretched
hands that may either hold double
maize ears decorated with strips of
ritual bark paper or appear empty,
possibly for the insertion of real
maize ears (cf. no. 19). Such a figure
is usually called a "maize goddess,"

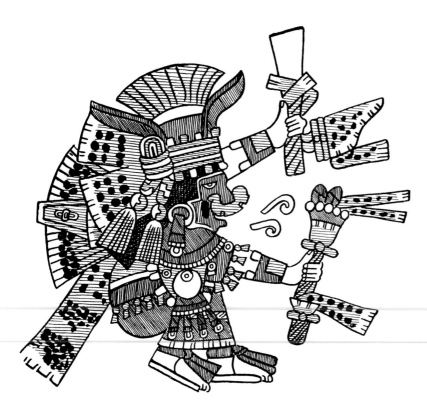

fig. 17a Water goddess, Chalchiuhtlicue. *Codex Borbonicus* 5. From Seler 1902-1923, 2:909, Abb. 5.

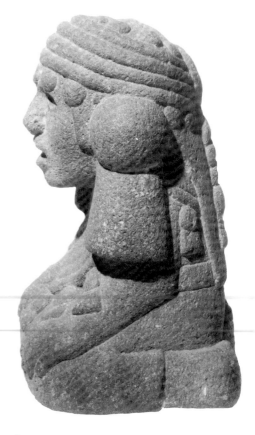

Side view, no. 17.

who was known by several names (Chicomecoatl, Xilonen, Centeotl, etc.). However, the headdress most commonly worn by the figures holding the double maize ears is an elaborate rectangular construction made of sections of stiff bark paper adorned with pleated rosettes at the corners (*amacalli*) (cf. no. 20). Designating the type with the wrapped cord headdress and large tassels at the sides of the head, as here, a water goddess, or Chalchiuhtlicue, and the other type with the quadrangular paper headdress as a maize goddess, or Chicomecoatl, seems justified by convenience and tradition, so long as it is recognized that iconographically and ideologically no sharp line can be drawn between them.

This figure wears a classic example of the water goddess headdress consisting of four thick, probably cotton, bands, bordered above and below with a row of cotton balls. Tied at the back, they form a prominent knot from which depend two twisted cords tipped with fringed tassels. These cover her hair, which falls straight down behind her. At-tached to either side of her head are large tassels reaching well below her shoulders. On her upper body she wears the triangular shawllike garment (*quechquemitl*) also trimmed with tassels. Her open hands rest on her knees, which are covered by her skirt (*cueitl*). Her bare feet, bent back with toes touching, are tucked neatly underneath her.

This piece was collected by William Bullock, the enterprising proprietor of the Egyptian Hall, Piccadilly, London, on his trip to newly independent Mexico in 1823, and illustrated in a sideview engraving in his travel book, *Six Months' Residence and Travels in Mexico,* published the following year (1824b: Ancient Mexican Sculpture, pl. 1). It was included in his famous exhibition, "Ancient Mexico," at the Egyptian Hall in 1824, the first significant exhibition ever mounted anywhere of Mexican archaeological pieces (Altick 1978: 246-248). It is described in his catalogue (Bullock 1824a: 39-40) as:

STATUE OF AN AZTECK PRINCESS. No. 10. Baron de Humboldt in his *"Researches concerning the Institutions and Monuments of the Ancient Inhabitants of America,"* has given three views of a statue similar to this, except a trifling difference in the drapery on the back of the head. The lady is represented sitting on her feet, which are bent under her, the common position of the Indian women in the church at the present day; her hands rest on her knees, and give the appearance, at first sight, of the front of the Egyptian Sphinx, to which the resemblance of the headdress greatly contributes. The Baron, by some unaccountable mistake, says the figure is without hands, and that the feet are placed in front, whilst his plates represent the hands and feet as they really are.

Interestingly, the piece illustrated and discussed by Humboldt (fig. 17b), who saw it in New Spain in 1803-1804 in the possession of Guillermo Dupaix, a pioneer student of Mexican antiquities, was acquired by Henry Christy, an avid British collector who visited Mexico in 1856, and eventually found its way into the British Museum as well. It differs principally from our piece in that it wears the pleated bark paper neckbow (*amacuexpalli*) commonly displayed by fertility deities. Auctioned off with most of Bullock's Mexican archaeological pieces after the closing of the exhibition, our goddess was acquired by the Rever-

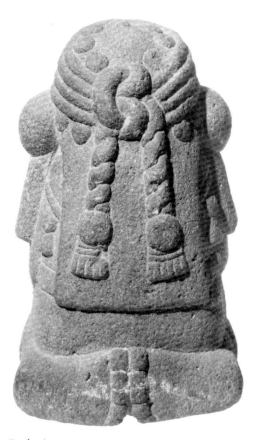

Back view, no. 17.

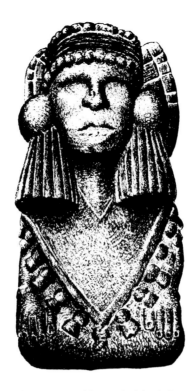

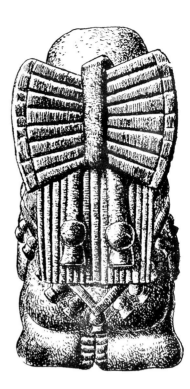

fig. 17b Water goddess, Chalchiuhtlicue. Museum of Mankind, The British Museum, London. From Seler 1902-1923, 2: 906, Abb. 1, 2.

end Dr. Buckland of Christchurch, Oxford, and in 1825 was purchased from him, along with the other objects he had obtained from Bullock, by the British Museum (Bullock 1961: 439).

Many similar images are known, but two are particularly close in style. One, long displayed on loan at the American Museum of Natural History, New York, and currently exhibited in the Mesoamerican Hall of the Michael Rockefeller Wing of the Metropolitan Museum of Art, New York, was acquired in 1900 with the Petich collection (Spinden 1928: fig. 80). Another nearly identical piece in the Museum für Völkerkunde, Basel, was acquired in 1844 with the Vischer collection (Anders, Pfister-Burkhalter, and Feest 1967: Tafel 50, upper right). Perhaps all three came from the same workshop.

A superior member of its class with its strong plastic qualities, this appealing figure effectively portrays the goddess in the image of the Aztec ideal of fertile young womanhood, the potential progenitress of courageous warriors, who expressed the complementary ideal of virile young manhood in this militaristic society. Typical of the seated female figures, this sculpture is solid, compact, volumetric. Aside from the head, however, few areas are carved fully in the round, and nowhere is the mass of the stone penetrated. Some features, like the hands, are carved only in relief. Within the simplified outline of the form there is minimal anatomical definition. The lower section of the body, for example, exists as a rectangular block with the arms and legs merged with the torso. The head, large in proportion to the body, is further emphasized by its more detailed and naturalistic depiction. The face itself, subtly delineated by delicately rounded facial contours, is gently animated without, however, conveying a specific expression. The eyes and mouth appear as recessed oval forms, which almost certainly once contained inlays. Both the sculptor's skill and his predilection for decorative effect are revealed in the attention given to details. For example, the large, complicated twist of the back knot economically translates the flexibility of cloth, and the round toe pads of the turned-in feet echo the circular ornamentation of the costume.

Richard D. Altick, *The Shows of London* (Cambridge, Massachusetts, and London, 1978); Ferdinand Anders, Margarete Pfister-Burkhalter, and Christian F. Feest, *Lukas Vischer (1780-1840): Künstler-Reisender-Sammler,* Völkerkundlische Abhandlungen, 2, Publikations-reihe der Völkerkunde-Abteilung des Niedersächsischen Landesmuseums und der Ethnologischen Gesselschaft Hannover E.V., herausgegeben von Hans Becher (1967); Irwin Bullock, "A Pioneer of Cultural Relations between England and Mexico," in *Homenaje a Pablo Martínez del Río en el vigésimoquinto aniversario de la primera edición de los orígenes americanos* (Mexico, 1961): 439-443; William Bullock, *A Description of the Unique Exhibition, Called Ancient Mexico; Collected on the Spot in 1823, by the Assistance of the Mexican Government, and Now Open for Public Inspection at the Egyptian Hall, Piccadilly* (London, 1824a); and *Six Months' Residence and Travels in Mexico* (London, 1824b); H. B. Nicholson, "An Aztec Stone Image of a Fertility Goddess," *Baessler-Archiv* 11, no. 1 (1963): 9-30; Eduard Seler, *Gesammelte Abhandlungen zur Amerikanischen Sprach- und Altertumskunde,* 5 vols. (Berlin, 1902-1923); Herbert J. Spinden, *Ancient Civilizations of Mexico and Central America,* American Museum of Natural History, Handbook Series, no. 3, 3d ed. rev. (New York, 1928).

18
Kneeling fertility goddess
Height .527 (20¾)
Stone
Völkerkundliche Sammlungen der Stadt Mannheim im Reiss-Museum, West Germany, no. V. Am. Nr. 1084
Ex-Gabriel von Max collection; attributed to San Agustín del Palmar, Puebla

This remarkable piece was acquired by the Mannheim museum in 1916 following the death of its owner, the Munich painter Gabriel von Max, who had purchased it around 1880 from an unknown party (Krickeberg 1960). Although it displays most of the diagnostic features of the water goddess (Chalchiuhtlicue) images, its posture differs from that in customary portrayals. The figure kneels as usual, but instead of resting passively, the body is balanced somewhat tentatively on its knees and toes. This expectant pose, particularly noticeable from a side view, lends a dynamic tension to the piece that contrasts with the attitude of quiet repose characteristic of most of the many other kneeling figures of this type (cf. no. 17). The more elongated torso of the figure also departs from the usual, anatomically compact depiction of the kneeling goddess. The lower portion of the body is not conceived as a consolidated mass that incorporates the torso and lower limbs; rather, the legs are expressed as independent sculptural forms, with the feet fully carved in three dimensions. The costume details are also fashioned more three dimensionally than is common, especially the exceptionally high relief of the numerous tassels. An additional unique feature is the position of the hands. The right one, carved in shallow relief, rests on the right knee, while the left, raised up and carved in the round, displays a hollow fist. As in the case of no. 19, it is likely that an actual maize ear was set into the hollow of the curved left hand on certain ritual occasions.

The costume is typical of the attire of this popular goddess: a headdress composed of three bands and edged above and below with a row of cotton balls; the pleated paper neck bow (*amacuexpalli*); the massive knot beneath it from which hang two thick, twisted cords tipped with tassels; the large tassels, here doubled (a rare feature), attached to the side of the head; and the heavily tassled triangular shawl (*quechquemitl*). This distinctive sculpture is unquestionably one of the finest examples of its type.

Walter Krickeberg, "Xochipilli und Chalchiuhtlicue: Zwei aztekische Steinfiguren in der völkerkundliche Sammlung der Stadt Mannheim," *Baessler-Archiv*, Neue Folge, 8 (1960): 1-30.

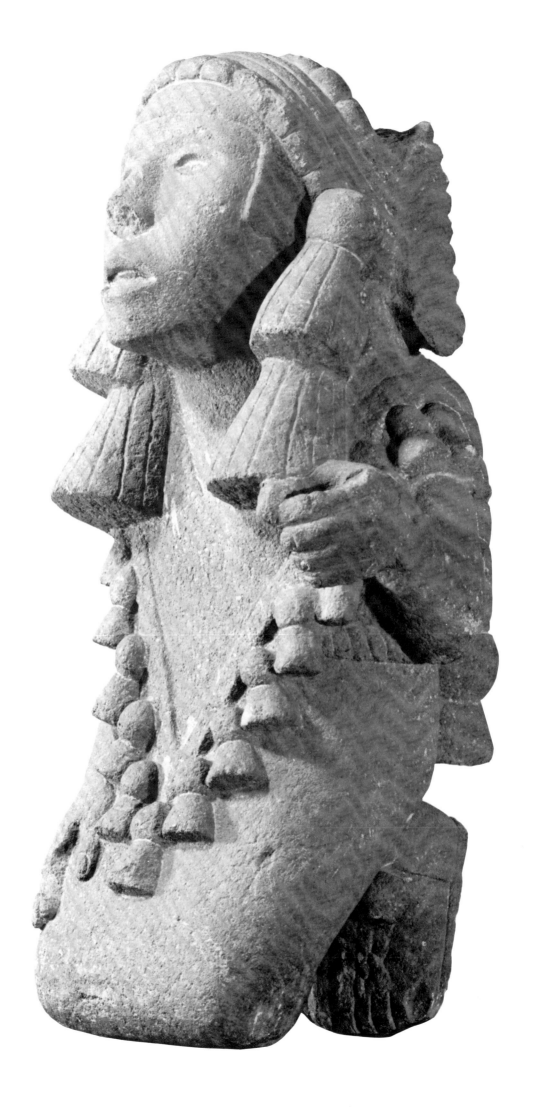

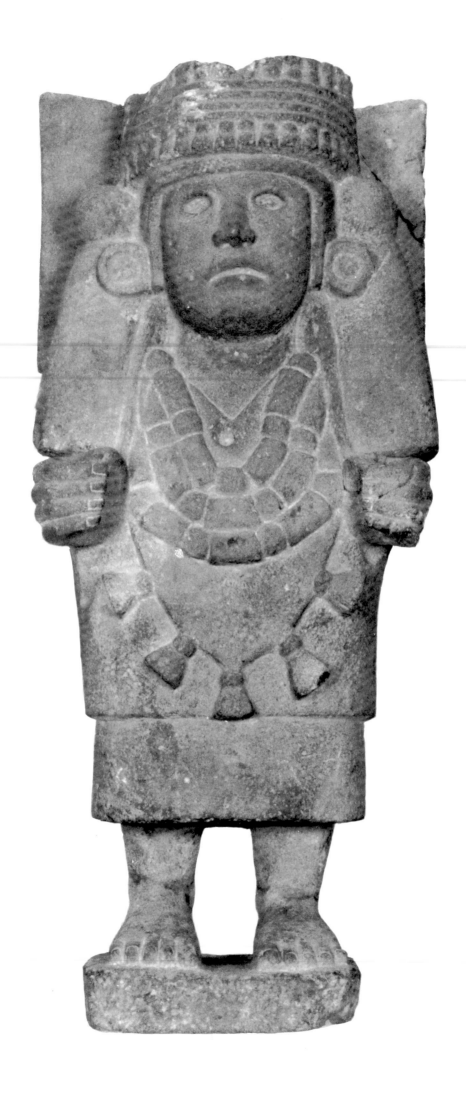

74

19
Standing fertility goddess
Height .68 (26¾); width .29 (11½);
depth .29 (11½)
Basalt
Colección Prehispánica, Fundación
Cultural Telavisa, A.C., Mexico
City

This handsome figure represents fundamentally the same deity as nos. 17 and 18. Aside from its standing posture, it differs from no. 17 principally in the addition of costume elements: a large neckfan, circular earspools, and a massive, three-strand beaded necklace. A clear distinction is also evident between an upper shiftlike garment (*huipilli*) and the skirt (*cueitl*). In back two thick, braided rather than twisted cords, tipped with tassels, hang down. The hands, fists enclosing hollow spaces, stretch away from the body. It shares with no. 18 the neckfan and the heavy braided cords in back, but differs in that both its hands extend out while the right hand of the seated Mannheim figure rests on its knee.

The outstretched hands of this piece connect it more closely with those figures usually identified as maize rather than water goddesses. As indicated in the annotation to no. 20, the former, almost always depicted standing, normally hold double maize ears (*cemmaitl*) with attached rectangular pieces of ritual bark paper. Also, they usually wear the distinctive quandrangular paper headdress, one type of *amacalli*, with pleated paper rosettes at the corners. However, other standing examples are known of the water goddess type, characterized like this piece by the wrapped cord headdress and large side tassels, with their outstretched hands either empty or holding double maize ears (e.g., Nicholson 1963: fig. 5 [Albright-Knox Art Gallery, Buffalo, New York, ex-Goupil collection]). As Franco (1978: 146-148) has suggested, perhaps real maize ears were inserted in the hollows of the hands of this and similar pieces during cer-

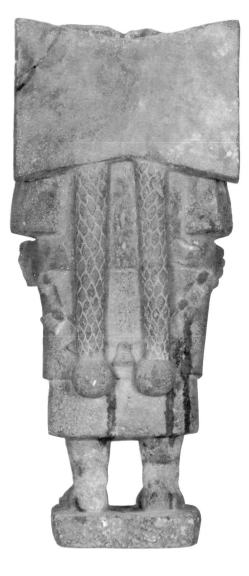

emonies. This image well illustrates the merging of the features of the maize and water goddesses emphasized in the annotation to no. 17 and discussed at greater length in Nicholson 1963.

The representation of this standing goddess conforms to the usual conventions for depicting female figures in Aztec sculpture. The statue is conceived primarily as a cohesive form; the stone is fully cut through only around the ankle areas, and the hands alone project away from the body mass. The figure's closed silhouette is contained within generalized outlines that are primarily indicated by costume elements rather than by the contours of the body itself. Aside from the spare details of the face, hands, and feet, there is little definition of the forms of the body beneath the concealing garments. Emphasis is on the costume, with much attention devoted to the ornamental details of the crown of the headdress, the tassels, and beads. The figure is typically stocky, with the head large in proportion to the rest of the body. She stands erect, static in pose, her feet firmly planted on the base, with her head facing forward. The regular disposition of features results in an image that is bilaterally symmetrical, with little deviation from the body's axes. The face is characteristically impassive. Although slightly downturned, the mouth conveys little expression. The eyes, now seen as hollowed out, oval forms, were probably set with inlays, which may have provided modest animation to the face.

José Luís Franco C., *Manuel Reyero, colección prehispánica, Fondo Cultural Telavisa, A.C.* (Mexico, 1978); 1; H. B. Nicholson, "An Aztec Stone Image of a Fertility Goddess," *Baessler-Archiv* 11, no. 1 (1963): 9-30.

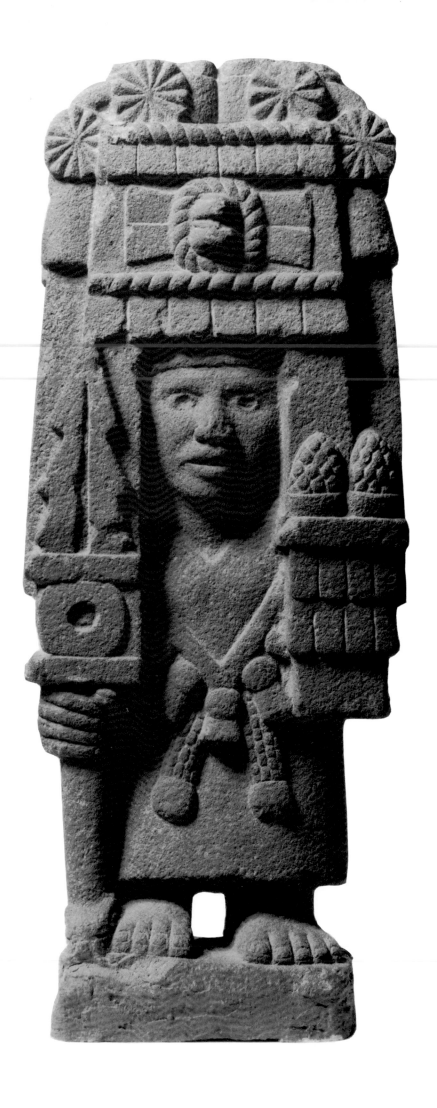

20

Standing fertility goddess
Height .68 (26¾); width .27 (10⅝);
depth .14 (5½)
Volcanic stone
Staatliche Museen Preussischer
Kulturbesitz,
Museum für Völkerkunde, West
Berlin, no. IV Ca 46167
Ex-Uhde collection

This piece was collected by Carl
Uhde, a German who pursued busi-
ness interests in Mexico from the
1820s to the 1840s, and who
amassed what was undoubtedly the
largest private collection of Central
Mexican archaeological pieces
brought together up to that time.
After his death the statue was ac-
quired in 1862 by the then König-
liche Museum für Völkerkunde in
Berlin with the rest of his extensive
collection.

Represented is a standing female
figure with bare feet wearing a tas-
seled *quechquemitl*, long skirt
(*cueitl*) with a knotted belt, and
towering, quadrangular headdress
made of bark paper and adorned
with pleated rosettes at the corners
(*amacalli*). As noted in the annota-
tion to no. 17, this headdress is the
most typical diagnostic feature of
the maize goddess, Chicomecoatl
(e.g., fig. 20a). In her left hand she
holds the double maize ears (*cem-
maitl*), to which a sectioned, rectan-
gular piece of ritual bark paper has
been attached. Her right hand
grasps the shaft of a "rattle staff"
(*chicahuaztli*), a ritual instrument
employed in ceremonies to promote

fertility, which was particularly as-
sociated with Xipe Totec, a male
deity connected with agricultural
fertility (see annotation to no. 36).
Depicted in typical form, it features
an arrowhead-shaped finial above a
circular element framed by two
strips, mounted on a long staff.

In contrast to the figures of the
water goddesses, whose compact
forms are usually fully carved in the
round, this type of maize goddess
retains a blocklike solidity, with the
four faces of the stone, as it were,
carved in relief. The flattened, angu-
lar planes that define the costume
elements of this maize goddess are
typical. Only the rounded contours
of the face that peers out from an
opening in the elaborate headdress
digress from this characterization.
Maize goddess images wearing the
amacalli, and normally holding the
double maize ears as well, are very
common in the collections. Exam-
ples holding the *chicahuaztli* are
rarer, but a few are known. Perhaps
the best of these is a piece also in the
Berlin museum. In this case, how-
ever, the goddess wears the cord-
wrapped headdress typical of the
water goddess figures. Members of
the maize goddess group are often
rather undistinguished artistically,
particularly the smaller ones, which
were clearly mass produced, prob-
ably to serve as household idols.
Marked by a calm solidity, this
maize goddess is one of the most at-
tractive specimens known.

Eduard Seler, *Gesammelte Abhandlungen
zur Amerikanischen Sprach- und Alter-
tumskunde*, 5 vols. (Berlin, 1902-1923).

fig. 20a Maize goddess ritual impersonator
wearing quadrangular paper headdress. *Co-
dex Borbonicus* 30. From Seler 1902-1923,
3: 424, Abb. 17.

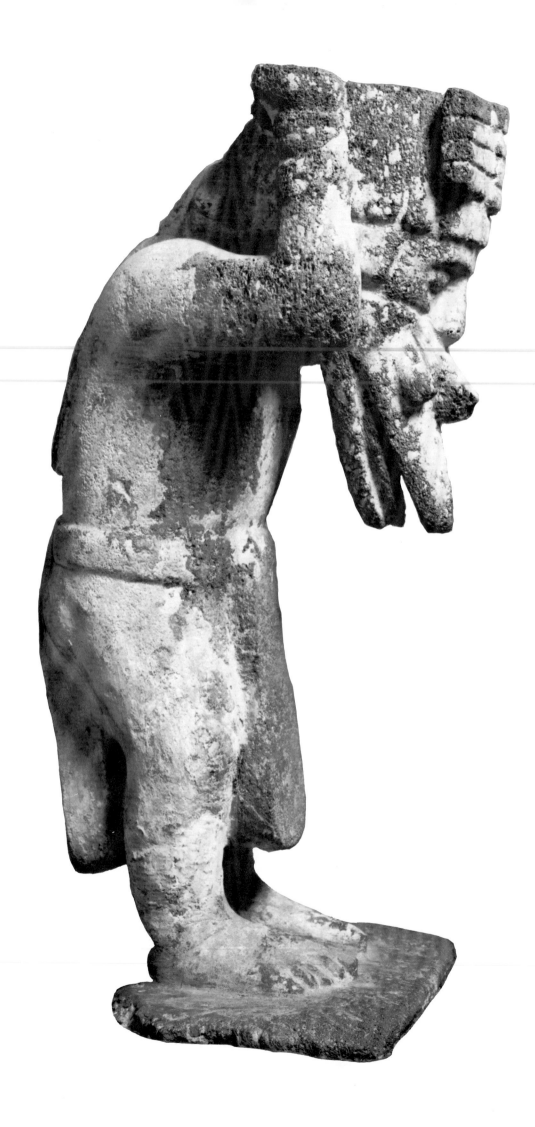

21

Atlantean Ehecatl Quetzalcoatl
Height .58 (24⅝); width .25 (9¾);
depth .25 (9¾)
Volcanic stone
Museo Nacional de Antropología,
Mexico City, no. 11-3307
Found in Mexico City in 1900

Discovered in 1900, this unusual statue was part of the same extraordinarily rich Escalerillas Street cache that yielded the gold butterfly nasal ornament (see annotation to no. 65). Another virtually identical image was found with it. Both figures are slightly bent over and raise their arms high alongside their heads, the tops of their heads and hands forming a flat, horizontal upper surface. The posture of the pair indicates that they served as a type of figure called atlantean, that appears in Mesoamerica as early as the Olmec era (c. 1200-400 B.C.) (e.g., Potrero Nuevo Monument 2, Coe and Diehl 1980: fig. 496), but is particularly diagnostic of the Early Postclassic or Toltec period (c. A.D. 900-1200), of which the type site is Tula in Central Mexico (e.g., Cervantes 1978: fig. 116). They are especially common at "Toltec" Chichen Itza in Northern Yucatan (fig. 21a). While the Toltec figures stand upright with their arms held rigidly overhead, the stooped posture, slightly bent knees, and flexed arms of the Aztec statues convey an impression of the weight of the load

fig. 21c The deity Ehecatl Quetzalcoatl as atlantean sky-bearer. *Codex Borgia* 51. From Seler 1902-1923, 2: 848, Abb. 45.

fig. 21a "Maya-Toltec" atlantean figure. Temple of the Jaguars, Chichen Itza, Yucatan. From Seler 1902-1923, 5: 272, Abb. 99.

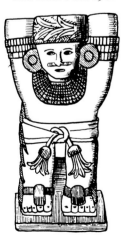
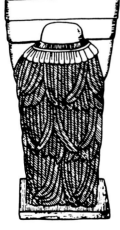

being borne. These two sculptures are the only Aztec atlanteans known.

The figure is posed with his sandaled feet set firmly on a quadrangular base. He wears only a simple loincloth, the two wide flaps with rounded ends hanging down in front and behind without the usual central knot. The distinctive buccal mask attached to the lower part of the face is typical of a particular aspect of the deity Quetzalcoatl (Feathered Serpent), known as Ehecatl (Wind), and constitutes the most striking feature of this image. According to the Spanish commentary to the mid-sixteenth-century Aztec pictorial manuscript, the *Codex Magliabechiano* (1970: fol. 60v), Ehecatl blew the wind through this projecting mouth mask (fig. 21b). The headdress is a version of Quetzalcoatl's characteristic zigzag band, to the front of which is attached a quadruple bow device knotted in the center, occasionally worn by other Ehecatl images. Bracelets and anklets adorn his wrists and legs, and he wears circular earplugs rather than Ehecatl's more usual curved shell ornaments (cf. no. 60 and fig. 21b). Instead of being deeply carved to receive inserts, the eyes are incised in the stone, an unusual feature on Aztec anthropomorphic images. The figure was once brightly painted, for considerable polychromy remains on it: black, red, and yellow applied to a white undercoating.

The Toltec-style atlanteans at Chichen Itza supported massive, tablelike stone slabs. The two Aztec telamones were not found with the supported upper section intact, but they may have functioned in a simi-

fig. 21b Wind god, Ehecatl Quetzalcoatl. *Codex Magliabechiano* 62. From Seler 1902-1923, 2: 397, Abb. 11b.

lar way. In the *Codex Borgia* (51), a pre-Hispanic ritual-divinatory screenfold, Ehecatl Quetzalcoatl appears as one of the four directional celestial atlanteans supporting the sky of the East (fig. 21c), leading Seler to suggest that this figure, with its twin, may have supported some kind of celestial symbol (Seler 1902-1923, 2:848).

María Antonieta Cervantes, *Treasures of Ancient Mexico from the National Anthropological Museum* (New York, 1978); *Codex Magliabechiano CL.XIII.3* (B.R. 232), Biblioteca Nazionale Centrale di Firenze. Einleitung und Resumen Ferdinand Anders. (Graz, Austria, 1970); Michael D. Coe and Richard A. Diehl, *In the Land of the Olmec: The Archaeology of San Lorenzo Tenochtitlan* (Austin and London, 1980); Eduard Seler, *Gesammelte Abhandlungen zur Amerikanischen Sprach- und Altertumskunde*, 5 vols. (Berlin, 1902-1923).

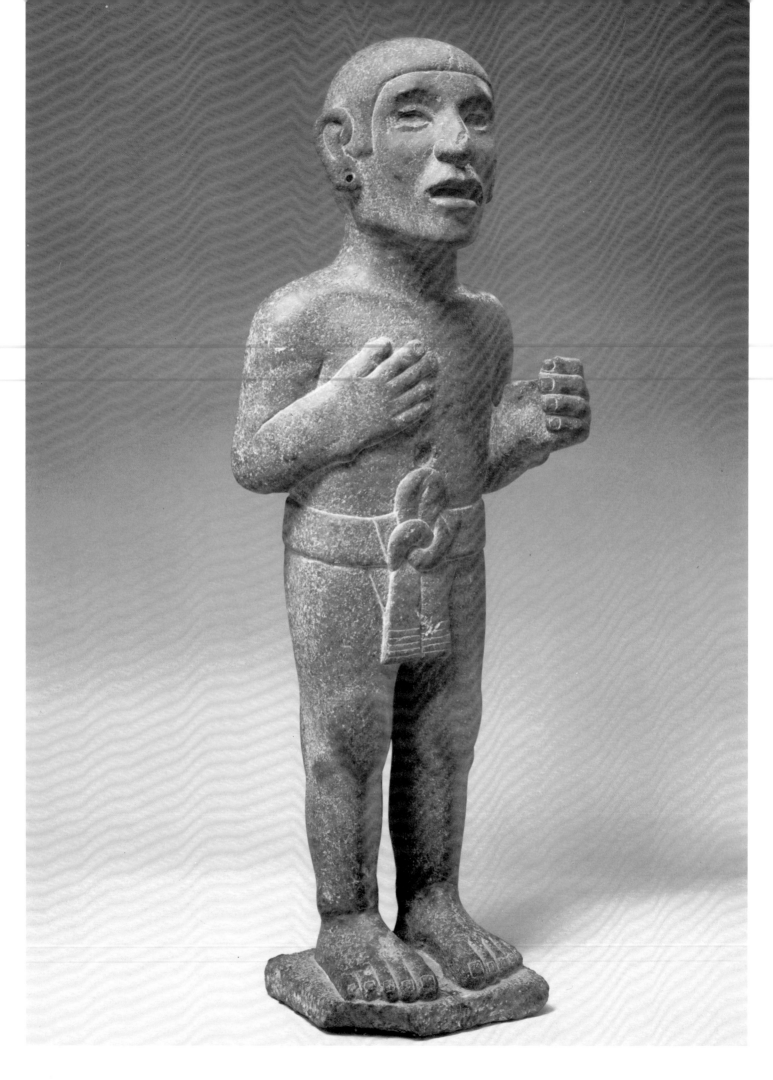

22
Standing male figure
Height .81 (31¾); width .26 (10¼)
Andesite
Museo Nacional de Antropología,
Mexico City, no. 24-276; 11-3362
Attributed to Mexico City

This unadorned male statue has been designated a "*macehual*" (commoner) (e.g., Toscano 1952: 284) and is often referred to by that term, with little justification. It is one of a large group of standing male figures whose sole garment is the standard loincloth (*maxtlatl*) tied in front (see Anawalt 1981: 21-24), the prominent knot constituting the only carved decorative feature of the piece. The simple, sturdy figure is frontally posed, its bare feet solidly placed on a shallow pedestal. The right arm is drawn up, with the large, open hand held against the right side of the chest. The left arm is extended, the hand open as if to grasp an object. The fleshy pads of the knees are exaggerated, an unusual feature on this otherwise anatomically understated piece that stresses a smooth surface definition of the bodily forms. The barely defined collarbone is one of the few references to the underlying physical structure. Typically, the head is disproportionately large in relation to the body, as are the hands and feet. The firmly rendered features include a slightly aquiline nose, and eye and mouth depressions that were originally set with inlays. The ears are large and stylized, with both lobes perforated for the insertion of ornaments. The hairline is, as usual, emphasized, but the hair is not otherwise indicated. A small hole, located just above the top of the loincloth knot, once contained an inlay of jade, obsidian, or some other exotic stone to indicate the "heart," an addition intended to vivify the image.

Scantily attired male statues probably functioned as genuine idols, but they evidently represent only models to which costume items and ornaments were added, perhaps interchangeably, as the ritual occasion demanded. In this case, the left hand possibly held a weapon or other object. Perhaps the figure served as a "standard bearer" equivalent to the archaic style images (see fig. 6) found leaning against the steps of Stage III of the Templo Mayor (Hernández Pons 1982). The hand-against-the-chest pose is unusual but not unknown. Few standing male figures in this category can be rated as superior examples of Aztec sculpture; this piece is an exception. It is a vigorously rendered image, strong in its basic simplicity and clean, economical lines. Though asymmetric in posture, it conveys a sense of balanced solidity.

Elsa C. Hernández Pons, "Sobre un conjunto de esculturas asociadas a las escalinatas del Templo Mayor," in *El Templo Mayor: excavaciones y estudios*, edited by Eduardo Matos Moctezuma (Mexico, 1982): 221-232; Salvador Toscano, *Arte precolombino de México y de la América Central*, 2d ed. rev. (Mexico, 1952).

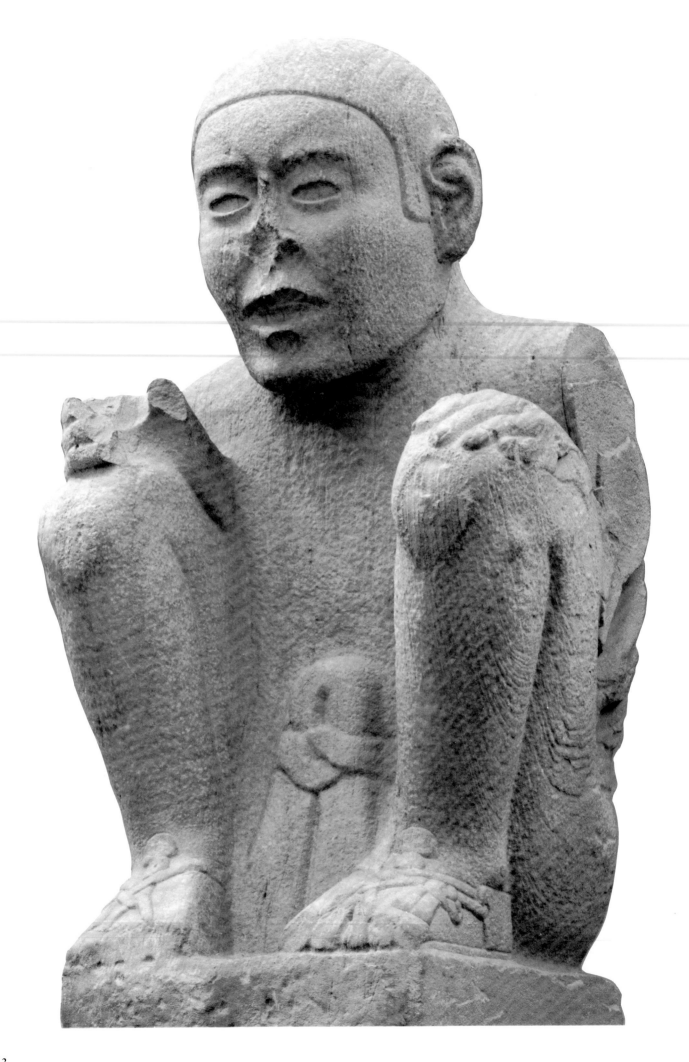

23
Seated male figure
Height (including base) .80 (31½);
width .34 (13⅜); depth .30 (11¾)
Laminated sandstone
The Metropolitan Museum of Art,
New York, Harris Brisbane Dick
Fund, 1962, no. 62.47
Found in Castillo de Teayo, Vera-
cruz (Monument 42)

This spare but powerfully rendered male figure was found in the small town of Castillo de Teayo in northern Veracruz, a modern community founded about 1870, directly on a pre-Hispanic site. Its ancient name may have been Zapotitlan, still the name of a hill at the edge of the town. In any case, it must have been abandoned soon after the conquest, for when the area around its temple-pyramid was cleared of its vegetational covering for the establishment of the modern community, a large number of intact sculptures were discovered, carved in an interesting provincial version of the metropolitan Aztec style, including this piece.

After visiting the site in January 1903, Eduard Seler published an extensive, well-illustrated account of it three years later, which included drawings and a photograph of this statue (Seler 1906: Abb. 55-56, Tafel XVI). Local inhabitants had taken the seated figure to their town hall and nicknamed it "Benito Juárez," after the popular ex-president of Mexico. After its removal from the town in 1945, it was acquired by the Metropolitan Museum of Art in 1962 (Easby 1962). Judging from

Seler's photograph, it has suffered additional damage since his visit, particularly to the right hand and face. The seated figure, wearing only a loincloth and sandals, rests on a massive block, its upper body leaning slightly forward with the bent knees held close against the chest. The open left hand, carved in relief, rests on the left knee; the damaged right one, carved in the round as a hollow fist, on the right knee. Because of the position of the right hand, the figure has usually been designated a "standard bearer," of the type that was stationed at the head of a stairway of a temple-pyramid holding a pole tipped with banners. The more usual type of seated "standard bearer," however, is represented with the hands cupped between the knees (e.g., the famous "Indio Triste"; Seler 1902-1923, 2: 441, Abb. 39). Various Aztec seated figures similar to this one are known. Perhaps the closest example is a crudely carved piece of unknown provenance in the Santa Cecilia Acatitlan Museum (Solís Olguín 1976: 16), also seated on a massive block, but with both hands cupped and resting on its knees.

Dudley T. Easby, "A Man of the People," *The Metropolitan Museum of Art Bulletin* (December 1962): 133-140; Eduard Seler, "Die Alterthümer von Castillo de Teayo," *Verhandlungen des XIV Internationalen Amerikanistenkongresses, Stuttgart, 1904* (Stuttgart, 1906): 263-304; Felipe Solís Olguín, *La escultura mexica del Museo de Santa Cecilia Acatitlan, Estado de Mexico* (Mexico, 1976); and *Escultura del Castillo de Teayo Veracruz, México: catálogo,* Universidad Nacional Autónoma de México, Instituto de Investigaciones Estéticas, Cuadernos de Historia del Arte, 16 (1981).

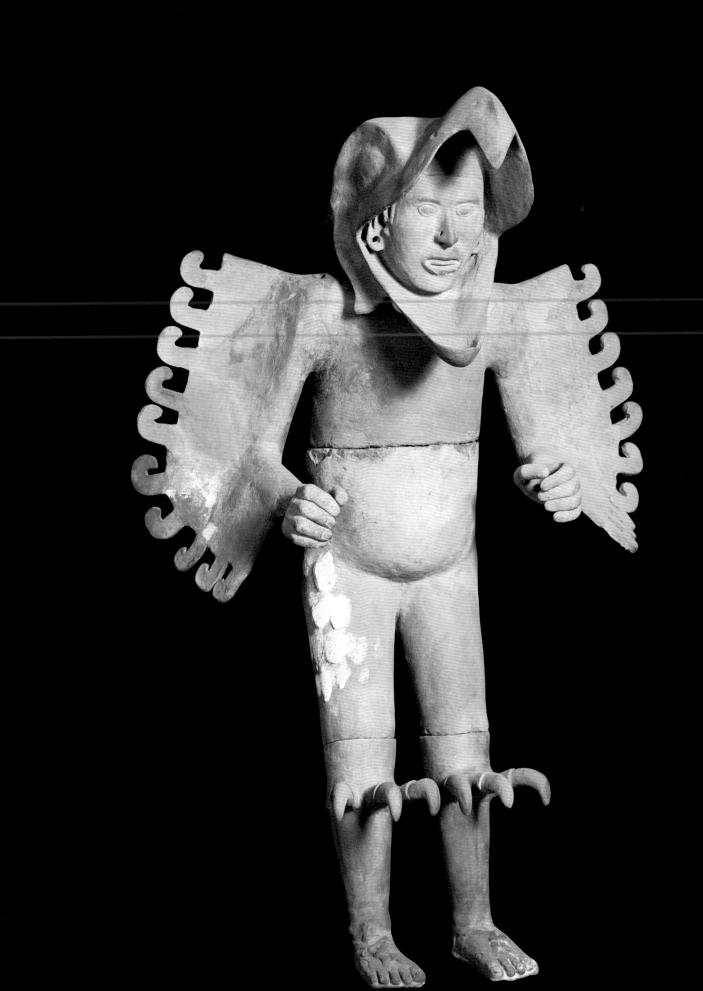

24
Ceramic "eagle warrior"
Height 1.68 (66); width 1.19 (47)
Clay
Proyecto Templo Mayor, Mexico
City, no. 10-220366
Found in the Templo Mayor pre-
cinct of Mexico Tenochtitlan in
1982

This extraordinary, life-size, anthro-
pomorphic ceramic image, built up
in four sections, was one of a pair
flanking a doorway of one room in
the series of rooms excavated be-
neath and to the east of the "Plat-
form of the Eagles," northeast of the
Great Temple of Huitzilopochtli and
Tlaloc. Its fired clay color is a warm
tan, and it exhibits traces of applied
white plaster. It represents a stand-
ing male figure wearing the costume
of an eagle, the bill of the fierce bird
serving as a kind of helmet. The
warrior's head peers out of the
open, exaggeratedly protruding but
gracefully molded beak. The face is
characterized by a simplified real-
ism, the eyes and mouth defined by
oval forms, the nose delicately mod-
eled and slightly aquiline. The lobes
of the ears, pierced through, indicate
that ornaments were attached. The
wings, with upwardly curving pro-
jections , extend from the figure's
outstretched arms, and the hands
are curved around and hollow to re-
ceive inserts. The eagle "suit" ends
in the great claws just below the
knees.

Warriors depicted in the costumes
of eagles and jaguars are common in
the native tradition pictorials and
other illustrated ethnographic
sources (e.g., figs. 24a and 61a). As
noted in the annotation to the colos-
sal jaguar *cuauhxicalli* they effec-
tively pictorialized the Nahuatl
metaphor for warriors, *in cuauhtli
in ocelotl*, "the eagles, the jaguars,"
a phrase that expressed a typically
Mesoamerican contrastive dualism,
sky-eagle vs. earth-jaguar. Above all,
the eagle symbolized the sun, to
whom, in theory, all sacrifices were
addressed. The warriors, eagles and
jaguars, were engaged in the inces-
sant "sacred war," primarily to sup-
ply the sun with his food, human
hearts, and drink, human blood, in
order to maintain and promote the
well-being of the universe.

Two other life-size ceramic figures
representing skeletal creatures were
also excavated during the Templo
Mayor project, flanking a doorway
in the same complex of rooms north
of the Main Temple. Although large
Aztec ceramic vessels with figural
attachments have been found (e.g.,
Tablada 1927: fig. 114), no other
anthropomorphic images as large as
these have apparently been discov-
ered. Like the products of the Aztec
goldsmiths that have for the most
part disappeared, few ceramic fig-
ures have survived to convey an
idea of what must have been a
major Aztec art form. A few small
ceramic figurines show persons
wearing bird costumes (e.g., Seler
1902-1923, 2: 312, Abb. 36c). The
most famous stone sculpture of this
type is the so-called "Eagle Knight"
head in the Museo Nacional de An-
tropología, which was donated in
1890 and has variously been as-
cribed to Mexico City or Texcoco
(e.g., Vaillant 1941: pl. 40). Here the
eagle head helmet is more realistic-
ally presented, with the feathers well
delineated and the beak much less
exaggerated in length.

*La conquista de México, Lienzo de
Tlaxcalla, Artes de México,* año 11 (1964);
Eduard Seler, *Gesammelte Abhandlungen
zur Amerikanischen Sprach- und Alter-
tumskunde,* 5 vols. (Berlin, 1902-1923); José
Juan Tablada, *Historia del arte en México*
(Mexico, 1927); George Vaillant, *Aztecs of
Mexico* (New York, 1941).

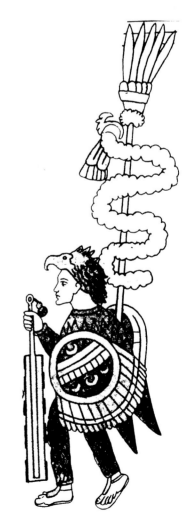

fig. 24a Eagle warrior.
Lienzo de Tlaxcalla 48.

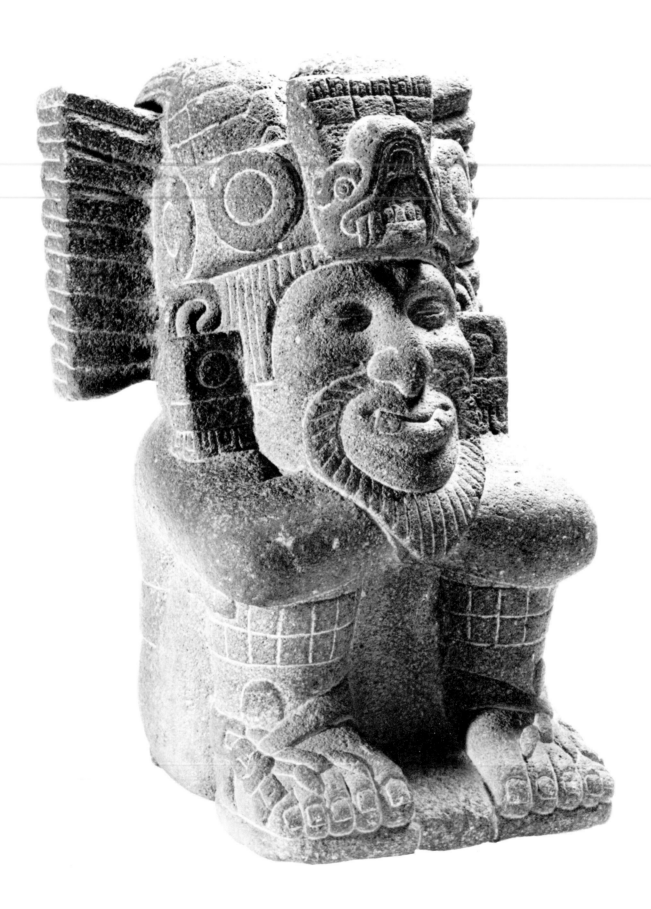

25
Seated male deity (Tepeyollotl?)
Height .34 (13⅜)
Basalt
Museum für Völkerkunde, Basel,
no. IVb 649
Found in Mexico City, barrio of San
Sebastian, probably before 1792

This impressive sculptured image of
a seated male personage, collected in
Mexico between 1828 and 1837 by
the Swiss artist, merchant, and trav-
eler Lukas Vischer (Anders, Pfister-
Burkhalter, and Feest 1967), was ac-
quired by the Basel museum in
1844. A caption on an unpublished
engraving of it prepared for the
Mexican astronomer Antonio León
y Gama for his classic 1792 study of
the Calendar Stone and the colossal
Coatlicue statue provides the clue to
its provenance. According to the an-
notation, it was found in the barrio
of San Sebastian in the northeast
quarter of Mexico City and be-
longed originally to José Telles Gi-
rón. The colorful amateur archaeol-
ogist and artist Jean Frédéric
Waldeck made a drawing of it,
probably during his sojourn in Mex-
ico City between 1826 and 1832,
and credited its ownership at that
time to José Luciano Castañeda,
who some years before had accom-
panied Guillermo Dupaix as artist
on the latter's three archaeological
expeditions throughout western
New Spain. Waldeck's lithographic
version was not published until
1866 (Brasseur and Waldeck 1866:
pl. 4).

The figure is seated, compactly
posed, arms resting on knees, chin
resting on arms. Viewed frontally,
the consolidated figure seems to
consist solely of head and limbs, al-
though the side and back views re-
veal a fuller bodily definition. The
headdress consists of a broad strap
decorated with four circles-within-
circles, symbolizing jewels. Attached
to the front of this fillet is a trape-
zoidal element, the upper edge of
which is bordered with a row of
stylized feathers that generally de-
note preciousness. The lower end

merges into a projecting, gape-
jawed, reptilian head, its fangs
prominently displayed. The hair
above the headband is drawn
through two turtle carapaces (usu-
ally misidentified as maize cobs) and
falls down behind the fanlike,
pleated bark paper ornament (*ama-
cuexpalli*) attached to the back of
the head. Underneath it, covering
the back, is a long panel composed
of three sections: an upper part of
vertical rows of braided strips, a
central section of parallel, horizon-
tal lines, and a lower portion with
incised vertical lines, the latter pos-
sibly serving as a fringe or perhaps
representing the rest of the hair. In
any case, attached to it in the center
is another large carapace. The figure
wears thick, rectangular earplugs
with a circle in the middle and the
lower edge trimmed with the char-
acteristic border motif denoting pre-
ciousness. Contrary to the usual
mode of representation, the eyes are
not hollowed out for inlays but
carved in the stone as narrow slits.
The hair of the pointed beard,
which forms a circle around the
mouth and a heart shape around the
outer edge, is delineated by radial
lines that complement the same stri-
ated treatment of the head hair evi-
dent below the headdress. The
mouth is turned up at the corners
and features two protruding upper
teeth, often an indication of ad-
vanced age. Plain, sectioned bands
define the anklets, while the curvi-
linear crossings of the sandal straps
are more decoratively described in
the stone, as are the toes of the
broad feet. The loincloth hardly ap-
pears, except as lightly incised strips
at the sides of the figure, and—a
rare feature—the typical large cen-
tral knot is absent.

This piece has been variously
identified, usually as an aspect of
Quetzalcoatl, the feathered serpent
creator-fertility god; Tonacatecuh-
tli, the male aspect of the preemi-
nent bisexual creator deity; or the
old fire god, Xiuhtecuhtli-Huehue-
teotl. It almost certainly, however,
represents a different god, Tepeyol-

lotl (Hill Heart). This deity, not
even mentioned by the leading pri-
mary chroniclers of the religious-
ritual system of late pre-Hispanic
Central Mexico, nevertheless ap-
pears to have been of some impor-
tance. In the divinatory manuscripts
he figures as the principal patron of
the third section (13-day period) of
the 260-day divinatory cycle (*tonal-
pohualli*), and as the eighth of the
Nine Lords of the Night, who pa-
tronized the days of this cycle in a

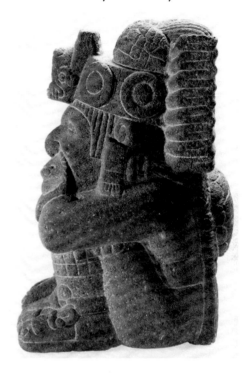

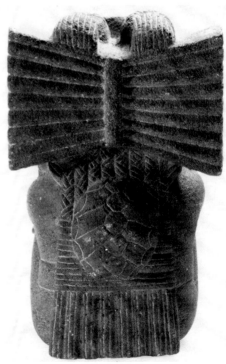

Side and back views, no. 25.

87

repeating sequence (fig. 25a). One of his most diagnostic iconographic features was the unusual arrangement of his hair, which was pushed up into two pads on top of his head, or drawn up into two thick locks, like "horns," tied at the bases. In these illustrations Tepeyollotl appears in two distinct aspects, jaguar (cf. annotation to the colossal jaguar *cuauhxicalli*) and human, in this latter case often in jaguar disguise (fig. 25b). He sometimes wears the insignia of the protean supreme god, Tezcatlipoca, and he was obviously considered to be one of his many avatars. The Central Mexican Tepeyollotl had close analogues in other parts of Mesoamerica, particularly in its eastern section (Oaxaca, Chiapas, Guatemala), where the names "Heart of the Town" and/or "the Kingdom" or similar appellations were applied to him or related deities. A basic terrestrial connotation for Tepeyollotl seems well supported by the evidence. The *Codex Telleriano-Remensis* (Hamy 1899: fol. 9v) describes him as the echo that reverberates in a valley from one hill to the next—like the mighty roar of the jaguar.

During the Templo Mayor project excavations, a large number of seated stone images with two protruding knobs on the tops of their heads, more simply defined but basically similar to our figure, were discovered in several offertory caches (e.g., *El Templo Mayor de México* 1982: 17, 19, 20, 36). The project team, directed by Eduardo Matos Moctezuma, applied the more traditional identification of Xiuhtecuhtli-Huehueteotl to these figures. They appear, however, to be versions of the same deity as the Basel image that can best be identified as Tepeyollotl from the iconographic evidence. Similar figures found in the Escalerillas Street excavations in 1900 (see annotations to nos. 21, 65) were first identified as such by Eduard Seler in the 1907 copy of his catalogue of the archaeological department of the Museo Nacional de México. Nearly all sizable Aztec col-

fig. 25a The deity Tepeyollotl as eighth of the Nine Lords of the Night. *Codex Borgia* 14. From Seler 1902-1903: 103, fig. 295.

lections contain some of these numerous images, most of them small, simple, and stylized, unlike this more elaborate version of the deity, but usually displaying the two pads of hair or "horns" (e.g., Seler 1902-1923, 2: 85, Abb. 48, 49; 853, Abb. 51).

Why sculptures of this poorly documented deity are so ubiquitous in offertory caches poses a considerable problem. Perhaps, commensurate with the god's name, they were considered to be the "heart" of the cache, as the temple they were associated with constituted the ritual heart of the Empire of the Triple Alliance. Conceivably, Tepeyollotl was regarded as a deity particularly connected in this way with the offertory caches that we now know, as a result of the Templo Mayor project, were so commonly deposited in sacred structures when they were renovated or enlarged. This putatively specialized role of Tepeyollotl, who, apart from serving as a patron of the 260-day divinatory cycle, may have otherwise lacked a significant cult, may explain his lack of mention by the principal primary chroniclers of Aztec religion and ritual.

fig. 25b The deity Tepeyollotl in jaguar form (as disguise of Tezcatlipoca). *Codex Borbonicus* 3. From Seler 1902-1923, 2: 739, Abb. 28a.

Ferdinand Anders, Margarete Pfister-Burkhalter, and Christian F. Feest, *Lukas Vischer (1780-1840): Künstler-Reisender-Sammler*, Völkerkundliche Abhandlungen, 2, Publikationsreihe der Völkerkunde-Abteilung des Niedersächsischen Landesmuseums und der Ethnologischen Gesselschaft Hannover E.V., herausgegeben von Hans Becher (1967); Charles Etienne Brasseur de Bourbourg and Jean Frédéric Waldeck, *Recherches sur les ruines de Palenqué et sur les origines de la civilisation du Mexique* (Paris, 1866); Guillermo Dupaix, "Descripción de monumentos antiguos mexicanos," 1794 (manuscript in the Museo Nacional de Antropología, Mexico); E.-T. Hamy, ed., *Codex Telleriano-Remensis* (Paris, 1899); Antonio León y Gama, collection of unpublished illustrations (Bibliothèque Nationale, Paris, Ms. Mexicain No. 97); Eduard Seler, *Codex Vaticanus No. 3773 (Codex Vaticanus B): An Old Mexican Pictorial Manuscript in the Vatican Library*, translated by A. H. Keane (Berlin and London, 1902-1903); and *Gesammelte Abhandlungen zur Amerikanischen Sprach- und Altertumskunde*, 5 vols. (Berlin, 1902-1923); and Inventario de los objetos exhibidos en los Departamentos de Arqueología del Museo Nacional (manuscript copy of 23 October 1907 in the Museo Nacional de Antropología, Mexico); *El Templo Mayor de México* [exh. cat., Museo Arqueológico Nacional] (Madrid, 1982).

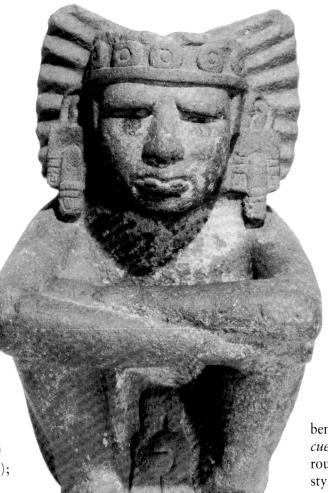

26
Seated male deity (Tepeyollotl?)
Height .33 (13); width .21 (8¼);
depth .21 (8¼)
Volcanic stone
Museum of Mankind, The British
Museum, London, no. 1849.6-29.8
Ex-González Carvajal, ex-Wetherell
collections

This small but imposing figure was collected in the late eighteenth century, probably in Mexico City, by a Spanish official of the Audiencia of Mexico, Ciriaco González Carvajal, who was one of the first to bring together a sizable collection of Mexican antiquities. He took his collection to Spain upon his return there following Mexico's independence in 1821. After his death it was acquired by John Wetherell, resident in Seville, who published a catalogue of it there in 1842, illustrated by lithographs of the pieces, including this sculpture (láms. 3, 6, front and back views). Wetherell's entire collection was purchased by the British Museum in 1849.

The figure is seated, legs drawn up against the chest, with arms crossed and resting on the knees. The only article of clothing worn is the loincloth, with the frontal knot clearly shown. A broad fillet, edged with plain bands, adorns the head. It is studded with circles-within-circles that represent jewels. The ears display massive, quadrangular earplugs with pendant elements issuing from the centers, both the earplugs and pendants decorated with motifs that connoted preciousness. Attached to the back of the head is the pleated fan made of bark paper (*amacuexpalli*). A depression at the top of the head was probably hollowed out in post-conquest times. The face displays beetling brows, with the deep-set eyes themselves only sketchily indicated. The mouth is shown with two upper teeth protruding from the corners. A plain, rectangular panel on the back probably represents the hair falling down beneath and below the *amacuexpalli*. Attached to it are two rounded forms that appear to be stylized turtle shells.

Although, the two diagnostic pads of hair or "horns" are lacking on this piece, a good case can be made that this image represents the deity Tepeyollotl. It shares with the Basel figure, identified as such in the annotation to no. 25, the same seated, arms-on-knees posture, the projecting upper teeth, the jeweled fillet, the pleated occipital paper fan, the quadrangular ear ornaments, and the turtle shells on the backpiece. The main differences are the absence of a beard and the two hair "horns" on the British Museum figure. The latter might have originally been present here before the statue was damaged on top. The overhanging brows also favor the Tepeyollotl identification, for this feature is common on depictions of the deity in the native tradition pictorials (e.g., fig 25a) and on some sculptures.

Juan Wetherell, *Catálogo de una colección de antigüëdades mejicanas con varios ídolos, adornos, y otros artefactos de los indios, que ecsiste en poder de Don Juan Wetherell* (Seville, 1842).

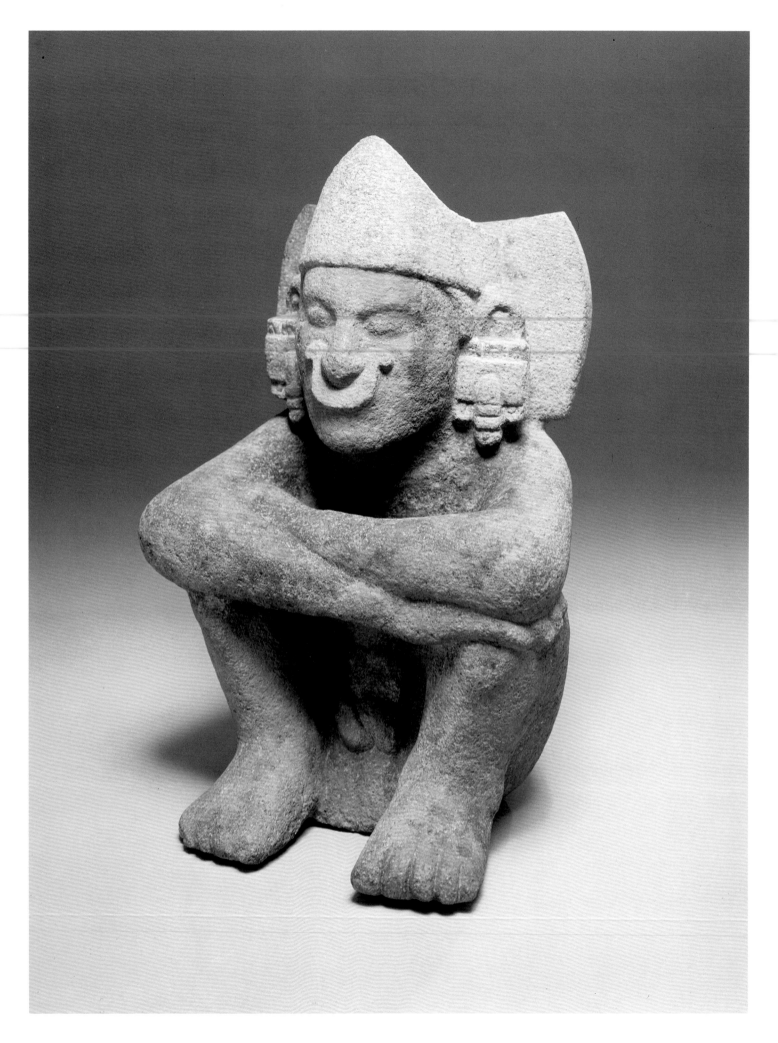

27
Seated pulque (octli) deity
Height .36 (14⅜); width .23 (9);
depth .20 (7⅞)
Stone
Proyecto Templo Mayor, Mexico
City, no. 10-162940
Found in the Templo Mayor pre-
cinct of Mexico Tenochtitlan in
1978

This richly polychrome statue was
found in 1978 in Offertory Cache 6
near the great Coyolxauhqui stone
relief, which would correspond to
Matos Moctezuma's Stage IVb of
the Templo Mayor superpositions,
tentatively equated with the reign of
Motecuhzoma I (1440-1469) (Matos
Moctezuma 1981: 37; Wagner
1982: 119-124). The figure sits with
its arms crossed and resting on
raised knees. Although it wears ear
and nose ornaments and a head-
dress, its body is covered simply by
the standard male loincloth
(*maxtlatl*). It is quite similar to nu-
merous stone images in an identical
seated pose that were found in other
offertory caches during the Templo
Mayor excavation project. The
problem of their identification is
discussed in the annotations to nos.
25 and 26, wherein the hypothesis is
presented that they represent the de-
ity Tepeyollotl rather than the old
fire god, Xiuhtecuhtli-Huehueteotl,
as has been more commonly as-

sumed. This piece differs strikingly
from most of these seated figures in
its costume elements. Although it
wears the pleated paper neck fan
and the quadrangular ear ornaments
displayed by these sculptures, in-
stead of the usual jeweled headband
and the hair drawn up into two
"horns," our image wears the
peaked crown of the lords (*xiuhuit-
zolli*) (cf. fig. 27a) and the lunar na-
sal ornament (*yacametztli*). The lat-
ter item is typically worn by pulque
deities (e.g., fig. 27b), who presided
over the standard Aztec intoxicant,
the fermented juice of the maguey
plant (*octli*), which was consumed
freely on ritual occasions. The hair,
depicted as a plain rectangular
panel, falls down on the back below
the neck fan. The polychrome deco-
ration of this sculpture is unusually
well preserved, and its identification
as a pulque god is supported by the
coloration of its face. A central red
zone flanked by dark areas, together
with the dark body paint, consti-
tutes one of the most diagnostic fea-
tures of the iconography of pulque
deities (useful discussion in Seler
1900-1901: 87-89).

Why this figure, otherwise so sim-
ilar in posture and aspect to the
other cache images tentatively iden-
tified as Tepeyollotl, displays these
well-recognized features of the
pulque deities poses a problem. As

noted by Hernández Pons (1982:
227-229), some members of the
group of archaic style "standard
bearers" found leaning against the
steps of the structure Matos Mocte-
zuma designated as Stage III of the
Templo Mayor in their insignia and
color schemes often exhibit close
iconographic connections with the
pulque deities. These deities, sym-
bolizing an important aspect of ag-
ricultural fertility, were unquestion-
ably important in the cult, and
images displaying their insignia
found in the Templo Mayor may re-
flect this—although some more spe-
cific reason may eventually be re-
vealed.

Elsa C. Hernández Pons, "Sobre un con-
junto de esculturas asociadas a las escalina-
tas del Templo Mayor," in *El Templo
Mayor: excavaciones y estudios*, edited by
Eduardo Matos Moctezuma (Mexico,
1982): 221-232; Eduardo Matos Mocte-
zuma, *Una visita al Templo Mayor de Teno-
chtitlan* (Mexico, 1981); Eduard Seler, *The
Tonalamatl of the Aubin Collection: An Old
Mexican Picture Manuscript* (London,
1900-1901); and *Gesammelte Abhandlun-
gen zur Amerikanischen Sprach- und Alter-
tumskunde*, 5 vols. (Berlin, 1902-1923); Di-
ana Wagner, "Reporte de las ofrendas
excavadas 1978," in Matos Moctezuma, ed.,
El Templo Mayor (1982): 119-142.

fig. 27b Pulque deity Tepoztecatl. *Codex
Magliabechiano* 37. From Seler 1902-1923,
2: 211, Abb. 18.

fig. 27a Pulque deities wearing versions of
the peaked crown of the lords and the lunar
nose ornament. Left: *Codex Borgia* 13;
right: *Codex Vaticanus B* 31. From Seler
1902-1923, 2: 927, Abb. 29, 30.

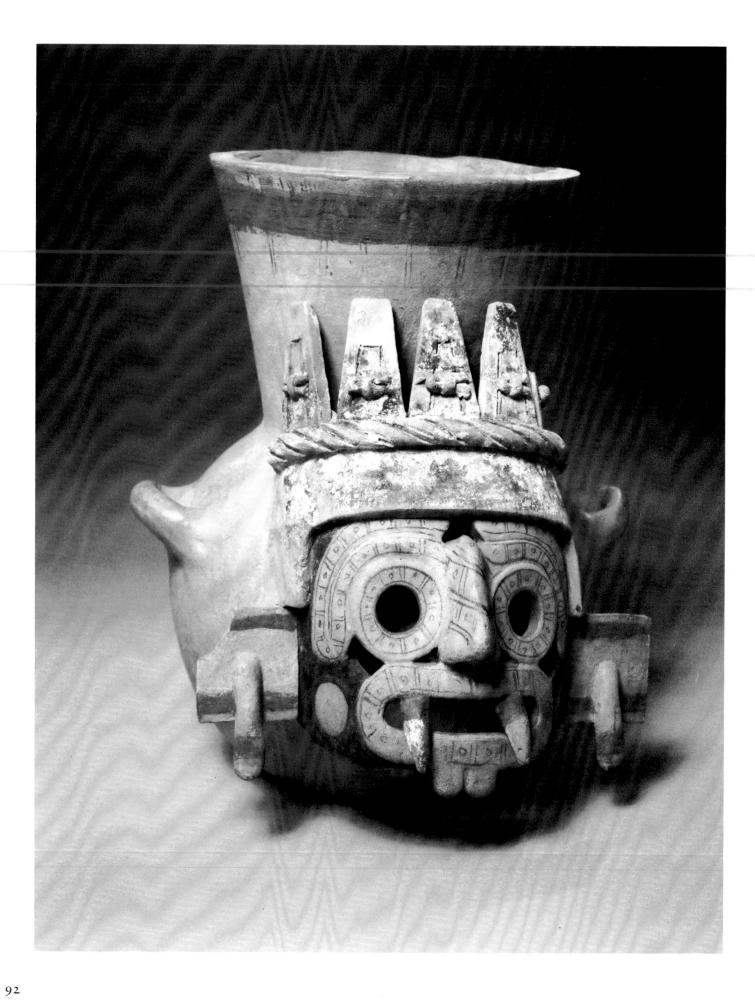

28

Tlaloc effigy vessel
Height .35 (13¾); width .325 (12¾)
Clay
Proyecto Templo Mayor, Mexico City, no. 10-168830
Found in the Templo Mayor precinct of Mexico Tenochtitlan in 1979

This brightly colored ceramic effigy vessel featuring the distinctive head of the great deity of rain and agricultural fertility, Tlaloc, was found in June 1979 in Offertory Cache 21, near the northeast corner of the Great Temple, corresponding to construction Stage II. Another very similar specimen was later encountered in Offertory Cache 56, located in the fill between the fifth and sixth construction stages of the northern Tlaloc temple. Both constituted the principal item in their respective caches, and both contained mother-of-pearl shells and greenstone beads. Found with them were balls of copal incense, stone knives, bird bones, and swordfish snouts. Encountered in a somewhat damaged state, they were carefully restored and studied by Barbara Hasbach Lugo (1982).

The face and ornamentation of the deity have been created by attaching separately modeled clay sections to the body of a double-handled, globular vessel with a high, flaring neck. Four pigments applied to the natural tan fired color of the vessel were: blue for most of the vessel, including the god's mask and the center of the earplugs; red for bands on the rim, earplugs, and fangs, and the inner rims of the eyes, nose, and cheeks; black on the face and for outlining design elements on the mask and elsewhere; and white for the paper crown and tips of the fangs. The features of the face are essentially composed of a long strip, marked with rectangular compartments with circles in their centers, that twists about to form the mouth, nose, and diagnostic

"goggle eyes" of the deity. In some Tlaloc representations, particularly a well-known stone sculpture in the Berlin Museum für Völkerkunde (fig. 28a), this strip explicitly represents the twisted body of a serpent. The serrated white bark paper crown, also called an *amacalli* like the large quadrangular headdress of the "maize goddesses" (see annotation to no. 20), consists of a horizontal twisted cord that separates the plain lower band from the five prongs, adorned with small knotted elements, that form a row above it.

Tlaloc vessels are relatively common in the collections. A number of stone examples were discovered in the Templo Mayor offertory caches (e.g., *El Templo Mayor de México* 1982:6). Another striking polychrome ceramic vessel, with an incised rather than appliquéd Tlaloc visage, was found in Offertory Cache 31 (*El Templo Mayor de México* 1982: 5). On these vessels the head of Tlaloc is usually portrayed, as here, in typical fashion, for the iconography of this ancient and fundamental Mesoamerican fertility deity was particularly standardized.

Barbara Hasbach Lugo, "Restauración de dos ollas," in *El Templo Mayor: excavaciones y estudios,* edited by Eduardo Matos Moctezuma (Mexico, 1982): 369-376; Eduard Seler, *Codex Borgia: Eine altmexikanische Bilderschrift der Bibliothek der Congregatio de Propaganda Fide,* 3 vols. (Berlin, 1904-1909); and *Gesammelte Abhandlungen zur Amerikanischen Sprach- und Altertumskunde,* 5 vols. (Berlin, 1902-1923); *El Templo Mayor de México* [exh. cat., Museo Arqueológico Nacional] (Madrid, 1982).

fig. 28a Head of the rain-fertility deity Tlaloc. Museum für Völkerkunde, West Berlin. From Seler 1904-1909, 1: 109, Abb. 299.

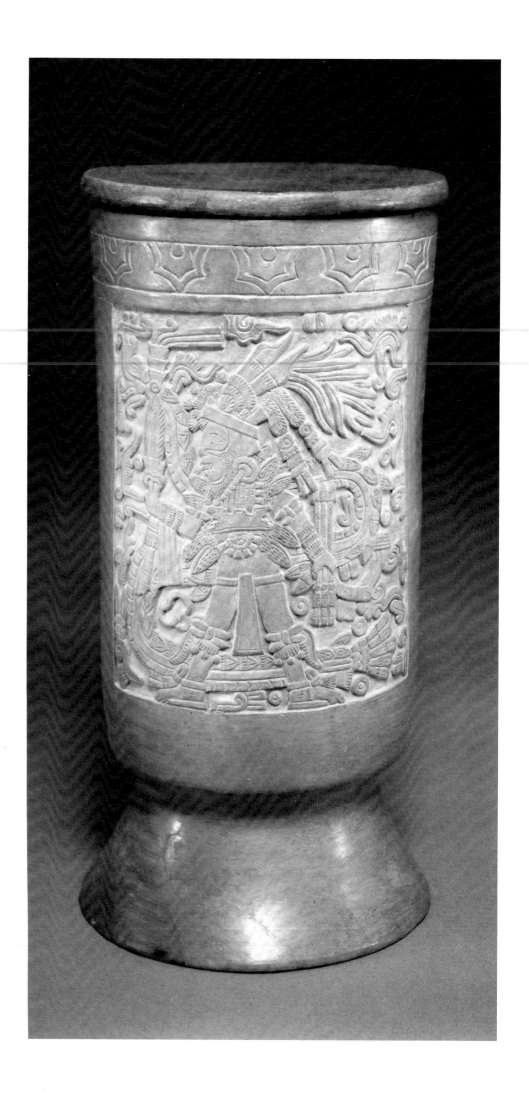

29

*Imitation fine orange vessel
with figural relief panel*
Height .332 (13); diameter .18 (7)
Clay
Proyecto Templo Mayor, Mexico
City, no. 10-16822
Found in the Templo Mayor pre-
cinct of Mexico Tenochtitlan in
1978

In 1978 during the first year of the
Templo Mayor project this interest-
ing lidded vessel and a companion
piece (no. 30) were discovered in
offertory caches (10, 14) in the plat-
form immediately fronting the stair-
way leading up to the Huitzil-
opochtli shrine, between the great
Coyolxauhqui relief (fig. 5) and the
colossal feathered serpent head at
the base of the northern balustrade
(Matos Moctezuma's Stage IVb). It
contained only human bones and a
greenstone serpentiform pectoral
(Wagner 1982). A monochromatic
bright orange, the vessel resembles a
cylindrical form with a pedestal
support that is common in "X Fine
Orange" (Silho) (Smith 1971,
1:182-184), a type of untempered
orangeware produced somewhere in
the Gulf Coast area (southern Cam-
peche?) during the Early Postclassic
or Toltec period (A.D. 900-1200).
The vessel bears a rim band deco-
rated with a repeating motif that re-
sembles the sliced conch pectoral of
Quetzalcoatl (*ehecailacacozcatl*). A
large panel carved in relief carries
its main decoration. It represents a
bearded male figure, standing with
feet apart, his body frontal but his
head in profile. He holds a spear-
thrower (*atlatl*) in his right hand
and a bundle of three spears in his
left. Iconographically, he appears to
be a composite of the fire god
(Xiuhtecuhtli) and a stellar hunting
god (Mixcoatl). The stepped pecto-
ral is diagnostic of the former; the
mask around the eye (colored black
in the pictorial manuscripts), the
strap around the head, and the or-
nament that rises from it composed
of two feathers with a down ball at
the base (*cuauhpilolli*) are character-

istic of the latter. More down balls
and a feather ornament decorate the
hair. He wears an elaborate neck-
lace and circular earplugs with
pendants extending from the cen-
ters. Knotted bows and skin cuffs
encircle the arms and legs. Arrayed
behind the figure is a snake whose
body is edged with elements that ap-
pear to be stone knives. Elaborated
smoke or breath volutes fill the in-
terstices of the panel.

The overall format, with the fig-
ure backed by an undulating ser-
pent, harks back to Toltec models
(cf. carved pedestal vessel in Vienna
Museum für Völkerkunde [Becker-
Donner 1965: Tafel 33]). This un-
usual vessel, an imitation of a type
of vase that was manufactured and
widely traded during Toltec times,
must therefore be regarded as an in-
teresting example of conscious ar-
chaism (cf. "fire god" image, no. 2).

Etta Becker-Donner, *Die Mexikanischen
Sammlungen des Museums für Völkerkunde*
(Vienna, 1965); Robert E. Smith, *The Pot-
tery of Mayapan; Including Studies of Ce-
ramics Material from Uxmal, Kabah, and
Chichen Itza*, Papers of the Peabody Mu-
seum of Archaeology and Ethnology, Har-
vard University, Cambridge, Massachusetts,
66, 2 vols. (1971); Diana Wagner, "Reporte
de las ofrendas excavadas 1978," in *El Tem-
plo Mayor: excavaciones y estudios*, edited
by Eduardo Matos Moctezuma (Mexico,
1982): 119-142.

30

*Imitation fine orange vessel
with figural relief panel*
Height .329 (13); diameter .168
(6⅝)
Clay
Proyecto Templo Mayor, Mexico
City, no. 10-168823
Found in the Templo Mayor pre-
cinct of Mexico Tenochtitlan in
1978

This lidded, cylindrical vessel with a
flaring foot was found in Offertory
Cache 14, a short distance north of
Offertory Cache 10, which con-
tained its companion piece (no. 29)
that it replicates in all but the fig-
ures carved in the relief panel. The
vessel contents included cremated
human bones; fourteen obsidian
pendants in the form of ducks'
heads; two tubular obsidian beads;
two greenstone beads; two disk
fragments, one of obsidian; and a
bone point (Wagner 1982). The re-
lief panel shows a fancily attired,
standing male figure, his body fron-
tal but his face in right profile. He
holds a spearthrower in his left
hand and two spears in his right.
The shirtlike garment with the
fringed lower border that covers his
upper body is probably a version of
the sacred jacket (*xicolli*) worn in a
ritual context by priests and lords
(cf. no. 11). A five-cuff armband
surrounds his right arm, while a
bracelet encircles his wrist, and
three-cuff legbands cover his lower
legs. He wears a sandal on his right
foot, but a "smoking mirror" re-
places his left foot, and smoke vo-
lutes flanking a "fire tongue" is-
suing from the back of his head
symbolize another (cf. no. 35). On
his chest below the multi-strand
necklace he wears a shell pectoral
ring with hanging leather strips
with bifurcated ends (*anahuatl*).
Two horizontal stripes cross his
face, one at the level of the mouth,
the other at eye level (cf. relief figure
of Tezcatlipoca on the colossal jag-
uar *cuauhxicalli*). A nose ornament
(*yacamitl*) consisting of an arrow
with a pendant element pierces his

nose. Atop his head is an ornamen-
tal device made of two feathers is-
suing from a down ball (*aztaxelli*)
and trimmed with additional down
balls. In contrast to the usual long
striations that represent hair on Az-
tec figures, the hair of this person-
age is arranged in short, furry rows.
Behind the figure undulates a snake,
whose body is adorned with long,
graceful feathers, that is, a feathered
serpent (*quetzalcoatl*) (cf. nos.
57-60). As on the vessel from Offer-
tory Cache 10 (no. 29), smoke vo-
lutes fill the unoccupied areas of the
panel.

This figure clearly represents the
supreme deity of the Aztec pan-
theon, Tezcatlipoca. The smoking
mirrors, pectoral, transverse face
stripes, nose bar, and the feather
hair ornament are all diagnostic of
this god. The presence of the feath-
ered serpent is puzzling, however,
since this is the well-known icon of
Quetzalcoatl, who in myths and leg-
ends is the opponent, and some-
times victim, of Tezcatlipoca. As on
the other vessel, the disposition of
the figures imitates Toltec models, as
does the vase form with the carved
panel, both features signaling inten-
tional archaizing.

Diana Wagner, "Reporte de las ofrendas
excavadas 1978," in *El Templo Mayor: exca-
vaciones y estudios,* edited by Eduardo
Matos Moctezuma (Mexico, 1982).

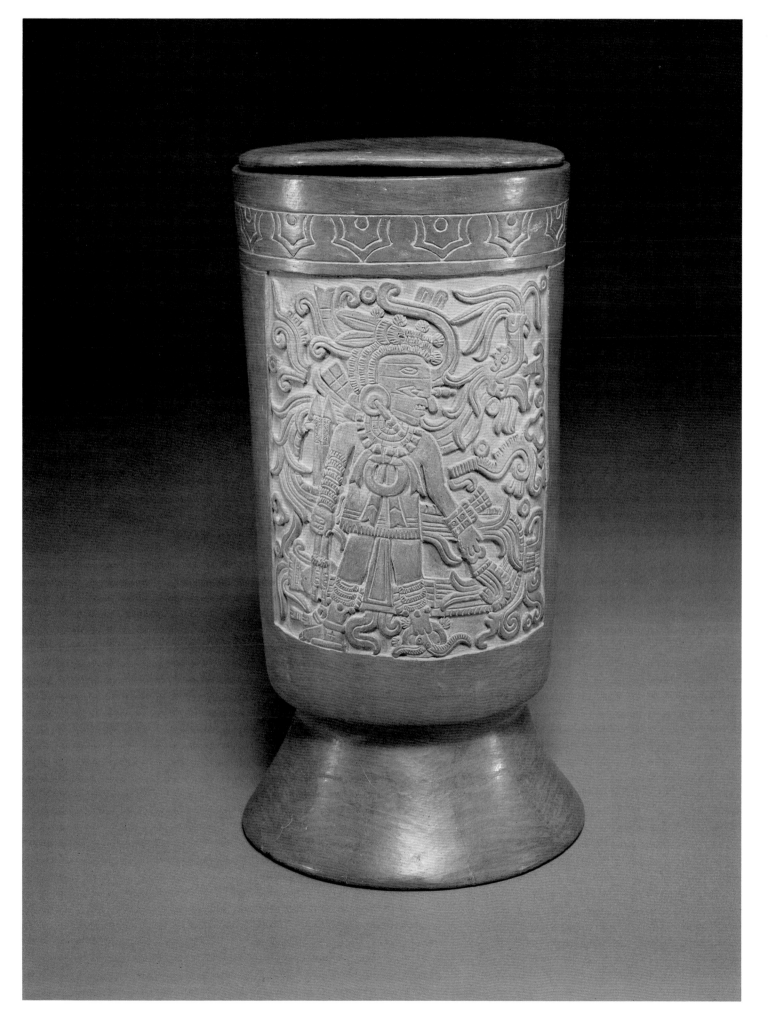

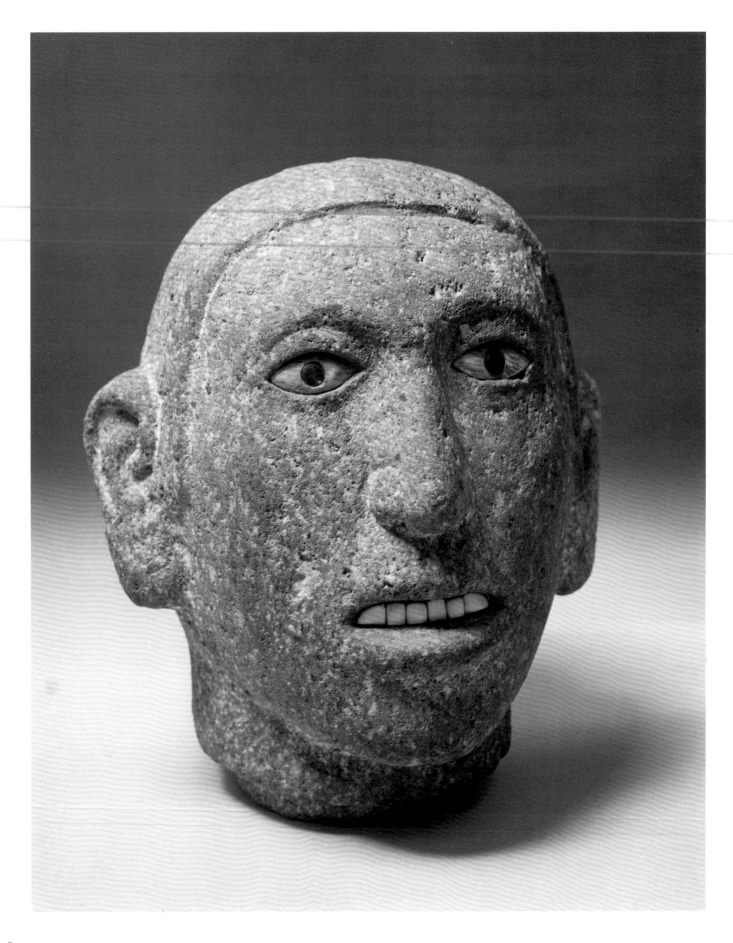

31
Male head
Height .19 (7½); width .17 (6¾);
depth .16 (6¼)
Basalt, shell, pyrite
Museo Nacional de Antropología,
Mexico City, no. 24-1368; 11-3429
Found in Mexico City in 1940

This typical late Aztec style head
was found, with another almost
identical specimen, in an excavation
near the corner of Madero and Bolí-
var streets in Mexico City in 1940
(Toscano 1940: 88). It appears to
have once belonged to a complete
anthropomorphic statue. Although
the eyes and mouths of most Aztec
images once contained shell inlays
that imparted a more lifelike effect,
many of these additions have been
lost. The survival of such inlays
lends special significance to these
heads (both illustrated in Bernal
1972: 113) since they allow us to re-
construct the original appearance of
Aztec figural sculpture. The pupils
of the eyes on this piece are pyrite.
On other examples they are some-
times made of obsidian or *cha-
papote* (asphalt). The features are
defined with minimal detail. As on
most Aztec depictions of human
heads, the hairline is emphasized,
but the head itself is smooth rather
than striated to indicate hair (cf.
nos. 22, 23). The ears, although ex-
aggerated in size, are quite realistic-
ally delineated.

Ignacio Bernal, *Museo Nacional de Antro-
pología de México: arqueología,* 3d ed.
(Mexico, 1972); Salvador Toscano, "Arte y
arqueología en México, hallazgos en 1940,"
*Anales del Instituto de Investigaciones Esté-
ticas, Universidad Nacional Autónoma de
México* 2, no. 6 (1940): 86-89.

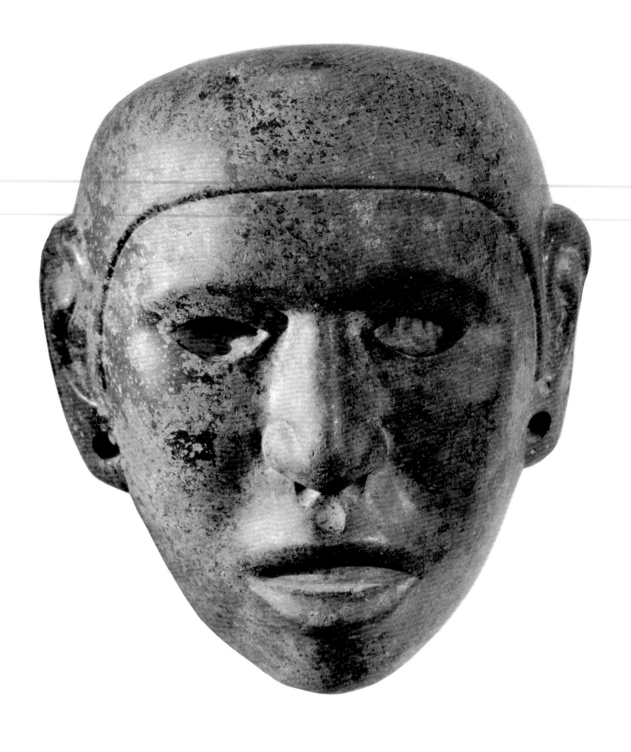

32
Human mask
Height .18 (7⅛)
Porphyry
American Museum of Natural History, New York, no. 30-11847
Found near Castillo de Teayo, Veracruz

This superb mask was found in or near the site of Castillo de Teayo, Veracruz, which is well known for its great number of sculptures in provincial Aztec style (see annotation to no. 23). A drawing of it was published by Eduard Seler in his classic 1906 article on Castillo de Teayo (Seler 1906: Abb. 54). It was acquired in 1903 by the American Museum of Natural History, New York, from Teobert Maler, who visited the site shortly after Seler. It is clear that the Aztecs were particularly aware of the mask traditions of earlier cultures since masks in various styles have been found in the Templo Mayor offertory caches (e.g., *El Templo Mayor de México* 1982: 44, 57-61). The inclusion of such ancient objects among contemporary offerings implies that these works were valued and available as models in the late pre-Hispanic period. In contrast to the older, more stylized pieces, however, Aztec masks are distinguished by a greater degree of depictive realism. The planes of the face are more fully rounded, suggesting their actual contours. Generally, a curved, deeply grooved line across the top of the face designates the hairline. On this mask the hair is left smooth, but on others striated lines suggest strands of hair (cf. no. 34). As with nearly all Aztec human sculptures, the deeply cut, unsmoothed eye and mouth depressions indicate that these cavities originally held inlays

(cf. no. 31). The ears are usually enlarged, with the top convolutions decoratively carved and the lobes pierced to attach ornaments. Rather than being individualized representations, Aztec human masks portray an idealized male face, usually somewhat prognathous, with high, rounded cheekbones and a slightly aquiline nose with a broad base, reflecting the physical type of the Central Mexican Indian.

The function of these stone masks is problematic (Caso 1929). Although commonly referred to as masks, almost certainly they were not worn over the face. Wood masks were tied onto mummy bundles before their cremation, but it is unlikely that stone masks would have been used for this purpose. Writing in 1523, Pedro Mártir de Angleria (1964, 2:541)—after being shown a mosaic mask by Cortés' secretary Juan de Rivera—stated that these masks were placed over the faces of idols when the ruler was sick. Again, however, stone masks would seem inappropriate for this function. Some, especially the smaller ones with perforations, may have served as pectorals worn on the chest. However this type of mask might have been used, the finely modeled piece exhibited here ranks among the very best of the surviving Aztec stone masks.

Alfonso Caso, "El uso de las máscaras entre los antiguos mexicanos," *Mexican Folkways* 5 (1929): 111-113; Pedro Mártir de Angleria *Decadas del Nuevo Mundo, por Pedro Martir de Angleria, primer cronista de indias*, 2 vols. (Mexico, 1974); Eduard Seler, "Die alterthümer von Castillo de Teayo," *Verhandlungen des XIV Internationalen Amerikanistenkongresses, Stuttgart, 1904* (Stuttgart, 1906): 263-304; *El Templo Mayor de México* [exh. cat., Museo Arqueológico Nacional] (Madrid, 1982).

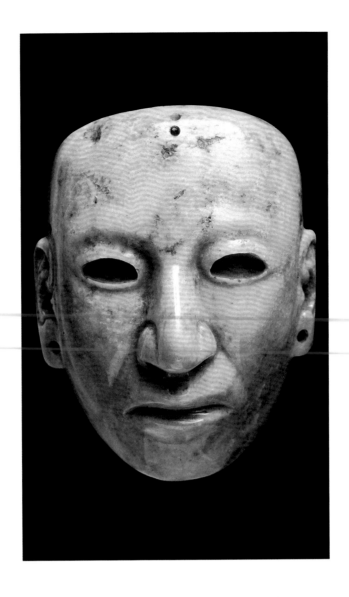

33
Human mask
Height .115 (4½)
Jadeite
Museum für Völkerkunde, Basel,
no. IVb 666
Ex-Vischer collection

This fine mask of high quality, pol-
ished jadeite was collected by Lukas
Vischer (see annotation to no. 25).
It came to the museum in 1844 with
the rest of the extensive Vischer col-
lection. Most of his Aztec pieces ap-
pear to have been collected in and
around Mexico City. Aztec masks
of jadeite are quite rare. Other
examples of this material are the
Coyolxauhqui mask in the Peabody

Museum (no. 10) and two tiny
masks in the British Museum (Joyce
1927: 171, II and III). The simpli-
fied planes of the face are delicately
rendered. The hollowed out eye
sockets once contained inlays, and
the squared off lobes of the elon-
gated ears display perforations for
the insertion of ornaments. Large
holes at the edges of the mask may
have been used to secure attach-
ments, to mount the mask as a pec-
toral, or to fasten it to another ob-
ject. This lustrous, gemlike object is
one of the most attractive of the few
surviving Aztec stone masks.

Thomas A. Joyce, *Maya and Mexican Art*
(London, 1927).

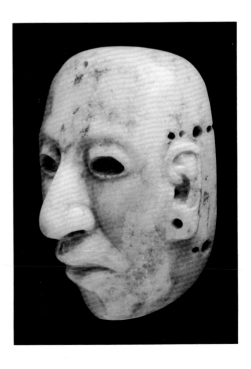

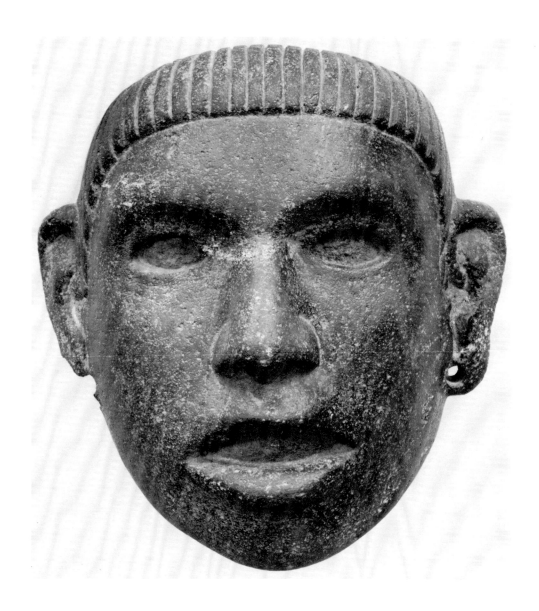

34
*Human mask with representation of
9 Wind (Ehecatl Quetzalcoatl)*
Height .14 (5½); width .14 (5½)
Basalt
Staatliche Museen Preussischer
Kulturbesitz,
Museum für Völkerkunde,
West Berlin, no. IV Ca 26077
Ex-Seler collection

The front of this stone mask shows
a male face whose features, simply
but forcefully defined, typify this
group of Aztec sculptures. In addi-
tion, the concave back surface bears
a relief carving of a major deity. In-
lays applied to the eye and mouth
depressions of the face originally an-
imated its appearance, as did orna-
ments attached to the perforated ear
lobes. The hairline is boldly indi-
cated, and the hair, as is occasion-

ally the case on these masks, is
deeply striated. The mask was ac-
quired by the Museum für Völker-
kunde in Berlin in 1905 from
Eduard Seler who stated that it had
originally been collected about fifty
years earlier by a man living at that
time in Mexico, in whose family it
had remained. It was first published
with a detailed iconographic analy-
sis by Seler in 1903 (reprinted in
Seler 1902-1923, 2: 953-958).

The carving on the back of the
mask represents Ehecatl Quetzal-
coatl (cf. no. 21, fig. 21b), "the road
sweeper of the rain gods," an impor-
tant deity invoked to promote fertil-
ity. He sits cross-legged, his body
frontally oriented but his face in
profile. In his outstretched hands he
holds his curved baton studded with
small circles (*ehecahuictli*). He
wears a projecting buccal "wind

mask," surrounded by a beard, and,
an unusual feature, two additional
"wind masks" appear on his bent
knees, both emitting speech scrolls
or, more likely, wind puffs. Eyes
with eyebrows are also shown on
his elbows. On his head he wears
the conical cap of jaguar skin (*oce-
locopilli*) above a band decorated
with the symbol for turquoise or
precious jewel. Other ornaments in-
clude a feather head fan (*cuezalhui-
toncatl*) and curved shell ear pen-
dants (*epcololli*). Notably lacking is
his diagnostic pectoral, the sliced
conch shell or "wind jewel" (*ehecai-
lacacozcatl*) (cf. no. 48). Nine
circles-within-circles above and to
the left of his head transform this
deity image into a date as well, 9
Ehecatl (Wind), one of the recog-
nized calendric names of Quetzal-
coatl.

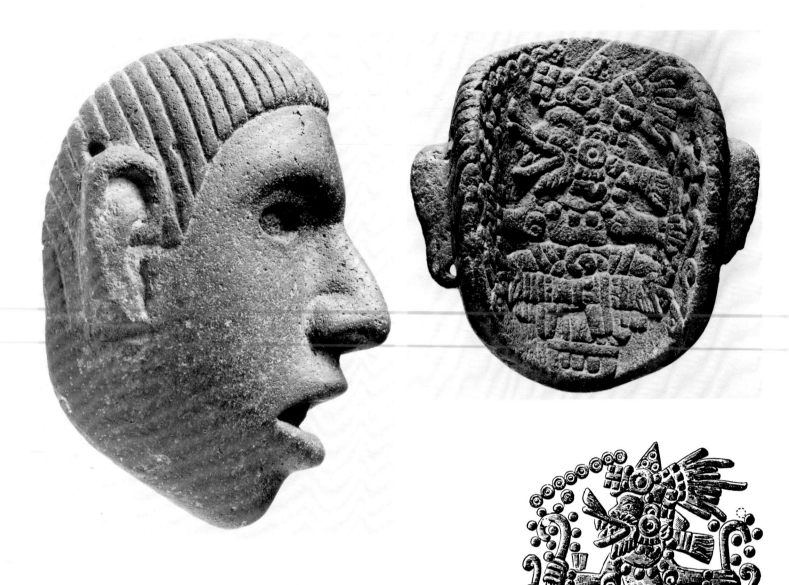

Side, back, and drawing of carving inside back, no. 34. (Seler 1902-1923, 2: 956, Abb. 3)

Aztec masks with carvings of deities on their reverse sides are not common. The best-known examples are two masks of Xipe Totec in the British Museum, whose authenticity has recently been challenged but not definitively demonstrated (Pasztory 1982). Another, concerning whose authenticity there can be no doubt since it appears in the 1794 Dupaix catalogue, is in the Museo Nacional de Antropología in Mexico City. It has been published and analyzed by Caso (1950). The front of this mask shows the water goddess (Chalchiuhtlicue) with typical headdress (see annotation to no. 17). Incised on the back is a female figure with hair composed of *malinalli* grass, accompanied by a numerical coefficient of eight, producing the date 8 Malinalli (Twisted Grass), by implication a calendric name for the water goddess whose face is depicted on the obverse.

Alfonso Caso, "Una máscara azteca femenina," *México en el Arte* 9 (1950): 3-9; Guillermo Dupaix, "Descripción de monumentos antiguos mexicanos," 1794 (manuscript in the Museo Nacional de Antropología, Mexico); Esther Pasztory, "Three Aztec Masks of the God Xipe," in *Falsifications and Misreconstructions of Pre-Columbian Art, 1978 Conference Proceedings*, edited by Elizabeth H. Boone (Dumbarton Oaks, Washington, D.C., 1982): 77-105; Eduard Seler, *Gesammelte Abhandlungen zur Amerikanischen Sprach- und Altertumskunde*, 5 vols. (Berlin, 1902-1923).

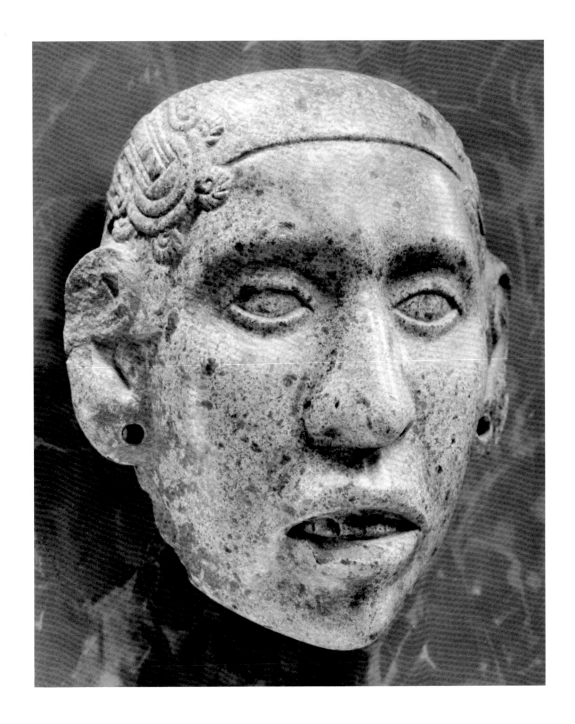

35
Mask of Tezcatlipoca
Height .185 (7½); width .163 (6⅜)
Stone
Dumbarton Oaks,
Washington, D.C., no. B-72. AS
Attributed to Xochimilco, Basin of
Mexico

The deity represented on this handsome mask can surely be identified as Tezcatlipoca, the supreme deity of the Aztec pantheon, because of the symbols that appear above the ears and the date carved on the back. The only other masks carved with dates on the reverse are the

Chalchiuhtlicue greenstone mask in the Museo Nacional de Antropología in Mexico City (see annotation to no. 34) and the Ehecatl Quetzalcoatl mask in the Museum für Völkerkunde in West Berlin (no. 34). An unusual feature of this mask is the fact that the eyes and upper teeth are carved in the stone instead of being hollowed out to be set with shell inlays (cf. no. 31). The lobes of the large, realistically depicted ears are pierced through for the insertion of ornaments.

The symbols carved in relief on the sides of the head above the ears represent the "smoking mirror," the

symbol that pictorialized the name of Tezcatlipoca. This emblem, in a standard conventionalized form, is fairly common on Aztec sculptures and in the ritual pictorials (See Beyer 1921; Nicholson 1958: pl. II, fig. 2). The version here, expertly carved, is composed of the circular rim, four edging balls of eagle down (a sacrifice symbol), and smoke volutes issuing from its center. The bone element representing the stump of Tezcatlipoca's leg, commonly included, is absent. When present on the figure of the deity, the smoking mirror emblem usually replaces one of his feet (cf. relief

Detail of back, showing date.

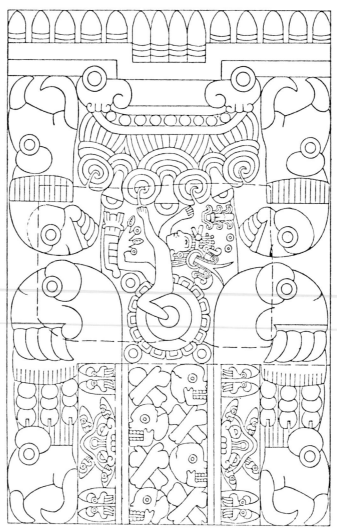

fig. 35a Reconstruction of an Earth Monster (Tlaltecuhtli) relief based on two fragments showing the supreme deity Tezcatlipoca, wearing a smoking mirror device at his temple, emerging from the heart (*chalchihuitl* symbol) of the earth on the date 2 Acatl (Reed). Museo Nacional de Antropología, Mexico City. From Nicholson 1954: 165, fig. 4, with minor corrections.

figures on the colossal jaguar *cuauhxicalli* and no. 30) and/or is positioned at his temple, as here (cf. also no. 7 and fig. 25b). The concept involved has never been satisfactorily explained but may be connected with the mirrors of polished obsidian (*nahualtezcatl*) that were used for divination. Tezcatlipoca was regarded as the omniscient arch-sorcerer, and his association with this important divinatory device—which might even have been the origin of his supernatural personality and cult—seems reasonable. Several examples of these Aztec divinatory mirrors still exist. The most famous of these, the "magic mirror" of Dr. Dee, was used for divination by Queen Elizabeth I's court astrologer, Dr. John Dee (Tait 1967).

The simply incised date on the back of the mask, 2 Acatl (Reed), is closely connected with Tezcatlipoca (Caso 1959: 90-91), probably the day of his birth (Nicholson 1954; fig. 35a). It has also been interpreted historically (Lothrop, Foshag,

and Mahler 1957: 243; Benson and Coe 1963: 23), equated with the year 2 Acatl, 1507. A multiple reference may have been intended. This Acatl sign is stylistically similar to that on the Stone of the Five Suns (no. 6) and, especially, to the one on the Fifty-two-year bundle stone (*xiuhmolpilli*) (no. 7). Like them it depicts a section of jaguar skin on the vessel that is portrayed here in cross-section. Also on the back are three holes, one just above the Acatl date and the other two flanking it near the edges of the mask, which were probably drilled to facilitate attachments. In overall configuration this mask is very similar to the mask from Castillo de Teayo (no. 32) and ranks with the very finest of its class.

Elizabeth P. Benson and Michael D. Coe, *Handbook of the Robert Woods Bliss Collection of Pre-Columbian Art* (Washington, D.C., 1963); Hermann Beyer, "El relieve del espejo humeante," *Revista de Revistas*, 589 (21 August 1921): 42-43 (reprinted in *El México Antiguo* 10 [1965]: 337-342); Alfonso Caso, "Nombres calendáricos de los dioses," *El México Antiguo* 9 (1961): 77-100; S. K. Lothrop, W. F. Foshag, and Joy Mahler, *Robert Woods Bliss Collection, Pre-Columbian Art* (New York, 1957); H. B. Nicholson, "The Birth of the Smoking Mirror," *Archaeology* 7, no. 3 (1954): 164-170; and "An Aztec Monument Dedicated to Tezcatlipoca," in *Miscelleanea Paul Rivet: Octogenario Dicata*, Universidad Nacional Autónoma de México, Instituto de Historia, Publicaciones, primera serie, 50, 2 vols. (1958), 2: 594-607; Hugh Tait, "'The Devil's Looking Glass': The Magical Speculum of Dr. John Dee," in *Horace Walpole: Writer, Politician, and Connoisseur, Essays on the 250th Anniversary of Walpole's Birth*, edited by Warren Hunting Smith (New Haven and London, 1967): 195-212.

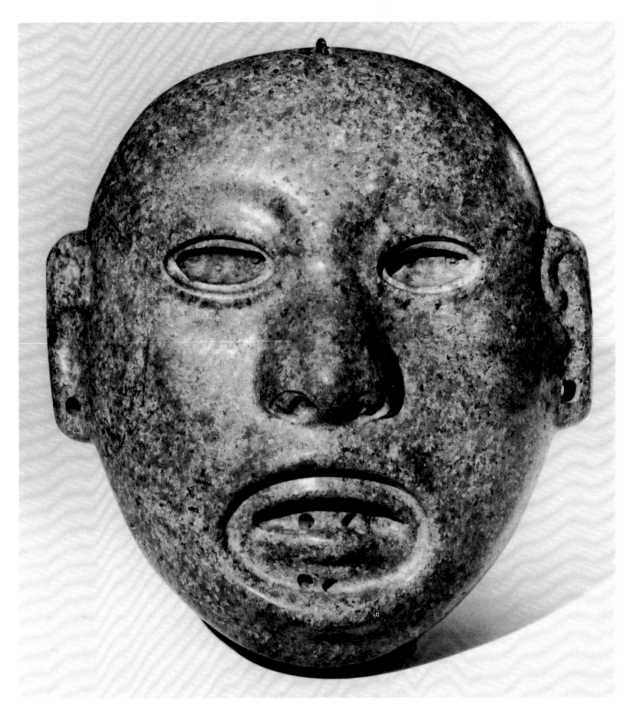

36
Mask of Xipe Totec
Height .212 (8⅜); width .19 (7½);
depth .092 (3⅝)
Greenstone
Museum für Völkerkunde, Vienna,
no. 12415
Ex-Emperor Maximilian of Mexico
collection

This finely carved, highly polished greenstone mask represents a deity whose cult was one of the most macabre and horrifying ever recorded in the history of religion. Called Xipe Totec (Flayed Our Lord), this deity was propitiated at the annual feast of *Tlacaxipehualiztli* (Flaying of Men) with the sacrifice of numerous war captives and slaves. Dispatched by the usual heart extraction method, the lifeless bodies of the victims were then flayed. These human skins, including the faces, were worn by ritual penitents for periods of up to twenty days to gain favor with the god and, in some cases, to seek cures for various eye and skin ailments. The significance of the cult, which was very ancient and widespread in Mesoamerica, has given rise to diverse interpretations. The most influential has been that of Eduard Seler, first fully enunciated in 1899 (Seler 1899: 76-100), who suggested that the flaying and wearing of the victim's skin symbolized the annual spring renewal of vegetation, the "earth's skin." A more historically oriented hypothesis (Acosta Saignes 1950; Nicholson 1972) would view the cult as having originally been derived from the practice of producing trophies from the stuffed skins and heads of slain enemies, a custom that survived until the time of the conquest in some parts of Mesoamerica. Another possible interpretation of the significance of the skinwearing is that by donning this terrible garment the

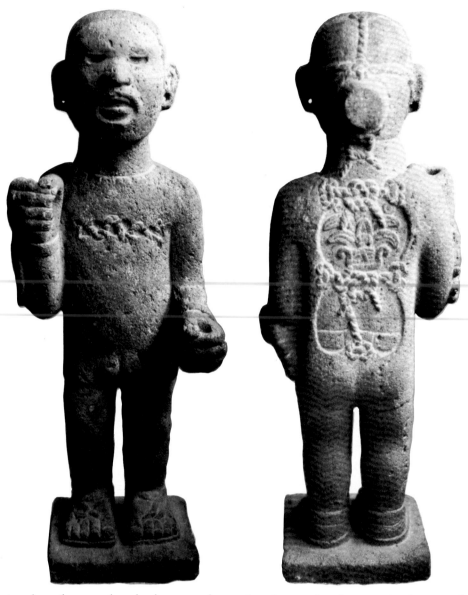

figs. 36a, 36b "Flayed god," Xipe Totec (front and rear views). Museum of the American Indian, Heye Foundation, New York.

ples in several details. These latter masks all delineate the hair with heavily striated lines; the hair is not represented on the Vienna piece. The eyes of the Vienna mask are carved as regular oval forms, while those of the London masks are defined as crescent shapes (cf. no. 9). The eyeholes of the Paris piece are more irregularly shaped, also a common mode of representation (cf. no. 37). On the Vienna mask the wearing of the victim's skin over the face is clearly indicated by the double outlines of the eyes, mouth, and nostrils, and the higher planar surface of the outer skin. The mouth of the wearer is also evident on the Maudslay and Musée de l'Homme specimens, but not on the Christy mask. The ear lobes of the Vienna piece are pierced through, as is the nasal septum and two areas of the skin wearer's mouth to allow for attachments. Circular drill marks are also present in the eye sockets, and these were very likely set with inlays. Three holes on the top edge of the mask permitted its attachment to another object. The artistic sensibility and excellent craftsmanship exhibited by this beautifully sculptured piece contrast strikingly with its macabre subject matter.

Miguel Acosta Saignes, *Tlacaxipeualiztli: un complejo mesoamericano entre los caribes* (Caracas, 1950); *El arte del Templo Mayor* [exh. cat., Museo del Palacio de Bellas Artes] (Mexico, 1980); Angel Ma. Garibay, *Veinte himnos sacros de los nahuas; los recogió de los nativos Fr. Bernardino de Sahagún, Franciscano*, Universidad Nacional Autónoma de México, Instituto de México, Seminario de Cultura Náhuatl, Fuentes Indígenas de la Cultura Náhuatl, Informantes de Sahagún, 2 (1958); Esther Pasztory, "Three Aztec Masks of the God Xipe," in *Falsifications and Misreconstructions of Pre-Columbian Art, 1978 Conference Proceedings*, edited by Elizabeth H. Boone (Dumbarton Oaks, Washington, D.C., 1982): 77-105; Eduard Seler, "Die achtzehn Jahresfeste de Mexikaner (Erste Hälfte)," *Königliche Museen zu Berlin, Veröffentlichungen aus dem Königlichen Museum für Völkerkunde*, 6 (2/4) (1899): 67-204.

ritual performer thereby became the deity into which the victim had been transformed at the moment of sacrifice, literally "crawling into his skin." In any case, there can be no doubt that fertility promotion was the central purpose of the sacrifice, flaying, and skinwearing rituals in propitiation of Xipe Totec—but this says little enough since the same could be stated of almost all pre-Hispanic Mesoamerican religious ceremonies.

A number of complete stone and clay images of Xipe Totec exist, realistically displaying how the victim's skin was attached to the body and worn (e.g., figs. 36a, 36b). A few heads are also known, including one found during the Templo Mayor project (*El arte del Templo Mayor* 1980: 35). Masks are much rarer. The most famous, very closely related to each other, are in the British Museum: one with an open mouth, originally in the Christy collection and apparently obtained between 1856 and 1861; the other, attributed to Texcoco, collected by Alfred Maudslay and sold by him to the British Museum in 1902. Another well-known example, attributed to Teotitlan del Camino, Oaxaca, was collected by Boban in the 1860s and is now in the Musée de l'Homme, Paris. All three masks were recently illustrated and discussed by Pasztory (1982: figs. 1-3), who casts doubt on their authenticity. This mask, which was part of the estate of the Emperor Maximilian of Mexico, was acquired by the Imperial Cabinet of Coins and Antiques in 1868 and was transferred to the Vienna museum in 1881. It differs from the London and Paris exam-

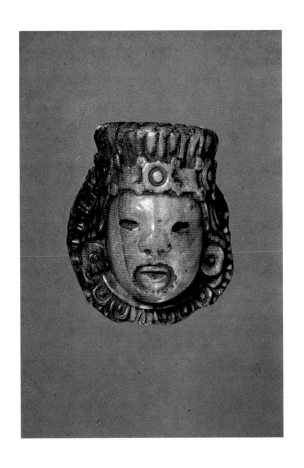

37
Head of Xipe Totec
Height .055 (2⅛); width .046 (1¾)
Spondylus shell
Dumbarton Oaks,
Washington, D.C., no. B-82. AL

This well-carved little head, of un-known provenance, represents the "flayed god," Xipe Totec, in the tra-ditional fashion, with the skin of a sacrificed victim placed over the face. The mouth of the wearer is clearly visible beneath the oval cut of the superimposed skin. He wears a broad headband studded with three circular symbols for turquoise or precious jewel, from which rises

a crest of stiff, vertically set feath-ers. A ruff of stylized feathers also surrounds the face. On either side of the face a small section of the hair is depicted above the circular earplugs. Incised on the back of the head is the representation of a pleated pa-per rosette, decorated in the center with two cone-shaped elements set in circular bases, from which two bifurcated strips extend horizon-tally. This rosette device often adorns the rattle-staff (*chicahuaztli*), the ritual instrument most closely associated with Xipe Totec (e.g., *Codex Borbonicus* 1974: 14, 20; cf. no. 20), and the double cones often appear on the headdresses of fertil-

ity deities (cf. no. 20). The back also displays a large horizontal perfora-tion obviously to facilitate attach-ment, perhaps to a cord if, as seems likely, the little head served as a pec-toral. The choice of pinkish-white spondylus shell for this piece was hardly accidental, for a red and white color scheme is emphasized in the Xipe Totec iconography in the native tradition ritual-divinatory pictorials. The general significance of the Xipe Totec cult and its grue-some flaying ritual is discussed in the annotation to no. 36.

Codex Borbonicus. Commentary by Karl A. Nowotny (Graz, Austria, 1974).

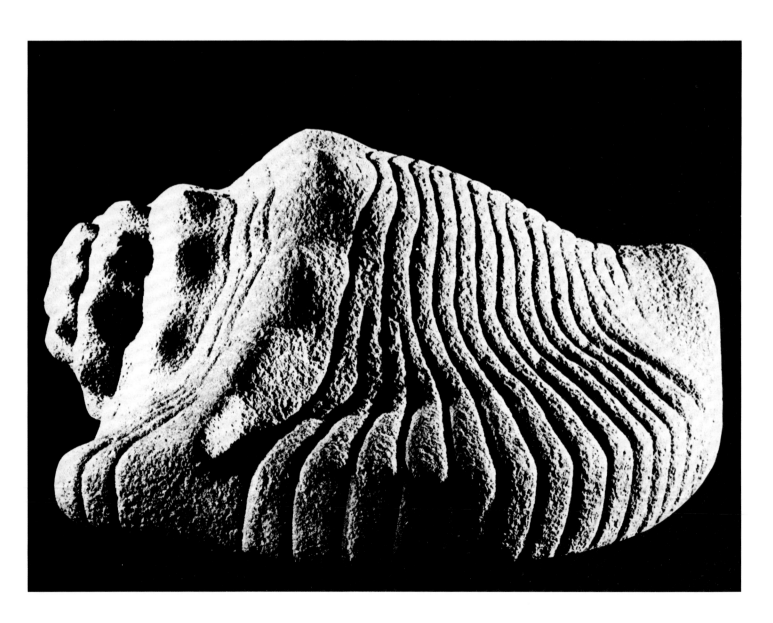

38
Colossal conch shell
Length .87 (34¼); height .44 (17⅜);
width .75 (29½)
Andesite
Proyecto Templo Mayor, Mexico
City, no. 10-168845
Found in the Templo Mayor pre-
cinct of Mexico Tenochtitlan in
1979

This remarkable sculpture was dis-
covered on 29 March 1979 in
Trench D', Square 29, Section 2, east
of the Main Temple. It was imbed-
ded in the foundations of a colonial
wall, on the axis of the dividing line
between the Huitzilopochtli and
Tlaloc temples, and had clearly been
redeposited there after the conquest
(Luna Erreguerena 1982). It is a
realistic stone replica of the Carib-
bean conch, *Strombus gigas*. The
Aztec sculptor has sensitively trans-
lated the subtle contours of this
shell into the gently undulating
carved surfaces of the stone. This
type of large conch and smaller re-
lated species were frequently depos-
ited in Templo Mayor offertory ca-
ches (Wagner 1982). Commonly
utilized as trumpets, blown daily at
important ritual intervals (fig. 38a),
the conch also symbolized fertility.
As one of the annotators of the di-
vinatory section (*tonalamatl*) of the
sixteenth-century *Codex Telleriano-*

Remensis (Hamy 1899: fol. 13r)
stated:

Tecziztecatl [a lunar deity] was so called be-
cause in the same way that a snail creeps
from its shell, so man proceeds from his
mother's womb. They placed the moon op-
posite the sun because it always encounters
the sun; this they say causes human genera-
tion.

In keeping with these connota-
tions of the conch shell, this lithic
model may originally have been po-
sitioned in our near the shrine of
Tlaloc, the great deity of fertility. A
nearly identical specimen was also
found during the Templo Mayor ex-
cavations and is on display at the
Museo Nacional de Arte in Mexico
City, and a similar, slightly smaller
example of unknown provenance,
once part of the Arensberg Collec-
tion, is now in the Philadelphia Mu-
seum of Art (Kubler 1954: 39).

E.-T. Hamy, ed., *Codex Telleriano-Remensis*
(Paris, 1899); George Kubler, *The Louise
and Walter Arensberg Collection: Pre-
Columbian Sculpture* (Philadelphia Museum
of Art, 1954); Pilar Luna Erreguerena, "El
caracol marina de piedra rosa," in *El Tem-
plo Mayor: excavaciones y estudios*, edited
by Eduardo Matos Moctezuma (Mexico,
1982): 241-244; Eduard Seler, *Gesammelte
Abhandlungen zur Amerikanischen Sprach-
und Altertumskunde*, 5 vols. (Berlin,
1902-1923); Diana Wagner, "Reporte de las
ofrendas excavadas 1978," in Matos Mocte-
zuma, ed., *El Templo Mayor* (1982):
119-142.

fig. 38a Ritual performer blowing on conch
shell trumpet. *Codex Magliabechiano* 35.
From Seler 1902-1923, 4: 753, fig. 995a.

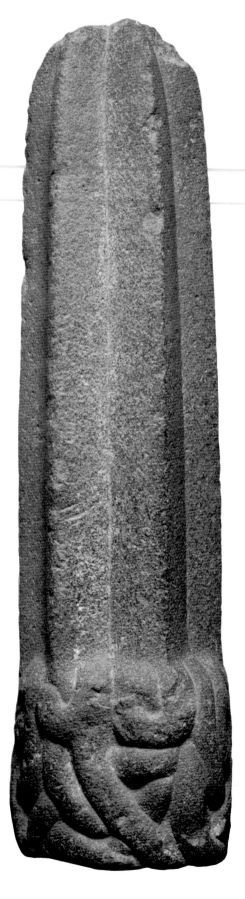

39
Organ cactus
Height .98 (38⅝); width .18 (7⅛)
Andesite
Museo Nacional de Antropología,
Mexico City, no. 24-18; 11-3352
Found in Mexico City before 1874

Replicas of plants in stone are not
very common in Aztec collections,
but a few are known (see no. 40).
This example is one of the most fa-
mous. According to its first owner,
the prominent nineteenth-century
student of Mexican archaeology and
ethnohistory Alfredo Chavero, it
was found in a "baño de caballos"
("horse bath") on the second block
of the Calle de Pila Seca (present-
day Avenida República de Chile),
about four blocks northwest of the
Zócalo (Chavero in Mendoza and
Sánchez 1882: 485). It was donated
by him to the Mexican national mu-
seum in 1874 (Mateos Higuera
1979: 210). The sculpture shows a
realistic representation of an "ór-
gano," a very common type of cac-
tus in the Basin of Mexico. Besides
the cactus itself, accurately por-
trayed as a tapering, columnar form
composed of intersecting vertical
planes, the tangled roots of the plant
are also depicted, as overlapping,
tubular shapes carved in high relief.

Another almost identical piece,
but lacking the top portion, is also
in the museum's collection, its prov-
enance and date of acquisition un-
known. On the undersides of both
pieces are virtually identical com-
plex figural reliefs, whose worn de-
tails are somewhat difficult to dis-
cern. Each appears to represent a
profile human head, from the top of
which sprouts a nopal cactus. In
Arte azteca (1979: 21, no. 5) the
head on the fragmentary piece is
identified as Tenoch ("Stone Cac-
tus"), the legendary founder of the

city of Tenochtitlan, which literally
means "Next to the Stone Cactus."
Chavero (in Mendoza and Sánchez
1882: 485; 1887: 751-752) believed
that this monument served as a sac-
rificial stone (*techcatl*). He also
cited the view of the leading Mexi-
can historian of the last century,
Manuel Orozco y Berra, that the
cactus connoted the name Tenochti-
tlan and might have served as the
roof ornament of a temple or palace
located on the boundary between
this community and its northern
twin city, Tlatelolco. Because this
type of cactus is often used in Mex-
ico as fencing, its function as a
boundary marker might be a possi-
bility. To signify the name Tenochti-
tlan, however, the plant represented
should be a replica of the nopal cac-
tus rather than the órgano.

Alfredo Chavero, *México a través de los sig-
los: primera época: historia antigua* (Barce-
lona, 1887); *Arte azteca* [exh. cat., Museo di
Palazzo Venezia , introduction and bibliogra-
phy by Alessandra Ciattini] (Rome, 1979);
Salvador Mateos Higuera, "Herencia ar-
queológica de México Tenochtitlan," in *Tra-
bajos arqueológicos en el centro de la ciudad
de México*, edited by Eduardo Matos Mocte-
zuma (Mexico, 1979): 205-273; Gumesindo
Mendoza and Jesús Sánchez, "Catálogo de
las colecciones histórica y arqueológica del
Museo Nacional de México," *Anales del
Museo Nacional de México*, primera época,
2 (1882): 445-486.

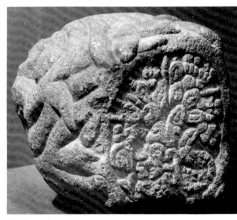

Underside

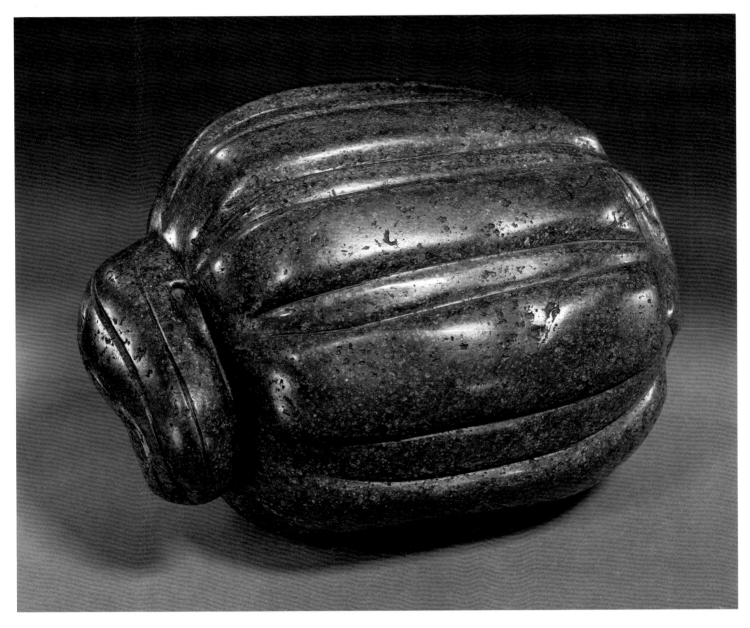

40
Squash (pumpkin)
Height .197 (7¾); width .245 (9⅝)
Porphyry with traces of feldspar
Collection Mrs. Dudley T. Easby, Jr.
Ex-A. W. Bahr collection

Except for its slightly smaller size, this remarkable stone replica of a squash is in most respects a "twin" of a famous piece in the Museo Nacional de Antropología in Mexico City (e.g., Easby and Scott 1970: 288). Both are of unknown provenance. A photograph taken for the Mexican exhibit in the 1892 Madrid exposition celebrating the four-hundredth anniversary of the discovery of America (Galindo y Villa 1902: 39) indicates that the one in Mexico has been in the museum

since at least late in the last century. According to Easby and Scott (1970: 289), leading botanists agreed on a tentative identification of this object as representing *Cucurbita pepo*, the common Mexican pumpkin. Although both examples display the pumpkin flower at one end, the short, stubby stem on the other end of the Mexican specimen is replaced in the Easby piece by a longer, twisted stem.

The squash, together with maize and beans, formed the basic triad of staple food cultigens in pre-Hispanic Mesoamerica. The function of this lithic model of a squash is problematic. Easby and Scott (1970: 289) suggest that it might have been an offering "in a temple of agriculture." Because of the high quality of

the carving of this piece, it is more likely that, instead of an "offering," it and similar pieces were installed permanently as display items in temples dedicated to the fertility deities. Whatever its purpose, this astonishing stone representation testifies to the Aztec sculptor's powers of observation and his ability to capture with veracity and virtuosity the essential features of an object as ordinary as an everyday food item.

Elizabeth Kennedy Easby and John F. Scott, *Before Cortés, Sculpture of Middle America: A Centennial Exhibition at the Metropolitan Museum of Art from September 30, 1970 through January 3, 1971* (New York, 1970); Jesús Galindo y Villa, *Album de antiguedades indígenas que se conservan en el Museo Nacional de México* (Mexico, 1902).

41
Squash
Length .134 (5 ¼)
Aragonite (*tecali*)
Museum of Mankind, The British
Museum, London, no. 1952 Am.
18.1
Attributed to Mitla, Oaxaca

This amazing stone reproduction of
a squash, somewhat smaller than
no. 40 and carved from a different
stone, appears to represent another
variety of squash, *Cucurbita mixta*,
the cushaw (Easby and Scott 1970:
290). It lacks the flower on the end,
however, and the form of its pro-
jecting stem more closely resembles
that on the squash in Mexico City
(see annotation to no. 40). This
piece is superbly carved. The subtle
delineation of the surface and its
alabaster-like sheen express not only
the form of the fruit, but imply its
textural qualities as well. As sug-
gested, these stone squash models
may have been placed in temples
consecrated to the deities of fertility.

Elizabeth Kennedy Easby and John F. Scott,
*Before Cortés, Sculpture of Middle America:
A Centennial Exhibition at the Metropolitan
Museum of Art from September 30, 1970
through January 3, 1971* (New York, 1970).

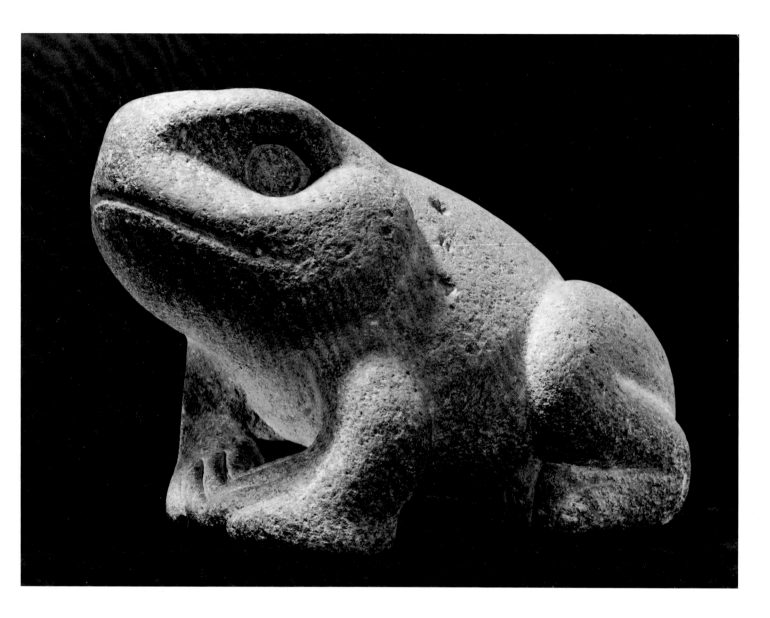

42
Colossal toad
Height .315 (12⅜); length .47
(18½); width .34 (13½)
Stone
Staatliche Museen Preussischer Kul-
turbesitz, Museum für Völkerkunde,
West Berlin, no. IV Ca 44331
Ex-Völlmoller collection

Various stone sculptures of frogs
and toads are extant. This piece, one
of the largest so far reported, was
purchased by the Berlin museum in
1960 (Disselhoff 1961: 19-20). The
Dupaix catalogue of 1794 includes
an illustration (no. 4) of a large
toad sculpture closely resembling
this piece, although it is so poorly
drawn that its firm identification
cannot be certain. The creature is
shown sitting on its haunches,
crouching as if ready to spring. As is
usual in Aztec animal sculpture, the
features of the toad are described in
stone with a naturalism that is ap-
pealingly but economically con-
veyed. The feet are realistically de-
lineated on the undersides, with the
two front ones slightly overlapping.
A row of three holes is bored on
each shoulder, apparently to indi-
cate the venom-secreting pores of
the paritoid glands (Kennedy 1982:
276-277). Carved on the belly is the
symbol for jade (*chalchihuitl*). This
symbol had many connotations, but
the one most pertinent here is prob-
ably the association between the
precious blue-green stone and the
precious blue-green fluid, water, the
source of agricultural fertility.

This piece has two close ana-
logues in the Museo Nacional de
Antropología in Mexico City. One,
a part of the important collection of
José Mariano Sánchez y Mora, ex-
Conde del Peñasco, in the first half
of the nineteenth century, was illus-
trated by Brantz Mayer (1844: 275)
following his inspection of it in

1841 when it was still in this collection. Attributed to Tula, Hidalgo, the old Toltec capital, it is classic Aztec in style. Although comparable in size to the Berlin toad, its anatomical details are somewhat more realistically defined, particularly on the undersides of the feet. Instead of a row of three holes on each shoulder, it shows six holes in three pairs. The *chalchihuitl* symbol on its belly is almost identical to that on our piece. The other Mexican example, the largest of the three, is much less well preserved (illustrated in a poor photograph by Herrera [1925: fig. 15]). It also displays three pairs of holes on each shoulder and shares with the first Mexican specimen a circular pad under the chin that is lacking on our piece. Its *chalchihuitl* sign is also similar to those on the other two sculptures.

A pair of identical crouching frogs adorns the construction Stage IVb platform that divides the stairs of the great platform fronting the stairway leading up to the Tlaloc shrine atop the Templo Mayor of Mexico Tenochtitlan (Matos Moctezuma 1981: fotos 11, 12). These were used as "standard bearers" since they contain cylindrical cavities in their backs for the insertion of poles tipped with banners. In overall configuration they are similar to our piece but somewhat more stylized. The frog and the toad were creatures that were intimately associated with moisture, bodies of water, rain, and fertility in general (Seler 1902-1923, 4: 695-701), an association well exemplified by their presence in front of this great temple to Tlaloc, the preeminent deity presiding over this sphere.

H. D. Disselhoff, "Berliner Museum für Völkerkunde: neuerwerbungen mexikanischer Altertümer," *Baessler-Archiv*, Neue Folge 9, 1 (1961): 5-21; Guillermo Dupaix, "Descripción de monumentos antiguos mexicanos," 1794 (manuscript in the Museo Nacional de Antropología, Mexico); Moisés Herrera, *Las representaciones zoomorfas en el arte antiguo mexicano*, Publicaciónes de la Secretaría de Educación Pública, Mexico, 2, no. 8 (Mexico, 1925); Alison Bailey Kennedy, "*Ecce Bufo*: The Toad in Nature and in Olmec Iconography," *Current Anthropology* 23, no. 3 (1982): 273-290; Eduardo Matos Moctezuma, *Una visita al Templo Mayor de México Tenochtitlan* (Mexico, 1981); Brantz Mayer, *Mexico As It Was and As It Is* (New York, London, and Paris, 1844); Eduard Seler, *Gesammelte Abhandlungen zur Amerikanischen Sprach- und Altertumskunde*, 5 vols. (Berlin, 1902-1923).

Underside, no. 42.

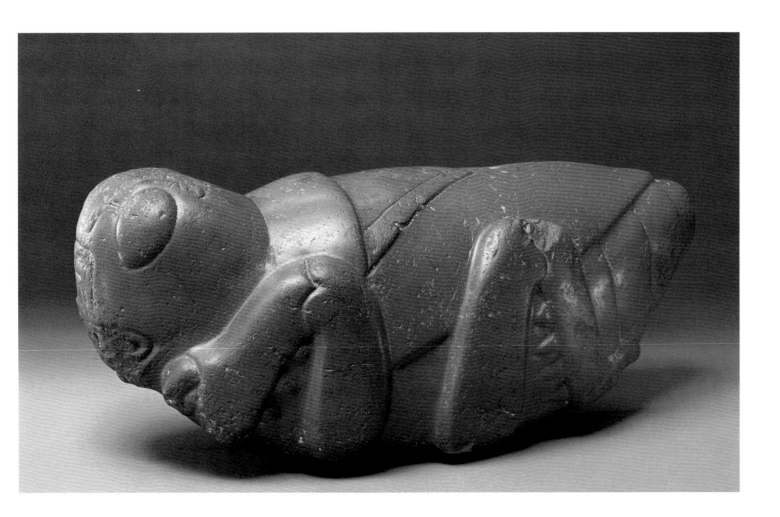

43
Colossal grasshopper
Height .195 (7¾); length .47 (18½);
width .16 (6¼)
Carneolite
Museo Nacional de Antropología,
Mexico City, no. 24-431; 11-3361
Probably found in Mexico City or
on the Hill of Chapultepec before
1841 (1785?)
Ex-Peñasco collection

This extraordinary piece was first
described and illustrated (drawing)
by Brantz Mayer (1844: 275), who
examined it in Mexico City in 1841
while it was in the collection of José
Mariano Sánchez y Mora, ex-Conde
del Peñasco. He also stated that it
had been found in Mexico City.
After it had passed into the posses-
sion of the Mexican national mu-
seum, along with the rest of the Pe-
ñasco collection, it was illustrated
by another drawing in the W. W.
Blake catalogue, an early, quaint En-
glish guidebook to the archaeolog-
ical and historical collections of the

Mexican national museum. Blake
(1891: 55) reported more specifi-
cally that the grasshopper had been
"unearthed in the Hill of Chapulte-
pec during the work of building the
Castle in the year 1785," which
would have been an appropriate
place of discovery since the name
Chapultepec means "grasshopper
hill" (fig. 43a). Even Brantz Mayer,
however, had recognized a connec-
tion with Chapultepec, at that time
an area located outside and to the
west of Mexico City, for he had
commented that the grasshopper
was said to be "the god of Chapul-
tepec—the 'hill of the Cica[d]a'."

This colossal grasshopper ranks
as one of the most exceptional ex-
amples of monumental insect sculp-
tures in the world, along with the
gigantic stone scarab of the great
Eighteenth Dynasty ruler of Egypt,
Amenhotep III, near the sacred lake
of Karnak, and another of green
granite from the Ptolemaic period,
brought by Lord Elgin from Istan-
bul to London and now in the Brit-

ish Museum (Sarton 1949). The
most prominent structural features
of the insect, although compressed
against the body, are boldly and re-
alistically depicted, with emphasis
on the powerful legs, the bodily seg-
mentations, and the large, round
eyes. It is noteworthy, however, that
only two of the three pairs of limbs
are shown. The legs are represented
here as being about the same size,
although the forelegs of the real in-
sect are actually much smaller and
thinner than the hind legs, which
also feature thin tibias covered with
spines. Unable to carve the project-
ing antennae as they actually ap-
pear, the sculptor placed them in-
stead against the top of the head
between the eyes. The material, red
carneolite, smoothly modeled and
highly polished, enhances the work's
aesthetic appeal.

Other stone grasshoppers are
known. Herrera (1925: 13) de-
scribed three others in the Mexican
national museum, illustrating one in
a poor photograph. Another insect

very similar to it and now in the Santa Cecelia museum was published by Solís Olguín (1976: 73). Although more crudely carved than our piece, both correctly display the three pairs of legs. Two others are in the Philadelphia Museum of Art (ex-Arensberg collection; Kubler 1954: 40, 41), the smaller with one pair of legs, the larger with two. Like the other Mexican examples, they are roughly executed. A more expertly carved piece in the Vienna Museum für Völkerkunde with two pairs of legs wears a sliced conch shell pectoral (*ehecailacacozcatl*) on its chest, an ornament usually worn by the god Quetzalcoatl (Becker-Donner 1965: Tafel 50). The head of a four-legged example in the Berlin Museum für Völkerkunde (ex-Uhde collection) is replaced by that of a monkey wearing the egg-shaped ear ornaments characteristic of the deities of sensual pleasure. Another quite well-carved and realistic specimen in the same repository, unfortunately mutilated, lacks its head altogether. Despite the number of existing grasshopper sculptures, their specific purpose is unknown. Some Aztec pictorial chronicles provide evidence that grasshopper plagues occurred in the Valley of Mexico, sometimes causing devastating famines, but whether these images can be linked to such events, possibly as propitiary offerings, is problematic. The presence of deity emblems on some of these insects, however, suggests that they were made for ritual purposes. Other types of insects, such as the lowly flea, were also occasionally carved in stone, and their function is even more mysterious.

Etta Becker-Donner, *Die Mexikanischen Sammlungen des Museums für Völkerkunde, Wien* (Vienna, 1965); W. W. Blake, *The Antiquities of Mexico as Illustrated by the Archaeological Collections in Its National Museum* (New York, 1891); Moisés Herrera, *Las representaciones zoomorfas en el arte antiguo mexicano*, Publicaciónes de la Secretaría de Educación Pública, México, 2, no. 8 (Mexico, 1925); George Kubler, *The Louise and Walter Arensberg Collection: Pre-Columbian Sculpture* (Philadelphia Museum of Art, 1954); Brantz Mayer, *Mexico As It Was and As It Is* (New York, London, and Paris, 1844); George Sarton, "Monumental Representations of Insects, Apropos of a Pre-Columbian Aztec Grasshopper," *Isis* 32, no. 2 (1949): 339-340; Felipe Solís Olguín, *Catálogo de la escultura mexica del Museo de Santa Cecilia Acatitlan* (Mexico, 1976).

fig. 43a Place sign of Chapultepec (Hill of the Grasshopper). *Codex Boturini* 18.

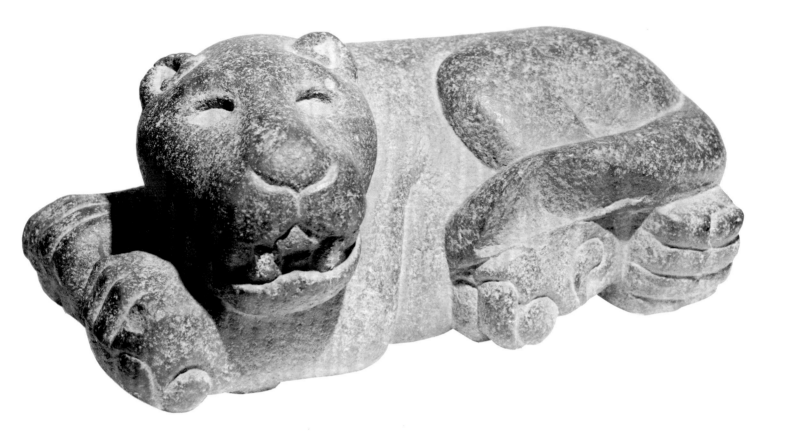

44
Reclining jaguar
Height .125 (5); width .145 (5¾);
length .28 (11)
Stone
The Brooklyn Museum, Brooklyn,
New York, Carll H. de Silver Fund,
no. 38.45

In keeping with the importance of the jaguar in their conceptual universe, Aztec depictions of this impressive animal are among their boldest and most successful (cf. colossal jaguar *cuauhxicalli*). Acquired by the museum in 1938, this naturalistically carved piece, featuring the animal in a reclining position, is one of the most striking of the smaller Aztec jaguar sculptures. Although the great cat is depicted at rest, its carefully delineated musculature and alert head effectively express its latent ferocity. In spite of its modest size, there is a monumentality about this piece that compares favorably with some of the well-known feline sculptures of ancient Egypt, Assyria, and Anatolia. Note-

worthy is the attention to detail on the underside of the creature, with the crossed legs and paw pads realistically carved. As usual, the hollow eye sockets must have contained inlays, which would have considerably enhanced the lifelike quality of this powerful image of the king of Middle American beasts.

Feline images in this reclining posture are not uncommon in Aztec sculpture (e.g., *Escultura mexicana antigua* 1934: láms. 31, 35). None

of these jaguar sculptures has been found *in situ*, and their original placement and precise function are problematic. They may have been set up in and around temples as "cult objects," to express some of the concepts associated with the jaguar in Mesoamerican ideology (see annotation to colossal jaguar *cuauhxicalli*).

Escultura mexicana antigua [exh. cat., Palacio de Bellas Artes] (Mexico, 1934).

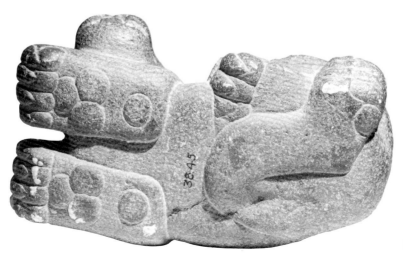

Underside

45
Seated canine (ahuitzotl?)
Height .475 (18¾); width .20 (8);
depth .29 (11½)
Stone
Museo Regional de Puebla,
no. 10-203439

This striking animal sculpture, of
unknown provenance, has tradition-
ally been identified as a dog. Easby
and Scott (1970: 279), however,
have proposed that it actually repre-
sents the quasi-mythical aquatic ani-
mal that was called *ahuitzotl*, which
Thompson (manuscript) suggested
was partly based on the water opos-
sum, *Chironectes panamensis*, a rare
creature of tropical Middle America
(cf. Seler 1902-1923, 4: 513-518).
They wrongly cite in support of
their identification the famous
Vienna Museum für Völkerkunde
feather shield (Becker-Donner 1965:
Farbtafel III), which almost cer-
tainly displays a representation of a
coyote rather than the *ahuitzotl*.
Our figure, however, undeniably re-
sembles depictions of this latter hy-
brid creature that also served as the
name sign of Ahuitzotl, eighth ruler
(1486-1502) of Mexico Tenochti-
tlan. It appears, for example, behind
the head of the ruler Ahuitzotl on
the upper section of the Dedication
Stone (no. 11), as well as alone on a
stone plaque that was set into the
south wall of the Tepoztlan
pyramid-temple and is now in the
Museo Nacional de Antropología in
Mexico City (fig. 45a). The configu-
ration of the large head with its
thick snout, the body proportions,
the long tail, and the prominent
paws of the *ahuitzotl* shown on this
relief panel are almost identical to
those of our image. Another well-
known animal sculpture in the Mu-
seo Nacional de Antropología, usu-
ally identified as a dog (Bernal
1972: lám. 95), shows a caninoid
creature sitting with its long tail
(ending in a hand) coiled under it,
which appears also to represent the
ahuitzotl (cf. a figure of this crea-
ture also crouched on its long,
coiled tail on the lid of a stone box

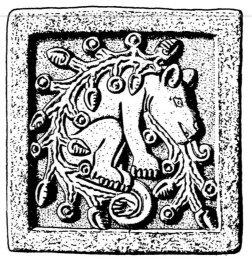

fig. 45a Stone plaque from the temple of the
pulque god Tepoztecatl, Tepoztlan, Morelos,
with the name sign of the ruler Ahuitzotl.
Museo Nacional de Antropología, Mexico
City. From Seler 1902-1923, 4: 513, fig. 198.

in the Berlin Museum für Völker-
kunde [Seler 1902-1923, 4: 517, fig.
200a]). On the other hand, our
image is similar in general aspect to
other sculptures whose identifica-
tion as dogs appears more likely.

Whatever the correct zoological
identification might be, this piece
constitutes one of the most success-
ful Aztec animal sculptures. The
compact solidity of the bodily forms
is played off against the dynamic,
upward thrust of the head. The ex-
pressive delineation of the face also
communicates more animation than
is usual in zoomorphic Aztec images
of this type, a feature that would
have been further enhanced by the
presence of inlays in the now-vacant
eye depressions.

Etta Becker-Donner, *Die Mexikanischen
Sammlungen des Museums für Völkerkunde,
Wien* (Vienna, 1965); Ignacio Bernal, *Mu-
seo Nacional de Antropología de México:
arquelogía*, 3d ed. (Mexico, 1972); Elizabeth
Kennedy Easby and John F. Scott, *Before
Cortés, Sculpture of Middle America: A
Centennial Exhibition at the Metropolitan
Museum of Art from September 30, 1970
through January 3, 1971* (New York, 1970);
Eduard Seler, *Gesammelte Abhandlungen
zur Amerikanischen Sprach- und Alter-
tumskunde*, 5 vols. (Berlin, 1902-1923);
J. Eric S. Thompson, "Myth, Metaphor and
Other Factors in Maya Representations of
Fauna with Special Reference to the Water
Opossum" (manuscript).

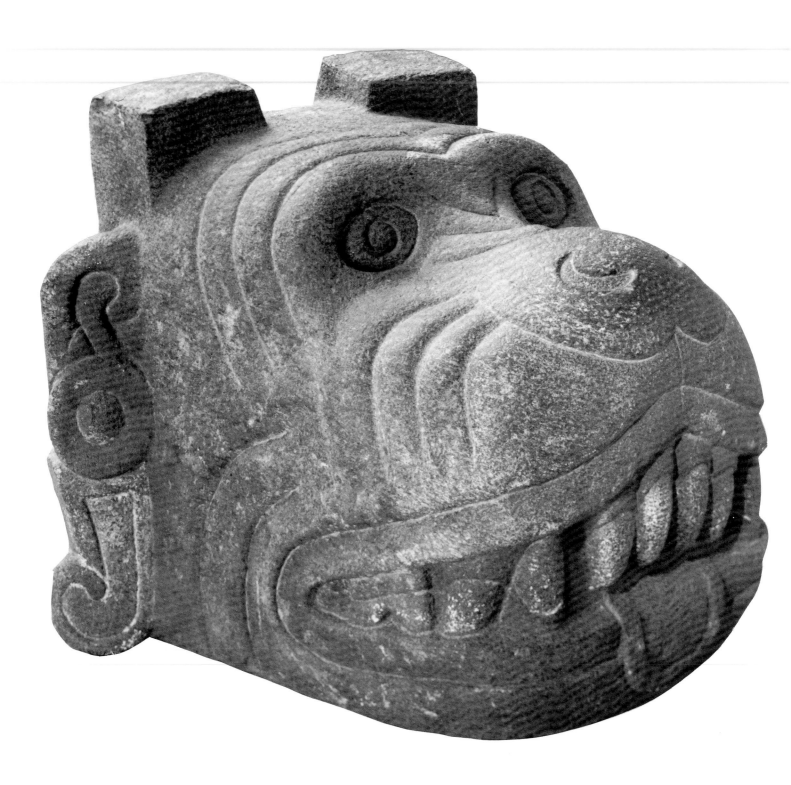

46
Head of a monster deity (Xolotl)
Height .49 (19¼); width .66 (26);
depth .73 (28¾)
Andesite
Museo Nacional de Antropología,
Mexico City, no. 11-3744
Found in Mexico City in 1969

On 29 October 1900, Mexico City workers digging a sewer line along Escalerillas Street north of the cathedral discovered a well-carved but damaged, oversize stone zoomorphic head while excavating around three pre-Hispanic masonry walls. Leopoldo Batres, General Inspector of Archaeological Monuments, obtained it for the Mexican national museum and later published a photograph of it, identifying it as a monkey's head (Batres 1902: 33-34). Two years later Eduard Seler (1902-1923, 2: 871, Abb. 70) published another photograph of the head, also identifying it as a monkey but suggesting, in addition, that it might represent the monstrous caninoid god Xolotl.

Sixty-nine years later, about two blocks further west on Tacuba Street between Palma and Isabel la Católica streets, a second virtually identical head in excellent condition—our piece—was found, also associated with a pre-Hispanic wall (Gussinyer 1969), and nearby, numerous small zoomorphic ceramic figures (e.g., coyotes, dogs, monkeys, rabbits, birds, scorpions) (Mateos Higuera 1979: 241). The two heads definitely form a pair and can be described together. They represent an animal that most closely resembles a dog, but with some simian overtones (enough to induce Batres and Seler to suggest the monkey identification). Incised parallel lines indicate the deeply creased forehead and muzzle areas. The open mouth reveals large teeth, and a broad tongue, carved in low relief against the lower part of the mouth, hangs out. The creature displays human ears, adorned with the distinctive, curved ear ornaments (*epcololli*) characteristic of the god Quetzal-

coatl and his avatars, including Xolotl. In addition to these ears on the sides of the head, two prismatic "knobs" appear atop it. The back of the head is smooth, but the lightly carved lines of the underside resemble the ventral markings of the snake. The head retains considerable red color, with the teeth and ear ornaments appropriately painted white, while traces of black remain on the rear.

These heads clearly represent not a monkey but Xolotl (Monster), the caninoid deity of twins and monsters described as Quetzalcoatl's brother (probably twin), who typically wears his insignia (fig. 46a). Depicted in this fashion, he appears in the ritual-divinatory pictorials with a creased face and two sets of ears, human ones with the *epcololli* and dog ears with torn upper edges (cf. Caso 1970: 32-33). Although the blocklike knobs on the top of the head do not resemble torn canine ears, they may be stylized versions of them (cf. the cylindrical "knobs" on the little wood effigy of Xolotl, no. 47). In some myths Quetzalcoatl was closely connected with the planet Venus, and it has been speculated that Xolotl, as Quetzalcoatl's twin, might have been considered to have been the evening star manifestation, complementing Quetzalcoatl's role as primarily the deity of the morning star. Xolotl may also have been associated with the dog who in Aztec belief guided the dead soul to the underworld. Although he figures in cosmogonical myths and serves as the principal patron of the sixteenth 13-day period of the 260-day divinatory cycle (*tonalpohualli*), he does not appear to have played a particularly important role in propitiatory ritual.

There is no mention of a temple to Xolotl in the Great Temple precinct of Mexico Tenochtitlan, but Caso (1970: 33) has suggested that one may have been located in the south of the city, adjacent to the great southern causeway, in the ward of Xoloco (Place of Xolotl).

fig. 46a The deity Xolotl. *Codex Borbonicus* 16.

These two heads, found a considerable distance to the northwest, may have adorned another temple in or near the Templo Mayor. Although discovered somewhat separated from each other, they are so clearly a pair that they might have been placed at the bases of stairway balustrades in such a shrine. Another head in the Museo Nacional de Antropología, somewhat smaller and rather different in overall appearance but probably also representing Xolotl, has been published and compared to our piece by Caso (1979).

Leopoldo Batres, *Archaeological Explorations in Escalerillas Street, City of Mexico: Year 1900* (Mexico, 1902); Alfonso Caso, "Xolotl, no jaguar," *Boletín del Instituto Nacional de Antropología e Historia* 39 (1970): 31-33; Jordi Gussinyer, "Una cabeza de jaguar," *Boletín del Instituto Nacional de Antropología e Historia* 38 (1969): 40-42; Salvador Mateos Higuera, "Herencia arqueológica de México Tenochtitlan," in *Trabajos arqueológicos en el centro de la ciudad de México*, edited by Eduardo Matos Moctezuma (Mexico, 1979): 205-273; Eduard Seler, *Gesammelte Abhandlungen zur Amerikanischen Sprach- und Altertumskunde*, 5 vols. (Berlin, 1902-1923).

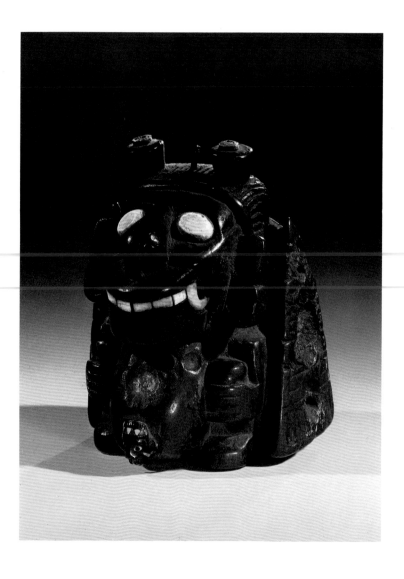

47
Monster deity (Xolotl)
Height .09 (3½); width .07 (2¾);
depth .063 (2½)
Wood, with shell, turquoise, mala-
chite, jet, obsidian, gold, silver, and
fiber
Museum für Völkerkunde, Vienna,
no. 12.585
Possibly listed in the inventory of
the collection of Archduke Karl of
Stiermark in 1590

In the annotation to the upright, cy-
lindrical wood drum (*huehuetl*)
from Malinalco (no. 61), the place
of woodcarving among the major

Aztec arts is discussed, as well as the
sad recognition that very few speci-
mens have survived. This little
image is one of the few, and a par-
ticularly interesting one. It probably
reached Europe soon after the con-
quest, possibly even with one of the
various Cortesian shipments of gifts
and loot sent to Spain between 1519
and 1526. It cannot be traced with
certainty much further back than
1881, however, when it was trans-
ferred from the then Imperial Cabi-
net of Coins and Antiquities to the
then Anthropological-Ethnographi-
cal Division of the Imperial Mu-
seum of Natural History (present

Museum für Völkerkunde) in
Vienna. It may have been mentioned
in a 1590 inventory of the collection
of the Archduke Karl (von Haps-
burg) of Stiermark, but the descrip-
tion given is too general to be con-
clusive. It was first described (and
identified as Xolotl by Eduard Seler)
in 1890 (Heger 1890: 94; Seler com-
ment 1890: 104-105), but not until
1949 did a thorough description
and discussion of it appear, by Karl
A. Nowotny, accompanied by pho-
tographs of the piece from every rel-
evant angle.

The unusual image shows a
crouching, nude male figure clutch-

ing his legs below the knees. The head, greatly exaggerated in size, is somewhat bestial in appearance, with large shell inlaid eyes (the pupils perhaps once inset) and prominent dentition, also inlaid, including two long fangs at the corners of the mouth. As in the case of the large stone Xolotl head of no. 46, the figure displays both human ears (ornaments lost) and two knobs, finished with gilded silver pins, on the top of the head that probably represent dog's ears. Carved on the chest is a motif that Nowotny interpreted as a stylized butterfly, and projecting from the navel of the swollen belly is a tiny human head of jet with mother-of-pearl, obsidian, and red shell inlays. Carved, triangular sidepieces (inlays lost) appear at the sides and below the striated hair. The resin-filled concavity on the back must have been inset, possibly with a pyrite mirror or some relevant iconographic device such as a solar disk (see discussion in Nowotny 1949:59). Underneath, sandals with plaited bottoms are evident. Between them, the genitals are incised, although an inlay for the glans has been lost.

There seems little doubt that this extraordinary image represents the caninoid monster deity and "twin" of Quetzalcoatl, whose general significance is discussed in the annotation to no. 46. The essentially bestial face and combination of human and animal ears make this a virtual certainty. In style, this piece is not classically Aztec; a Gulf Coast provenance might be a possibility (cf. Burland 1949). The earliest gift shipments from Mexico to Spain included many objects from this area, and the possible Hapsburg connection with the piece (Karl von Hapsburg, Carlos I of Spain, Karl V, Holy Roman Emperor, was the principal recipient of the Cortesian consignments) would also seem to point in this direction.

C. A. Burland, "Further Comments on the Wooden Figure from Mexico," *American Antiquity* 15, no. 3 (1950): 251; Ferdinand Heger, "Sur quelques objects archéologiques du Mexique et de l'Amérique du Sud," *Congrès International des Américanistes, Compte-rendu de la Septième Session, Berlin, 1888* (Berlin, 1890): 93-97; Karl A. Nowotny, "A Unique Wooden Figure from Ancient Mexico," *American Antiquity* 15, no. 1 (1949): 57-61; Eduard Seler, "Comment" on Heger, *Congrès International des Américanistes, Compte-rendu de la Septième Session, Berlin, 1888* (Berlin, 1890): 104-105.

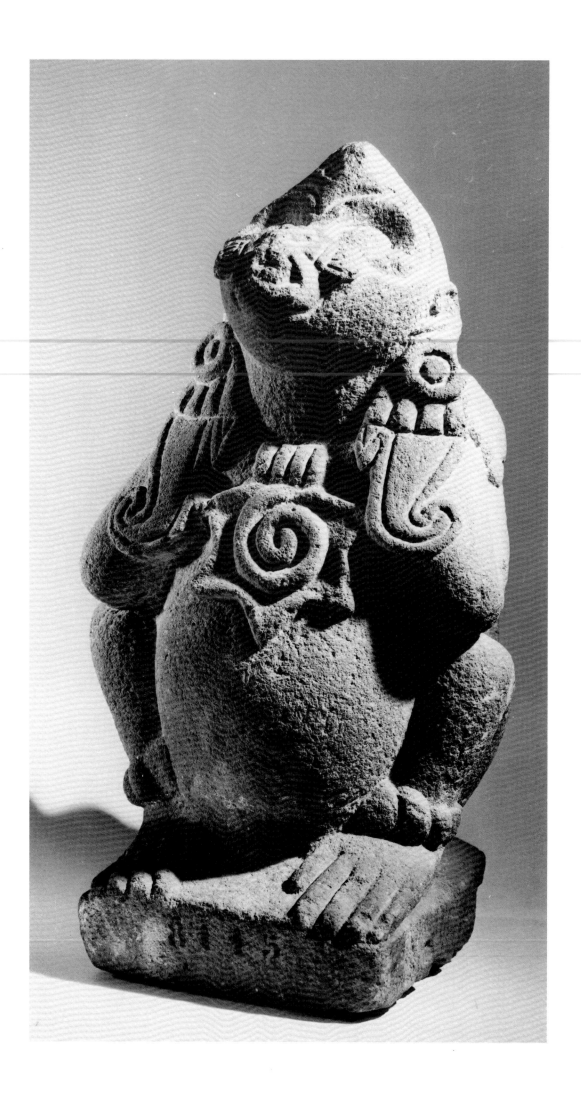

126

48
Seated monkey

Height .445 (17½); width .24 (9½);
depth .255 (10)
Stone
Musée de l'Homme, Paris,
no. 78.1.89
Ex-Boban, ex-Pinart collections

The spider monkey is one of the most playful and vivacious creatures in the Middle American environment. Although largely confined to the more tropical, heavily vegetated lowland zones, this active, amusing creature was well known to the Aztecs and other highland peoples. Monkeys were probably kept as pets and as caged curiosities in Aztec zoos (Nicholson 1955). Since the monkey particularly connoted playfulness, a natural association arose between this frolicsome animal and the group of deities, headed by Xochipilli, that expressed the more sensual, sportive side of the culture: dancing, singing, music, poetry, luxury crafts, among other related activities. In effect, the monkey became their symbol (for a general discussion of the symbolic aspects of the monkey, see Seler 1902-1923, 4: 456-464). He is often shown wearing items of the insignia of these gods, particularly the perforated egg-shaped device (usually, but erroneously, called *oyohualli*) worn as a pectoral or as ear ornaments. This agile, hyperactive creature was also associated with the whirling, equally restless wind and, as here, frequently wears the insignia of Ehecatl Quetzalcoatl, the wind deity. This connection is effectively pictorialized in the representation of the destructive finale of the third of the cosmic eras, the "Wind Sun," in the *Codex Vaticanus A* (1979: fol. 6), where spider monkeys float amidst the wind swirls and the heads of the wind god, as all mankind, with the exception of a single couple, is transformed into these creatures (cf. Stone of the Five Suns, no. 6, where this era is the second in the sequence). This intimate link between the monkey and the wind god is even more dramatically demonstrated by the remarkable sculpture of a standing monkey wearing Ehecatl's buccal "wind mask" found in one of the stages of a pre-Hispanic structure located in what is now the Pino Suárez metro station, five blocks south of the Zócalo (e.g., Cervantes 1978: fig. 154). Here the dynamic force of the wind is effectively conveyed by the twisted posture of the creature, who stands cross-legged on a circular base, hip jutting out, body bent back, arms extended and holding up his long tail, with his head turned to one side. The activated disposition of the parts of this monkey's body departs strikingly from the more static and frontal representations characteristic of Aztec human and animal sculptures.

This piece, of unknown provenance, was originally in the collection of Eugène Boban, who lived in Mexico for some years commencing in the 1860s, then acquired from him by the linguist-ethnographer Alfonse Pinart. It was included in the Universal Exhibition in Paris in 1878 and passed into the possession of what is now the Musée de l'Homme in 1883. It is very similar in several aspects to another monkey figure in a private collection (Easby 1966: 209). The monkey sits on a guadrangular base, its legs drawn up alongside its bulbous belly. The hands, whose long, tapering fingers complement the equally elongated toes, reach back over the shoulders and grasp the upper back. Its long tail forms a great, decorative spiral on its lower back. The head of the monkey is slightly upturned, and its mouth appears to be somewhat puckered, as if it were blowing. It wears the sliced conch shell pectoral of Ehecatl Quetzalcoatl (*ehecailacacozcatl*), his curved shell ear ornaments (*epcololli*), a long nose bar decorated at the ends with the symbols for preciousness, and bracelets and anklets composed of globular beads. Although posed solidly and symmetrically, the tilted head and unusual position of the body suggest the restless activity of this nimble creature whose movements were as swift and whirling as the wind itself.

Maria Antonieta Cervantes, *Treasures of Ancient Mexico from the National Anthropological Museum*, 2d ed. (New York, 1978); *Codex Vaticanus 3738* (Graz, Austria, 1979); Elizabeth Kennedy Easby, *Ancient Art of Latin America from the Collection of Jay C. Leff* [exh. cat., Brooklyn Museum] (New York, 1966); H. B. Nicholson, "Montezuma's Zoo," *Pacific Discovery* 8, no. 4 (1955): 3-11; Eduard Seler, *Gesammelte Abhandlungen zur Amerikanischen Sprach- und Altertumskunde*, 5 vols. (Berlin, 1902-1923).

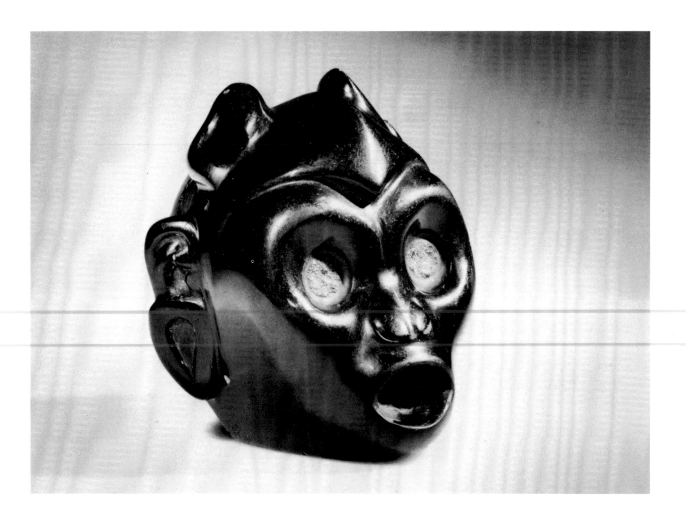

49
Monkey head
Height .97 (3⅞); width .97 (3⅞);
depth .75 (3)
Obsidian
Museum für Völkerkunde, Vienna,
no. 59253
Ex-Becker collection; attributed to
Huexotzinco, Puebla

Aztec obsidian sculptures are not
common, but a few examples, such
as masks, vessels, and ear orna-
ments, do exist. Apparently this is
the only obsidian monkey head so
far reported. It was collected by Phi-
lipp J. Becker and acquired by the
Vienna museum with his collection
in 1897. It was attributed to
Huexotzinco, down the eastern
slopes of the great volcanoes, Popo-
catepetl and Iztaccihuatl, in the Ba-
sin of Puebla. At the time of the
Spanish Conquest, Huexotzinco was
the capital of a major Nahuatl-
speaking province independent from
the Empire of the Triple Alliance.

The animal is represented with an
open mouth in which three small
holes are visible near the top, possi-
bly bored to facilitate the attach-
ment of inlays. The large, round
eyes display a roughened surface, an
almost certain sign that inlays origi-
nally adhered to them. The charac-
teristic sharp crest that appears on
monkey heads is present, but the
two ovoid projections attached to
both sides of this crest are an un-
usual feature. These may corre-
spond to the circular devices with
pendant streamers that commonly
appear at these locations on the
heads of images of the god of sensu-
ality, Xochipilli, and related deities.
In the pre-Hispanic codices *Borgia*
and *Cospi*, which may have origi-
nated in the general Pueblan area,
these disks with pendants issuing
from their centers are sometimes
pictured on the heads of monkeys
(fig. 49a), the animal associated
with Xochipilli. In the ears are cir-
cular earplugs. The back of the head

is hollowed out, again to allow for
inserts or to mount the head to an-
other object. This highly polished,
little monkey head is an appealing
representation of the lively, sportive
animal that symbolized the light-
hearted, hedonistic side of Aztec
culture (see annotation to no. 48).

Eduard Seler, *Gesammelte Abhandlungen
zur Amerikanischen Sprach- und Alter-
tumskunde*, 5 vols. (Berlin, 1902-1923).

fig. 49a Monkey wearing the side rosettes
of the headdress of Xochipilli, youthful god
of sensuality. *Codex Borgia* 13. Seler
1902-1923, 4: 458, fig. 22.

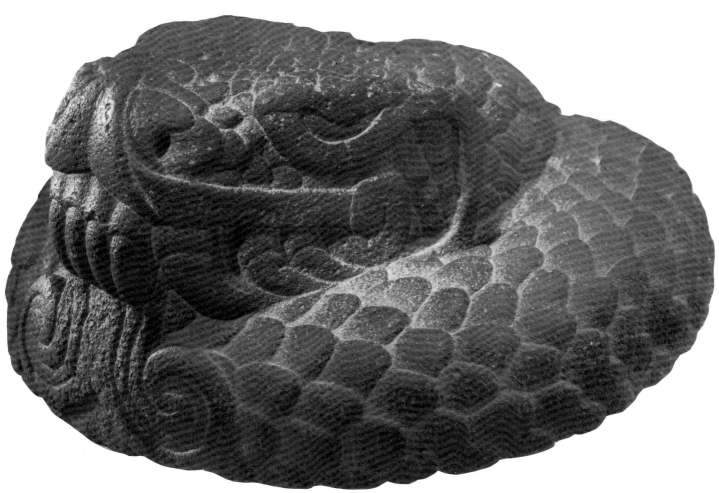

50
Coiled rattlesnake
Height .15 (5⅞); diameter .35 (13¾)
Andesite
Museo Nacional de Antropología,
Mexico City, no. 24-535; 11-2260

The precise, bold relief carving of
this Aztec coiled rattlesnake sculp-
ture emphasizes the scaly body, in
contrast to other examples whose
coils are smoothly molded or elabo-
rately plumed. Of unknown prove-
nance, it has been in the Mexican
national museum since before 1891
when it was photographed for the
Mexican exhibit in the Madrid Co-
lumbian exposition of 1892 (Ga-
lindo y Villa 1902: 80). The config-
uration and delineation of the head,
quite large in relation to the body,
as well as the great bifurcated
tongue, recall the features of the
feathered serpent of no. 57. How-
ever, the lattice motif on the supra-
orbital plaque, so prominent on the
feathered serpent, is omitted here.
An unusual aspect of this sculpture
is the fact that it is not carved in one

solid piece with the head, like other
Aztec reptiles. Instead, small gaps
appear between the rear of the head
and the body proper, occasionally
allowing a more fully rounded,
three-dimensional definition of the
coils from certain angles. The de-
tailed carving of the scales, decora-
tive in its overall effect, continues
on the underside (cf. no. 51).

Snake symbolism pervades the
iconography of pre-Hispanic Me-
soamerica. No creature appears
more often in the sculpture or in the
painted ritual-divinatory screenfolds
and manuscripts. Apparently the
serpent had multiple connotations,
as in many other cultures the most
important one clearly being fertility
(often with phallic overtones) which
was probably suggested by its ter-
restrial habitat and periodic skin-
shedding. Rattlesnake images pre-
dominate; the coral snake, so closely
associated with the earth-fertility

goddesses, is not depicted three-
dimensionally. It is possible that the
contiguous scales of the rattle-
snake's body suggested the rows of
maize grains on the ripe ear (cf. no.
53), which would have strength-
ened, and given visual expression to,
the association between the serpent
and agricultural fertility. The func-
tion of these sculpted snakes is un-
certain. No Aztec period temple or
temple complex has been discovered
intact to test the hypothesis, often
advanced, that they were placed in
and around the shrines as "cult ob-
jects." Although such a characteriza-
tion is too generalized to be of much
aid in arriving at an understanding
of the actual purpose of these re-
markable zoomorphic images, a
more definitive explanation cannot
be made with the present lack of ar-
chaeological evidence.

Jesús Galindo y Villa, *Album de antigüeda-
des indígenas que se conservan en el Museo
Nacional de México* (Mexico, 1902).

51
Underside of a coiled rattlesnake
Height .28 (11); diameter .81 (3 1⁄8)
Stone
Museo Nacional de Antropología,
Mexico City, no. 24-1375; 11-3011
Found in Mexico City in 1943

This superbly sculpted underside of a coiled rattlesnake, the head and upper body of which were probably cut away in colonial times, was discovered in 1943 during construction of a new edifice at 5 Calle de Venustiano Carranza. The Chacmool (no. 1) was found nearby, less than a block from the Zócalo (Mateos Higuera 1979: 233). The ventral scales and eleven rattles of this great reptile are depicted with remarkable realism, as well as considerable decorative effect. The spiral of the coiled body forms a deep hollow that, when the sculpture was properly reversed, would have matched the ascending spiral of the missing parts. The large, overlapping scales of what remains on the lower body, as well as the tiny scales on the interior surfaces of the coils, an unusual inclusion, are carefully delineated.

The undersides of Aztec ophidian images are frequently carved, as here, with conscientious attention to detail, although once the sculptures were installed this meticulously carved undersurface would have been invisible. This is true, too, of the Earth Monster (Tlaltecuhtli) images also often carved on the undersides of Aztec monuments (see annotation to no. 13). The British Museum coiled rattlesnake (no. 54) provides another excellent example of this Aztec sense of artistic completion, and there are various others in the Mexican national museum (e.g., Galindo y Villa 1902: 85) and elsewhere. The native attitude expressed here suggests that it was proper and necessary to carve all relevant surfaces of certain sacred images whether perceptible to a human observer or not.

Jesús Galindo y Villa, *Album de antigüedades indígenas que se conservan en el Museo Nacional de México* (Mexico, 1902); Salvador Mateos Higuera, "Herencia arqueológica de México Tenochtitlan," in *Trabajos arqueológicos en el centro de la ciudad de México*, edited by Eduardo Matos Moctezuma (Mexico, 1979): 205-273.

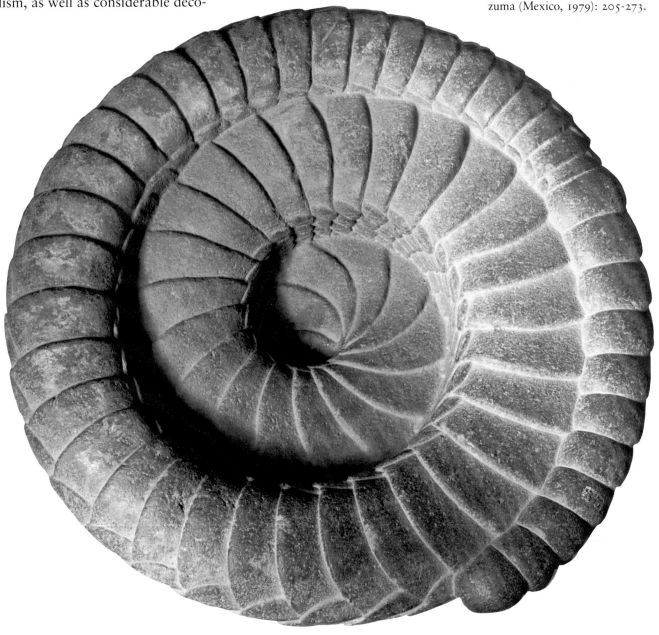

53
Colossal rattlesnake tail
with six maize cobs
Height .99 (39); width .55 (21⅝);
length 1.25 (49¼)
Basalt
Museo Nacional de Antropología,
Mexico City, no. 24-810; 11-3197
Found in Mexico City probably in
the 1930s

This singular sculpture represents the tail portion, including the rattles, of a colossal rattlesnake. In the repertoire of Aztec sculpted snake images, it is unusual in representing the body of the snake extended rather than coiled. It was discovered in the foundations of the National Palace in Mexico City, along with other sculptures, fronting the Calle de la Corregidora, apparently in the 1930s (Mateos Higuera 1979: 230-231). Six large maize ears with tassels are incorporated into the scales of the body of the creature, appearing to grow out of them, two on each side and two on top. Although only six ears are present, Caso (1958: photograph 6) suggested that the appropriate designation for this piece would be Chicomolotzin (Seven Maize Cobs), an alternative name for Chicomecoatl (Seven Serpent), one of the more common names of the maize goddess (cf. annotation to no. 20). The ventral scales visible along the sides of the piece are also vigorously carved in high relief. Traces of polychromy remain, red and yellow on the scales and blue on the rattles.

The function of this oddly shaped monument is uncertain. Its structure resembles the tail pieces of feathered serpent columns that supported lintels in temple structures in Tula, the Toltec capital, and in "Toltec" Chichen Itza in northern Yucatan (e.g., Seler 1902-1923, 5: 265, Abb. 92). The upper portion where the lintel would have rested is fully carved, however, weakening such a hypothesis. In any case, it almost certainly served as an architectural adornment of some kind, perhaps as Mateos Higuera (1979: 230-231) suggested, in a temple dedicated to the maize goddess, Chicomecoatl, or another deity of agricultural fertility. The carving of this piece is expert and sure, the relief of the scales and rattles deep and bold, imbuing the monument with a powerful sculptural effect.

Alfonso Caso, *The Aztecs: People of the Sun* (Norman, Oklahoma, 1958); Salvador Mateos Higuera, "Herencia arqueológica de México Tenochtitlan," in *Trabajos arqueológicos en el centro de la ciudad de México*, edited by Eduardo Matos Moctezuma (Mexico, 1979): 205-273; Eduard Seler, *Gesammelte Abhandlungen zur Amerikanischen Sprach- und Altertumskunde*, 5 vols. (Berlin, 1902-1923).

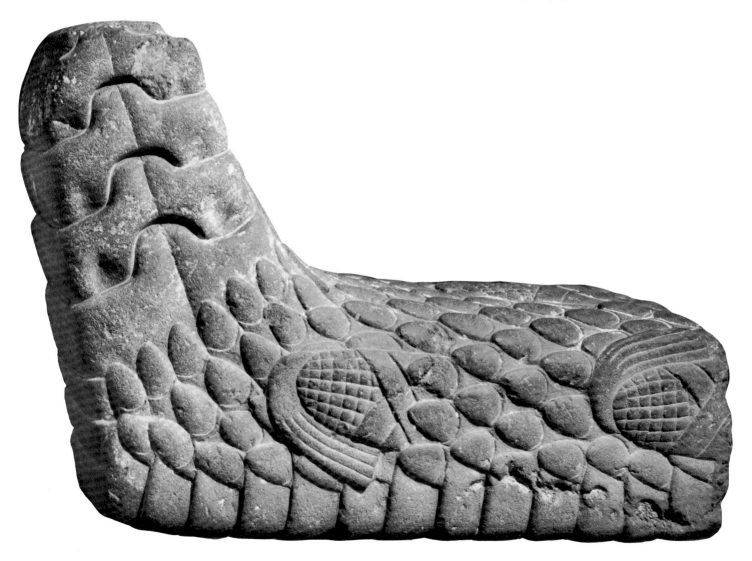

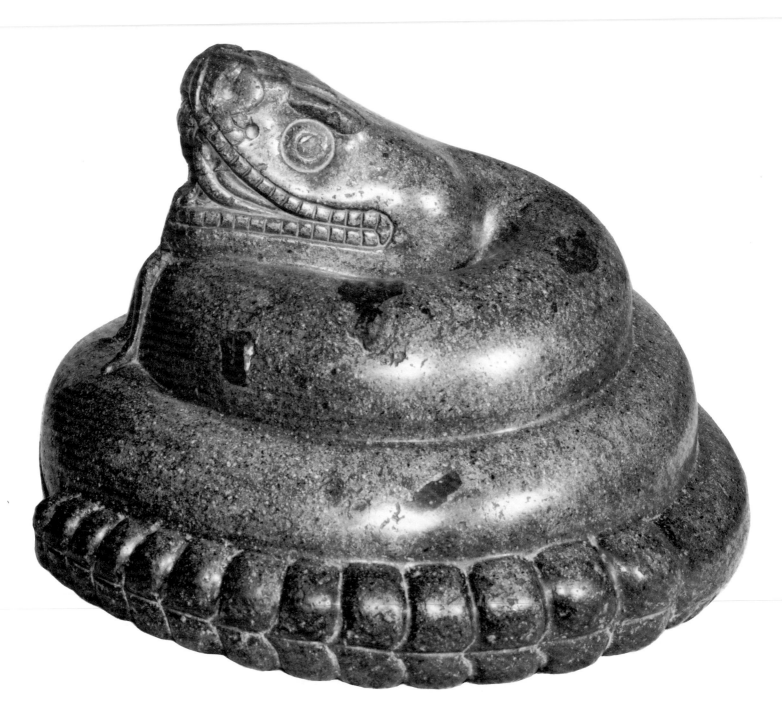

54

Coiled rattlesnake
Height .36 (14⅛); diameter .53
(20⅞)
Granite
Museum of Mankind, The British
Museum, London, no. 1849.6-29. 1
Ex-González Carvajal, ex-Wetherell
collections

This outstanding coiled rattlesnake
has been one of the treasures of the
British Museum since 1849, when it
was acquired along with the rest of
the Wetherell collection (see annota-
tion to no. 26). While still in the lat-
ter's possession in Seville, Spain,
lithographs of it (angle view and un-
derside) were published in the cata-
logue of his collection (Wetherell
1842: lám. 1). The piece is expertly
carved from a dark granitic stone,
and the luster of its highly polished
surface adds considerably to its im-
pact as one of the finest zoomorphic
sculptures in the Aztec corpus.

The large head appears to emerge
from a depression formed by the up-
wardly evolving body coils. It is
characterized by eyes formed by
two concentric circles with the cen-
ters cut out, under moderately sized
supraorbital ridges. It also features
somewhat stylized mouth ridges,
along with two more realistically
depicted long fangs and pointed up-
per teeth at the top of the open
mouth, and an extended forked
tongue, carved in low relief, that
reaches down as far as the top of the
lowermost coil. The segmentations
of the thirteen rattles provide a dec-
orative contrast to the impeccably
carved, smoothed, and polished
body of the reptile. Despite the fact
that it would have been invisible to
the eye, the underside of the piece is
also finely detailed, the ventral coils
unfurling elegantly around a deep,
hollow core (cf. no. 51).

Two nearly identical specimens
are in the Museo Nacional de An-
tropología in Mexico City. One,
quite mutilated around the head and
tail, is included in the Mateos Hi-
guera catalogue (1979: 266; no.
24-88) among monuments ascribed
to Mexico City without precise
provenance or date of acquisition.
The other (e.g., Bernal 1972: lám.
90) is in better condition, although
it bears some damage about the
head and tip of the tail. It was
found in February 1944, during
construction activity at the corner
of Palma and Cuba streets, two
blocks northwest of the Zócalo.
Both are beautifully carved on their
undersides. The two pieces, cut
from a somewhat lighter colored
stone than that of our sculpture, are
so close in style that they were prob-
ably produced in the same work-
shop, perhaps by the same master
hand. A third very similar specimen
was included in the 1794 Dupaix
catalogue. If the crude drawing is at
all accurate, the mouth of this snake
was closed and its head faced in the
opposite direction from the other
three related pieces. Described in the
caption as being in the "Casa de Xi-
cotencatl," Plazuela de Santo Do-
mingo, its present location is un-
known.

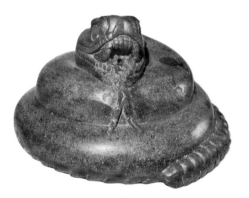

Ignacio Bernal, *Museo Nacional de Antro-
pología de México: arqueología,* 3d ed.
(Mexico, 1972); Guillermo Dupaix, "Des-
cripción de monumentos antiguos mexica-
nos," 1794 (manuscript in the Museo Nacio-
nal de Antropología, Mexico); Salvador
Mateos Higuera, "Herencia arqueológica de
México Tenochtitlan," in *Trabajos arqueoló-
gicos en el centro de la ciudad de México,*
edited by Eduardo Matos Moctezuma (Mex-
ico, 1979): 205-273; Juan Wetherell, *Catá-
logo de una colección de antigüedades meji-
canas con varios ídolos, adornos, y otros
artefactos de los indios, que ecsiste en poder
de Don juan Wetherell* (Seville, 1842).

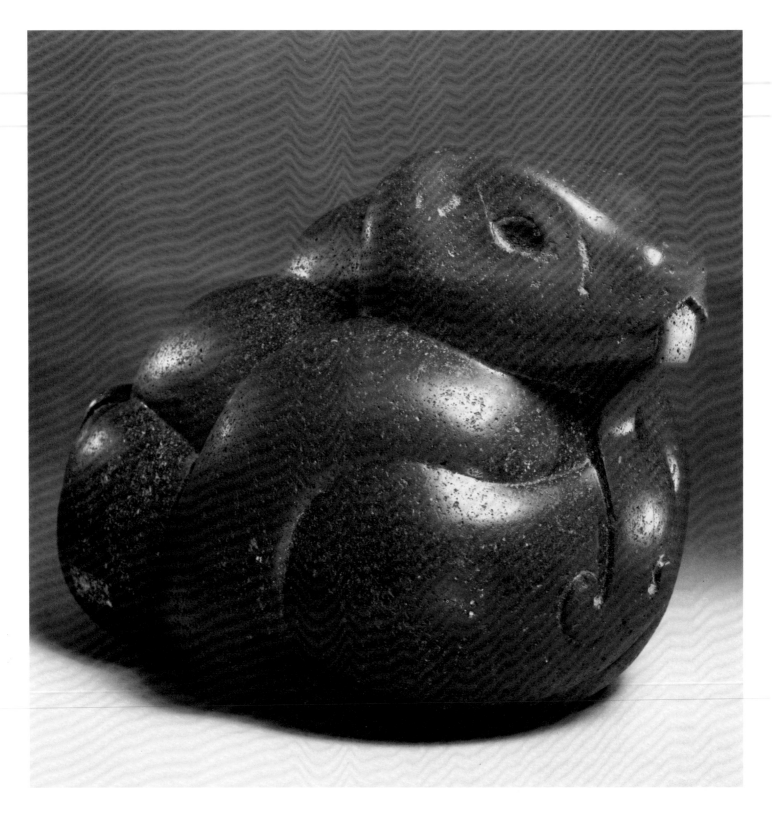

55
Knotted rattlesnake
Height .24 (9½); length .46 (18⅛);
width .23 (9)
Basalt
Museo Nacional de Antropología,
Mexico City, no. 24-533; 11-3010

One of the most arresting of all Aztec coiled rattlesnake images, this sculpture has been ascribed to the Valley of Mexico (Bernal 1969: 29). It was in the collection of the Mexican national museum by 1891, when it was photographed for the Exposición Histórico-Americana de Madrid of 1892 (Galindo y Villa 1902: 86).

Carved from well-polished black basalt, the body of the reptile is shown as a tightly wound knot, the complex path of its convolutions emphasized against the smooth, simplified contouring of the coils. The deep, oval eye sockets once contained inlays that must have provided this piece with a more animated appearance than it now exhibits. The bifurcated tongue is unusually long, its flat relief carving contrasting with the volumetric definition of the coils and of the entire piece itself. A remarkable aspect of this famous ophidian image is its abstract quality, a feature that can probably be appreciated more today than at any other time since the piece was carved. With a masterly economy of line, characteristic of much three-dimensional Aztec sculpture, the essential lineaments of the deadly snake are communicated with both subtlety and power. Also apparent here is another aspect of the Aztec aesthetic, the interplay between the demands of the representation and the characteristics of the material itself. Different kinds of stone were employed for Aztec sculptures, with the choice of the stone, as is evident here, matched to the subject and exploited for its textural and coloristic effects. The contribution of the chosen material to the overall effect of this piece is a significant factor in its success.

Ignacio Bernal, *100 Great Masterpieces of the Mexican National Museum of Anthropology* (New York, 1969); Jesús Galindo y Villa, *Album de antiguëdades indígenas que se conservan en el Museo Nacional de México* (Mexico, 1902).

56

Coiled rattlesnake
Height .28 (11); diameter .83 (32⅝)
Andesite
Museo Nacional de Antropología,
Mexico City, no. 24-87; 11-3359
Attributed to Mexico City

The intricate twists of this reptile's supple and sinister body are powerfully conveyed in this masterful example of Aztec animal sculpture. It is tentatively attributed to Mexico City, but there appears to be no reliable data on precise provenance or even on the date when it was acquired by the Mexican national museum, although it was certainly part of the collection by the early 1930s at the latest (Mateos Higuera 1979: 266). Ostensibly a portrayal of the great serpent at rest, the realistically depicted musculature, prominently exposed rattles, and long forked tongue are forceful reminders of the creature's deadly strength. The rather flattened head appears to emerge from the tangled body knot, characterized by sunken oval eyes (which probably once contained inlays), bulbous supraorbital ridges, well-defined nostrils, and a closed mouth from which a long forked tongue has descended. Among the most naturalistically carved of the numerous Aztec coiled rattlesnakes, this example deserves a high place on the list of superior pieces in this category.

Salvador Mateos Higuera, "Herencia arqueológica de México Tenochtitlan," in *Trabajos arqueológicos en el centro de la ciudad de México*, edited by Eduardo Matos Moctezuma (Mexico, 1979): 205-273.

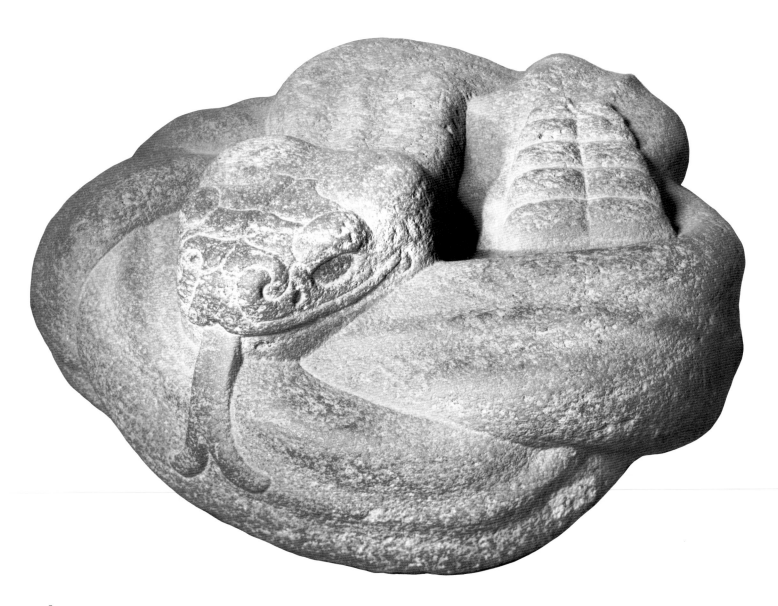

57
Coiled feathered serpent
Height .21 (8¼); diameter .40
(15¾)
Andesite
Museo Nacional de Antropología,
Mexico City, no. 24-534; 11-2769

This expertly carved sculpture of
the famous mythological creature,
the feathered serpent, has been in
the Mexican national museum at
least since 1897, if it is the same
piece described in the Galindo y
Villa catalogue as item 27 (Galindo
y Villa 1897: 27). It represents a
coiled rattlesnake covered with the
elegantly curving feathers of the
quetzal bird, thus the name Quetzal-
coatl or "feathered serpent." Char-
acteristically, the prominent supra-
orbital plaques display an interlaced
motif, while the eyes proper are re-
duced to mere slits. The open mouth
features a formidable row of fangs
and also includes the curled element
commonly found at its corners. The
huge tongue bifurcates into oppos-
ing scrolls. Behind the head set in a
square cartouche is the date 1 Acatl
(Reed), the calendric sign of the
deity Quetzalcoatl. According to Se-
ler's observation (manuscript), the
worn underside of the piece origi-
nally featured a representation of
the Earth Monster or Tlaltecuhtli
(cf. nos. 3, 12, 13, 14, 15, 58).

In the Aztec or Nahuatl language
Quetzalcoatl literally means
"quetzal-feather (*quetzalli*) snake
(*coatl*)." Most metaphoric second-
ary meanings, such as "precious
twin," are possible but not certain.
Perhaps the most persuasive inter-
pretation of this blending of bird
feathers and slithering reptile would
be that the former symbolize the ce-
lestial avian environment, while the
latter connotes the terrestrial ophid-
ian milieu. Quetzalcoatl probably
symbolizes the union of earth and
sky, a creative concept in many cos-
mologies. This contrastive-
complementary dualism is typical of
Mesoamerican religious ideology,
which often features cosmic opposi-
tions. The deity who bore the name
Quetzalcoatl was believed to have
played a major part in the mytholo-
gical creation of man and of the uni-
verse and to exercise a continuing
role in the conception of human
beings. These creative activities are
a dynamic manifestation of Quetzal-
coatl's fundamental identity as a
fertility deity, among other aspects
of the complex personality of this
ancient and important god.

Coiled feathered serpents are
fairly common in Aztec collections.
Some of them also feature the
carved date 1 Acatl (Reed), includ-
ing the Musée de l'Homme piece
(no. 58). Two other examples are in
the Museo Nacional de Antropolo-

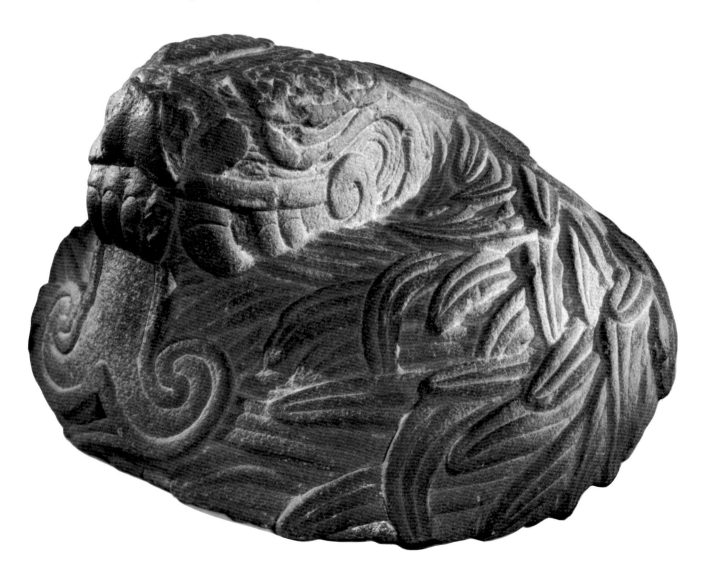

gía in Mexico City. One of them, a large, flattish feathered snake, was once incorporated in the pavement of the atrium of the Convento de Nuestra Señora de la Merced, turned upside down to display the Earth Monster (Tlaltecuhtli) image carved on its underside. A circular frame surrounds the date carved on this creature, but the more usual square cartouche appears around the date of the other. This piece, attributed to Mexico City and unpublished, is the largest coiled feathered serpent ever found but now survives only in badly damaged fragments. Another similar feathered serpent in the regional museum of the State of Mexico, Tenango del Valle, exhibits a "stone knife tongue" instead of the curling bifurcated tongue of our piece. It also features the 1 Acatl (Reed) date in a square cartouche behind the head (Nicholson 1973: fig. 16). A closely related specimen in private hands displays the stone knife tongue superimposed on the forked, curled tongue. It also shows the 1 Acatl (Reed) in the same position in a square cartouche behind the creature's head (Nicholson 1971: fig. 37).

In the traditional narratives of the ill-starred career of the great Toltec priest-ruler who also bore the name "feathered serpent," Topiltzin Quetzalcoatl, 1 Acatl is usually given as the year (and/or day) of his birth and also sometimes as the year of his disappearance in the east. Certainly this year was closely associated with him and his expected return. When Cortés landed on the eastern coast of Veracruz precisely in a 1 Acatl year, 1519 (possible only once every fifty-two years), this coincidence seems to have contributed significantly to the belief that he might be the returning Topiltzin Quetzalcoatl or his emissary. This impression may have played a role in the early conduct of the Aztec ruler, Motecuhzoma II, toward the mysterious arrivals, the Spanish *conquistadores*. His doubt concerning Cortés' identity and purpose, and his subsequent vacillating behavior, appear to have facilitated Cortés' gaining a crucial advantage in their initial dealings, which eventuated in the downfall, in fire and blood, of the Empire of the Triple Alliance.

Jesús Galindo y Villa, *Catálogo del Departamento de Arqueología del Museo Nacional; Primera Parte, Galería de Monolitos* (Mexico, 1897); H. B. Nicholson, "Major Sculpture in Pre-Hispanic Central Mexico," in *Handbook of Middle American Indians*, edited by Robert Wauchope, Gordon Ekholm, and Ignacio Bernal, 10, pt. 1 (Austin, 1971): 92-134; and "The Late Pre-Hispanic Central Mexican (Aztec) Iconographic System," in The Metropolitan Museum of Art, New York, *The Iconography of Middle American Sculpture* (New York, 1973): 72-97; Eduard Seler, "Inventario de los objetos exhibidos en los Departamentos de Arqueología del Museo Nacional," 23 October 1907 (manuscript in the Museo Nacional de Antropología, Mexico).

Back view, showing date glyph, no. 57

58
Coiled feathered serpent
Height .299 (11¾); width .54 (21¼)
Andesite
Musée de l'Homme, Paris, no.
87.155.1
Ex-Latour-Allard collection; acquired in Mexico before 1828

This large, impressive sculpture of the composite mythical creature, the feathered serpent Quetzalcoatl, was obtained in Mexico in the 1820s by the French artist Latour-Allard. In 1828 it was copied in Paris by Agustino Aglio, who supervised all of the art work for Lord Kingsborough's *Antiquities of Mexico* (1831-1848).

A sideview painting of it was included as an illustration, along with other pieces in the Latour-Allard collection, in the fourth volume of that monumental set (cf. angle-view photograph in Basler and Brummer 1928:80). Long in the Musée du Louvre (Longpérier 1852: no. 59), it reached its present repository in 1887.

This piece exhibits nearly all the classic features of Aztec feathered rattlesnakes, including the cross-hatched supraorbital plaques, slit-like eyes, curled elements at the corners of the mouth, and long, bifurcated tongue composed of opposing scrolls. On the back of the head within a square cartouche is the date 1 Acatl (Reed), the calendric name of the deity Quetzalcoatl (cf. no. 57). Carved on the underside is a typical representation of the crouching, gape-jawed Earth Monster (Tlaltecuhtli) (see annotation to no. 13), the upper part of which is quite abraded. The general symbolic connotations of the feathered serpent icon are discussed in the annotation to no. 57.

Adolphe Basler and Ernest Brummer, *L'Art Précolombien* (Paris, 1928); Lord Kingsborough, *Antiquities of Mexico, Comprising Facsimiles of Ancient Mexican Paintings and Hieroglyphs* (London, 1831-1848); Adrien de Longpérier, *Notice sur les monuments exposés dans la salle des antiquités mexicaines du Musée du Louvre*, 2d ed. (Paris, 1852).

59
Feathered serpent
Height .48 (18⅞); width .26 (10¼);
depth .26 (10¼)
Stone
Museum für Völkerkunde, Vienna,
no. 12406
Ex-Becker collection

This upwardly spiraling, reptilian
creature, swathed in a profusion of
plumes, is one of the most striking
of the Aztec feathered serpent
(Quetzalcoatl) sculptures. The gen-
eral ideological connotations of
Quetzalcoatl are summarized in the
annotation to no. 57. This piece,
which came to the museum in 1897
with the rest of the Philipp J. Becker
collection, is particularly distin-
guished by the remarkable vertical
interpretation of the form, which
provided the sculptor with more lat-
itude to display the complex inter-
twined coiling of the body. The
feathers of the precious quetzal bird,
as is usually the case, are gracefully
modeled and arranged and dex-
trously carved. The rattled tail,
sculpted in high, rounded relief, is
prominently placed at the front of
the body. The supraorbital ridges
are smooth and slightly bulbous
above the deeply set oval eyes that
are carved in the stone and into
which a thin inlay may have been
inserted. The double-outlined
forked tongue (repaired) projects
outward from the open, fanged
mouth.

A comparable vertically posi-
tioned piece is part of the ethno-
graphic collections of the Vatican
Museum (*The Vatican Collec-
tions: The Papacy and Art* 1983:
234-235). The configuration of the
head of the Rome feathered serpent
is slightly different, leveled with a
less emphatic upward thrust of the
snout than in the case of this Vienna
example. Its similarly double-
outlined, bifurcated tongue features
a horizontal band in its upper sec-
tion. Among the numerous Aztec
feathered serpent sculptures, these
two pieces form a decidedly distinc-
tive group.

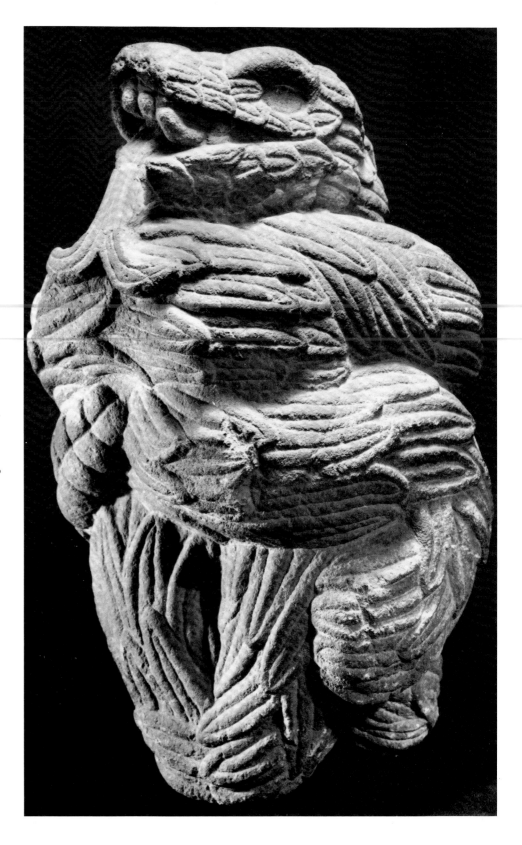

*The Vatican Collections: The Papacy and
Art* [exh. cat., Metropolitan Museum of
Art] (New York, 1983).

60
Quetzalcoatl
Height .44 (17⅜); width .25 (9¾);
depth .23 (9)
Porphyry
Musée de l'Homme, Paris,
no. 78.1.59
Ex-Boban, ex-Pinart collections

Among the many Aztec feathered serpents, this spectacular image stands out as an exceptional piece. Of unknown provenance, the sculpture was obtained from Eugène Boban by Alfonse Pinart, the French linguist, ethnographer, and traveler, and was acquired by the Paris museum in 1883. Earlier it was shown in the Paris Universal Exhibition of 1878 and, possibly even earlier, when it was still in the Boban collection, in a special exhibition of Mexican archaeological pieces mounted during the Second International Congress of Anthropology and Prehistoric Archaeology in the same city in 1867.

The sculpture shows the compact, upright form of the famous Mesoamerican composite creature, the feathered serpent, here further combined with a human figure (see the annotation to no. 57 for a discussion of the ideological connotations of the feathered serpent). The coiled body of a rattlesnake, covered with beautifully carved quetzal feathers, is intertwined with a human body, with only the face, arms and hands, lower right leg and foot, and toes of the left foot visible, the latter resting on the large rattles of the snake. The ventral scales of the snake are occasionally exposed—for example, next to the right foot of the figure, in front of the right hand, and on the right shoulder—sometimes overlaid with one or two delicate quetzal feathers. The smooth, highly polished surfaces of the body (face, hands, feet) contrast with the rest of the sculpture, which is fully carved with the swirling feathers, segmented scales, and rattles of the plumed snake. A human face peers out of the gaping mouth of the fierce reptile, whose head, overall,

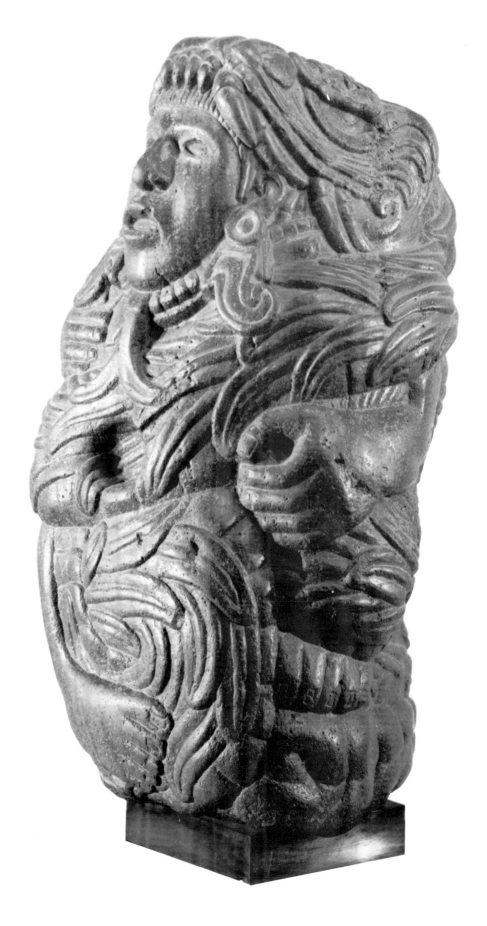

resembles that of the feathered serpent of no. 57. A fringe of striated hair is clearly delineated across the top of the face beneath a row of the serpent's prominent upper fangs, and also at the sides of the face. The figure wears the diagnostic, curved shell ear ornaments (*epcololli*) of Quetzalcoatl, appended to disks. What functions as a kind of beaded necklace beneath the jaw of the human figure is actually the lower ridged section of the creature's mouth, with the long forked tongue extending below the chin of the figure. The eye and mouth ovals were deeply cut to receive inserts, now lost. The circular depression on the "chest" of the figure probably once contained a precious stone inlay.

Perhaps the best-known related example is a colossal, upright specimen, its head now sadly mutilated, in the Museo Nacional de Antropología in Mexico City. It was first illustrated in the 1794 Dupaix catalogue (provenance not specified) and later, after it had reached the museum, in a somewhat more accurate sideview drawing by Mayer (1844: 32; photograph in Galindo y Villa 1902: 18). The museum has constructed a full-scale restored replica (Nicholson 1967: 109) that enables one to discern its details more clearly, including the stone knife tongue (cf. no. 13), and the "sacred war" symbol beneath it. The figure on this piece apparently wears circular earplugs with the pendant strip rather than the more diagnostic *epcololli*.

Although many feathered serpents exist, some showing heads emerging from their mouths, the Paris sculpture is unique in representing the combined bird-snake creature with a whole figure. The concept perhaps being expressed here by this fantastic interweaving in stone of human, reptilian, and avian forms is that of the *nahualli* or animal disguise (companion) of the deity. In one sense, the feathered serpent was the *nahualli* of the human aspect of Quetzalcoatl, and this sculpture may express the human aspect of Quetzalcoatl combined with his disguise. Deities were sometimes depicted with their zoomorphic disguises, either totally subsumed by the animal form or wearing its costume. A good example of the expression of this idea is Tepeyollotl, who, in his jaguar form, serves as the jaguar disguise of Tezcatlipoca (see fig. 25b). This sculpture is remarkable in its conception and execution, characteristically Aztec in its ingenious visualization of a complex religious concept.

Guillermo Dupaix, "Descripción de monumentos antiguos mexicanos," 1794 (manuscript in the Museo Nacional de Antropología, Mexico); Jesús Galindo y Villa, *Album de antigüedades indígenas que se conservan en el Museo Nacional de México* (Mexico, 1902); Brantz Mayer, *Mexico As It Was and As It Is* (New York, London, and Paris, 1844); Irene Nicholson, *Mexican and Central American Mythology* (London, 1967).

61
Upright drum (huehuetl)
Height .98 (38⅝); diameter .52
(20½)
Wood
Museo de Arqueología e Historia
del Estado de México, Tenango del
Valle, Mexico
From Malinalco, State of Mexico

. . . wood, carved and painted or gilded, was
extensively employed in the interior of
houses and temples, in fashioning idols, for
various articles of furniture, and for cere-
monial and other objects. Highly intricate
designs were graved with a delicacy not ex-
celled by the work of any other people of
antiquity, and certainly equal to the best
carved work of ancient Egypt. The greater
part of this art is irretrievably lost by reason
of the perishable character of the material,
hence the few existing specimens must nec-
essarily give only an approximate idea of the
range of uses to which wood-carving was
applied. . . .

So Marshall Saville, in 1925, char-
acterized one of the great Aztec arts
on the first page of his classic mono-
graph on the subject. Among the
handful of surviving examples of
Aztec woodcarving, this masterfully
carved drum of the upright, cylin-
drical type called *huehuetl* stands
out as one of the finest (see Cas-
tañeda and Mendoza 1933 for an
excellent discussion of the *huehuetl*,
with illustrations and descriptions
of known specimens). Attributed to
Malinalco in the southern Basin of
Toluca southwest of Mexico City, it
was obviously carefully preserved as
a precious ceremonial object from
the time of the conquest. Malinalco
was an important Nahuatl-speaking
community, closely linked dynasti-
cally and culturally to the imperial
capital. In the last years before the
conquest master sculptors and
builders were sent out from Mexico
Tenochtitlan to Malinalco to con-
struct the remarkable complex
structures hewn out of the rocky
face of a great cliff overlooking the
present town—on the order of the
great temple of Rameses II at Abu
Simbel in Upper Egypt (García
Payón 1946; Townsend 1982). In
1887 Chavero (596-597) illustrated
poor drawings of the designs on the

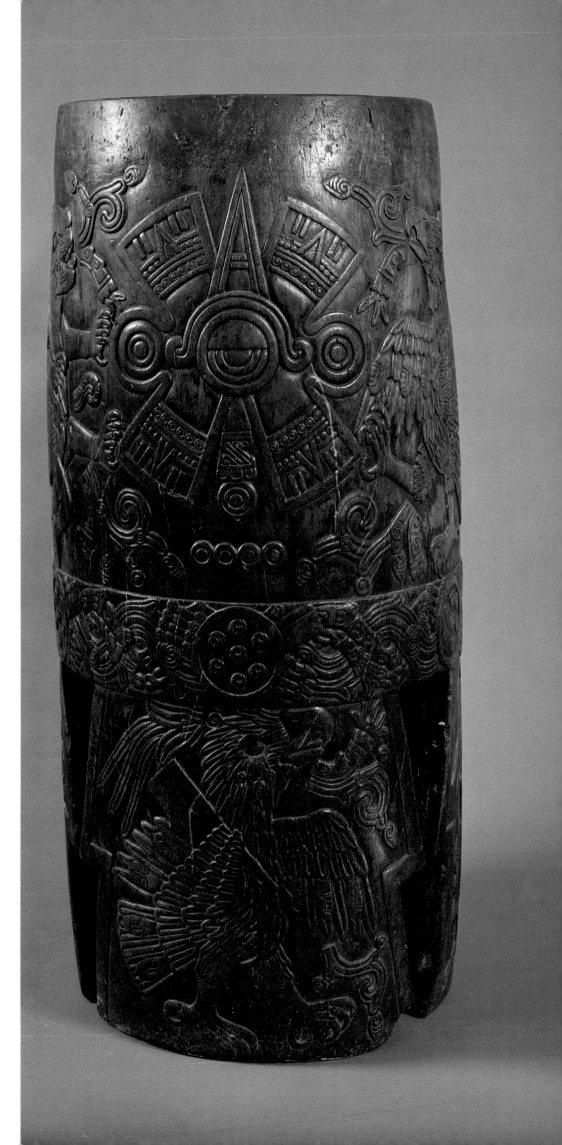

Roll-out, no. 61. From Saville 1925: Pl. XLV.

drum, and in 1904 Eduard Seler (1904; Abb. 67) published four photographic views of it, with an interpretation of its iconography. The first accurate roll-out drawing of the drum was published by Saville (1925: pl. XLV; photographic roll-out, plus close-ups of details in Romero Quiroz 1958).

The designs of the drum are divided into two major fields by a broad strip that runs along the top of the serrated pieces that serve as legs. The principal representation of the upper register is the large 4 Ollin (Movement) sign, symbol of the Fifth Sun, flanked by an eagle on the right and a jaguar on the left. Stone sacrificial knives decorate the wings and tail of the eagle. Depicted in a dancing pose, wearing what may be a version of the forked heron feather ornament (*aztaxelli*), both figures carry sacrifical paper flags. Their "speech scrolls" are the sacred war symbol (*atl tlachinolli*), which repeats below the 4 Ollin (Movement) sign. Tears flow from the eyes of both creatures. The arms of the Ollin (Movement) sign are ornamented with the standard motifs that edge solar disks (cf. interior of

cuauhxicalli, no. 3). The other image on this upper portion of the piece is a figure attired in an elaborate bird costume, his arms and legs outstretched. In his right hand he holds a flower and in his left a feather fan. He wears a nose-rod tipped with the motif denoting preciousness. Below his face and to the left and right of his feet are elaborated "song scrolls," decorated with the symbol for preciousness and, in the lower set, floral motifs. The bird, whose body is replaced by intertwined triple bands, has been identified both as the *coxcoxtli*, the pheasantlike disguise (*nahualli*) of Xochipilli, the god of music, dancing, and flowers, and as an eagle. The Xochipilli-*coxcoxtli* interpretation, first advanced by Seler, seems more likely. The strip that separates the upper and lower registers is composed of the intertwined sacred war symbol (*atl tlachinolli*), further interwoven with the "sacrificial rope" used to bind sacrificial victims and trimmed with down balls (cf. no. 9). Five shields decorated with down balls, similar to that carried by Huitzilopochtli, the Aztec patron deity, plus accompanying

hand banners and sheafs of four spears, complete the complicated motifs of this horizontal band. Carved on the three legs are two jaguars and one eagle in a virtual replication of their images in the upper part of the drum.

All of the imagery of this elaborately carved drum relates to the solar cult (see annotation to no. 3). It was probably played in rituals involving the "knights of the sun," a special order of elite warriors especially dedicated to the orb of the day (Durán 1971: 194-202; fig. 61a), who were *in cuauhtli in ocelotl*, "the eagles and the jaguars" par excellence. They appear to have conducted their rituals in the unique rock-hewn temples on the Malinalco cliff (García Payón 1946). Only one other *huehuetl*, in the Museo Nacional de Antropología in Mexico City, compares in quality with this example. Also from the Toluca Basin, Tenango del Valle (ex-Heredia collection), it depicts an eagle and a vulture sharing the sacred war symbol (*atl tlachinolli*) as their common speech scroll (Saville 1925: pls. XLII-XLIV). These two superb drums provide some notion of the magnifi-

fig. 61a Ritual dance with warriors attired as eagles and jaguars, accompanied by musicians playing the upright drum, *huehuetl,* and the horizontal slit gong, *teponaztli.* From Duran 1867-1880, 1: lám. 19a, lower.

cence of the Aztec art of woodcarving, sadly exemplified by few other surviving specimens.

Daniel Castañeda and Vicente T. Mendoza, "Los huehuetls en las civilizaciones precortesianos," *Anales del Museo Nacional de Arqueología, Historia, y Etnografía,* época 4, 8, no. 2 (1933): 287-310; Alfredo Chavero, *México a través de los siglos: primera época: historia antigua* (Barcelona, 1887); Fray Diego Durán, *Book of the Gods and Rites and the Ancient Calendar,* translated and edited by Fernando Horcasitas and Doris Heyden (Norman, Oklahoma, 1971); and *Historia de las Indias de Nueva-España y Islas de Tierra Firme,* edited by José F. Ramírez, 2 vols. (Mexico, 1867-1880); José García Payón, "Los monumentos arqueológicos de Malinalco, estado de México," *Revista Mexicana de Estudios Antropológicos* 8 (1946): 5-63; Javier Romero Quiroz, *El huehuetl de Malinalco* (Toluca, 1958); Marshall H. Saville, *The Wood-Carver's Art in Ancient Mexico,* Contributions from the Museum of the American Indian, Heye Foundation, 9 (1925); Eduard Seler, "Die holzgeschnitzte Pauke von Malinalco und das Zeichen atl-tlachinolli," *Mittheilungen der Anthropologischen Gesellschaft in Wien* 34 (1904): 222-274; Richard F. Townsend, "Malinalco and the Lords of Tenochtitlan," in *The Art and Iconography of Late Post-Classic Central Mexico, A Conference at Dumbarton Oaks, October 22nd and 23rd, 1977,* edited by Elizabeth Hill Boone (Washington, 1982): 111-140.

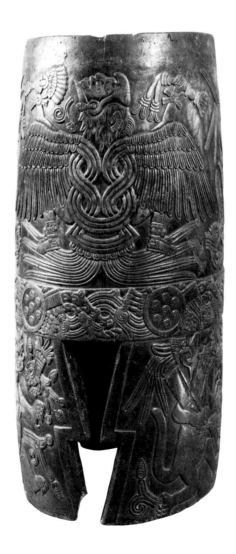
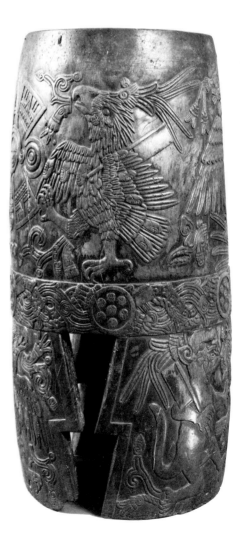

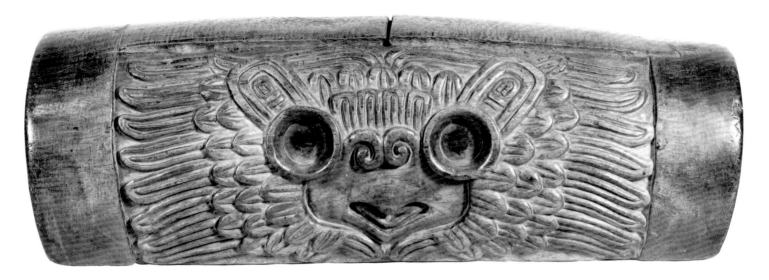

62

Slit gong (teponaztli) with owl head image

Length .49 (19¼); diameter .17 (6¾)

Wood

Museum of Mankind, The British Museum, London, no. 1949 Am. 22, 218

Ex-Oldman collection

The *teponaztli* was a hollowed out, cylindrical block of hard wood, the top of which was slotted to form two tongues that when struck with two sticks emitted different tones. Along with the upright cylindrical wood drum (*huehuetl*) (cf. no. 61), it played an important role as a basic percussion instrument that functioned primarily to maintain the metrical rhythm of musical accompaniment to ritual dances. A few pre-Hispanic *teponaztlis* survive, most of them decorated with designs in relief, as here, or carved to represent anthropomorphic or zoomorphic (cf. no. 63) forms (Saville 1925; Castañeda and Mendoza 1933; Noguera 1958).

This exceptionally well-preserved instrument was acquired in 1949 by the British Museum with all of the African and New World items of the extensive ethnographic collection of W. O. Oldman (Braunholtz 1951). Its earlier history is unknown. It is the only known specimen that features the head of the horned owl (*tecolotl*), carved in high relief on a panel on one side. Its large, circular, rimmed eyes convey a striking effect, as does the smoothly polished surface of the creature's face, decoratively surrounded by radiating layers of finely incised feathers. Its stylization is somewhat similar to that of the owl on the Stone of the Death Monsters (no. 12), but the latter, an earless variety called *chichtli* or *chicuatli*, lacks the "horns" of the *tecolotl* boldly featured on our piece. A remarkable, three-dimensional stone image of an earless owl, with a shallow cylindrical receptacle on its back indicating its probable function as a type of vessel for blood and hearts (*cuauhxicalli*) (cf. no. 3), was collected in Mexico in 1823 by William Bullock and exhibited in London in 1824 in his "Ancient Mexico" show (cf. no. 17). It is now also in the British Museum.

In the indigenous ideological system the owl was a creature of ill omen, whose appearance and nocturnal calls were invariably believed to presage misfortune and death. Associated with the powers of darkness and the Lord of the Underworld, Mictlantecuhtli, for whom it served as a messenger, it also symbolized evil sorcery. In the divinatory manuscripts (*tonalamatl*), the *chichtli* figured as the sixth of the Thirteen Sacred Birds accompanying the Thirteen Lords of the Day, the *tecolotl* as the tenth (fig. 62a).

Because of the lugubrious connotations of this dreaded nocturnal flyer, displayed here so prominently, it has been suggested (Easby and Scott 1970: 292) that this particular *teponaztli* "served some funerary purpose." It is not unlikely that it was intended to be played primarily during mortuary rituals, which were often quite elaborate in pre-Hispanic times.

H. J. Braunholtz, "The Oldman Collection: Aztec Gong and Ancient Arawak Stool," *The British Museum Quarterly* 16, no. 2 (1951): 54-55; Daniel Castañeda and Vicente T. Mendoza, "Los teponaztlis en las civilizaciones precortesianas," *Anales del Museo Nacional de Arqueología, Historia, y Etnografía*, época 4, 8, no. 1 (1933): 5-80; Elizabeth Kennedy Easby and John F. Scott, *Before Cortés, Sculpture of Middle America: A Centennial Exhibition at the Metropolitan Museum of Art from September 30, 1970 through January 3, 1971* (New York, 1970); Eduaro Noguera, *Tallas prehispánicas en madera* (Mexico, 1958); Marshall H. Saville, *The Wood-Carver's Art in Ancient Mexico*, Contributions from the Museum of the American Indian, Heye Foundation, 9 (1925); Eduard Seler, *Gesammelte Abhandlungen zur Amerikanischen Sprach- und Altertumskunde*, 5 vols. (Berlin, 1902-1923).

fig. 62a Horned owl, tenth of the Thirteen Sacred Birds. *Codex Borbonicus*. From Seler 1902-1923, 4: 609, fig. 533.

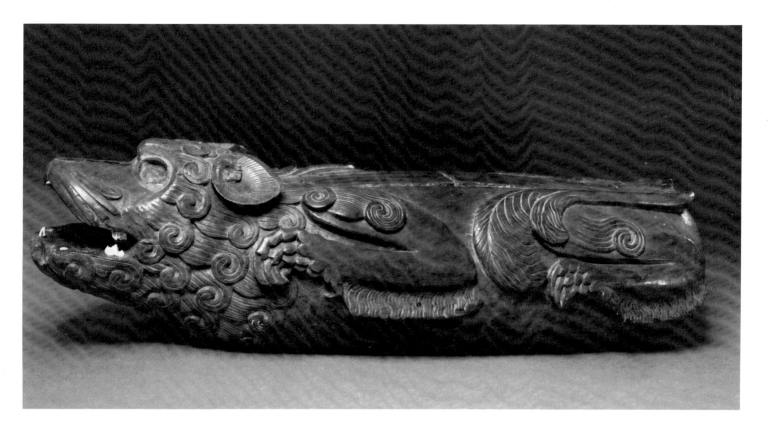

63
Zoomorphic slit gong (teponaztli)
Length .86 (33¾); diameter .22
(8⅝)
Wood, animal teeth
Museo Nacional de Antropología,
Mexico City, no. 11-2805
From Malinalco, State of Mexico

The slit gong (*teponaztli*) is de-
scribed in the annotation to no. 62,
where it was noted that various an-
thropomorphic and zoomorphic
specimens are known. This example
is one of the more spectacular *tepo-
naztlis* in animal form. It has been
attributed to both Chalco and Mali-
nalco (discussion in Romero Quiroz
1964: 7-8). Since the word "Mali-
nalco" is actually written on it, this
is more likely the correct attribu-
tion, in which case it serves as a
worthy companion piece to the fa-
mous *huehuetl* from there, no. 61. It
was acquired by the Mexican na-
tional museum some time before
1891 when it was photographed for
the 1892 Exposición Histórico-
Americana de Madrid (Galindo y
Villa 1902: 153, labeled "Teponaztli
Chalca"; drawings in Saville 1925:
pl. xxxvi, a; and Castañeda and
Mendoza 1933: lám. II).

The *teponaztli*, usually considered
to be pre-Hispanic but possibly dis-
playing some slight European stylis-
tic influence, is carved in the form
of a hairy animal, with its legs
drawn up on either side of the body
in a position that suggested to the
first commentators that it was
swimming. The hair, which is con-
centrated around the head, is incised
in stylized ringlets. The mouth is
open, with animal teeth set into the
gums. The deeply cut eyes must also
have contained inserts, probably of
shell. The upper part of the inside of
the mouth is painted red.

The identification of the animal
represented has given rise to consid-
erable difference of opinion: croco-
dile, mythical *cipactli*, *ahuitzotl* (see
annotation to no. 45), and coyote
(discussion in Romero Quiroz
1964). However, it may represent a
wolf (*cuetlachtli*), an animal that
has now disappeared in Central
Mexico but was once prevalent
there (cf. Seler 1902-1923, 4:
502-503, who identified the *cuet-
lachtli* with the kinkajou). Along
with the eagle, jaguar, puma, and
coyote, this animal connoted the fe-
rocity and predatory nature associ-
ated with the warrior class. What-

ever the precise identification, the
rendering of the animal here, with
open mouth, sharp teeth, and claws
at the ready, conveys its fierceness
effectively.

Daniel Castañeda and Vicente T. Mendoza,
"Los teponaztlis en las civilizaciones precor-
tesianas," *Anales del Museo Nacional de Ar-
queología, Historia, y Etnografía*, época 4,
8, no. 1 (1933): 5-80; Jesús Galindo y Villa,
*Album de antigüedades indígenas que se
conservan en el Museo Nacional de México*
(Mexico, 1902); Javier Romero Quiroz, *El
teponaztli de Malinalco* (Toluca, 1964);
Marshall H. Saville, *The Wood-Carver's Art
in Ancient Mexico*, Contributions from the
Museum of the American Indian, Heye
Foundation, 9 (1925); Eduard Seler, *Gesam-
melte Abhandlungen zur Amerikanischen
Sprach- und Altertumskunde*, 5 vols. (Berlin,
1902-1923).

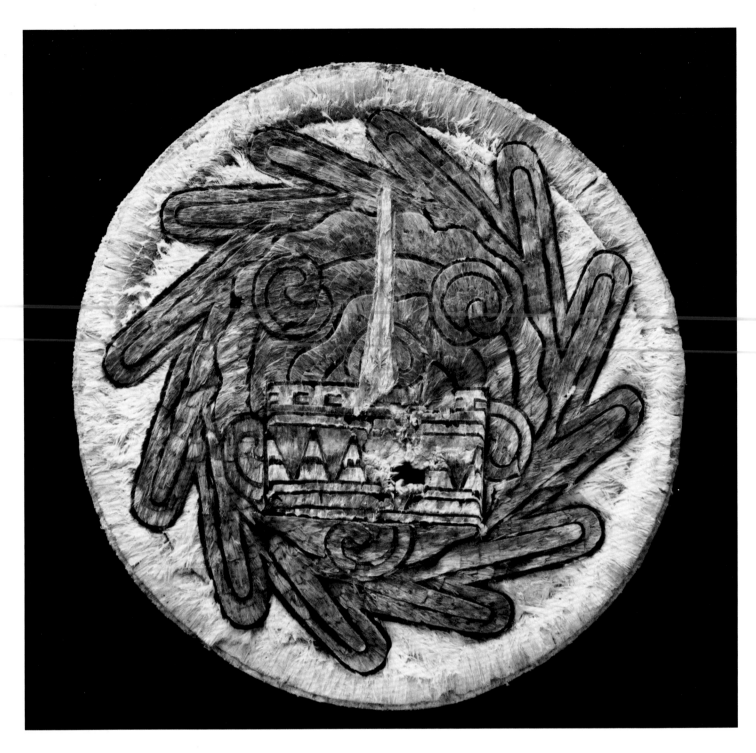

64
Featherwork disk
Diameter .24 (9½)
Feathers
Museo Nacional de Antropología,
Mexico City, no. 10-1008
Acquired by Rafael García Grana-
dos in the State of Hidalgo

Aside from the products of the gold-
smith, which fascinated the *conquis-
tadores* for obvious reasons, per-
haps no other examples of native
art so dazzled the eyes of the Span-
iards as the exotic and splendidly
crafted featherwork objects they be-
held on their arrival in the New
World. These stunning feather mo-
saic designs, produced by meticu-
lously combining brilliantly colored
plumes on a wood or leather back-
ing, were fashioned into objects of
different kinds, such as body gar-
ments, mantles, head crests, fans,
cords, shields, and animal figures,
many of them further embellished
with gold ornamentation and, in
some cases, stone mosaic. The in-
ventory of just one early shipment
sent by Cortés to Spain lists approx-
imately 100 featherwork items des-
tined for various churches, monas-
teries, nobles, ecclesiastics, and
other dignitaries (Saville 1920:
56-66). The art of featherworking
continued to flourish after the con-
quest, although the types of objects
and the subject matter of the designs
were replaced by Christian themes.
Examples exist in the collections of
liturgical vestments incorporating
featherwork designs and of feather-
work pictures of the saints, imitat-
ing with astonishing skill the style
of European religious art.

Of the once numerous and exquisite pre-Hispanic featherwork items, only a handful have survived, possibly including this specimen, although an early colonial date is perhaps even more likely. It was acquired in the state of Hidalgo by the well-known Mexican ethnohistorian Rafael García Granados, who published it in 1939 in color in an article on ancient and colonial native featherwork. He stated that it had been found hidden under the lining of a straw container for a sixteenth-century chalice used by the Franciscan friars. The central image of the disk consists of a large circular swirl of water with smaller eddies within it (cf. underside of Chacmool, no. 1, and top of "fire god," no. 2). The overall design and details are outlined in black; the water area is composed of blue feathers, and the plain background of predominantly yellow ones. A rectangular panel is superimposed on the aquatic field, with triangular prongs decorating the central strip. The upper band is adorned with a row of small U-shaped elements, a common device in Aztec iconography on component strips of place signs connoting the cultivated field or earth (discussion and illustrations in Seler 1902-1923, 3: 224-227). The long yellow spinelike element above and slightly overlapping this panel resembles the agricultural digging stick, *huictli* (fig. 64a), reinforcing the notion that the panel might represent a field—although the triangular elements are atypical. The overall design on this disk resembles a place sign, particularly the type found in the *Codex Mendoza* (cf. fig. 64b). García Granados first advanced this place sign hypothesis, suggesting that the rectangular panel represented a tilled field, although he interpreted the vertical motif overlapping it as a maguey spine for auto-sacrifice. Toscano (1970: 184) also held this view, even hazarding two specific locations, but he identified the rectangular panel as a basket.

The design of the water current with its centrifugal frame is ingeniously adapted to the circular format of the disk, which may have functioned as a ceremonial shield or an accessory for a deity image. Other existing examples of Aztec featherwork include an enormous crest, popularly referred to as "Montezuma's headdress," in the Vienna Museum für Völkerkunde; a fan with a butterfly design in the center and a shield with a profile figure of a coyote, also in the same repository; two large circular shields with stepped fret designs in the Württembergisches Landesmuseum in Stuttgart; and another shield with curved and U-shaped motifs in the National History Museum in Chapultepec, Mexico City (all illustrated in Anders 1970).

The continuation of the craft of featherworking into the colonial period enabled the Franciscan missionary Fray Bernardino de Sahagún in the mid-sixteenth century to provide an extensive description and numerous illustrations of the tools, methods, and materials used to create these plumed objects (Sahagún 1979, 2: fol. 369v-375v). He details the two techniques used to fashion the delicate featherwork designs: a knotting method by which feathers were fastened with maguey threads to a base of small wooden strips, and a complicated and exacting gluing technique by which precious, vividly colored feathers were attached one by one to a color-harmonized bed of common feathers mounted on a wooden board.

Ferdinand Anders, "Minor Arts," in *Tesoros de México: Arte plumario y de mosaico, Artes de Mexico* 137 (1970); Rafael García Granados, "Mexican Feather Mosaics," *Mexican Art and Life* 5 (1939): 1-4; Antonio Peñafiel, *Nombres geográficos de México* (Mexico, 1885), Fray Bernardino de Sahagún, *Códice Florentino, Ms. 218-220 de la Colección Palatina de la Biblioteca Medicea Laurenziana*, 3 vols. (color photoreproduction of original manuscript) (Florence, 1979); Marshall H. Saville, *The Goldsmith's Art in Ancient Mexico*, Museum of the American Indian, Heye Foundation, New York, Indian Notes and Monographs, 7 (1920); Eduard Seler, *Gesammelte Abhandlungen zur Amerikanischen Sprach- und Altertumskunde*, 5 vols. (Berlin, 1902-1923); Salvador Toscano, *Arte precolombino de México y de la América Central*, edited by Beatriz de la Fuente, 3d ed. (Mexico, 1970).

fig. 64a Agricultural digging stick. Left: *Codex Mendoza* 70r; right: *Codex Osuna* 38v. From Seler 1902-1923, 1: 210, Abb. 102, 103.

fig. 64b Place sign of Acozpan (On the Yellow Water). *Codex Mendoza* 49r. From Peñafiel 1885: 48, lower.

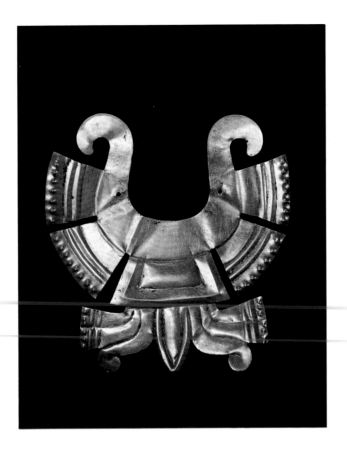

65
Butterfly nose ornament
(yacapapalotl)
Height .078 (3 ¹/₁₆); width .075
(2 ¹⁵/₁₆)
Gold
Museo Nacional de Antropología,
Mexico City, no. 21-49
Found in Mexico City in 1900

One of the most impressive Aztec arts was that of gold metallurgy. Even the *conquistadores,* who, as Cortés facetiously informed Motecuhzoma II's emissary, "suffered from a disease of the heart that only gold could cure" and were much more interested in the intrinsic as opposed to the aesthetic value of the ornamental productions of the Indian goldsmiths, genuinely admired their artistic excellence. Many inventories of the gifts conveyed to Cortés by Motecuhzoma and of the loot of the conquest are still extant (Saville 1920: 21-35, 56-102). It is highly frustrating to peruse their lengthy itemized descriptions of a great variety of gold ornaments, nearly none of which apparently escaped the melting pot. Nor have archaeological excavations in the capi-

tal or its neighborhood, including the recent Templo Mayor project, yielded many significant finds of gold objects. The Aztecs normally cremated their noble dead and deposited little mortuary furniture with their ashes. Most modern finds of gold ornaments, such as the discovery in 1932 of a large quantity of magnificent jewels in Tomb 7 at Monte Albán (Caso 1969), have been made in Oaxaca, an area southeast of the Basin of Mexico. There an ancient tomb tradition persisted into Postclassic times when gold metallurgy came into its own in Mesoamerica after diffusing up from South America. This has led some archaeologists to ascribe to the goldsmiths of the Mixteca of western Oaxaca a decided preeminence in this art. However, the conquest-period descriptions of the ornaments produced at Azcapotzalco and other metallurgical centers in and around the Basin of Mexico indicate that the goldsmiths (*teocuitlahuaque*) of Central Mexico were equally skilled in this demanding craft, whose techniques are extensively described and illustrated in Fray Bernardino de Sahagún's *Flor-*

entine Codex (Historia Universal de las Cosas de Nueva España) (1950-1982, part 10: 73-78).

This ornament is one of the few of any sophistication that has been found in the Aztec capital. It represents the highly stylized image of the butterfly, which was a fairly typical representation in Postclassic western Mesoamerica. It features trapezoidal wing elements, which fan out from a central U-shaped section, and an ovoid body. It lacks a head, which would have been supplied by the nose of the wearer (Franco 1959). It has two small perforations, perhaps to facilitate attachment to a sacred image. This piece was part of an extraordinarily rich offertory cache (which included no. 21), found at the foot of a small stairway in the western section of the Templo Mayor precinct, which was penetrated on 16 October 1900, during the excavation for a sewer line along the Calle de las Escalerillas (present-day Guatemala Street) that runs north of the cathedral. Apparently most of the objects in this cache were salvaged and reached the Mexican national museum. They were itemized and illustrated by

Leopoldo Batres, the General Inspector of Archaeological Monuments, in his report on the Escalerillas Street excavations (Batres 1902: 16-26). Many were also discussed and illustrated by the leading Mexicanist of this period, Eduard Seler (1902-1923, 2: 848-868). This piece stood out among a small group of ornaments of sheet gold, which included two circular pectoral disks (photograph in Batres 1902: 23). Batres (1902: 22-23) correctly noted its butterfly form and use as a nasal ornament, comparing it to one worn by a deity equivalent to Xochipilli, the god of flowers and feasting, shown in the Cuicatec *Codex Porfirio Diaz* (p. F'). Seler, who included a drawing of it (1902-1923, 2: 867, Abb. 66; cf. Saville 1920: pl. XXa), designated it by its correct name, *yacapapalotl*. It is commonly worn by Xochiquetzal, the young goddess of sensuality, flowers, feasting, and feminine crafts, the female counterpart of Xochipilli, and by deities allied to them (e.g., fig. 65a). The butterfly (*papalotl*), in general, is intimately associated with the "Xochipilli complex" of deities because of its strong floral associations, including the corollary connotations of beauty and sensual delights. It also symbolized the flickering flame. Although formed from a thin sheet of hammered gold rather than by the more sophisticated technique of solid casting, this piece is a product of elegant craftsmanship.

Leopoldo Batres, *Archaeological Explorations in Escalerillas Street, City of Mexico: Year 1900* (Mexico, 1902); Alfonso Caso, *El tesoro de Monte Albán*, Memorias del Instituto Nacional de Antropología e Historia, 3 (Mexico, 1969); José Luís Franco, "Representaciones de la mariposa en Mesoamérica," *El México Antiguo* 9 (1959): 195-244; Fray Bernardino de Sahagún, *Florentine Codex, General History of the Things of New Spain, translated from the Aztec into English, with notes and illustrations, by Arthur J. O. Anderson and Charles E. Dibble,* Monographs of the School of American Research, Santa Fe, New Mexico, no. 14, parts 1-13 (1950-1982); Marshall H. Saville, *The Goldsmith's Art in Ancient Mexico,* Museum of the American Indian, Heye Foundation, New York, Indian Notes and Monographs, 7 (1920); Eduard Seler, *Gesammelte Abhandlungen zur Amerikanischen Sprach- und Altertumskunde,* 5 vols. (Berlin, 1902-1923).

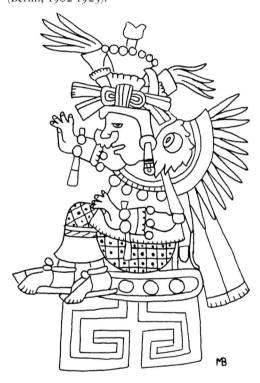

fig. 65a The goddess Tonacacihuatl-Xochiquetzal wearing the butterfly nose ornament. *Codex Telleriano-Remensis* 8r.

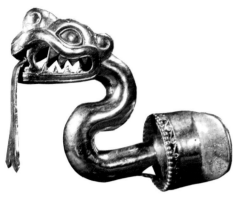

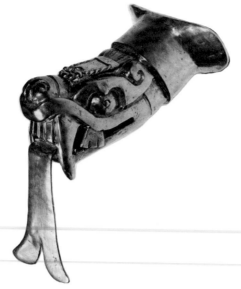

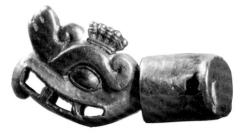

66
Serpent labret
Height .07 (2¾)
Cast gold
Private collection
Attributed to Tlacolula, Oaxaca

The Mesoamerican labret was an ornamental object intended to be inserted into an opening bored below the lower lip. The extended flange held it in place within the wearer's mouth, while the modeled end projected outward from the face (see fig. 70a). This superbly crafted labret portrays the head of a serpent with typical features: a well-defined mouth ridge, serrated teeth and fangs, a pronounced supraorbital plate ending in a curl behind the eye, and a prominent snout. An ingenious feature of this object is the long, bifid tongue, which has been made separately so as to allow it to move freely within the jaws (cf. no. 67). The body of the slithery creature is suggested by the serpentine form of the tube by which the head is connected to the short cylinder which flares out into the lip attachment. The edge of the cylinder attached to the body of the serpent is decorated with a ring of tiny gold spheres and scroll designs. This expertly designed and balanced gold object displays the virtuosity of the Indian goldworker, whose products excited the admiration of the *conquistadores,* even as they consigned them to the melting pot.

67
Serpent head labret
Length .065 (2½); height .065 (2½)
Cast gold
Museum of the American Indian, Heye Foundation, New York, no. 18/756
From Ejutla, Oaxaca

This finely worked labret features a suspended, movable tongue, like that of the serpent labret of no. 66. The flatter modeling and compressed features of this serpent's head and its exaggerated fangs, however, convey a fiercer expression. An example of technical proficiency, this labret also displays the craftsman's evident delight in animating his creations—the dangling tongue of the serpent being comparable to the necklace pendants of nos. 72, 73, and 74.

68
Bird head labret
Height .02 (¾); width .041 (1⅝)
Cast gold
Dumbarton Oaks,
Washington, D.C., no. B-91.MIG

The little bird head of this labret has been identified as an eagle (Lothrop, Foshag, and Mahler 1957: 244; Benson and Coe 1963: 28), but the knobbed crest on top of the head is also typical of birds such as the pheasant, and the projection above the beak, here highly exaggerated, is often seen on the vulture. The prominent, curved supraorbital ridge is not a feature of a bird's head, moreover, but more characteristic of reptiles (cf. nos. 66, 67). The presence of this motif suggests that this head may be that of a composite creature. In his discussion of the craft of goldworking, Fray Bernardino de Sahagún cites two kinds of workers: the smiths, whose job was to hammer or beat gold, and the real craftsmen, who, he says, cast it (Sahagún 1950-1982, part 10: 69). This skillfully cast gold object is clearly the work of a master of his craft.

Elizabeth P. Benson and Michael D. Coe, *Handbook of the Robert Woods Collection of Pre-Columbian Art* (Washington, D.C., 1963); S. K. Lothrop, W. F. Foshag, and Joy Mahler, *Robert Woods Bliss Collection: Pre-Columbian Art* (New York, 1957); Fray Bernardino de Sahagún, *Florentine Codex, General History of the Things of New Spain, translated from the Aztec into English, with notes and illustrations, by Arthur J. O. Anderson and Charles E. Dibble,* Monographs of the School of American Research, Santa Fe, New Mexico, no. 14, parts 1-13 (1950-1982).

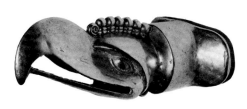

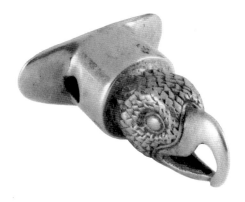

69
Bird head labret
Length .05 (2)
Cast gold
Museum of the American Indian,
Heye Foundation, New York, no.
16/3446
From Oaxaca

Although the bird head of this finely
executed labret has been identified
as that of a quetzal, whose brilliant,
green plumes were so prized by the
Aztecs, certain features provide
clues to an alternative identifica-
tion. The thick, elongated beak and
the feather crest on top of the head
suggest that the bird represented
may be a vulture; in fact, the image
better matches paintings of this spe-
cies in the pictorial manuscripts
(Seler 1902-1923, 4: 598-609).

The Aztec ruler obtained his vast
store of gold by exacting tribute
from subject towns. This was col-
lected annually in the form of
worked gold ornaments, such as this
labret, or in the raw state as gold
powder, nuggets, or small bars.
Copies of these tribute payments
still survive, listing the subject
towns, types of items requisitioned,
and the quantities demanded. The
Matrícula de Tributos and the re-
lated third part of the *Codex Men-
doza* specify the Oaxaca area,
among others, as a productive
source of gold tribute.

Eduard Seler, *Gesammelte Abhandlungen
zur Amerikanischen Sprach- und Alter-
tumskunde*, 5 vols. (Berlin, 1902-1923).

70
Eagle head labret
Length .038 (1½); width .029 (1⅛)
Cast gold
The St. Louis Art Museum, Gift of
Morton D. May, no. 275:1978
Attributed to Puebla or Oaxaca

This exquisitely modeled eagle head
labret features a smoothly con-
toured, elegantly curving beak. A
narrow curving band separates it
from the delicately delineated head,
where the eye serves as the focus of
the tiny, radiating feathers. Eagle
heads were popular subjects for or-
namenting labrets (e.g., fig. 70a),
and several fine examples are ex-
tant. Fray Bernardino de Sahagún's
detailed discussion of Aztec gold-
working techniques carefully de-
scribes the process of lost-wax cast-
ing by which this piece was made. It
began with the making of rough
core from a clay and charcoal mix-
ture, molded to the intended shape.
This core was then covered by a
wax coating, which was smoothed
and provided with details, then
overlaid with another clay and char-
coal mold. When the wax was
melted out, molten gold was poured
into the channel between the core
and outer shell. Finally, the core was
broken up and removed, leaving the
cast object hollow inside (Sahagún
1950-1982, part 10: 73-78).

fig. 70a Aztec ruler wearing a gold bird
head labret. *Codex Ixtlilxochitl* 106r.

*Codex Ixtlilxochitl: Bibliothèque Nationale,
Paris (Ms. Mex. 65-71)*, Kommentar/Com-
mentaire, Jacqueline de Durand-Forest
(Graz, Austria, 1976); Lee A. Parsons, *Pre-
Columbian Art: The Morton D. May and
the Saint Louis Art Museum Collections*
(New York, 1980); Fray Bernardino de
Sahagún, *Florentine Codex, General History
of the Things of New Spain, translated from
the Aztec into English, with notes and illus-
trations*, by Arthur J. O. Anderson and
Charles E. Dibble, Monographs of the
School of American Research, Santa Fe, New
Mexico, no. 14, parts 1-13 (1950-1982).

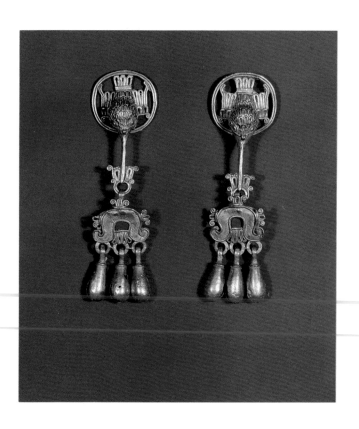

71
Hummingbird ear ornaments
Length .061 (2½)
Cast gold
Dumbarton Oaks,
Washington, D.C., no. B-101.MIG

These delicate ear ornaments were discovered with a necklace of twenty-two disks (no. 72). Each earring shows a hummingbird positioned upside down within a double outlined gold ring, his large head projecting outward from the disk. The feathers of his body are minutely detailed by the cast loops of gold thread: the closely worked strands defining the body feathers; the more elongated ones, his tail feathers and wings. His long beak extends downward, grasping an openwork plaque that is attached to yet another dangling section composed of a large, double-outlined volute, below which three bells hang. The intricate linkage of multiple cast elements to form an extended, articulated ornament is characteristic of the jewels found in Tomb 7 at Monte Albán, Oaxaca, in 1932. Even more specifically, the descending bird or bird head set in a ring and holding a suspended section in its beak is a common motif (e.g., Caso 1969: láms. XII, XIII).

Alfonso Caso, *El tesoro de Monte Albán,* Memorias del Instituto Nacional de Antropología e Historia, 3 (Mexico, 1969); S. K. Lothrop, W. F. Foshag, and Joy Mahler, *Robert Woods Bliss Collection: Pre-Columbian Art* (New York, 1957).

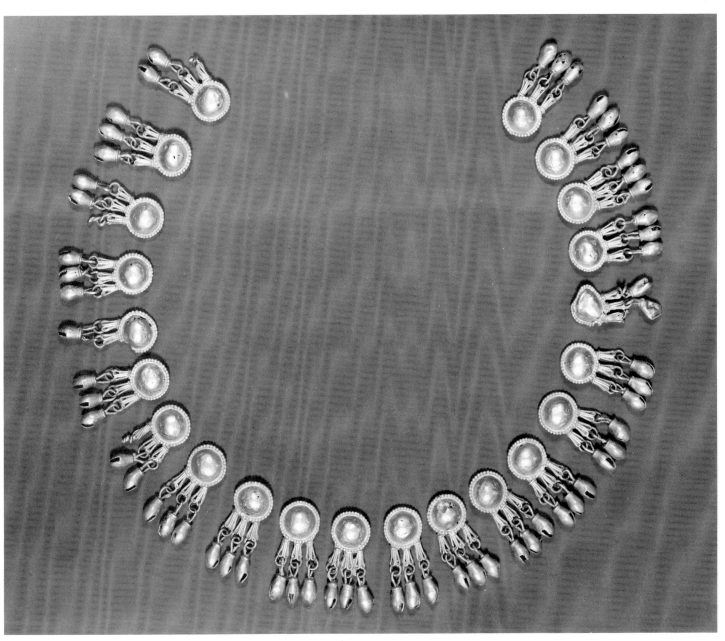

72
Necklace of disks
Length (each unit) .03 (1 3/16); width
.031 (1 1/4)
Cast gold
Dumbarton Oaks,
Washington, D.C., no. B-100.MIG

Each of the twenty-two spheres of
the disks that compose this necklace
is surrounded by a circular frame of
tiny gold beads. Three tassels
formed of slender, looped gold
threads are suspended below the
disks, with three ovoid bells at-
tached to them by round links. The
superior workmanship of the
hinged, meticulously worked sec-
tions of this ornament is typical of
the cast products of Mixtec crafts-
men.

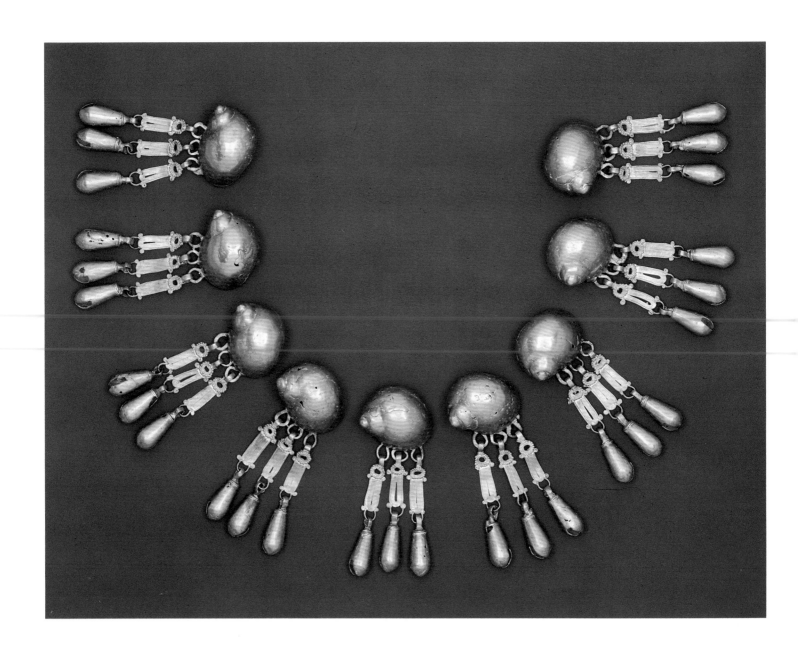

73
Necklace of snail shells
Length (each unit) .08 (3⅛)
Cast gold
Dumbarton Oaks,
Washington, D.C., no. B-104.MIG
Attributed to the Soconusco region,
Chiapas.

This necklace consists of nine delicately modeled shells to which three oval bells are attached by flat, looped elements. Like the turtle shell (cf. no. 74), the snail shell was a popular motif imitated in gold by ancient Mexican craftsmen. In an undated inventory that lists gold items sent to Emperor Charles V from Mexico, several snail shell necklaces, with and without pendants, are itemized (Saville 1920: 68). The same inventory also mentions snail shells set with greenstones. The units grouped together to form necklaces were sometimes used independently, with their attached bells, as pendants.

Elizabeth P. Benson and Michael D. Coe, *Handbook of the Robert Woods Bliss Collection of Pre-Columbian Art* (Washington, D.C., 1963); Marshall H. Saville, *The Goldsmith's Art in Ancient Mexico*, Museum of the American Indian, Heye Foundation, New York, Indian Notes and Monographs, 7 (1920).

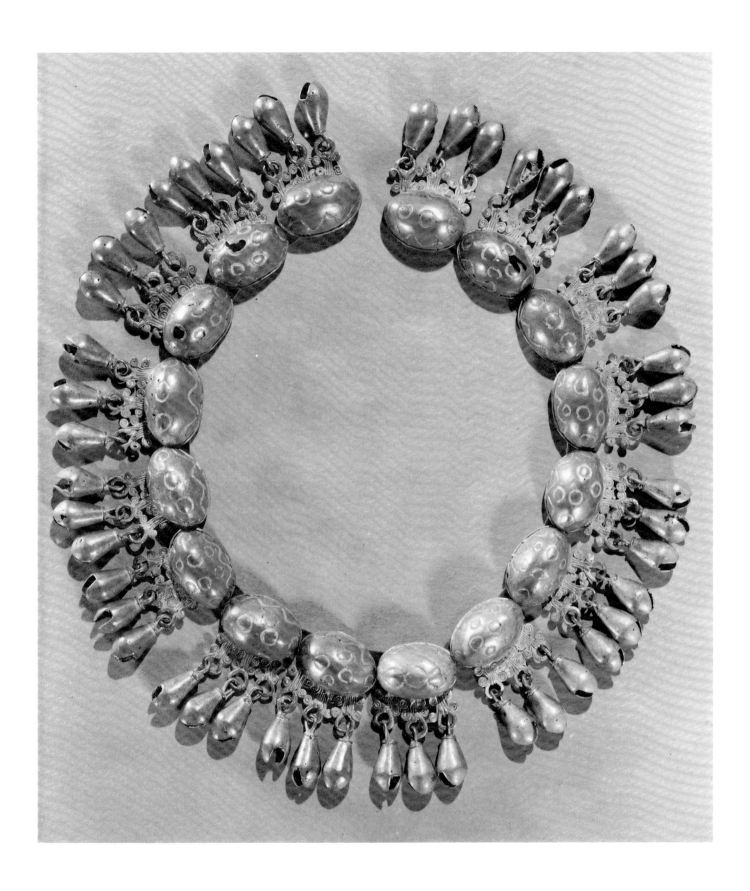

74
Necklace of turtle shell ornaments
Length (total) .395 (15½)
Cast gold
Dumbarton Oaks,
Washington, D.C., no. B-103.MIG
Attributed to southwest Chiapas

The sixteen stylized turtle shells that make up this necklace are decorated with circular markings and zigzag lines. Three teardrop-shaped bells hang from each shell, attached by minutely crafted filigree elements. Apparently the turtle shell motif of

this necklace was a popular one in the late pre-Hispanic period, for it appears in the inventory lists of the treasure sent back to Spain after the conquest. In one undated list necklaces with either turtle shell or turtle elements are mentioned, one of

the latter described as having forty-eight pieces (Saville 1920: 67). Comparable turtle shell necklaces were found in Tomb 7 at the site of Monte Albán in Oaxaca (Caso 1969: láms. 51, 52), but the slightly more square form of these carapaces differs from the oval shape of the Dumbarton Oaks necklace, and the design emphasizes the zigzag rather than the oval markings. A similar necklace of turtle shells with pendant bells, strung on a leather cord, appears in Part 2 of the *Codex Kingsborough* (1912: 216r; fig. 74a), a mid-sixteenth-century document from the Basin of Mexico, as a tribute item made by the Indians of Tepetlaoztoc to their Spanish *encomendero* (overlord).

Alfonso Caso, *El tesoro de Monte Albán*, Memorias del Instituto Nacional de Antropología e Historia, 3 (Mexico, 1969); *Codex Kingsborough*, edited by Francisco del Paso y Troncoso (London, 1912); Marshall H. Saville, *The Goldsmith's Art in Ancient Mexico*, Museum of the American Indian, Heye Foundation, New York, Indian Notes and Monographs, 7 (1920); Hasso von Winning and Alfred Stendahl, *Pre-Columbian Art of Mexico and Central America* (New York, 1968).

fig. 74a Gold necklace composed of turtle shell elements. *Codex Kingsborough* 216r.

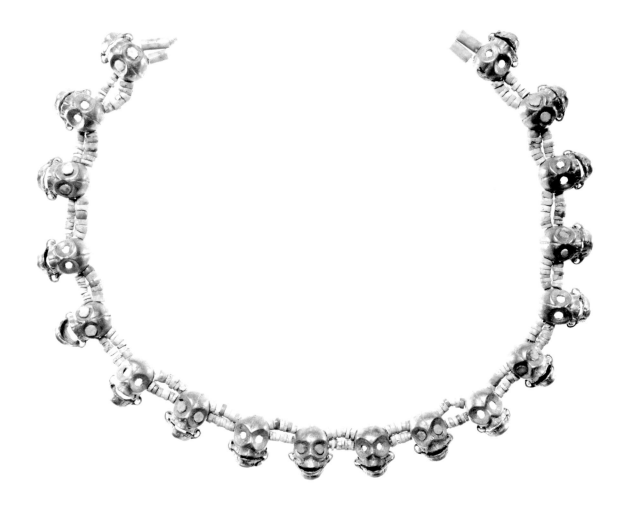

75
Necklace of skulls
Length (total) .345 (13½)
Cast gold and turquoise
Dumbarton Oaks,
Washington, D.C., no. B-108.MIG
Attributed to southwest Chiapas

The skill of the pre-Columbian gold-worker is exhibited in this necklace composed of eighteen miniature skulls with articulated jaws. The heads are mounted on a double strand of turquoise beads in variegated shades of blue, and the eye holes of every other one are inlaid with turquoise stones. A frequent motif in ancient Mexican art, the macabre skull is here playfully interpreted by the wide, grinning mouth. The animation of the faces is further enhanced by the variable expressions produced by the mobile jaws. The movement of the wearer would have activated the motion of these lively little death heads.

Hasso von Winning and Alfred Stendahl,
Pre-Columbian Art of Mexico and Central America (New York, 1968).

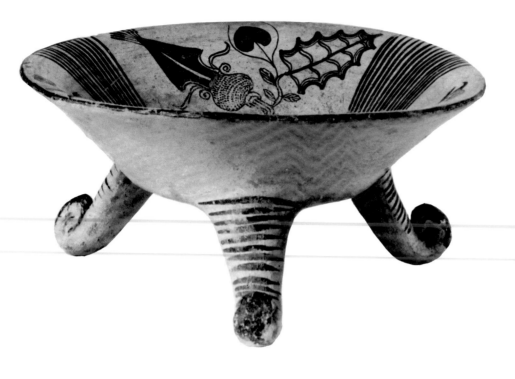

76
Tripod plate
Height .10 (4); diameter .222 (8¾)
Clay
Staatliche Museen Preussischer Kulturbesitz, Museum für Völkerkunde, West Berlin, no. IV Ca 2391
Ex-Uhde collection

The naturalistic designs on this black-on-white tripod plate are expressed with a cursive, decorative line that appeared at the end of the Aztec ceramic sequence (Noguera 1975: 181-188). Typical of the earlier phases of Aztec ceramics, usually black-on-orange, are formats featuring parallel and abstract design layouts. The parallel lines here are a continuation of these early decorative patterns, while the realistically delineated flowers, birds, and sea creatures represent a late development that continued into the colonial period. The beautifully drawn floral and animal designs of this plate are an excellent example of this latest phase of the ceramic sequence variously designated as Aztec IV or Tlatelolco. The scoring of the interior indicates that this piece served as a grinder (*molcajete*). The tripod supports display "butterfly antennae" curled ends, a fairly common feature on late Aztec ceramics, and are simply decorated with parallel horizontal lines.

Eduardo Noguero, *La cerámica arqueológico de Mesoamérica*, 2d ed. (Mexico, 1975).

77
Tripod plate
Height .062 (2½); diameter .185 (7¼)
Clay
Staatliche Museen Preussischer Kul-
turbesitz, Museum für Völkerkunde,
West Berlin, no. IV Ca 32143
Acquired in Huexotla by Eduard
Seler

This black and orange tripod plate
was collected by Eduard Seler from
Huexotla, south of Texcoco in the
Basin of Mexico, an area that was
apparently a major center of ce-
ramic production during the Aztec
period. It represents an excellent ex-
ample of the radial layout formed
by variously configured concen-
tric bands, often seen on Aztec ce-
ramics and stone relief carvings.
The central motif of this plate re-
sembles a multi-petaled flower, and
succeeding rings feature interlocking
scroll devices. While the pattern of
circular banding is typical of late
pre-Hispanic Aztec ceramics, the
flamelike design of the outer rim is
an unusual feature, indicating a late,
possibly colonial, development. The
tripod supports are triple-pronged
and decorated with parallel horizon-
tal lines with stylized floral motifs
on the prongs.

78
"Pulque vessel"
Height .14 (5½); width .13 (5⅛)
Clay
Museo Nacional de Antropología,
Mexico City, no. 11-4912
Ex-Valetta Swan collection; attrib-
uted to Mexico City area

Often called a "pulque vessel" or
"pulque goblet," this type of distinc-
tively shaped hour-glass vessel is
diagnostic of the late Aztec period.
Black-on-red and polychrome exam-
ples decorated with primarily linear
motifs are known, but the most
elaborate specimens feature, as does
this one, iconographically more
complex black-on-white designs on
a burnished red slip. The uppermost
exterior band is white with doubled
vertical black lines at the rim. The
next, much broader band is divided

into three panels, separated by verti-
cal white strips, each featuring a dif-
ferent motif: a profile skull, edged
with small circles-within-circles,
with what appears to be a stylized
feather in the center; the familiar
crossed bones device decorated with
small black circles, the spatial lay-
out of which approximates a quin-
cunx; and a large complex circular
motif with three small circle-within-
circles on each side, somewhat simi-
lar to the standard symbol for *chal-
chihuitl*, preciousness. The next,
much narrower band consists of six
"stellar eyes" linked by three thin
horizontal lines. On the lowermost
portion of the vessel are two large
panels separated by alternating
black and white vertical strips. One
shows what appears to be a feather
ornament composed of a down ball,

a row of three feathers, and two
longer parallel feathers with three
smaller down balls on both sides.
The other panel displays a rectangu-
lar section at the top flanked by ver-
tical strips ending in volutes and
bordered by a row of three stylized
feathers of the type denoting pre-
ciousness, edged with three small
circle-within-circles. Depending
from this device is a black serpen-
tine motif decorated with circles-
within-circles and terminating at the
foot of the vessel with a stellar eye
and large eyebrow, with a paper sac-
rificial banner on the left. These
black-on-white "pulque vessels"
often feature macabre motifs of the
type adorning this handsome piece,
suggesting that they may have been
used in a funerary context.

79
Polychrome urn
Height .254 (10); width .343 (13½)
Clay
Museum of the American Indian,
Heye Foundation, New York,
no. 24/1147
Attributed to Cholula, Puebla

This type of capacious polychrome urn is fairly well represented in collections of Mesoamerican ceramics. These vessels are sometimes attributed to Cempoala in Central Veracruz, although they probably had a much wider distribution. In any case, they represent a significant variant of Cholulteca polychrome, a widely traded, Late Postclassic ware centered in the large, sacred city of Cholula in the Puebla Basin, to the east of the Basin of Mexico (see Noguera 1954; Müller 1978). The band format and the design motifs are typical (cf. nos. 80, 81, 82). The top rim band is solid red. The next decorative band features the characteristic bird head facing upward, a volute below his beak, and a trapezoidal device rising from the top of the head. Alternating with these bird heads are *chalchihuitl* pendants denoting preciousness. Short vertical lines edge the top of the band. These lines and the *chalchihuitl* pendants often decorate the outer rims of solar disks. Two thin bands encircle the vessel below this, one white (sectioned), the other red. The typical step-fret motif in red and gray occupies the next register. The lowermost decorative band features alternating rectangular panels, one composed of a stylized head with a volute on its beak or snout, the other displaying three stylized feathers with down balls at their bases. The solid red base of the vessel matches the solid red rim. Two handles, placed low on the body of the vessel, complete its design.

Florencia Müller, *La alfarería de Cholula* (Mexico, 1978); Eduardo Noguera, *La cerámica arqueológica de Cholula* (Mexico, 1954).

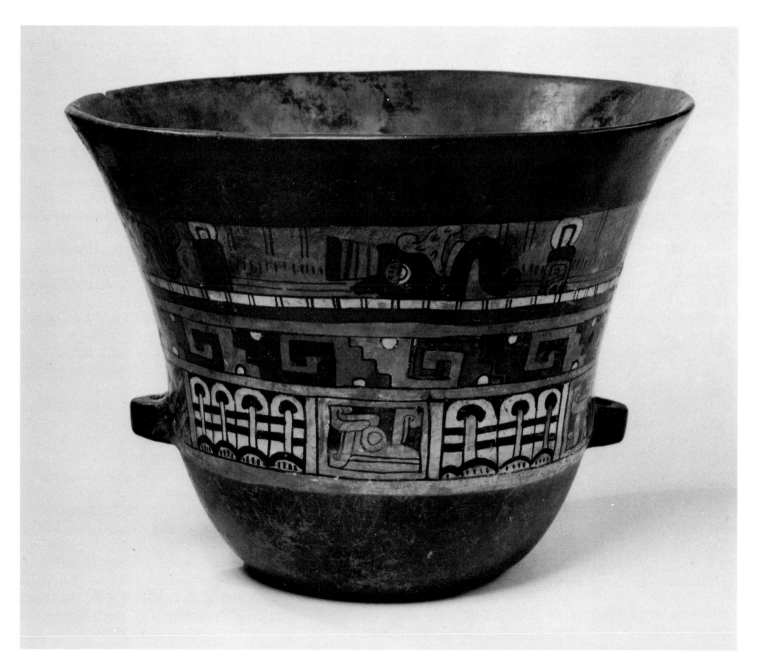

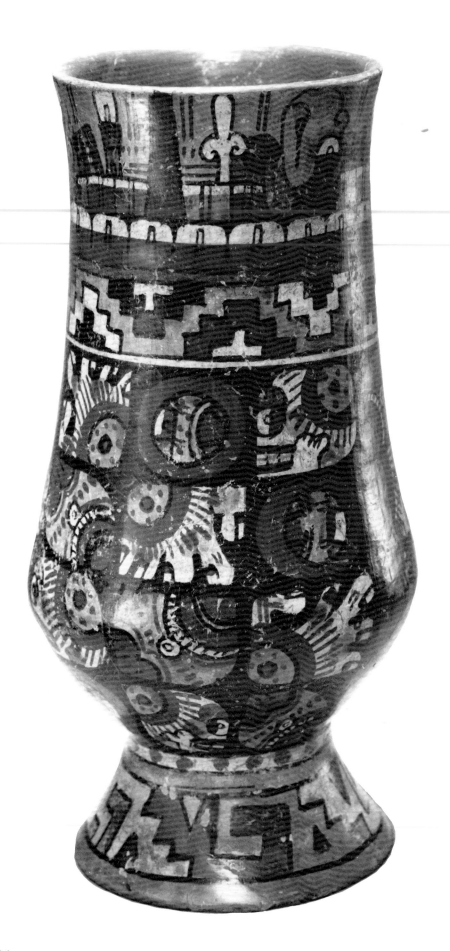

80
Polychrome pedestal vessel
Height .28 (11)
Clay
Los Angeles County Museum of
Natural History, no. P.655.67-4
Ex-Stendahl collection; attributed
to Cholula, Puebla

This pear-shaped vessel on a flaring
pedestal base represents a form typi-
cal of Cholulteca polychrome ce-
ramics, whose lustrous colors were
achieved by a lacquer technique
rather than by fired glazes. The top
band displays the same edge motifs
also found on the rims of poly-
chrome plates (cf. nos. 81, 82): the
typical raptorial bird head facing
upward, alternating with the "fleur-
de-lis" motif that possibly indicates
a bone, and the *chalchihuitl* pendant
that was a symbol for preciousness.
Below this is a row of stylized
feather motifs, the top sections
white, the bottom red. A thin dark
strip separates it from the next band
featuring the typical step-fret de-
sign, followed by another thin,
white strip. The principal field cov-
ers the swelling base of the jar. As is
characteristic on this type of vessel,
rows of alternating skulls, hearts,
hands, and shield motifs cover the
dark ground surface. The pedestal
support bears a step-fret design sim-
ilar to that of the upper section,
though in a different configuration.

Hasso von Winning and Alfred Stendahl,
*Pre-Columbian Art of Mexico and Central
America* (New York, 1968).

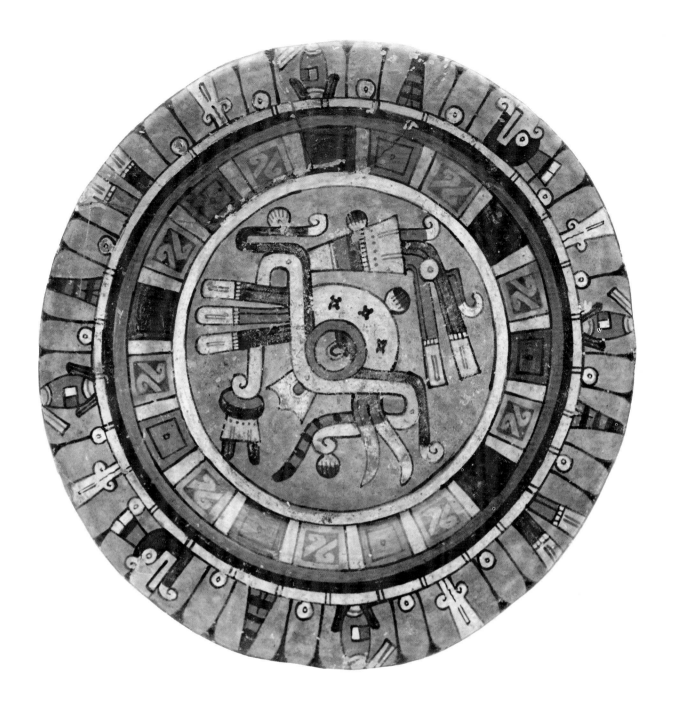

81
Polychrome plate
Diameter .23 (9⅛)
Clay
The St. Louis Art Museum,
no. 85:1950
Attributed to Cholula

The layout and banding of this plate are characteristic of Cholula polychrome. Also typical are the colors of the plate: red, orange, yellow, black, gray, white. The central section displays a stylized serpentine head in profile composed of long, curved double strips edged with down balls. The large circular eye of the creature rests in a nook formed by the bands, surmounted by a thick, curved supraorbital ridge. The bifurcated tongue droops down over his lower jaw, and three feathers project from a crook at the top of the mouth, while a single stylized tooth protrudes at a center bend of the mouth band. The complex headdress is composed of a trapezoidal section and two hanging feathers. This central field is encircled by a plain narrow band, then by a broader one divided into rectangular sections, some containing the *il-huitl* ("feast day") motif (two crooked, back-to-back strips), often a component of celestial bands. The sectioned border features the typical bird head facing up, whose image alternates with maize ears (an unusual feature), pointed shapes that can be interpreted as stylized solar rays, the so-called "bone motif," and little circles probably symbolizing *chalchihuitl*, preciousness.

Lee A. Parsons, *Pre-Columbian Art: The Morton D. May and the Saint Louis Art Museum Collections* (New York, 1980).

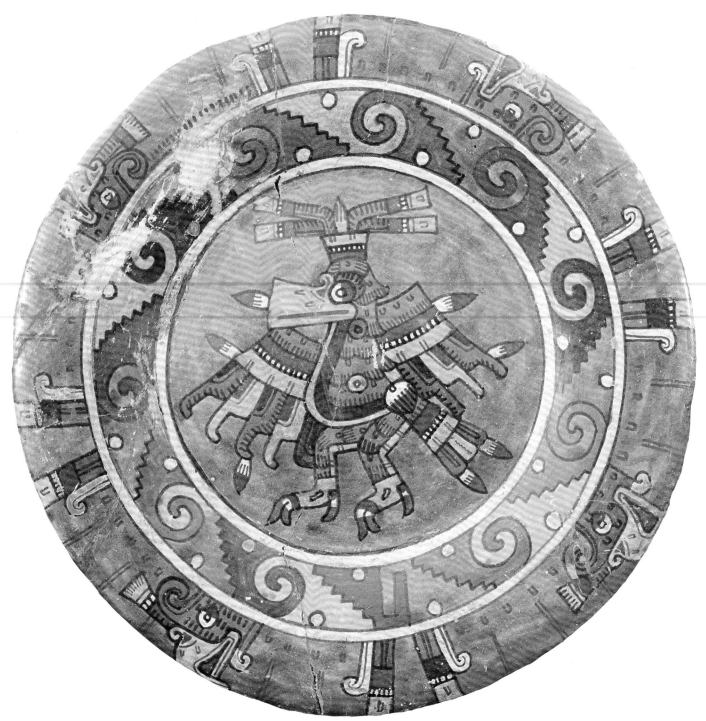

82
Polychrome plate
Diameter .23 (9)
Clay
Thomas Gilcrease Institute of American History and Art, Tulsa, Oklahoma, no. 5445.7771
Attributed to Cholula, Puebla

The format and motifs of this brilliant polychrome plate are typical of Cholulteca ceramics. The design is divided into a central field encircled by two bands, with these areas separated by two narrow, plain white strips. The center zone is occupied by the bristling image of a large-billed bird, his outstretched wings tipped by stone sacrificial knives, which also edge his beak, tail feathers, and headdress. The clawed feet display jaguar markings, a common feature, suggesting a somewhat composite creature but with the raptorial bird features predominating. In addition to the stone knife, his headdress displays two sets of stylized feathers flaring outward from the sacrificial instrument. A characteristic row of step-frets surrounds this circular field. The outer band is also typical of Cholulteca plates, decorated with alternating bird heads facing upward, sectioned vertical strips with white volutes that perhaps represent the conventionalized symbol for preciousness, and double parallel lines edging the vessel's rim.

Hasso von Winning and Alfred Stendahl, *Pre-Columbian Art of Mexico and Central America* (New York, 1968).

83
Polychrome eagle effigy vessel
Height .219 (8⅝)
Clay
Los Angeles County Museum of
Natural History, no. F.A. 1059.71-1
Ex-Douglas Armstrong collection;
attributed to Cholula

Although the polychromy and mo-
tifs of this vessel are in classic Cho-
lula style, the form of this raptorial
bird effigy vessel is unusual. The top
band of the flaring rim includes the
"fleur-de-lis" device that has been
interpreted as a bone motif and ap-
pears as a standard component on
rim bands of other Cholulteca ce-
ramic pieces (cf. nos. 80, 81, 82).
The second register features two ad-
joining ovoid forms, probably shells,
on a background of horizontal lines
and undulating vertical ones, appar-
ently indicating liquid. The third
band shows a stylized butterfly de-
sign (cf. no. 65), alternating with a
rectangular tri-colored patch. Both
these motifs are characteristic of
Xochipilli, the deity of flowers,
music, and dancing, the butterfly
frequently appearing over his mouth
and the quadrangular emblem on
his cheeks. Two *chalchihuitl* (jade,
preciousness) symbols adorn the
rear of the vessel. The form of the
bird cleverly incorporates the shape
of the bulbous vessel, which be-
comes his body. The projecting head
and wings have been attached sepa-
rately, as have the legs (with jaguar
markings) and the tail, which serves
as the third member of the tripod
support. All three contain pellets
that rattle when the vessel is shaken.
The feathers of the body are ex-
pressed as expanding, flowerlike de-
signs, with blood-stained stone
knives, a common decorative fea-
ture, edging some of them.

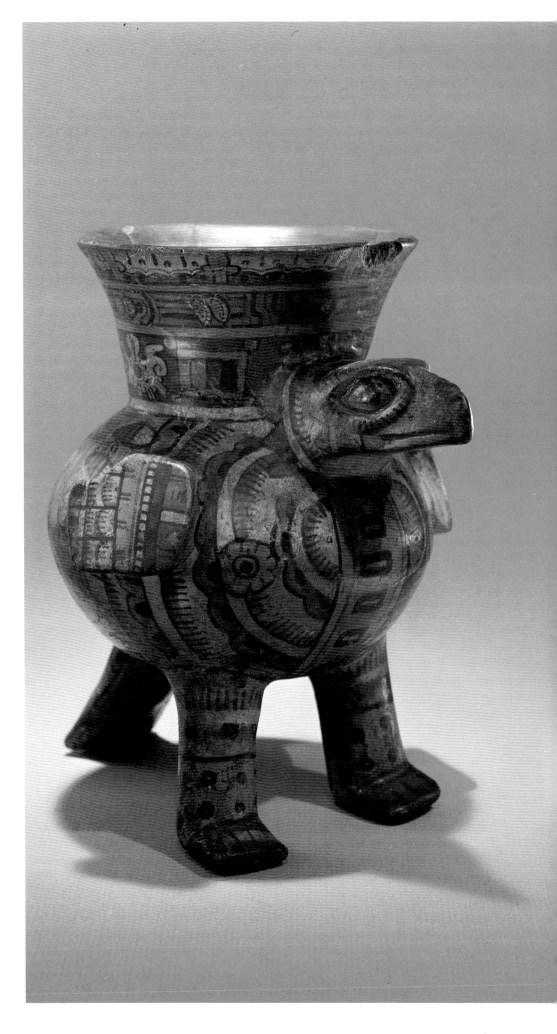

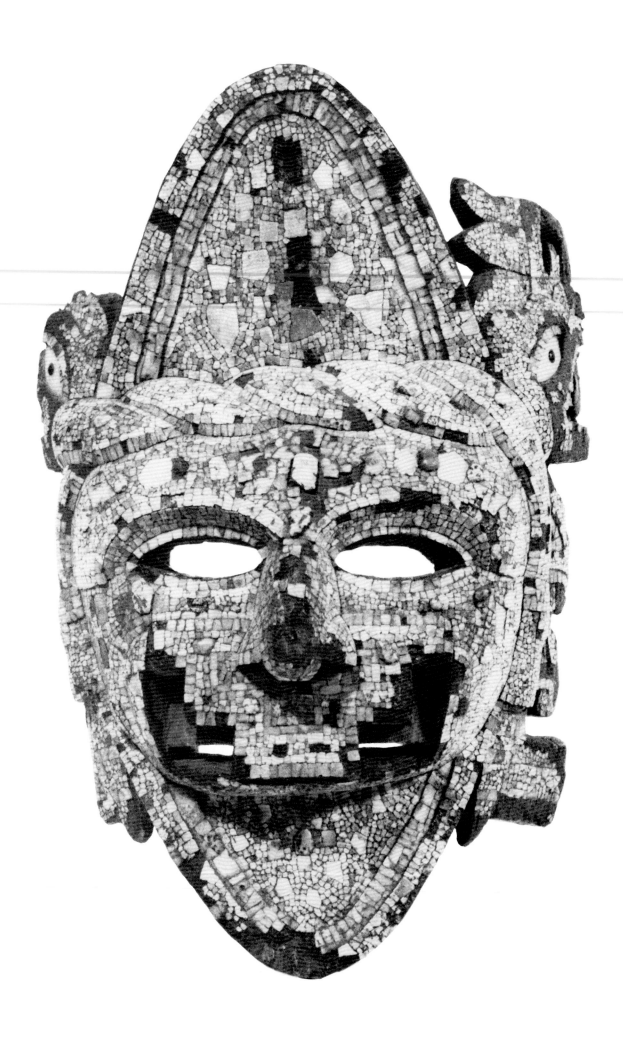

84
Mosaic mask

Height .24 (9½); width .15 (5⅞)
Wood, with turquoise, jadeite, shell,
mother-of-pearl
Museo Nazionale Preistorico-
Etnografico Luigi Pigorini, Rome,
inv. 4213
Possibly ex-Cosimo I de' Medici col-
lection

One of the most remarkable Meso-
american arts was that of mosaic,
featuring turquoise but also utiliz-
ing many other types of stone (jade-
ite, obsidian, quartz, malachite, lig-
nite, marcasite, garnet, beryl, jet,
pyrite), as well as coral and vari-
ously colored shells and sheet gold.
The mosaic usually seems to have
been attached with an effective veg-
etal glue. Among a wide variety of
objects decorated with mosaic were
masks, shields, scepters, spear-
throwers, headpieces, pectorals,
back devices, nose and ear orna-
ments, armlets, bracelets, and ank-
lets, and anthropomorphic and zoo-
morphic images. The usual
foundation was wood, but occasion-
ally other media (stone, bone, shell,
metal, leather, clay) were employed.
Unfortunately, because of poor pres-
ervation conditions throughout
most of the area, few specimens
have survived. The finest pieces ex-
tant reached Europe during and
shortly after the conquest, sent as
gifts or transported there as souve-
nirs, but less than twenty-five are
preserved today. More may still be
discovered; a mosaic mask turned
up in Italy recently and was ac-
quired by the Dallas Museum of
Fine Arts (Sotheby's 1978: 45
[101]). Extensive literature has accu-
mulated on the subject, and nearly
all significant pieces have by now
been illustrated in color and more
or less adequately described. The
classic comprehensive study, still not
superseded although much in need
of updating, is that of Saville
(1922). He is weak on origins and
pedigree (including the pieces in this
exhibition), however, and for this
information the concise survey of all

known Mexican mosaics in Euro-
pean collections as of 1906 by Wal-
ter Lehmann and the more recent
study of the nine British Museum
pieces by Elizabeth Carmichael
(1970) are especially useful.

Although the earlier histories of
most of the mosaics in Europe were
not well recorded, the majority ap-
pear to have been at one time in
Italy, particularly Florence, where
the Medici princes assembled one of
the largest and most variegated Ren-
aissance Kunstkammern, "cabinets
of curiosities," in all Europe. In
1880 Luigi Pigorini (1885: 338-339)
encountered our mask forgotten in a
chest in the loft of the Opificio delle
Pietre Dure in Florence and ob-
tained it for the Museo Preistorico
ed Etnografico that he had founded
in Rome. He believed that it could
be traced back through various in-
ventories to one of 1553 that men-
tioned "una maschera venuta del-
India composta di turchine sopra il
legno" in the Guardaroba of Co-
simo I de' Medici, Duke of Florence
1537-1574. In his recent comprehen-
sive study with Ferdinand Anders,
Mexico and the Medici (1972),
Detlef Heikamp accepted Pigorini's
view and published the pertinent
passages from the relevant invento-
ries.

It is often assumed that at least
some of the Mexican mosaics in Eu-
rope were included in the famous
first shipment by Cortés (July-
November 1519) of the gifts con-
veyed to him by Motecuhzoma II,
along with other objects he had col-
lected on the coast, which were pre-
sented to Charles V in Valladolid in
March 1520. Attempts have even
been made to identify particular
pieces in the European collections
with items of deity costumes de-
scribed by Fray Bernardino de Saha-
gún as having been sent down from
Mexico Tenochtitlan by Motecuh-
zoma to Cortés while the latter was
still on the coast (e. g., Lehmann
1906: 320-321, 1907: 335; Mauds-
lay 1908-1916, 1: 299-300). As
Heikamp (1976: 456-457) has
stressed, however, these speculations

must be treated with reserve, for
many more shipments later reached
Europe and the inventory descrip-
tions are often quite generalized.

Mosaic masks were also collected
during the pre-Cortesian explora-
tory voyage of Juan de Grijalva,
May-September 1518, from the east
coast of Yucatan to northern Vera-
cruz (Saville 1922: 3-8; Wagner
1942). The official inventory of the
gifts stemming from this expedition,
which were presented to the Spanish
monarch in Barcelona in May 1519
(Oberem 1969), specifically men-
tions mosaic masks. Since none of
the 1519-1526 Cortesian inventories
(Saville 1920: 21-102) does so, it is
possible—but not presently demon-
strable—that our mask was in-
cluded in the 1518 remission to
Spain sent by Diego Velásquez, the
governor of Cuba who had sent out
Juan de Grijalva's expedition.
Thompson (1966: 169) identified
the other mosaic mask in the Pigo-
rini museum (ex-Aldrovandi collec-
tion, Bologna) (Saville 1922: pl. 8,
fig. 15) and another, purchased in
Rome in 1856, in the National Mu-
seum of Copenhagen, Denmark (Sa-
ville 1922: pl. 31), as representa-
tions of the Maya merchant god
(God M). He further suggested that
they may have been obtained in the
Putun-Maya center of Potonchan, at
the mouth of the Río Grijalva in Ta-
basco. If correct this would increase
the likelihood that some of the other
mosaics in Europe were also ob-
tained in the Gulf Coast area.

Our mask consists of a face with
hollow eyes and mouth framed
above and below by gaping, trian-
gular jaws, probably reptilian,
whose gums are indicated by strips
of red shell. A stepped nasal orna-
ment is worn, also bordered with
red shell. If it is the same mosaic
mask described in Medicean inven-
tories of 1640, 1665, 1744, 1770,
and 1783 (Heikamp and Anders
1972: 34-35), the mouth originally
held a gold ring, possibly one reason
for the missing mosaic in that area.
The forehead is adorned with two
intertwined snakes whose bodies are

outlined with the usual red shell borders. Their large heads (that on the right missing its upper portion) flank the upper reptilian jaw, and their lower bodies and tails hang down on either side. Rather complicated pierced and fretted pieces are attached at the sides, the lower portions of which possibly represent ear ornaments. The snake heads display angular back-curving snouts of the type characteristic of the fire serpent (*xiuhcoatl*) (see annotation to no. 8), capped by a triple-pronged element. The back of the mask is roughened wood; it is not hollowed out although holes for attachment are present (for a possible function of Aztec mosaic masks, see annotation to no. 32).

Although the mask has often been designated as Quetzalcoatl (e.g., Saville 1922: 22), Beyer (1921) identified it as a water-fertility goddess cognate with one bearing the calendric name 9 Reed. The deity is frequently depicted in the Mixteca pictorial screenfolds *Vindobonensis*, *Zouche-Nuttall* (fig. 84a), and *Bodley* and on carved bones included in the mortuary furniture of Tomb 7, Monte Albán, Oaxaca (Caso 1969: figs. 185, 206). Quetzalcoatl does wear an intertwined serpent headdress when he figures as patron of the second 13-day period of the 260-day divinatory cycle in the codices *Borgia* 62 and *Vaticanus B* 50, but his more usual headdress is quite different. The intertwined snake headdress is more characteristic of the goddess 9 Reed and some other Mixteca deities, such as another fertility goddess, 11 Serpent, and the paired male deities 4 Serpent and 7 Serpent and 4 Deer and 4 Death (discussion in Furst 1978: 136-137, 167-169, 317-318). Nine Reed is also frequently shown with the stepped nasal ornament, as in fig. 84a. Although not the case in the Mixteca pictorials, in the closely allied screenfolds of the *Codex Borgia* group the water-fertility goddess, principally known to the Nahuatl-speakers as Chalchiuhtlicue (see annotation to no. 17), fre-

fig. 84a Goddess 9 Reed (extra numerical coefficient an apparent error). *Codex Zouche-Nuttall* 51a.

quently wears a reptilian helmet-mask and sometimes the stepped nose ornament as well (discussion in Nicholson 1961, with illustrations).

An unusual feature, never present on other depictions of the intertwined serpent headdress, is the back-curving snout of the surviving snake head. This characteristic is diagnostic of the fire serpent (*xiuhcoatl*), an identification supported by the presence of the triple-pronged finial. This element may represent a stylization—although the color scheme differs—of the stone knife flanked by outcurving motifs that frequently tips the snout of the *xiuhcoatl* (e.g., fig. 84b, especially when this creature appears as a component of the "Turtle-Xiuhcoatl Sacrificer" or *yahui* figures common in the Mixteca historico-genealogical pictorials (Caso 1964: 27, 75; Smith 1973: 60-64).

In view of these striking iconographic similarities to deity representations in pictorial manuscripts from western Oaxaca, the Mixteca, a provenance for this mask in that region would appear to be a distinct possibility. Perhaps equally possible might be an origin on the Gulf Coast, an area that also participated in the Mixteca-Puebla stylistic-iconographic tradition. Certainly, deities with intertwined serpent headdresses were also known there (Nicholson 1971: 14). As noted above, mosaic masks were collected

fig. 84b "Turtle-Xiuhcoatl Sacrificer" (the solar disk substitutes here for the usual turtle shell). *Codex Vindobonensis* 30a. From Beyer 1921: fig. 223.

in this area during the 1518 Grijalva expedition and subsequently sent to Spain.

Although damaged in certain portions, most of the mosaic of this striking mask, very much dominated by its turquoise tesserae, is in good condition. The projecting jadeite pieces provide its otherwise rather flattish surface with interesting, variegated relief. Among the handful of surviving turquoise mosaic masks, it well exemplifies the skill of the native lapidaries who practiced this remarkable Mesoamerican elite craft.

Hermann Beyer, *El llamado "Calendario Azteca"* (Mexico, 1921); and "Una máscara prehispánica con mosaico de turquesa," *Revista de Revistas* 12, no. 598 (1921): 43-44 (reprinted in *El México Antiguo* 11 [1969]: 340-344); Elizabeth Carmichael, *Turquoise Mosaics from Mexico* (London, 1970); Alfonso Caso, *Interpretación del Códice Selden 3135 (A.2)*; and *El tesoro de Monte Albán* (Mexico, 1969); Jill Furst, "Codex Vindobonensis Mexicanus I: A Commentary," *Institute for Mesoamerican Studies, State University of New York at Albany,* pub. 4; Detlef Heikamp, "American Objects in Italian Collections of the Renaissance and Baroque: A Survey," in *First Images of America: The Impact of the New World on the Old,* edited by Fredi Chiappelli (Berkeley, Los Angeles, and London, 1976), 1: 455-482; Detlef Heikamp and Ferdinand Anders, *Mexico and the Medici* (Florence, 1972); Walter Lehmann, "Altmexikanische Mosaiken und die Geschenke König Motecuzomas an Cortés," *Globus* 90, no. 20 (1906): 318-322; and "Die altmexikanischen Mosaiken des ethnographischen Museums in Kopenhagen," *Globus* 91, no. 21 (1907): 332-335; Alfred P. Maudslay, "Appendix: Montezuma's Gifts to Cortés," in Bernal Díaz del Castillo, *The True History of the Conquest of New Spain,* translated and edited by A. P. Maudslay, 5 vols. (London, 1908-1916), 1: 299-302; H. B. Nicholson, "An Outstanding Aztec Sculpture of the Water Goddess," *Masterkey* 35, no. 2 (1961): 44-55; and "The Iconography of Classic Central Veracruz Ceramic Sculptures," in *Ancient Art of Veracruz* [exh. cat., Los Angeles County Museum of Natural History] (Los Angeles, 1971): 13-17; Udo Oberem, "Die früheste Liste einer Sendung mesoamerikaner Gegenstände nach Europa," *Zeitschrift für Ethnologie* 94, no. 2 (1969): 293-296; Luigi Pigorini, "Gli antichi oggetti messicani incrostati di mosaico esistenti nel Museo Preistorico ed Etnografico di Roma," *Atti della R. Accademia dei Lincei; Memorie della Classe di Scienze Morali, Storiche e Filologiche, Seduta dei 17 Maggio,* series 3, 12 (1885): 336-342; Marshall H. Saville, *The Goldsmith's Art in Ancient Mexico,* Museum of the American Indian, Heye Foundation, New York, Indian Notes and Monographs, 7 (1920); and *Turquoise Mosaic Art in Ancient Mexico,* Contributions from the Museum of the American Indian, Heye Foundation, 6 (1922); Mary Elizabeth Smith, "The Relationship between Mixtec Manuscript Painting and the Mixtec Language: A Study of Some Personal Names in Codices Muro and Sánchez Solis," in *Mesoamerican Writing Systems, A Conference at Dumbarton Oaks, October 30th and 31st, 1971,* edited by Elizabeth P. Benson (Washington, 1973): 47-98; Sotheby's, *Catalogue of Pre-Columbian, American Indian, Oceanic, and African Art, Day of Sale, Monday, 11th December, 1978* (London, 1978); J. Eric S. Thompson, "Merchant Gods of Middle America," in *Summa Anthropologica en homenaje a Roberto J. Weitlaner,* edited by Antonio Pompa y Pampa (Mexico, 1966): 159-172; Henry R. Wagner, "The Discovery of New Spain in 1518 by Juan de Grijalva. A Translation of the Original Texts with an Introduction and Notes by . . . ," *Documents and Narratives concerning the Discovery and Conquest of Latin America, Published by the Cortés Society, Bancroft Library, Berkeley, California,* new series, 2 (1942).

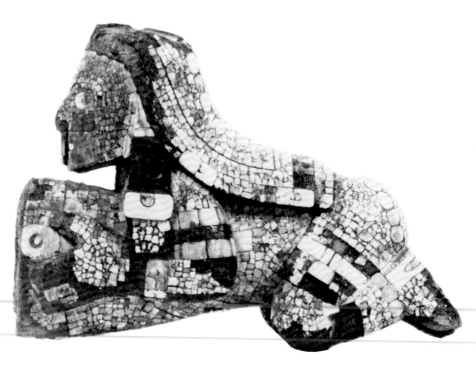

85
Anthropomorphic mosaic knife handle
Length .125 (4⅞); height .05 (2)
Wood, with turquoise, malachite, shell
Museo Nazionale Preistorico-Etnografico Luigi Pigorini, Rome, inv. 4216
Ex-Cospi collection

This generally well-preserved mosaic knife handle, together with that of no. 86, by 1667 was in the collection of the Bolognese nobleman, the Marchese Ferdinando Cospi (1619-1686), who donated his museum to his native city. It was described and illustrated by a woodcut in an account of his collection published ten years later (Legati 1677: 477; reproduced in Heikamp 1976: fig. 49). Cospi may have obtained the knife handle in Florence, for his mother was a Medici. In 1878 both pieces were in the archaeological museum of the University of Bologna. That same year, in a controversial exchange, they were obtained (along with a mosaic mask that had been in the Aldrovandi collection) for the Museo Nazionale Preistorico ed Etnografico di Roma by Luigi Pigorini, who published descriptions and color illustrations of them seven years later (Pigorini 1885: 337-338, 340-341).

This knife handle (a fragment of the stone blade is still embedded in the slit) represents a crouching human figure. A headcloth, edged with a border strip, includes what appear to be red and white eye motifs, suggesting a variant of a popular Aztec garment border called *tenixyo*, "having eyes on the edge" (see Anawalt 1981: 25). Edging this border are a series of small red shell circles. An inner strip, of red shell and darker inlays, parallels the outer border; contained within it are two additional bands composed of small multicolored circles. Side flaps terminating in motifs that resemble *chalchihuitl* (precious jewel) pendants (cf. ear ornaments of Chacmool, no. 1), hang down over the ears, which are decorated with circular white earplugs. A red shell inlay surrounds the mouth, which is designated by white shell inlays, and other red shell inlays form small circles on the cheeks. The arms, decorated with armbands and bracelets, thrust forward on each side of the handle. Between the thumbs and forefingers of the hands are red and white elements that, again, resemble eyes. Red and white inlays indicate sandals, and red and white bands adorn the calves of the sharply bent legs. Multi colored four-band panels decorate the thighs, possibly representing the hem of a skirt or robe.

Depending from the waist in back is a wide strip composed of multicolored bands, flanked by diagonal strings of small circles, also multicolored.

Determining the sex of this figure poses a problem. The back strip might be interpreted as the rear portion of a male loincloth, but similar strips are commonly depicted in the native tradition pictorials attached to the backs of female skirts. If the thigh bands are interpreted as decorations on the hem of a skirt, the case for a female would be considerably strengthened (robes worn by males usually extended to the ankles). The small circles on the cheeks would also support this view, since these are more common on goddesses (only the solar god regularly displays them). The red area around the mouth, on the other hand, seems to be largely confined to male deities. An important earth-fertility goddess, Tlazolteotl-Teteoinnan, normally displays a dark rather than red field around the mouth. The goddess most frequently depicted wearing a headcloth, Chantico, is never shown with check circles or a mouth patch. In view of these seeming ambiguities, perhaps no particular deity was intended.

As for provenance, one clue, the red zones in the corners of the eyes, points more to the Mixteca-Puebla

heartland (southern Puebla, western Oaxaca, Gulf Coast) than Central Mexico. This feature is typical of figures in the pictorial manuscripts of the former region, and its appearance on this piece adds support for its origin somewhere in this area.

In addition to no. 86, other similar knife handles from Mexico reached Europe. One, since lost, was also in Bologna in another famous museum, that of the erudite naturalist Ulisse Aldrovandi (1522-1606), and was illustrated in a woodcut in the posthumous work describing his collection published in 1648 (Aldrovandi 1648: 156; reproduced in Heikamp 1976: fig. 35). This handle, which held an obsidian blade, appears to represent a raptorial bird but it does not seem to have been encrusted with mosaic. Another, an image of a crouching figure similar to our piece and definitely covered with mosaic, has also since been lost. Over half of its blade was intact. It was briefly described and illustrated with a woodcut by Fortunato Liceti (1634: 123; reproduced in Heikamp 1976: fig. 51), who believed it to be African. He described the owner as "nobilis Vir Gaffarellius," who Pigorini (1885: 337; followed by Heikamp 1976: 474) identified as Jacob Gaffarell, the learned librarian of Cardinal Richelieu. A third specimen, the best known of all of the knife handles, still exists. It also represents a crouching human figure, attired in a bird costume, with the face peering out of the open bill (Carmichael 1970: 16). The chalcedony blade is complete, but one opinion challenges its originality (Easby and Scott 1970: 295). It was acquired in 1859 by the British textile manufacturer and inveterate collector Henry Christy at the London sale of the collection of Bram Hertz, who informed the purchaser that it had originally been in a Florentine collection sold over twenty years earlier (Carmichael 1970: 37). Since 1865 it has belonged to the British Museum.

Although less spectacular than some others, the simplicity, harmonious proportions, choice of colors, and precise workmanship of this piece rank it high among the small corpus of surviving mosaics from the territory of the Empire of the Triple Alliance.

Ulisse Aldrovandi, *Musaeum Metallicum* (Bologna, 1648); Patricia Rieff Anawalt, *Indian Clothing before Cortés: Mesoamerican Costumes from the Codices* (Norman, 1981); Elizabeth Carmichael, *Turquoise Mosaics from Mexico* (London, 1970); Elizabeth Kennedy Easby and John F. Scott, *Before Cortés, Sculpture of Middle America: A Centennial Exhibition at the Metropolitan Museum of Art from September 30, 1970 through January 3, 1971* (New York, 1970); Detlef Heikamp, "American Objects in Italian Collections of the Renaissance and Baroque: A Survey," in *First Images of America: The Impact of the New World on the Old*, edited by Fredi Chiappelli (Berkeley, Los Angeles, and London, 1976), 1: 455-482; Lorenzo Legati, *Museo Cospiano annesso a quello del famoso Ulisse Aldrovandi e donato alla sua patria dall' illustrissimo Signor Ferdinando Cospi* (Bologna, 1677); Fortunato Liceti, *Pyronarcha; sive de fulminum natura deque febrium origine libri duo* (Padua, 1634); Luigi Pigorini, "Gli antichi oggetti messicani incrostati di mosaico esistenti nel museo Preistorico ed Etnografico di Roma, *Atti della R. Academia dei Lincei; Memorie della Classe di Scienze Morali, Storiche e Filologiche*, seduta dei 17 Maggio, series 3, 12 (1885): 336-342.

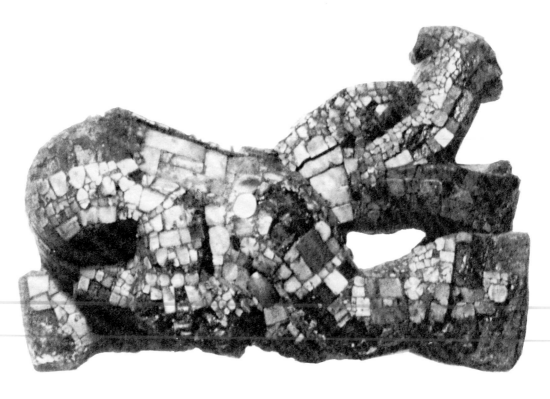

86
Anthropomorphic mosaic knife handle (staff finial?)
Length .14 (5½); height .055 (2⅛)
Wood, with turquoise, malachite, shell, gilded bronze (?), gold flakes
Museo Nazionale Preistorico-Etnografico Luigi Pigorini, Rome, inv. 4215
Ex-Cospi collection

This putative mosaic knife handle was in the collection of the Marchese Ferdinando Cospi of Bologna by 1667 and, together with no. 85, was described and illustrated by a woodcut (mirror image) in Legati's account of the Museo Cospiano (Legati 1677: 477; reproduced in Heikamp 1976: fig. 49). It might earlier have been in a Florentine (Medicean) collection (see annotation to no. 85). It was also obtained from the University of Bologna museum in 1878 by Luigi Pigorini for his new museum in Rome.

It represents another crouching figure, with one leg drawn up in front of the other, the arms thrusting forward with the hands grasping either side of the "handle." The body appears to be anthropomorphic, the head obviously that of an animal or monster. The mosaic pattern is complex and somewhat dam-

aged, but thigh bands, armlets, and bracelets are discernible. On the back is a slightly raised rectangular panel. The head is serpentine, at least reptilian, with a gaping mouth and a pronounced back-curving snout. Heikamp (1976: 469) identified the eyes as gilded bronze (?) cabochons. Pigorini (1885: 340) believed that a human head was originally inset in the mouth, similar to the British Museum knife handle (Carmichael 1970: 16), but if so, it was lost by 1677 when Legati published his woodcut.

Whether this piece actually functioned as a knife handle has been questioned. Lothrop, who examined the original for Saville (1922: 84), reported that the front of the specimen was smooth, covered by a kind of cement and lacking a slit for the insertion of a blade. He noted a sizable hole in the figure's belly, raising the possibility that it might have been placed on the end of a staff.

An even more difficult question is the identification of the figure. Personages with human bodies and animal or monster heads are occasionally depicted in the native tradition pictorials. The commonest animals are dog (deity Xolotl; see annotations to nos. 46 and 47, fig. 46a), coyote (deity Huehuecoyotl), jaguar,

monkey, and opossum. Reptilian heads on human bodies are extremely rare. One example is the Mixteca "Turtle-Xiuhcoatl Sacrificer" or *yahui* (see annotation to no. 84). This strange creature was apparently conceived to be a flying wizard-ritual impersonator-transformer especially involved with sacrifice (Smith 1973: 60-64). Its images display at least three distinct forms: with a human head; with a human head peering from the open jaws of the fire serpent (*xiuhcoatl*) (e.g., fig. 86a); and with only the *xiuhcoatl's* head (e.g., fig. 84b). The legs and arms can be human or zoomorphic with claws (e.g., figs. 84b and 86a).

Our mosaic figure might represent a version of a *yahui* or a closely related supernatural being. The characteristic turtle shell worn in the midsection seems to be missing, but the somewhat damaged mosaic in this part of the piece is complicated and difficult to interpret. The backward-curving snout certainly suggests the fire serpent (*xiuhcoatl*) (see annotations to nos. 8, 84). The tip of the snout is grooved and apparently not encrusted with mosaic. On the *yahui* figures a stone sacrificial knife with curved edging elements is often positioned here (e.g.,

fig. 84b). Such an element could originally have been attached at this place. The same motif is often depicted at the tip of the *xiuhcoatl's* tail (cf. figs. 84b and 86a) and might have been attached to the flattish tail-end of the figure, the center of which at least now lacks mosaic. The *yahui*, as sacrificer, often holds sacrificial knives in his hands (cf. fig. 86a). Even if our mosaic served as a finial for a staff rather than a knife, a knife blade or its simulacre might have been fastened to the flat area at the front, grasped by the hands. If Pigorini's speculation that the piece originally contained a human head in the open jaws is accepted, it would also fit the case—as fig. 86a clearly demonstrates. Even the position of the legs, with one drawn up ahead of the other, resembles some depictions of the flying *yahui* (e.g., fig. 86a).

This possible identification of the figure with the Mixteca "Turtle-Xiuhcoatl Sacrificer" or *yahui* is offered cautiously. While it would not necessitate a provenance for the piece in the Mixteca of western Oaxaca, that area is a strong possibility. An adjoining area, such as the Gulf Coast where mosaic art was also well developed, might also be considered.

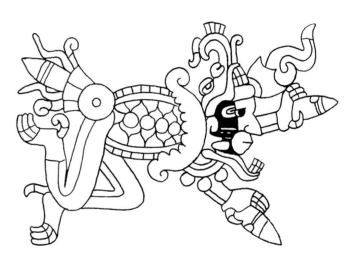

fig. 86a Flying "Turtle-Xiuhcoatl Sacrificer" (*yahui*). *Codex Zouche-Nuttall* 19b.

Elizabeth Carmichael, *Turquoise Mosaics from Mexico* (London, 1979); Detlef Heikamp, "American Objects in Italian Collections of the Renaissance and Baroque: A Survey," in *First Images of America: The Impact of the New World on the Old*, edited by Fredi Chiappelli (Berkeley, Los Angeles, and London, 1976), 1: 455-482; Lorenzo Legati, *Museo Cospiano annesso a quello del famoso Ulisse Aldrovandi e donato alla sua patria dall' illustrissimo Signor Ferdinando Cospi* (Bologna, 1677); Marshall H. Saville, *Turquoise Mosaic Art in Ancient Mexico*, Contributions from the Museum of the American Indian, Heye Foundation, 6 (1922); Mary Elizabeth Smith, "The Relationship between Mixtec Manuscript Painting and the Mixtec Language: A Study of Some Personal Names in Codices Muro and Sánchez Solís," in *Mesoamerican Writing Systems, A Conference at Dumbarton Oaks, October 30th and 31st, 1971*, edited by Elizabeth P. Benson (Washington, 1973): 47-98.

Aztec Deities

Coatlicue (Serpent Skirt)	Earth-fertility goddess; mother of Huitzilopochtli.
Centeotl (Maize Ear Deity)	Generic name for the maize deity.
Chalchiuhtlicue (Jade Skirt)	Goddess of flowing water and fertility; wife of Tlaloc, the preeminent rain-fertility deity.
Chantico (In the House)	Fertility goddess with strong igneous associations, merged iconographically with Coyolxauhqui.
Chicomecoatl (7 Serpent)	Calendric name of the maize goddess who presided over agricultural fertility; generally shown wearing a towering paper headdress and holding corn cobs.
Cihuapipiltin (Princesses) (sing. *Cihuapilli*)	Macabre spirits of women who had died in childbirth.
Cihuateotl (Female Deity)	Another name for Cihuapilli.
Coyolxauhqui (Painted with Bells)	Malevolent sorceress and half-sister of Huitzilopochtli, decapitated and dismembered by him at the moment of his birth; usually represented with bells on her cheeks, connoting her name; possible lunar association.
Ehecatl (Wind) *Quetzalcoatl*	Wind god; an important aspect of Quetzalcoatl, normally shown wearing a projecting buccal mask; associated with wind, rain, fertility.
Huehuecoyotl (Old Coyote)	Zoomorphic deity closely connected with Xochipilli, similarly presiding over sensual enjoyments.
Huehueteotl (Old God)	Patriarchal deity of fire. See Xiuhtecuhtli.
Huitzilopochtli (Hummingbird Left)	Militaristic patron god of the Aztecs, often depicted wearing a hummingbird helmet mask with his body and face painted blue and horizontal yellow stripes on his face; an aspect of Tezcatlipoca with solar connotations.
Matlalcueye (Blue Skirt)	Alternative name for Chalchiuhtlicue.

Mictlantecuhtli (Lord of the Underworld)	Preeminent death god characteristically portrayed in full or partial skeletal form.
Mixcoatl (Cloud Serpent)	Stellar hunting god connected with the less advanced hunting-gathering peoples of the north.
Pahtecatl (Medicine Lord)	Important pulque (*octli*) deity; name probably refers to the narcotic root added to pulque to strengthen its intoxicating effect; strong fertility associations.
Quetzalcoatl (Quetzal-feather Serpent)	Major creative, fertility deity with many aspects (Venus god, culture hero, archetype of priests, etc.).
Tecziztecatl (He of the Conch Shell)	Male lunar deity.
Temazcalteci (Our Grandmother of the Sweat Bath)	Patroness of sweatbaths; an aspect of Teteoinnan.
Tepeyollotl (Hill Heart)	Terrestrial fertility deity, sometimes appearing in jaguar form; an aspect of Tezcatlipoca associated with mountain caves.
Teteoinnan (Mother of the Gods)	Fundamental earth-fertility goddess.
Tezcatlipoca (Smoking Mirror)	Supreme deity of the Aztec pantheon, usually painted black with yellow horizontal stripes on his face and a smoking mirror at his temple and/or replacing one foot; associated with sorcery, the night, the jaguar.
Tlahuizcalpantecuhtli (Lord of the House of Dawn)	God of the planet Venus; shares Venus association with Quetzalcoatl.
Tlaloc	Major rain-fertility deity, usually painted black or blue and shown with goggle eyes and prominent fangs.
Tlaltecuhtli (Earth Lord)	Earth Monster typically conceived as a composite, grotesque creature in a crouching position with clawed hands and feet; often carved on the undersides of Aztec sculptures.
Tlazolteotl (Filth Goddess)	Major earth-fertility goddess, iconographically merged with Teteoinnan.
Tonacacihuatl (Lady of Our Flesh)	Female aspect of the bisexual creative diety.
Tonacatecuhtli (Lord of Our Flesh)	Male aspect of the bisexual creative deity.

Tonatiuh (Sun)	Principal name for the solar deity to whom, in theory, all sacrifices were addressed.
Xilonen (Young Maize-Ear Doll)	Goddess of the tender maize plant, generally portrayed as a maize goddess wearing a large rectangular headdress and holding maize ears.
Xipe Totec (Flayed Our Lord)	Fertility deity with strong militaristic overtones, usually represented wearing the flayed skin of a victim.
Xiuhtecuhtli (Turquoise Lord)	Patriarchal old fire god. See Huehueteotl.
Xochiquetzal (Flower Quetzal-feather)	Female counterpart of Xochipilli; presided over feminine activities such as weaving, crafts, and female sensuality.
Xochipilli (Flower Prince)	Youthful god of flowers, feasting, music, sensuality, games, crafts; male counterpart of Xochiquetzal; also solar associations.
Xolotl (Monster)	God of monsters and twins, usually depicted with a canine head wearing the ornaments of Quetzalcoatl.

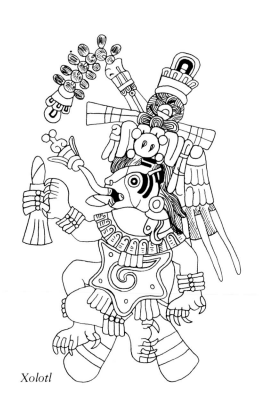

Xolotl

Glossary

Ahuitzotl	Semimythical aquatic creature; used as the name sign of the eighth ruler of Mexico Tenochtitlan, Ahuitzotl (1486-1502).
Amacalli (paper house)	Quadrangular headdress made of stiff bark paper with pleated paper rosettes at the corners worn by maize goddesses.
Amacuexpalli	Pleated bark paper neck fan worn at the back of the head by some fertility deities.
Atl tlachinolli (water-conflagration)	Nahuatl metaphor for war composed of a symbol for water and a "fire strip" signifying burning.
Aztamecatl (heron cord)	Sacrifical cord trimmed with down balls; used, for example, to tie the victim to the stone in the gladitorial combat.
Aztaxelli	Forked white heron feather head ornament; particularly connected with Tezcatlipoca and worn by warriors.
Aztec (person of *Aztlan*)	Name derived from *Aztlan*, the semilegendary homeland in the North, and applied to the migrating ancestors of the people of Mexico Tenochtitlan; widely used as a generic term for the peoples and cultures of late pre-Hispanic Central Mexico.
Cemmaitl	Double maize ears held by fertility deities.
Chacmool	Reclining human figure with its head turned to one side and holding a receptacle on its midsection; first appeared during the Toltec period and continued as an embellishment of Aztec temples.
Chalchihuitl (precious greenstone)	Jade or precious greenstone; usually symbolized as a large circular element surrounded by four smaller circles.

Chicahuaztli (rattle staff)	Long staff with compartments containing seeds or pebbles that was stamped on the ground to produce a rattling noise; particularly associated with fertility deities (Xipe Totec and the maize goddesses).
Cipactli	Zoomorphic image of the earth, represented as a crocodilian monster with a projecting snout; also used as the first of the twenty day signs of the *tonalpohualli*. Cf. Tlaltecuhtli.
Cuauhpilolli	Forked eagle feather ornament worn on the head; particularly diagnostic of Mixcoatl, the stellar hunting god, and deities allied to him.
Cuauhxicalli (eagle vessel)	Vessel for the deposition of sacrificed human hearts.
Cueitl	Simple skirt worn by Aztec women.
Day sign	One of twenty symbols used in combination with thirteen numerals to name the days in the Aztec calendar.
"Demon Face"	Grotesque face composed of a round eye, a labial band, and tusks; used to ornament sacrificial knives and the knees and elbows of the Earth Monster (Tlaltecuhtli) and related deities.
Ehecailacacozcatl (*ehecacozcatl*)	Spiral shaped pectoral formed from a sliced conch shell, worn by Quetzalcoatl and deities allied to him; called a "wind jewel," it apparently symbolized the swirling movement of the wind.
Epcololli	Curved white shell ear pendants worn by Quetzalcoatl and related deities.
Feathered serpent	Rattlesnake whose scales are replaced or covered by the feathers of the quetzal bird; symbol of the deity Quetzalcoatl.
Huehuetl	Upright wood drum with a drumhead of skin, which was struck with the hands.
Huipilli (*huipil*)	Long blouselike garment worn by Aztec women.
Malinalli (twisted grass)	Wild grass often twisted to form a binding cord; also used as the twelfth day sign.

Maxtlatl	Male loincloth usually knotted in front; those of the upper class were made of cotton, those of commoners from maguey fiber.
Mesoamerica	Area of North America extending from Central Mexico into Central America, occupied by the more advanced indigenous cultures.
Mexica	Name for the people of Mexico Tlatelolco, now used interchangeably with Aztec; used at the time of the conquest along with Tenochca.
Mexico Tenochtitlan	Capital of the Empire of the Triple Alliance located in the western portion of Lake Texcoco in the Basin of Mexico; ancestor of present-day Mexico City.
Mixteca	Western Oaxaca, the region dominated by the Mixtec-speakers, noted for their finely crafted, small scale, elite art works.
Mixteca-Puebla	Postclassic stylistic-iconographic tradition, centered in southern Puebla, western Oaxaca, and the Gulf Coast, closely related to the Aztec artistic tradition centered in the Basin of Mexico.
Nahualli	Animal disguise assumed by deities and sorcerers.
Nahuatl	Language of the Aztecs used widely as the *lingua franca* of the Empire of the Triple Alliance; member of the Uto-Aztecan language family.
New Fire Ceremony	Great "world renewal" ceremony that occurred at the end of one 52-year cycle and the beginning of another; celebrated on a hill south of Mexico City called Huixachtlan (modern Cerro de la Estrella).
Octli (pulque)	Mildly intoxicating drink made from the fermented juice of the maguey plant; the word "pulque," introduced by the Spanish, is currently used.
Quechquemitl	Triangular, shawllike garment worn by Aztec women on the upper body.
Standard bearer	Standing or seated figure usually positioned at the heads of stairway balustrades of temple-pyramids, holding long poles with banners in his cupped hands.

Templo Mayor (Great Temple)	Great temple of Huitzilopochtli and Tlaloc in the center of Mexico Tenochtitlan, the preeminent shrine of the Empire of the Triple Alliance.
Teotihuacan	Great ruined city northeast of Mexico City, the site of the major Classic Period (c. A.D. 100-750) civilization of Central Mexico.
Teponaztli	Horizontal wood slit gong struck by sticks.
Toltec (person of Tollan)	Political and cultural predecessors of the Aztecs in Central Mexico, centered at the site of Tula, Hidalgo, during the Early Postclassic Period (c. A.D. 900-1200).
Tonalamatl (book of the day signs)	Divinatory manual containing a pictorialization of the 260-day cycle (*tonalpohualli*).
Tonalpohualli (count of the day signs)	Divinatory cycle of 260 days divided into twenty periods of thirteen days, each section presided over by patron deities.
Triple Alliance	Political confederation of three cities in the Basin of Mexico, Mexico Tenochtitlan, Tetzcoco, and Tlacopan (Tacuba), established in 1433/1434 with the defeat of Azcapotzalco; conquered by Cortés in 1521.
Xihuitl	Turquoise, precious jewel; also the name for the 365-day year.
Xiuhcoatl (turquoise snake)	Composite dragonlike creature with a sectioned body, usually red and yellow in color; often edged with smoke volutes connoting fire, and thus frequently referred to as a fire serpent.
Xiuhuitzolli	Turquoise mosaic diadem worn by Aztec lords; an element in the name sign of the ninth ruler of Mexico Tenochtitlan, Motecuhzoma II.
Yacametztli (nose-moon)	Crescent-shaped nose ornament worn by *octli* (pulque) deities and those allied to them.
Yacapapalotl (nose-butterfly)	Nose ornament in the form of a stylized butterfly worn by Xochiquetzal and deities allied to her.

Yacaxihuitl (nose-turquoise)	Nose ornament, insignia of lords, inserted into a nasal perforation made at the time of their investiture as lords and worn on formal occasions as a sign of rank; also worn by some deities, especially those with igneous associations.
Zacatapayolli	Plaited grass ball into which were thrust the blood-stained maguey spines used for the ritual drawing of auto-sacrificial blood.
Zócalo	Plaza de la Constitución; central plaza of Mexico City, surrounded by the Metropolitan Cathedral, the National Palace, and other government buildings; located one block south of the Templo Mayor.

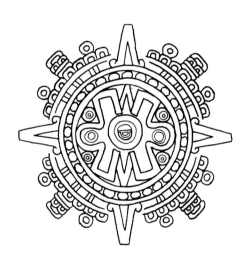

Selected Bibliography

Adams, Richard. *Prehistoric Mesoamerica.* Boston and Toronto, 1977.

Anawalt, Patricia Rieff. *Indian Clothing before Cortés: Mesoamerican Costumes from the Codices.* Norman, 1981.

Anders, Ferdinand. "Minor Arts." *Tesoros de México: Arte Plumario y de Mosaico, Artes de México* 137, año 17 (1970): 46-66.

Barlow, R. H. "The Extent of the Empire of the Culhua Mexica." *Ibero-Americana,* 28. Berkeley and Los Angeles, 1949.

Berdan, Frances F. *The Aztecs of Central Mexico: An Imperial Society.* New York, 1982.

Bernal, Ignacio. *Mexico before Cortés: Art, History and Legend.* Translated by Willis Barnstone. Garden City, 1975.

———. *A History of Mexican Archaeology: The Vanquished Civilizations of Middle America.* Translated by Ruth Malet. New York, 1980.

Boone, Elizabeth Hill, ed. *The Art and Iconography of Late Post-Classic Central Mexico: A Conference at Dumbarton Oaks, October 22nd and 23rd, 1977.* Washington, D.C., 1982.

Carrasco, Pedro. "Social Organization of Ancient Mexico." *Handbook of Middle American Indians,* vol. 10. Edited by Gordon F. Ekholm and Ignacio Bernal. Austin, 1971. 349-375.

Caso, Alfonso. *The Aztecs: People of the Sun.* Translated by Lowell Dunham. Norman, 1958.

———. "Calendrical Systems of Central Mexico." *Handbook of Middle American Indians,* vol. 10. Edited by Gordon F. Ekholm and Ignacio Bernal. Austin, 1971. 333-394.

Coe, Michael. *Mexico.* 2d rev. ed. New York, 1982.

Cortés, Hernán. *Hernán Cortés: Letters from Mexico.* Translated and edited by A. R. Pagden. New York, 1971.

Davies, Nigel. *The Aztecs: A History.* New York, 1973.

Díaz del Castillo, Bernal. *The Discovery and Conquest of Mexico.* Translated by A. P. Maudslay. New York, 1956.

Durán, Fray Diego. *Book of the Gods and Rites and the Ancient Calendar.* Translated and edited by Fernando Horcasitas and Doris Heyden. Norman, 1971.

Easby, Dudley T., Jr. "Ancient American Goldsmiths." *Natural History* 65 (October 1956): 401-409.

Gibson, Charles. *The Aztecs under Spanish Rule: A History of the Indians of the Valley of Mexico 1519-1810.* Stanford, 1964.

———. "Structure of the Aztec Empire." *Handbook of Middle American Indians,* vol. 10. Edited by Gordon F. Ekholm and Ignacio Bernal. Austin, 1971. 376-394.

Keen, Benjamin. *The Aztec Image in Western Thought.* New Brunswick, 1971.

Kubler, George. *The Art and Architecture of Ancient America.* 2d ed. Baltimore, 1975.

León-Portilla, Miguel. *Aztec Thought and Culture: A Study of the Ancient Nahuatl Mind*. Translated by Jack Emory Davis. Norman, 1963.

———, ed. *The Broken Spears: The Aztec Account of the Conquest of Mexico*. Translated by Lysander Kemp. Boston, 1972.

Matos Moctezuma, Eduardo. *Una Visita al Templo Mayor*. Mexico, 1981.

———, ed. *Trabajos Arqueológicos en el Centro de la Ciudad de México (Antología)*. Mexico, 1979.

Nicholson, H. B. "Major Sculpture in Pre-Hispanic Central Mexico." *Handbook of Middle American Indians*, vol. 10. Edited by Gordon F. Ekholm and Ignacio Bernal. Austin, 1971. 92-134.

———. "Religion in Pre-Hispanic Central Mexico." *Handbook of Middle American Indians*, vol. 10. Edited by Gordon F. Ekholm and Ignacio Bernal. Austin, 1971. 395-446.

———. "The Late Pre-Hispanic Central Mexican (Aztec) Iconographic System." In The Metropolitan Museum of Art, *The Iconography of Middle American Sculpture*. New York, 1973.

———. "Revelation of the Great Temple." *Natural History* 91 (July 1982): 48-58.

Pasztory, Esther. *Aztec Art*. New York, 1983.

Prescott, William H. *The History of the Conquest of Mexico*. 1843. New York, 1967.

Sahagún, Fray Bernardino de. *Florentine Codex: General History of the Things of New Spain*. 13 vols. Translated by Arthur J. O. Anderson and Charles E. Dibble. Salt Lake City, 1950-1982.

Saville, Marshall H. *The Goldsmith's Art in Ancient Mexico*. New York, 1920.

———. *Turquoise Mosaic Art in Ancient Mexico*. New York, 1922.

———. *The Wood-Carver's Art in Ancient Mexico*. New York, 1925.

Seler, Eduard. *Gesammelte Abhandlungen zur Amerikanischen Sprach- und Altertumskunde*. Berlin, 1902-1923. Reprint. Graz, 1960-1961. (*Register* by Ferdinand Anders, 1967.)

Soustelle, Jacques. *Daily Life of the Aztecs on the Eve of the Spanish Conquest*. Stanford, 1961.

Stuart, Gene S. *The Mighty Aztecs*. Washington, D.C., 1981.

Townsend, Richard F. *State and Cosmos in the Art of Tenochtitlan*. Washington, D.C., 1979.

Weaver, Muriel Porter. *The Aztecs, Maya, and Their Predecessors: Archaeology of Mesoamerica*. 2d rev. ed. New York, 1981.

Willey, Gordon R. *An Introduction to American Archaeology*. Vol. 1, *North and Middle America*. Englewood Cliffs, 1966.

von Winning, Hasso, and Alfred Stendahl. *Pre-Columbian Art of Mexico and Central America*. New York, 1968.

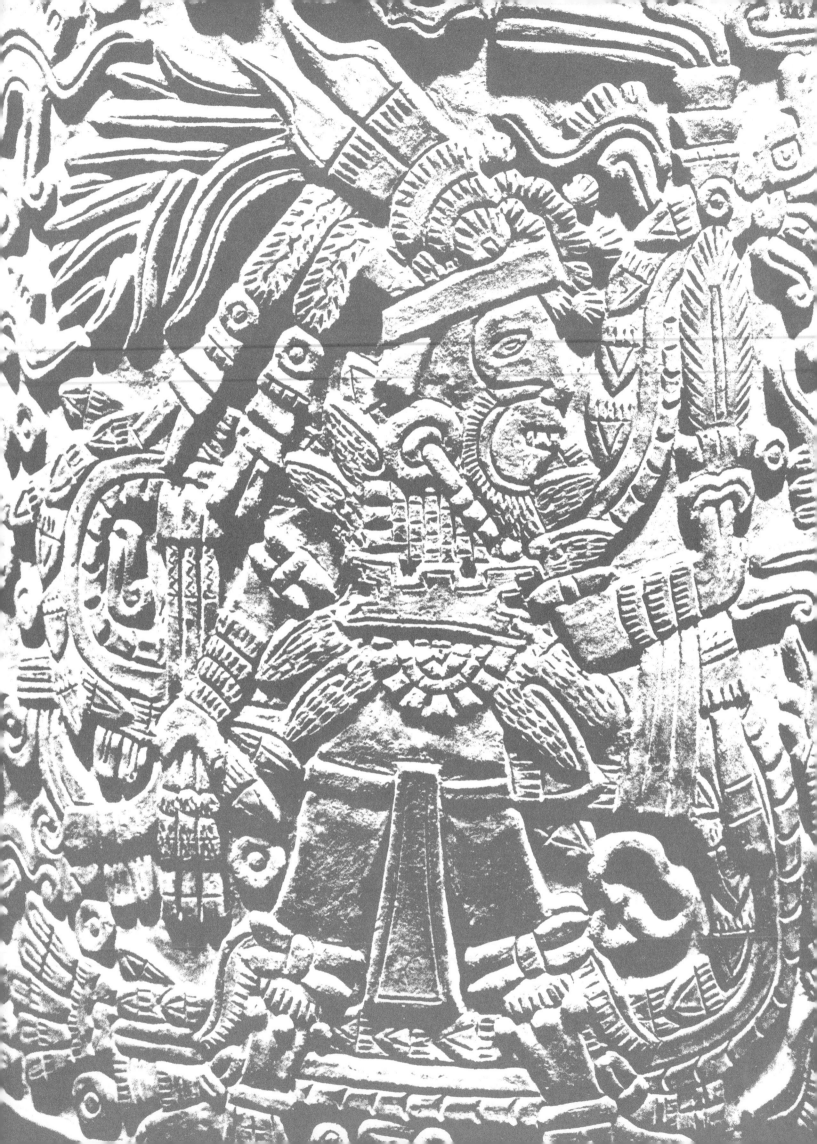